B+T
12.67

The Death and Rebirth of American Radicalism

The Death and Rebirth of American Radicalism

~STANLEY ARONOWITZ

ROUTLEDGE ~ NEW YORK ~ LONDON

Published in 1996 by
Routledge
29 West 35th Street
New York, NY 10001

Published in Great Britain by
Routledge
11 New Fetter Lane
London EC4P 4EE

Copyright © 1996 by Routledge

Printed in the United States of America on acid-free paper.

contents~

preface~

~American radicalism has never enjoyed anything like success, at least in conventional political terms. Yet, from time to time—the first decade of the twentieth century, the Depression era and the 1960s—radicals played important roles in popular movements for economic and cultural reform and were able to occupy significant territories of the imagination. The Old Left socialists and communists were prone to explain away their failure to build a powerful *mass* radical movement, even as they took pride in their achievements in building resistance to government and corporate attacks against individual and group rights to organize and speak freely. Echoing an idea proposed early in this century by Werner Sombart, Aileen Kraditor has recently argued—forcefully I think—that radicals have been stymied by the vigor of U.S. capitalism, not repression, capitalist propaganda, business's control over the means of information, or the internecine wars to which American radical organizations have become habituated.[1] She concludes that workers—the subject/object of the radical imagination until the 1960s and beyond—knew about the radicals and their solutions but *chose* to act *as if* capitalism, for practical purposes, remained the context within which their aspirations would be contained. They joined unions, voted Democrat, Republican, and even Socialist and occasionally participated in militant strikes and social movements. But they decisively rejected the revolu-tionary solutions offered by the left.

Some thirty-five years before Kraditor published her book, Dwight Macdonald, a prominent radical journalist, wrote a long essay on the failure of radicalism in the United States in *Politics*, then one of the most influential non-communist magazines of the independent left. He began *The Root is Man* with this quote from Leon Trotsky: "The second world war has begun. It attests incontrovertibly to the fact that society can no longer live on the basis of capitalism. Thereby it subjects the proletariat to a new and perhaps decisive test."

Trotsky proceeds to conjecture that the war would "provoke a proletarian revolution" not only in the defeated countries as it had following World War One, but in the Soviet Union as well. If, despite the carnage of the war and the demonstrated crisis of the system, the revolution does not occur, he ruefully admitted ("if however it is conceded the present war will not provoke a revolution but the decline of the proletariat"), then there remains the possibility that democracy will deteriorate and a totalitarian regime may rise. Under these conditions, he concludes, "if the world proletariat should actually prove incapable of

fulfilling the mission placed upon it by the course of development, nothing else would remain except openly to recognize that the Socialist program based on the internal contradictions of capitalist society ended as a Utopia."[2]

The rest of the essay opposes a frankly utopian, individualistic, and humanistic radicalism to Marxism's reliance on the contradictions of History. Macdonald's "new radicalism" is unabashedly critical, or at least frank about the chance that the working class may choose to affiliate with the revolutionary aims of the left. His starting point is not History but the self, its subjectivity. He is content to oppose the prevailing Order whether the "masses" want to or not. More than any other document of the post-war independent left, *The Root Is Man* forecasts the actuality of the most radical section of the New Left of the 1960s. While in the wake of the Cold War Macdonald felt compelled to "choose the West," his radicalism remained undiminished.

My own critique of Marxism, *The Crisis in Historical Materialism*, dealt with the theoretical issues and some of the historical failures of the socialist and communist movements, but was not especially concerned with the specificity of the American radical legacy. I had long rejected explanations for the weakness of this legacy that pointed to McCarthyism and other instances of political repression; nor was I particularly persuaded by the argument that the split in the Socialist Party after the Bolshevik Revolution mortally wounded the left. Finally, that the American Communist Party, by far the largest and most influential radical organization of the 1930s, "never thought of thinking of itself at all" and remained until the breakup of the Soviet Union a loyal supplicant of Moscow (in Macdonald and Sidney Hook's terms "The American branch office of the GPU" [predecessor to the KGB]) did not impress me as a sufficient reason for the party's demise after 1956. In fact, I believe the Moscow tie helped the Communists more than it hurt them.

I read Macdonald's long essay in 1982 and decided to address some of the questions he raised. Having been a political activist in the New Left of the 1960s and 1970s, but, like Aileen Kraditor, coming from the Old Left as well, I was concerned to find out what, if any, were the future possibilities for the left. In 1983 I published a two part answer to Macdonald in *Socialist Review* which, in retrospect, seems overly optimistic about the chances for radical revival as a result of the merger of the New American Movement, a New Left remnant of which I was a leader, and the Democratic Socialist Organizing Committee, a fairly large, but nonactivist collection of letterhead names and rank and file socialist sympathizers. In 1993, I wrote a ten year retrospective of that experience and described prospects for a Next Left for the same journal.

This book resumes my own quest. I have drawn some new conclusions, but most important I am persuaded that Macdonald is right: to be a radical does not *in the first place* require a historical estimate that capitalism will collapse. What it requires is the elementary belief that even if the answers remain somewhat elusive,

the prevailing system of political, economic and cultural power, late or advanced global capitalism, is opposed to individual freedom and happiness.

The Death and Rebirth of American Radicalism incorporates a small portion of the 1993 essay in chapter three. Chapter one, in somewhat different form, appeared in *60s Without Apology*, edited by Sohnya Sayres, Anders Stephanson, Fredric Jameson and myself (University of Minnesota Press, 1984), and a portion of chapter four appeared in *Social Postmodernism*, edited by Steven Seidman and Linda Nicholson (Blackwell, 1995). The introduction and chapters two, five, and six appear here for the first time.

As usual my intellectual and personal debts remain large. Ellen Willis read the entire manuscript and made important suggestions, especially in the last two chapters; Jonathan Cutler and Mike Roberts read substantial portions and gave criticism and feedback; Nona Willis-Aronowitz performed vital bibliographical research; David Staples and Mike Roberts were my research assistants for chapter two and David Trend and the *Socialist Review* collective edited the section of "The Situation of the American Left" incorporated into chapter three. Eric Zinner, my editor at Routledge, was instrumental in making some sense of a once unwieldy manuscript, but I take sole responsibility for the results.

introduction~

The Death of the Left

~In late fall 1993, I finally turned to a project which I had procrastinated starting for years: the problem of American radicalism. I say "problem" because the existence of American radicalism has been in question since the great break in the world economic and political environment in 1973, and since one of the most explosive consequences of that break, the collapse of communism. Every time I have told friends about my planned project, the invariable response has been "are you writing a history?" Apparently, to many, the idea of a present and future American radicalism is virtually unthinkable.

Yet, anyone dissatisfied with the current state of affairs must consider the possibility, on political, logical, and historical grounds, of a revival of American radicalism. For the past twenty years, modern welfare liberalism no less than communism has all but disappeared and, remarkably, doctrines reminiscent of those advanced by Herbert Hoover have taken center stage. There are differences: a chicken in every pot and the car in every garage, the characteristic slogan of Hoover's faith in free enterprise, is replaced by the promise of a computer equipped with the latest version of Windows and a CD-ROM. While the "free market" still has resonance for many who are weary of government rules and regulations, we are plied with a vision of a technological utopia in which play displaces work as the mode of life. Futurologist Alvin Toffler has become the resident intellectual of the secular right, whose intellectual discourse has claimed the territory of the imagination. Even the Christian Right no longer pitches its tent on a cornfield but has learned to deliver many of its messages by E-mail.

If radicalism in imagination is implausible, let alone a practical alternative to the kabuki dance that passes for contemporary American politics, then it may be argued that this book is merely an exercise in fantasy. Yet, as the right

learned, imagination is the stuff of which the future is made. If we can imagine a different path than that which appears today as inevitable, perhaps there is a chance
for a new movement for fundamental change to emerge from the ruin of the historical left.

Now, few deny that the traditional *conditions* for popular radicalization are perhaps more palpable than at any time since the turn of the twentieth century. Once again, the terms of economic, political and social life seem permanently altered: all the old arrangements—really compromises—by which the warring classes and groups were able to live together for nearly sixty years, have been abrogated; what some have called the "new enclosures" plague Africa, Asia and Latin America, as hundreds of millions of peasants have been driven from the land and herded into sprawling, gargantuan cities where, frequently, they live on the streets or in hastily built shantytowns; in the economically developed societies such as the United States, the "good" job is rapidly becoming a memory for millions of industrial and service workers, as Capital reorganizes the "labor market" on the basis of low-wage, part-time and contingent labor.

We may extend the metaphor of enclosure for the tens of millions in Western countries who have been permanently expelled and otherwise disempowered by the corporate-controlled technological machine. Even as the publicists of virtual reality and of cyberspace herald the erotic possibilities of computer-mediated communication, the relentless application of information flows to the work-place make of these images a cruel joke for its victims. Increasingly, it is not the radicals who warn corporate high flyers of the dire consequences that may result from unemployment, underemployment and stagnant wages. Economists, themselves victimized by corporate downsizing, are concerned that if present trends continue, the economy may be permanently in recession. More to the point, the long dormant labor movement may have a second wind.

As capital consolidates into fewer, mostly transnational corporations, the old political arrangements cannot be maintained, because they were predicated on an essentially national capitalism. Consequently, conservative and social-democratic governments alike attempt to resolve the contradictions of the welfare state resulting from sagging revenues and widespread capital strikes by dismantling whole sections of it. French public employees strike, and the vaunted European Union trembles. In the United States, all levels of government follow the bewildering shifts in corporate structures by shedding and otherwise reducing the apparatuses of social welfare, especially for the poor, women and children and the elderly.

The boldness of the right's initiatives against state regulation of all kinds, especially of business and of income, is a register of its determination to meet

the challenge of the globalization of capital by reducing state functions to coercion and repression. The pace of change is a measure of the weakness of the popular left of trade unions, the ecology, the women's and black freedom movements. In turn, the once influential ideological left—social democratic and communist groups, the anarchists, and the independent radicals—has virtually disappeared from public view. Its ranks are depleted and its minions are demoralized. More to the point, whereas in the last great global shift of the post-World War One era the left had solutions—reform on the basis of deficit financing and a measure of redistributive justice—now there is barely a margin of hope that some, not all, of the painfully constructed social welfare state can be preserved in some form.

In short, the left has run out of ideas that have even a faint chance of being heard. There seem to be no solutions to the end of the regulatory state, but as I will argue below, the left does not seem to have posed the right questions. For example, it persists in repeating to itself the fiction that there was nothing wrong with left political ideology and program; it was simply defeated by the superior forces of Capital. On the conventional account, the right controlled the media and other means of communications, captured the legislative branch and neutralized the executive branch of the federal government. Transnational corporations simply decided to avoid the constraints of national and local politics, which tended to expect a measure of social justice.

In this book, I contend the reverse. The defeat itself requires explanation, not only in terms of what Capital does, but in relation to the specific history of the various components of the political Opposition. In brief, I argue that the left—both its popular and ideological spheres—functioned, for the most part, as participants in the regulatory state introduced by the Wilson administration and developed by the New Deal and its successors. Far from representing the *alternative* to the liberal welfare state, it became its most fervent defender. When two world historical events conjoined, the eclipse of regulation (including its income support aspects) and the end of the Soviet Union as the institutionalized revolutionary alternative to capitalism, the left was utterly disarmed.

Corresponding to the decline of the left as a relevant political force, its historiography has flourished as never before. From Theodore Draper's *Roots of American Communism*, published forty years ago when the party was on the brink of calamitous splits, to the recent outpouring of work by younger historians, who, through histories of local communists have sought to find a usable radical past through a partial rehabilitation of the Communist Party, the debate about American radicalism is as vital as the movement is dead.[1]

What follows is historical, but not a history in the conventional sense. For instance, I leave the Great Debate about the Communist Party tradition and the lesser discussion of the legacy of American socialism to a separate volume. Instead, after this introductory essay, my story begins with the death rattle of

the American communist movement and the birth of the New Left. I try to make sense of the era of American radicalism following the demise of the Old Left, not by a conventional chronological account, but by a combination of memoir, analysis and dialogue with some of the movements and ideas that once sent terror into the hearts of America's corporate rulers.

The red thread that runs through this book is that there are two historical movements for social emancipation which overlap but are quite distinct: the great movement of the economically and politically disenfranchised *within* the Third Estate, from which the modern struggle for social justice derived and for which revolution and reform signified freedom from grinding poverty; perhaps an equally important result of this movement is the achievement of citizenship within the liberal state.[2] This struggle for decent living standards and for democratic "rights" has dominated the workers movement which, despite its decline, remains the leading force on the popular left. The great combat (and compromises) between labor and capital more or less successfully *marginalized* all other instances of domination: of men over women, of humans over nature, of heterosexuality over homosexuality, the old over the young and so forth. If these questions could not be posed as part of the social question—that is, made consonant with the economic and political struggle for (more) equality—the labor movement made up of trade unions and political parties effectively excluded them from its agenda.

The other movement, which I shall call *cultural radicalism*, contends that the idea of freedom is by no means confined to a narrow political definition. Cultural radicals hold that freedom entails self-management of the body and its environment: reproductive, sexual, labor. In the shadow of the French Revolution, the suppressed work of Sade held out a new vision of sexual freedom. This theme was reiterated and developed by figures like anarchists Emma Goldman and Paul Goodman, the Bolshevik-feminist Alexandra Kollontai and the radical psychoanalyst Wilhelm Reich.[3]

Later, I argue that cultural radicalism also fulfills one of the themes of the early work of Marx: the dream of the "whole man," the idea that social emancipation is not complete without cultural freedom. Alternatives to the ruthless pursuit of accumulated capital which fail to pose the possibility of the full development of individuality inevitably become part of the problem of domination instead of its resolution.

The history of cultural radicalism is not recounted chiefly in the development of the workers movements, but in feminism, radical educational reform, social ecology and sections of the gay and lesbian movement. Although it would be excessive to claim that there is some mathematical law of inverse proportion between social justice and cultural radicalism, I do contend that the wave of cultural radical ascendancy in the United States and Western Europe of the 1960s and the 1970s is incomprehensible without grasping the

significance of the space provided by the Crisis of the marxist and social-democratic lefts. This space weakened the hegemony of the parties over what may be termed the left "public sphere." That is, the ideology of the primacy of class politics over cultural politics was weakened. In this political environment, new social movements gained a more or less permanent footing in the political spectrum.

In every country, the *degree* to which social movements were able to advance their demands on the state, the socialist parties, the traditional popular left organizations and establish autonomous organizations varied according to the exigencies of the country's respective political culture, especially the strength and receptivity of the left. In France, for example, feminism remained a movement of women intellectuals who were unable, even unwilling, to generate a popular following for their ideas. This instance was *overdetermined* by the resistance of the French Communist Party and the labor federation it controlled, and by the narrow base of feminist thought. In contrast, U.S. feminism was abetted by the decline of the left, the emergence of a large and disorganized New Left and the tradition of earlier militant feminist movements which, particularly at the turn of the century, had lifted the issue of women's suffrage to a central political battle, to which socialists as well as modern liberals were obliged to affirmatively respond.

The United States, Spain and Germany were important centers of a world-wide anarchist-inspired education and communitarian movement. In the United States, with the virtual disappearance of the iww by 1930, the anarchists lost most of their political relevance in the conventional meaning of the term. But their influence in education and as utopian thinkers lingered. They started and maintained more than twenty elementary and adult schools, some of which have survived their general decline by the 1950s. Perhaps equally important, for the past sixty years the anarchists, not the socialists or communists, have provided the visionary thinking that influenced the emergence of the New Left, and without which any possible new radicalism is inconceivable.

It was from the spirit of anarchism, not the doctrines of the conventional social justice left that one of the most widely influential new social movements of the post-war era, ecology, emerged. Anarchism's antistatism and scepticism concerning industrialism was sympathetic to the strain in biological thinking sensitive to the consequences of human intervention in nature and critical of technology as the solution to human needs. It is not only that some of the most powerful ecological thinkers of this century—Dubos and Bookchin in particular—were directly influenced by anarchist ideas. What is profoundly radical about anarchism is its emphasis on the power of individuals and their communities to manage their relations to nature and between themselves autonomously. While the history of anarchist thought reveals important intellectual gaps and contradictions between theory and practice, its resolute cri-

tique of the state and its obsessive concern with domination is an indispensable antidote to the underlying authoritarianism of socialism and modern liberalism, neither of which is detained by the evils of bureaucratic domination.[4] These ideas antedate modern ecology's insistence that, despite its specific features, humanity is an intrinsic part of nature and that its estrangement from nature through technology is a violation of its own nature.

~One of the more famous cold war jokes: a man is called into the boss's office. "You're fired," says the boss. "Why?" asks the man. The boss replies, "I've been told you're a Communist." The man protests, "But, I'm an anti-Communist." "I don't care what kind of Communist you are," declares the boss.

For more than seventy years and especially since the Soviet Union emerged during World War Two as the second great military and economic power, until 1990 world politics were dominated by the spectre of communism. Whatever the realities of Soviet foreign policy—it was mostly conciliatory to the West— the very fact of an apparently antagonistic economic and political system, which until the 1970s seemed to be gaining momentum, loomed over capitalism and set the boundaries and the conditions for politics.

Before the Bolshevik Revolution, of course, it had been unsettling to the prevailing powers that progressively powerful socialist and workers' movements had won considerable parliamentary representation and industrial clout in the most economically advanced capitalist countries. But, while parliamentary socialism increasingly pressed for and won concessions from a reluctant capitalist state, the communist parties that emerged after World War One were strengthened by their links to the Great Revolution in Russia and later China and other parts of the post-colonial world.

In every major Western country, including the United States where the Communist Party was painfully weak after 1948, they retained their status as the symbolic representations of a potential world-wide negation of capitalism. It almost did not matter that many communist parties were unable to attract a popular following—in the post-war West, only in France and Italy did the communists succeed in building mass parties which enjoyed a modicum of electoral success. What counted was that they were the national representatives of a powerful international movement and were capable, on certain international issues, of popular mobilizations among all left and antiwar constituencies. The communist parties were activist organizations; members were expected to multiply the party's reach by organizing as much as by ideology.

For example, in the 1930s, the American Communist Party (CP) organized quite potent mobilizations on behalf of the Spanish Republican government and against Roosevelt's ostensible neutrality policy and otherwise led the

antifascist movement in the United States.[5] The CP was a leader of the peace movement, enjoyed considerable prestige in the burgeoning industrial union movement, achieved considerable cultural penetration and was a force to be reckoned with in key black communities such as Harlem and South Chicago.[6]

Whatever its retrospective accuracy, the French CP slogan "Communisme est la jeunesse du Monde" ("Communism is the youth of the world") was taken seriously by both the powerful and the powerless after the success of the Bolshevik Revolution in 1917. Spearheaded by forces who proclaimed the strategy of social reform at best a necessary but temporary detour on the road to revolution, an unprecedented revolutionary upsurge had followed World War One, especially in the defeated countries of Germany, parts of the Austro-Hungarian empire, and in Russia (which, although a member of the winning alliance, had actually been routed by Germany before it was forced by the October Revolution to withdraw from the war). Although most of the insurgencies were beaten back, the Bolshevik Revolution survived civil war, the invasion of twenty-one foreign armies, and mass privation. The newly formed communist parties, especially in Europe, the United States, India, and China, waited confidently if somewhat impatiently for the next opening which would bring them to power.

Many of the parties were led by arrogant, even delusional militants.[7] In Germany this hubris contributed to Hitler's rise to power as the Communists, ensconced in a deeply sectarian phase, refused to work with the majority social-democratic leadership and the mainstream trade unions they led. The fledgling American Communists had as much initial success as most others. After a brilliant beginning, where left-wing dissidents enthusiastic about the Revolution succeeded in winning over a majority of the relatively large Socialist party (especially the Language Federations, as the Socialist immigrant groups were called), the newly formed Communist Party quickly split into two and spent much of the 1920s in fruitless sectarian wrangling. The Communist International stepped in twice, first to unite the two warring wings and then to end debilitating factionalism, and forced the warring factions to make a sort of peace.[8]

It is difficult for many in these days of its apparent defeat to visualize how menacing communism seemed to the established powers and, conversely, how completely the first *successful* revolutionary socialist state, the Soviet Union, captured the hearts and minds of several generations of revolutionaries and radicals. Beyond those who chose to give their allegiance to the communist movement and, especially in Spain, their lives, many intellectuals were, nevertheless, obsessed with the "Russian" question.[9] Even the growing legion of left-wing detractors, most of whom were intellectuals, endlessly debated the virtues and sins of the regime that had emerged from the early tumultuous

years. Had Stalin's thirty-year rule completely destroyed the socialist promise? Or, as Trotsky, the exiled ex-leader of the Bolsheviks, maintained, was the revolution's *permanent* achievement that it had replaced private property in the means of production with a system of state production sufficient to warrant (critical) support of all revolutionaries?[10]

It is true that by 1920, after the revolutionary moment was spent and European and U.S. capitalism entered its period of "temporary stabilization," Lenin urged his followers to work in the parliaments and in the mass organizations of the working class, especially the trade unions.[11] But the Communists always had their eyes on the prize. After the Nazis were defeated, with the help of the Red Army, a series of post-war Communist regimes was installed in the countries of Eastern Europe. In Yugoslavia, the nation's Communists had built their own army, one that whipped the Italians and held the Germans at bay. For this reason—and Tito's independent frame of mind—Stalin could not control them and the Yugoslav Communists were literally read out of the world movement in 1947.

In Greece and Italy, it is conceivable that the communist- and socialist-led partisan forces might have seized political power without the aid of the Russians. While Tito and the Yugoslav Communists chose to ignore Moscow's orders to yield to the British-backed Chekniks, the Italian and Greek parties were more loyal: to honor Stalin's Metternichian deal with Roosevelt and Churchill ceding all territory but a region defined as the Soviets' "legitimate" sphere of domination, the Italian and Greek Communists laid down their weapons; like the French CP, the Italians joined coalition governments with conservatives and social-democrats only to be driven from shared power in 1947.

The American Communist Party grew from seven thousand members in 1930 to about eighty thousand in 1938 on the strength of its affiliation with the world movement, its successful pursuit of a coalition strategy after 1935, and its indefagitable organizing of unions and popular organizations—peace, civil rights, cultural, and local politics—emerged from the war more influential than ever. In 1945, the Communist Political Association, its successor, may have reached close to one hundred thousand members, perhaps a third of whom were activists, and many others of whom were implanted in some of the more important sectors of American life—the unions, the civil rights movement, cultural organizations, especially in Hollywood and among youth. While its independent electoral interventions were negligible—after 1936 it became part of the New Deal social reform coalition—the CP had become something of a force in the Democratic Party, not only in the large cities but even in some farm communities, especially Iowa, Wisconsin, Minnesota, and North and South Dakota.[12]

But by 1950, under the burden of its premature and calamitous break with

the Democratic Party, its isolation from the industrial unions, Cold War inspired government attacks on its legality, and inherent internal weaknesses, the CP was reduced—and reduced itself—to political insignificance. With the revelations of Stalin's crimes delivered to the Twentieth Congress of the Soviet Communist Party in 1956, the American Communists were mortally wounded and, after an incipient reform-wing was all but driven out of its ranks, survived for thirty more years on the sentiments of old militants and the sufferance of the Soviets. By the 1990s, now split in two after the collapse of the Soviet Union, the Communist movement has virtually disappeared.

In its heyday, the American Communists were respected, even courted by the liberal state but despised and feared by their left-wing competitors: the Socialists, whose party had been much larger than the CP, but were eclipsed after 1936 when the CP joined the Roosevelt coalition and became the leader of its left wing, leaving the Socialists out in the cold in splendid isolation;[13] the Trotskyists who also disdained coalition tactics and were especially contemptuous of the Party's theoretical poverty;[14] and by many independents—intellectuals and trade union activists—for whom the Party's international connections and subservience to Moscow were signs that it could never build a genuinely American revolutionary movement.

But the "Russian" question remained at the heart of American radicalism after 1917. Whether Russia was a savior of the world's working class, a "degenerate" workers state as the Trotskyists claimed, a form of state capitalism, or a new oligarchical society, the *fact* of a society claiming to have built socialism and, more to the point, having abolished private ownership of the means of production, captured the imagination of the radicals and sent tremors through the hearts of the Western governments and corporate board rooms.

The American party might have faded into near-oblivion (and with the Sino-Soviet split there was hardly a world communist movement after 1956), but the Soviet presence, and the CP's close ties to its leaders, could not be ignored by business and government, especially intelligence agencies. Despite troubles within the Soviet Union and the Eastern Communist regimes—in 1956 there were workers' uprisings in East Germany and Poland and a reform-minded socialist revolution broke out in Hungary which was snuffed out by Soviet tanks—there were also acknowledged signs of communist ascendancy: the Chinese, Vietnamese and Cuban revolutions; and the influence of the Soviet Union in the post-colonial countries of Africa, the Middle East, and Latin America.

In fact, by the early 1960s, in the Soviet Union it was generally believed that post-war U.S. global hegemony was nearing an end. If Moscow was losing some ground among its direct client states in Eastern Europe, its influence among such important states as Egypt and India and among several newly founded African nations was growing. These circumstances enhanced the pres-

tige of the U.S. Communist Party and independent leftists oriented to China, Cuba, or Vietnam. In an era when domestic politics seemed driven by the Cold War, those who spoke the language of communism and Marxism were accorded extraordinary recognition from the prevailing powers. The very conditions that limited the growth of the post-war welfare state in the United States—the Cold War-generated permanent war economy—also protected the gains made by workers and popular forces. The Bolshevik Revolution might not be repeated in any Western country, but after the Depression visited mass suffering, Capital was no longer able to survive without a new social contract with the organized working class in America as well as Europe. Highly unionized, with the help of the radicals, post-war industrial workers demanded and got a measure of justice through collective bargaining and New Deal legislation. On penalty of mass radicalization, the liberal states of Europe and the United States could no longer avoid making a more or less permanent agreement with their working classes. However weak in its U.S. incarnation, the welfare/warfare State, which by 1960 provided one fourth of all U.S. jobs and dispensed cash benefits to a wide swath of the population (as much as a third), was as indispensable to the American social and political landscape as it was in Western Europe. And, like in Europe, a political underpinning of its survival was the spectre of communism, the prevailing signifier of radicalism.

The strength of the labor movement was sufficient to restrain the most destructive impulses of the powerful conservatives. The conservative Eisenhower administration held the line against extension of the welfare state (except the federal highway program), and Richard Nixon dismantled many, if not all features of the antipoverty program. But, in the wake of the black uprisings of the 1960s, Nixon then initiated affirmative action to forestall a vast expansion of funding for black and working class public education. As late as the 1980s, even as his administration was trampling on traditional trade union rights, the arch-conservative President Ronald Reagan found that the road to dismantlement was strewn with thorns. After promising to dismantle the New Deal, and to reinstall the "free" market in services and goods, he was forced to abandon his boldest initiative, the reduction of Social Security benefits, and he even trod lightly on Aid to Families of Dependent Children, the core of the public assistance program. Like Eisenhower and Nixon before him, Reagan did as much damage as his administrative powers allowed.

Perhaps the Reagan administration's most important achievement was to have radically transformed the rhetorics of politics and the policy agenda. For even if Nixon spoke free market talk, it was just too early to completely obliterate the compassionate state. Reagan succeeded where others failed in part because his was a truly ideological presidency. But he was finally obliged to observe the status quo in social policy, at least in categorical terms. Eight years of Reaganism left most of the welfare programs weakened, but intact. Rea-

ganism's most visible warrior, Budget Director David Stockman, resigned in fury because he fervently believed the president had blinked in the wake of his clear mandate for conservative leadership.

Even the most reactionary Republicans seemed to lack the political will to reverse a half-century of social policy. While the Bush administration actually turned up the heat on liberal cultural politics and managed to preside over the further erosion of the welfare state, by 1990 there was a strong feeling that the Reagan Revolution had been spent and the way was clear for a new era of modified social liberalism and progressive social policy, especially to repair the seriously crippled health care system.

Although this reluctance can be ascribed to the Democrats' domination of Congress, by the mid-1970s the Democrats had shifted significantly to the right and were openly discussing the need to gradually reduce "entitlements." But the Cold War, as much as traditional New Deal liberalism, must be given credit/blame for the devolutionary rather than revolutionary pace of dismantlement. Under the shadow of communism, mass unemployment, homelessness, and hunger had become morally unacceptable. When the Soviet Union disappeared, the moral as well as political climate rapidly shifted to a new social Darwinism. The pent-up rage against the poor, shared between the rich and the middle class, was given full vent by the right-wing triumph in the midterm elections of 1994. And, with the absence of even a genuine social-democratic left in the United States, the pace of deterioration became incredibly rapid.

When, with the crashing of the Berlin Wall in 1989, Soviet Communism began its brief but steep descent into history, the stage was set for a massive counterattack by Capital and the conservative forces, which in the Cold War era had been obliged to stipulate many elements of the "social wage"—social security, unemployment compensation, and the more recently enacted Medicare and Medicaid programs. Even as centrist Democrat Bill Clinton boldly advanced the proposition that the end of communism had made room for a new round of social programs, particularly the long-awaited universal health care, the right was already setting a new agenda for national politics. Contrary to the fervent hopes of many that the end of the Cold War would produce a "peace dividend" by freeing once sacred military funds for social programs, the right was poised to take effective, if not ostensible, control. When Clinton's health care plan was shipwrecked, the now ideologically hegemonic conservatives grabbed the reins of political power and began, in earnest, to fulfill the promise of the Reagan revolution.

~Of course, what remains to be explained is the decline of communism itself. The first point to be made is that the same forces that have utterly transformed

the face of world economic and political power, including the precipitous decline of workers and other popular movements, account for the demise of Soviet power. I do not want to demean the significance of the internal contradictions within the communist regimes for their ultimate collapse. But the spectre of communism must be taken as one of the internal contradictions of capitalist powers as well. In the United States the peril of Soviet power became an occasion to build an unprecedented peacetime military colossus. In the name of fighting communism the federal government poured billions of dollars into the development of science and technology, much of which was not for military use. Federal aid to public education at all levels was vastly expanded after the Soviets put a rocket in space, and government contracts provided profits for corporations and millions of well-paid jobs for American workers.

Consumer society is an idea antedating the Russian Revolution, and state regulation is not directly linked to the Cold War. But who can doubt that the huge military budgets of the 1946–1980 era provided a large chunk of the income required to fuel the credit system that sustained high levels of mass consumption? Consumerism (which historians Warren Susman, William Leach, Emily Rosenberg, and Stuart Ewen trace to the introduction of mass production, advertising, and the concomitant growth of the retail trade at the turn of the twentieth century) became a characteristic feature of post-war U.S. capitalism with the help of the Cold War.[15]

Here I can only sketch the main elements of the new world we have entered. In the early 1970s, U.S. capitalism had reached the end of its long wave of economic expansion, which began with the rearmament of the leading powers in 1938 and ended when Europe and Japan once more became global economic players by the late 1960s. During this period, the labor movements of Western Europe accepted very modest wage agreements in the service of Capital's urgent need for renewal. By the late 1950s, Europe joined the United States—which did not suffer the economic vicissitudes of war to the same degree—in the Fordist cornucopia of production and consumption. In this regime of "organized" or regulated capitalism, wages were umbilically tied to labor productivity and to mass production and a liberal credit system that allowed nearly anyone with a steady job to own a car, buy a house, and send the kids to some kind of higher education institution. At the same time, European capital was obliged to yield to labor's demand for an extensive welfare state, including a substantial measure of income security against the frequent recessions that accompanied rapid but fitful economic growth.

By the 1950s, in the Soviet Union and its client states the Cold War imperative to maintain full military preparedness combined with working-class demoralization (produced by the infinite postponement of the promised socialist prosperity) to create conditions of near-crisis in the Soviet Union and

the Eastern countries. The containment strategy of the U.S. government, of which the creation of the permanent war economy and global military interventions were centerpieces, may not have been sufficient to topple the communist states, but they were enough to prevent the Russians from "delivering the goods" and from pillaging their allies.

Following the wrenching events of the late 1950s, in order to forestall disaster, Stalin's successors and the more "liberal" East European Communist regimes—Hungary, Poland, and Yugoslavia—moved decisively toward at last fulfilling the promise of higher mass living standards by abandoning forced industrialization in favor of providing consumer goods. But having poured almost all of their capital on heavy industry and arms in the 1930s and 1940s and having actively discouraged innovation in consumer products, the Communists lacked the technology and industrial efficiency to produce these goods, including food. The rise of living standards was financed by substantial loans from the World Bank and other Western financial institutions. Abetted by heavy borrowing, in the 1960s and 1970s nearly all Communist countries—including the Soviet Union—experienced a surge of consumer spending, and in some cases actually entered the once distant shore of consumer society.

Three countries were especially prominent in this trend. The independent Communist state Yugoslavia accumulated $22 billion in debt, Hungary about $10 billion, and Poland $30 billion or about $1000 per capita. For the first time in decades, at least in the major cities, stores were full of goods, many of which were imported, and the new class of managers and professionals began to purchase private cars, buy condominiums, and travel abroad. Many ordinary workers could, for the first time, procure low-interest loans to purchase private goods. Meanwhile, the agricultural crisis festered and became one of the cornerstones of the regimes' demise.

The period of Eastern European prosperity proved extremely short. The 1973 world energy and food crisis signaled the beginning of a major restructuration of capital away from its national moorings into a new era of transnationalism. Faced with worldwide overproduction, profits began to tumble. High wages, higher prices for oil demanded by OPEC and the continuing burden of taxes to pay for social benefits prompted Capital to undertake the first major restructuring since the turn of the twentieth century.

In order to reduce costs, capital decided to discipline the still-crucial Western working class. Corporations began to pull their capital from the high-wage Western countries to low-wage regions of the world. As corporations became global, tax revenues to national states fell, posing the question to all parties of government as to whether the welfare state remained feasible and if so, to what extent? The World Bank called in the debt in Eastern Europe, Asia, and Latin America, warning that to renegotiate and restructure the terms of

repayment let alone obtain new funds depended on whether the recipients were prepared to introduce austerity measures designed to discipline their populations by, among other things, curtailing wages and tightening the credit system.

Recall, as the decade wore on, inflation became a worldwide concern as investment lagged seriously behind rising demand, especially for energy resources, food, and real estate. Capital was busily engaged in global reorganization, intensifying mergers and acquisitions so that large corporations held even greater economic power. Faced with glutted markets, Capital turned inward, and literally imploded its own system. It greatly intensified its concentration and centralization. Much of this investment was unproductive of new goods, technologies, and services.

In the face of stagnation and decline in the world economy, productive investment in the two decades after 1973 was concentrated in the employment of labor-saving technologies in the workplace, particularly labor-saving computer-mediated processes. As millions of workers were expelled from factories, qualified labor of all sorts was being trained and employed in new industries such as communications, and as the technical cadre for the computerization of factory and office. Once esoteric processes, even science fiction staples, Computer Aided Design and Manufacturing (CAD-CAM), lasers, numerical controls, and robots became routine technologies of steel, auto, and machine tool production. Vast quantities of labor, including professional and managerial employees, were made redundant.

Although the destruction of more than six million mostly high-paying jobs in the 1970s and 1980s potentially cut into living standards, the temporary growth of retailing and financial services prevented the reduction of the *family* wage; the effect on living standards of the decline of factory jobs was offset by the entrance of large numbers of women into the clerical labor force in these growth sectors. But, the expansion of women's work also proved to be short lived. Signalled by the Stock-Market Crash of 1987, hundreds of thousands of women lost their jobs, as corporate mergers in banking, insurance, and retailing sharply reduced the need for administrative labor. Moreover, word processing and electronic telephone answering, both computer-mediated processes, replaced the file clerk, typist, and receptionist in all major offices.

At the same time, at least for the European countries, the concentration of capital eliminated many enterprises spelled rising unemployment and began to put strains on the extensive welfare state which, by this time, had extended considerably to include long-term income guarantees for laid off workers. Transnationalism is nowhere more extensive today than in Western Europe. Nationally based traditional industries such as French and British steel, British cars, and Belgian machine tools were deemed redundant in the context of the

emerging European union. National governments were unable or unwilling to recapitalize the nationalized sector in industries such as mining, and Capital refused to upgrade such arcane industries as those that cluttered the English midlands. By the 1980s, the British steel, car, and mining industries were sharply reduced, the great Lorraine region of French steel entirely shut down and the nation's textile industry reduced to specialties. The socialist governments of the 1970s and early 1980s were saddled with the unenviable task of being bringers of sad tidings. The Labour Party presided over the deindustrialization of Britain; by 1979, British conservatives were back in power. Although the Socialist president of France, François Mitterrand (first elected in a landslide in 1981), lasted through the 1990s, his reform program was all but dead by 1983.[16]

In the wake of this restructuring and the collapse of the Soviet Union under the weight of corruption and social stagnation, transnational capital has found little incentive to maintain its commitment to the historic compromise and its product, the welfare state. It simply refused to honor let alone renew the social contract with labor in most of the countries where the welfare state prospered after the war. Although the United States is probably one extreme and Germany and Sweden the other of differential responses to the new situation, Thatcherism, perhaps the most resolute of the conservative efforts to break the deal, has become a global model. But, since the British Labour Party retains some residual strength, the leadership in the wholesale dismantling of the welfare state (which includes undoing the rules governing labor relations established during the 1930s and breaking the back of popular legislation prohibiting race and sex discrimination), has fallen to the American right.

We live in an era of a true paradigm shift in world relations of economic and political power. It is not simply that the left—communist and noncommunist—"lost" a series of decisive battles. The very *conditions of possibility* for a politics of social justice on the basis of the historic compromise between labor and Capital have been destroyed, for the viability of social reform as a political strategy of labor was more or less assured by the era of capitalist regulation. By "regulation," I refer not only to the Keynesian policies of state economic intervention. More pertinent was the articulation of wages to productivity and to mass production, generally known as "Fordism." Under the regime of regulation, the labor and popular movements could rely on a system of social compromise undergirded by government regulation of labor relations, income-generating social welfare benefits and the institutionalization of the permanent war economy engendered by the Cold War.

What I call the "popular" left—principally unions, civil rights and women's organizations and the environmental movement—has, in the main, proven unable to mount resistance to what amounts to a historical reversal of the Deal. Faced with oblivion, many within the popular left have selected to

retreat and give back many hard-won gains as a means to insure organizational survival. Before the election of John Sweeney as AFL-CIO President in 1995, the labor movement had, in the main, turned its back on the working poor and the unemployed, leaving them vulnerable to attack without a shield of legitimate political power. At the same time, with the partial exception of pensioners organizations, labor and most popular movements have offered only token resistance to the corporate and right-wing onslaught against the welfare state.

The astonishing rate of change reflects the weakness of the popular left, especially ideologically. White and black workers are at each other's throats, men and women are arrayed into hostile camps and the old are abandoned by some of the young who, animated by the decline of living standards and the illusion of immortality, have become more sympathetic to arguments for reducing or eliminating the Social Security program. A significant fraction of male white workers and the middle class see the "government" rather than Capital as their enemy. "Government" is in many cases a stand-in for blacks.

Yet, there is a genuine division between the private and the public. Many Americans have conflated the public with large bureaucratic agencies of government which stand in polar opposition to the powerless individual. The idea that public facilities such as parks, schools, and wilderness areas are a social good has eroded in the wake of the perception that these amenities are barriers to the property rights of smallholders and to economic opportunity. Public sector employees are under unprecedented attack, and cities and states rush to privatize vital public services such as sanitation and education under the sign of lower costs and higher efficiency. Some states have virtually dismantled their oversight mechanisms, including planning and inspection agencies charged with protecting the public trust.

It is too easy for some on the left to confine their explanations for these changes to positing a right-wing corporate conspiracy to rob the people. While it would be naive to believe that antigovernment sentiment is entirely spontaneous (witness the right's capacity to mobilize a barrage of telegrams, faxes, and telephone calls on demand), to ascribe the totality of the privatization movement and antifederalism to manipulation is equally erroneous. As I explore in chapter two, in comparison to the idea of social responsibility through government intervention, the ideals of local control and individual initiative have as long and perhaps more powerful a history in American political culture and are shared widely, even among many who are otherwise socially liberal or radical.

~In fact, what we are witnessing in the United States and Western Europe is the decline of welfare state leftism as distinct from the other great strain, social

and cultural radicalism. Since the advent of organized capitalism at the turn of the twentieth century, and its enormous growth during the New Deal and after the war, popular movements have tended to put forward their demands for economic justice in terms of the regulation framework. The older radical tradition of antistatism suffered almost complete eclipse by the time of the Second New Deal (1935–38) as the ideology of government as the guarantor of economic justice captured the imagination of immiserated workers, professionals, and poor farmers. During the regulation era, the authority of the executive branch of the government far exceeded that of Congress and of state legislatures, which were seen by many as strongholds of "special interests": the antediluvian forces of Southern racism, Big Business, big farmers, reactionary religious lobbies, and the self-protecting professional organizations such as the American Medical Association.

In contrast, under Roosevelt, Truman, and Lyndon Johnson, the federal government presented itself as the creator and guardian of a caring society. The left, ever critical of modern liberalism for its penchant for war preparations and its vaccilation on labor and the civil rights movement's social justice agenda, nevertheless put its ultimate faith in the president and his administration rather than the people's representatives in Congress, most of whom were generally viewed as clients of the special interests.

As I argue in the next two chapters, the most dramatic departure of the New Left of the 1960s was to have rejected two of the cardinal features of the Old Left: its preoccupation with the Russian Question and its unadorned statism. While anti-imperialist and profoundly involved in the black freedom movement, the young radicals who came to maturity in the first half of the 1960s were sharply critical of the bureaucratic administration of the welfare and educational systems, suspicious of the motives and commitment of the Liberal Establishment and disappointed in the labor movement. They became convinced that the old communist and socialist lefts had become hopelessly integrated into the prevailing social order.

The main organizations of the new radicalism, in the first place the Students for a Democratic Society, were unable to sustain themselves as a significant post-university movement. What did not die was the political culture of identity rather than class politics and the strong commitment to radical democracy that it spawned. Although the feminist, ecology, and gay and lesbian movements of the late 1960s, 70s and 80s were not direct outgrowths of the New Left—indeed, second wave feminism emerged through its critique of New Left sexism—their more radical expressions were consonant with its political culture. In the case of radical feminism, the connection is direct, even by negation. The other new social movements openly adopted new radical ideas of direct democracy, direct action, and the beloved community. These themes are developed in the chapters on the New Left, the chapter on ACT-

UP, and the final chapters as well.

In this book I argue that if there is to be a rebirth of radicalism it would have no alternative but to revive the critique of political and economic liberalism and affirm the participatory democratic themes of the New Left. Like the New Left it would declare its independence from the legacy of the socialist and communist movements, without emulating the New Left's blithe refusal to address theory and history. My modest proposal to abandon the term "left" in favor of the more inclusive and accurate term "radicalism" depends on two closely related propositions: that the best moments in the history of the U.S. left were those when the movement invented an indigenous designating language of social transformation and linked itself to the older American radical traditions as well as those of Europe; and that radicalism is capable of recalling the best of the old left without being imprisoned in its specific histories.

The last chapter offers no neat recipes for rebirthing American radicalism. But it does offer an account of the conditions of possibility of a Next Radicalism, more historically and intellectually self-reflexive than the New Left, less doctrinaire than the Old Left and acutely aware that the burning question for radicals is whether they are prepared to rethink their past and future, to boldly acknowledge that the problem is not one of "losing," but of *refounding*. In this mode, no task looms larger than the urgent need to say farewell to the identity politics of workerism *and* of various nationalisms and abject identities without surrendering the radical core of historic demands for freedom.

When the New Left Was New

~In the quest for making sense of what often appears to be a bewildering flow of contradictory events the historian tends to search for order by means of periodization. You might say this often obsessive activity follows John Dewey's judgment that the "quest for certainty" is among the leading themes of modern science. Unhappily neither nature nor human history has been particularly obliging, at least in the twentieth century. While it is possible, say, to speak of the capitalist "stage" of development, the "epoch" of monopoly, late or organized capitalism, the "fascist" or the "New Deal" era, the age of the bourgeois or "proletarian" revolutions, these characterizations may not tell us how the various actors within these periods experience the time.

In fact, only if we regard time and space as absolute can periodization help us grasp how specific groups and individuals engaged with the period in question. While I would not want to deny the value of periodization—surely anyone who would deny or disregard the effects of transnational capitalism on the world in which we live would have to be considered somewhat naive—the issue is whether this level of description and the analysis that accompanies it is both necessary and sufficient for grasping the character of social life.

Since Henri Bergson's *Time and Free Will* (1889) and Ernst Mach's equally influential *Science of Mechanics*, the Newtonian concepts of absolute time and absolute space have been challenged and, in physics, overturned. Einstein's theory of relativity, Edmund Husserl's and Martin Heidegger's explorations of phenomonology of what Husserl terms "internal" time consciousness, and Ernst Bloch's provocative notion of nonsynchrony are efforts to grasp how individuals and groups mediate and modify macro-social ideas like epoch, era, etc.[1]

These writers have argued that time is a relational category. Bloch showed that in the fascist time, the lived experience of social groups was nonsynchronous, that their relation to the prevailing political order could not be explained

in purely class or ethnic terms. For Bloch the category of *generation* helped understand why young people experienced the political system differently than their elders. Bloch argues, in effect, that people inhabit different *worlds*, or "nows," even as they exist in the same moment of (absolute) time. From these suggestions, we may understand the social movement of the 1960s nonsynchronously.

My 60s did not begin until 1962. I had been living in a different Now, the worlds of the trade union movement, peace and community organizing, and reform Democratic politics. These were the "nows" of the activist late 50s, a time which saw the rise of a new Southern-based civil rights movement, a Northern struggle for black community empowerment, and a middle-class peace movement which was not unlike the nuclear disarmament campaigns of the early 80s. The civil rights movement had just entered its civil disobedience stage (lunch-counter sit-ins and freedom rides) but was still five years away from "black power," despite the respected but largely ignored voice of Malcolm X. I rode to Maryland to desegregate two lunch counters on the Eastern Shore. Many of us picketed Woolworth's. For perhaps the majority on those lines—mainly college and high school students—this was their first dose of activism.

The early years of the decade remained suffused with the culture of the 1950s. Rock and roll—an urban adaptation of the rhythm and blues music of the black migration—had emerged, but Dylan was still playing acoustic guitar and the Beatles were barely visible in Tin Pan Alley. The "high" culture of the post-war era dripped with modernist sincerity and literary intensity, much of it derived from the American assimilation of French existential thought, in the first place that of Albert Camus and Jean-Paul Sartre, and that peculiar moralization of Marxism associated with the *Partisan Review*.

For the most part the Beats who gathered at the Cedar, the White Horse, and other bars in Greenwich Village remained enraged suburbanites, and their energy, too, was channeled into rage, despite the weariness often attributed to them. Columbia alumnus Allen Ginsberg fulminated against a society that could reduce the "best minds" of his generation to drugged impotence, and the massively oedipalized Jack Kerouac, finding no home to replace Lowell, Massachusetts, returned to his mother. Clellon Holmes produced *Go!* and promptly vanished into college teaching. Like so many of the literary landmarks of the late 50s, his novel turned out to be a brief candle-light rather than a sustained flame that could guide a movement. In fact, only Kerouac, Ginsberg, Diane DiPrima, and San Francisco poet Lawrence Ferlinghetti survived the Beat movement. Most of their comrades literally sat out the 60s; by the late 50s their rebellion had degenerated into the cynical affectation characteristic of most failed romantic politics and art.[2]

For most intellectuals *Partisan Review* was still the measure of critical thought, even though its representative figures had long since abandoned the

journal and been replaced by writers like Susan Sontag, for whom the tradition spawned by Philip Rahv and William Phillips had passed and whose revival awaited the cascade of memoirs, intellectual histories, and biographies that appeared twenty-five years after what became commonplace to call the Golden Age of radical letters. For the succeeding generation, of which Sontag was surely the representative figure, preferred the high cultural aestheticism of Lionel Trilling, which had already been torn from the its original soil of revolutionary commitment, over the remnant of Marxism which still animated Rahv, Greenberg, and some other Founders. As it turned out, the 60s marked the end of *PR*'s intellectual hegemony; a new generation of literary and political intellectuals, but not Sontag, came to spurn its High Modern disdain for popular culture.

Although *PR* had long since abandoned any hint of revolutionary or radical politics, 1952 marked the official end of the rebellion; in the symposium "Our Country and Our Culture" some of its leading lights declared that the U.S. environment for literary and intellectual culture had vastly improved since the war and, with some discomfit, officially ended their internal exile and cautiously joined the American celebration. That this declaration occurred at the height of the Cold War's period of political repression of dissent made the document all the more remarkable. With the exception of Norman Mailer's refusal to climb on the bandwagon of comfortable literary liberalism, the rest heaved a collective sigh of relief at having been able to come in from the cold.

The 60s proved unkind to the intellectuals grouped around *PR*. In a period of popular radicalism which rejected their fervent anticommunism and equally passionate hatred of popular culture, they found themselves, to their own suprise, on the right, or worse, consigned by the young to irrelevance. For Phillip Rahv, the political implications of choosing the West proved, in the long run, unacceptable, so in the early 1970s he started his own magazine, *Modern Occasions*, which expired with his death. Others, notably William Barrett and Sidney Hook, remained unreconstructed. But William Phillips, ever the survivor, attempted to solve the problems entailed in making peace with the Establishment (or, as in the case of Clement Greenberg, becoming part of it), by inviting younger, hipper writers such as Sontag, Marshall Berman, and Steven Marcus to provide a pole of internal dissent to the magazine's rightward drift. Meanwhile, sometime *PR* contributor Irving Howe ventured in the space left by the integration of the review into the conservative mainstream to inaugurate *Dissent*. But, while Howe and his associate Lewis Coser distanced themselves from the more vociferous anticommunists like Hook, it was not enough to prevent their own disdain of the New Left, not merely its refusal of anti-communism, but also what was, for them, its dubious cultural politics.

Before 1962, I used to hang out at the White Horse, where I gazed at Delmore Schwartz dying at his corner table, laughed at Brendan Behan's drunken tales (not realizing that he too was about to expire), and listened to the earnest

conversations of the refugees of the political intelligentsia who had remained in the cities amid the general white suburban exodus of the 50s. I was part of the group of young trade union organizers, some of whom had quasiliterary pretensions. Some of us worked for a living in offices and factories. Others were organizers for the Garment Workers Union, which was then trying to revive itself by importing intense young radicals into the movement. Gus Tyler, the former leader of the revolutionary faction of the Socialist Party and now director of the union's Training Institute, knew then what labor leaders have still not learned: that rank-and-file mobilization is impossible when the members and the bureaucrats live in different worlds. Tyler's experiment, in what might be called John L. Lewisism—inviting your antagonist to participate in a Great Crusade on condition that the Other be content with glory without Power—failed under conditions of Cold War liberalism and the bureaucratic nightmare that had become the labor movement. A corps of talented and angry organizers who resembled the Beats in demeanor, but who did not write, were recent college graduates seeking a Vocation to replace the routinization of the traditional professions. But Gus Sedares, Ted Bloom, and Bob Wolk were simply unwilling to go along with the programs of top-down unionism unless the leadership permitted them to take the class struggle to the growing unorganized sector of the industry. What they failed to grasp was that accomodation had sunk deep roots into the psyche of the trade union bureaucracy, indeed that it had become a way of life, not just a set of practical measures to save a dying industry.

Sedares was frustrated in his efforts to push the sclerotic ILGWU towards a militant, aggressive organizing campaign, but he found an alternative outlet for his remarkable talents. He scandalized the old socialists who dominated the union not by mobilizing the rank and file, for the concept of an active membership had long since disappeared from the union's lexicon, but by organizing his fellow staffers into the first Federation of Union Representatives (FOUR). Sedares argued that if the union had lost its vision of class struggle, let alone that of a new society, it could at least pay its cadre a decent wage, provide good benefits and tolerable working conditions. Today, the "union within a union" idea has gripped the masses of tired trade union functionaries. The staffs of many international unions have organized for collective bargaining. Of course, the Garment Workers remained an open shop. As far as their staff representatives were concerned, the house David Dubinsky built adhered to the principle of self-sacrifice.

The Training Institute is disbanded but an important truth survives it: that unions cannot hope to become a major force in American life until they attract the most dedicated among young radicals *and* transform themselves into democratic organizations. On the other hand, it may be argued that the new social movements emerging in the 60s were defined by their departure (in a double sense) from what C. Wright Mills called the Labor Metaphysic. The generation

of the 50s still saw the labor movement as the lightning rod of global social trans-formation; their hopes were framed within the heroic visions of the struggle against capital, by the romantic idea of the self-emancipation of the toilers. Although the student movement of the time retained some reverence for the labor movement's potential might, most had few illusions about the trade union leadership.

The McCarthy era, the obvious deterioration of the labor movement's mili-tancy, and the advent of consumer society failed to daunt the small band of rad-icals who downed gallons of beer every Friday at the White Horse. How appro-priate it was that they should jostle in that packed room with the Beats and the veterans of an already eclipsed literary radicalism, a literary radicalism which had not been destroyed by the anti-Soviet denouement of the 30s alone. Its final resting place, of course, turned out to be the graveyard known as the Congress for Cultural Freedom and its journal *Encounter*, if it wasn't *Commentary* or the *Partisan Review* of the 50s. Max Eastman, perhaps the greatest of all radi-cal journalists and editors, ended up writing for the ultraconservative *Reader's Digest*. James Burnham, author of *The Managerial Revolution*, resigned from the *PR* board, which despite its own anticommunism was not prepared for his unapologetic defense of Senator McCarthy.

There were exceptions to the rightward drift, some attempts to keep a dis-tance from the Irving Kristols and the Sidney Hooks and other people for whom Stalin's betrayal had proved once and for all the superiority of liberal democra-cy over any possible revolutionary socialism. Norman Mailer, a participant in the 1952 symposium, maintained his distance from the ex-radical intellectuals. He remained for at least two more decades a critic of American state policy and a sympathizer of the young. There was also the small group around *Dissent*, which had been founded by Irving Howe and Lewis Coser in 1954, and the even smaller group following *New Politics*, Phylis and Julius Jacobson's attempt to preserve an independent left socialist presence in intellectual life.

From one perspective, Howe's position resembled that of the emerging con-servative/liberal majority among the formerly radical intellectuals. He concurred with the prevailing judgment that however egregiously awful capitalism remained, Stalinism and, by extension, Eastern Europe and China represented a worse alternative. Nonetheless, Howe retained his faith that democratic socialism could provide a "margin of hope" that we could overcome the antinomies of liberal exploitation and totalitarianism, even as most of his peers lost faith altogether in the visions of an organized left.

The American Communist Party had broken apart following the post-Stalin crisis within the world communist movement, a crisis which had become acute with Khrushchev's famous report to the twentieth Soviet Party Congress in 1956 which skimmed the surface of Stalin's crimes, but was a bombshell never-theless. Most young radicals, however, were relatively unaffected by this devel-

opment since the American CP had virtually gone underground in the 50s on the assumption that the political repression at the time was a dress rehearsal for fascism. Some, including myself, had been sympathetic to the party but remained troubled by its ideological conservatism and strategic caution. We were moved by the internal party debates and the concomitant slowly leaking information about Stalin's crimes, and were taken aback by the clear errors of the party's left. Our desire for some kind of radical affiliation was considerable, but it made no sense to join the decimated CP then, especially since the "right wing"—which had called for a democratic renovation of the party—was already on the way out. Its leaders, among them Joseph Clark, Albert Blumberg, and especially George Blake Charney, whose proposals for radical revision of doctrine as well as political form outraged the orthodox, and dozens of others were poised (like former *Daily Worker* foreign editor Clark) to take union staff jobs, accept academic appointments (like Philosopher Blumberg, who prior his long years as a party functionary had been one of the bright lights of the movement known as logical positivism) or, more typically, disappear into private life.

In the wake of the disintegration of the CP, radical pacifist A.J. Muste started a forum to explore the possibility of a new left-wing political formation. Several evenings in 1957 and 1958, I journeyed across the Hudson River to hear leftists from various Trotskyist sects, so-called "right-wing" CP leaders and Muste debate prospects for a "new" left. They discussed the necessity of independence from the Soviet Union and the United States of unremitting commitment to democratic rights under socialist rule, of renewed efforts to revitalize the labor movement on the basis of rank-and-file militancy, of a strong intervention into the burgeoning peace movement, which had shown considerable strength since Adlai Stevenson's adoption of the nuclear test ban plank in his losing 1956 campaign.

Once the alliance between William Z. Foster's conservative faction and General Secretary Eugene Dennis's "centrist" group had foreclosed any hope of renovating the Communist Party along democratic lines, there began a debate among democratic socialists regarding possible affiliation with the reform-minded minority Communists. Muste's effort failed because his guiding assumption, that there existed the political will among the large contingent of disaffected Communists to start over, proved overly optimistic. Most of them were intellectuals with few new ideas rather than political organizers with a series of practical tasks. But even the organizers among them were simply burned out, especially in a political environment that was poisoned by the past.

At the same time, in 1959, the Socialist-influenced League for Industrial Democracy (LID) decided that the moment had arrived to resuscitate its nearly moribund student group and invited the University of Michigan chapter to take charge of this task. It was symptomatic of the times that the concept of "industrial democracy" had lost entirely its meaning as a unifying slogan. The leaders of the student division of LID, Al Haber and Tom Hayden, insisted, accordingly,

that the name of the organization's student affiliate be changed to Students for a Democratic Society. Haber and Hayden shared the political perspective of LID's chairman, Michael Harrington—for a political realignment of the progressive forces in a new political bloc—but abhorred the more conservative position, especially the militant anticommunism, of most of its board members. I first met Harrington at the White Horse during his neo-Trotskyist period, when he was better known for his literary criticism than the political writings. He was ideologically closer to Jacobson's *New Politics* than to the more staid *Dissent* in that he considered himself a revolutionary democratic socialist who believed in the formation of a labor party built around a strong labor-civil rights alliance. He supported the broad "third camp" position of his organization, the Independent Socialist League, rather than the pro-Western line of *Dissent*.

As a trade unionist and Democratic Party activist influenced by the old Popular Front politics, I debated Harrington and other Trotskyists in the early 60s precisely on the issue that was to mark the break between SDS and the Harrington-Howe wing of the socialist movement a few years later: I argued that working people and trade unionists had no choice but to seek change within the Democratic Party, that the multiplicity of movements to reform party procedures and platforms which had arisen out of the anticorruption, peace, and civil rights movements of the late 50s prefigured the chance for a new alliance that could at least mount an effective challenge to the most conservative wing of the party. Harrington at the time took the classic third-party position that noncommunist socialists have adopted since the turn of the century. Later in the decade Harrington changed his mind, but then found that there were new radicals who had picked up where he and Howe had left off.

Because New York City was a Democratic stronghold, New York Democrats were more concerned with the leadership question within the party than with beating the Republicans. Ideology and power were contested in the primaries, not in the general elections. The Liberal Party, composed of some trade unionists, mostly from the apparel trades, and ambitious lawyers, had long since lost its role as the balance of power and had become more or less harmless. The more "left-wing" American Labor Party had disappeared after its disastrous performance in the 1954 election and some of its activists were now part of the Reform Democrats. In this situation, the main issue for the Democratic Party was whether it could become a mass liberal party, that is, whether it could mobilize the new postwar professional constituencies in the shaping of party policy.

These were the last years of the political machine, a form of cultural as well as more narrowly constructed political power. The machine was founded on the institutions of patronage and, in the cities, gained momentum during the immigration waves of 1880–1910. But by the 1950s the machine was already weakened by the introduction of the civil service system of public employment and the professionalization of the service as a whole. Moreover, the immediate

postwar period had witnessed the suburbanization of large fractions of the white working class and the lower-middle strata, a development that further eroded the electoral base of the machine.

When I had dinner in the early 60s at Cannon's, an old-time Irish bar on Broadway and 108th Street, I found Japanese food being served with the traditional Guinness stout, a sure sign of incipient gentrification on the Upper West Side. Likewise, Greenwich Village, which was no longer a haven for artists, housed the coming leaders of the Democratic reform movement: Stanley Geller, a shoe company heir who owned a gorgeous townhouse on 12th Street; Ed Gold, a journalist for Fairchild publications; Ed Koch, a lawyer with unbounded political ambition; and Sara Schoenkopf (later Kovner), a young professional politician whom I had first met during the Stevenson campaign when I was a leader of Young Democrats in New Jersey's Essex County.

Yorkville, once the neighborhood of German machinists, Hungarian laborers who worked in local factories like American Cystoscope (where I had worked briefly in the early 50s), was fast becoming the fashionable East Side. The district had been represented in Congress by a succession of moderately liberal Rockefeller Republicans, but the area still contained a strong local Democratic machine with a (declining) working-class constituency. To these precincts there came a young left-wing lawyer who, together with the Yorkville leader and erstwhile party regular John Harrington, attached himself to the reform movement. Mark Lane had been a criminal lawyer specializing in hopeless criminal cases on behalf of blacks and Latinos. He possessed a talent singularly conducive to a successful political career—an unerring sense of publicity—a sixth sense for what would capture the public's political imagination. He was not, however, endowed with a particularly vibrant or charismatic personality. Shy of personal encounters, his fiery social messages were delivered exclusively to larger audiences. He rented a small apartment in a slum building on Lexington Avenue in Yorkville, a sort of place that has all but disappeared now. He was also then recently separated from his wife, the actress and folk singer Martha Schlamme.

We were introduced by his brother-in-law Bill Nuchow, a Teamster official whose moment of glory had been the presidency of an ill-fated taxi drivers' union in the mid-50s. Nuchow might in fact have become a major figure in New York labor, had the Teamsters not abandoned the unionization campaign, but now he was a business agent for a Teamster local.[3] Nuchow asked me to join the effort to elect reformers to district leadership; Lane has been elected the previous year to the State Assembly. Even though I was living in Newark, New Jersey, I agreed. The position of the incumbent Democrat was less entrenched than usual, mainly because East Harlem's Puerto Rican voters, subordinate to the Irish and Italian machine politicians after the passing of Vito Marcantonio's left-wing machine in 1950, were beginning to strike out on their own, and Lane had gained prominence by representing poor Puerto Rican clients.

Lane's subsequent stay in the legislature was luminous, controversial, and brief. His great achievement was the exposure of an illicit scheme between Republican Assembly Speaker Joseph Carlino and a coterie of businessmen to build fallout shelters ostensibly to protect children from the effects of a putative nuclear attack, a scandal which led to Carlino's defeat in the next election and to instant stardom for Mark among the "clean government" types and the peace movement activists.

By late 1961, after his club captured the district leadership, he was calling small meetings of supporters, myself included, to determine if he should seek the nomination of the reform Democrats for the nineteenth congressional district, a horseshoe which came down the West Side and then curved around the Battery, ending up on the Lower East Side. Its current representative was Leonard Farbstein, a product of the still viable Democratic machine led by the almost legendary Carmine De Sapio. Farbstein was no worse than most others among the New York congressional delegation. His political base outside the machine lay primarily in the substantial orthodox Jewish community of the Lower East Side, but this once formidable socio-political force was now losing some of its weight because of the exodus to the suburbs and to Brooklyn, and because of the influx of Puerto Ricans. In 1960, the Greenwich Village reformers had succeeded in beating De Sapio himself in his home district, and won control over most West Side clubs for the first time. Other strong challenges were mounted in Chelsea, where the new ILGWU-sponsored cooperative housing was replacing longshore slums. In order to take on Farbstein, Lane first had to get past the reform movement; although he was by far the best-known reform legislator in Albany, he was not a resident of the district, and other reformers wanted the nomination too.

Early in 1962, Mark asked me to become his campaign manager. We got together a rather high-powered inner circle that included Michael Harrington (who didn't see the campaign through), chiefly because Lane was not particularly disturbed by the presence of some people suspected of being Communist-oriented in his campaign; the journalist Susan Brownmiller, who had sparked his assembly campaign; and Ed Wallerstein, who was an old captain in the Vito Marcantonio organization and now active in the Yorkville Democratic Club. From the start, Lane was accused of being an outsider and of surrounding himself with carpetbaggers.

But his campaign suffered from another and perhaps more crucial weakness: he fought on substantive issues before a group for whom such questions were subordinate, if not entirely irrelevant. For the reform movement was a loose antimachine coalition whose main concern was to eliminate corruption within the Democratic Party, by which was chiefly meant patronage. In short, "reform" entailed procedural renovation to achieve a kind of civil service for professionals, making sure that elected officials were democratically chosen and that the most meritorious would get the appointed jobs. Of course, since many of the

reformers were attorneys, they hoped to win nomination for civil, family, and criminal court judgeships, an ambition which was to be richly fulfilled in coming years. Lane paid lip service to these issues but in fact could not have cared less who selected the candidates. He ran on public issues, although he was obliged to use the theme of anticorruption extensively in his initial Assembly campaign.

In the spring of 1962, we tried to take the reformers by storm by raising such issues as the increasing U.S. intervention in Vietnam, the growing concern over poverty, and the importance of better housing and jobs for residents of the district. Indeed, by the end of the designation campaign all the candidates were echoing Lane's platform down to the obscure and anomalous issue of U.S. intervention in Vietnam. Yet these were side issues as far as the movement was concerned. The reform Democrats of New York, Illinois, California and elsewhere were plainly on the liberal wing of the party, but their chief interest lay in the question of party control over patronage, for which purpose the issues of Vietnam, nuclear weapons and civil rights had little relevance. Lane, on the other hand, considered Congress a place for national policy; procedural questions made him impatient.

The reform movement was an early expression of a new style in American politics. Large numbers of professional middle-strata and small businessmen had participated in the 1956 Stevenson campaign, which raised the possibility that the Democratic Party for the first time could become a mass organization of what later became known as the "new" class of professionals and managers (especially those in the growing public sector), something beyond a leadership coalition between labor, blacks, professional politicians, and a fraction of capital. The focus here lay on clean government and procedural democracy rather than on peace, civil rights, and economic justice, though unquestionably the movement could become the vehicle for these traditional concerns. In fact, the greatest and last triumph of this new political "class" was the 1972 presidential nomination of its epitome, George McGovern, a history professor turned politician from South Dakota.

Lane lost the designation fight and quit the Assembly seat shortly thereafter. His politics, grounded in the primacy of questions of economic justice, was rapidly fading from the scene. Later, he was to reenter the discourse of the 60s in a rather peculiar way by his relentless conspiracy investigations of the John F. Kennedy assassination.

I entered the 60s myself through my friendship with Evelyn Leopold, who, at the time of Lane's campaign, was running Ed Koch's losing primary fight for the Assembly; Koch ran on behalf of the Village Independent Democrats, one of the key clubs in the designation fight and regarded as a potential Lane stronghold. Evelyn was living on West 21st Street with several SDS leaders. She had met them in 1960 when editing the Douglass College paper. Hayden was then

the editor of the *Michigan Daily* and was organizing college newspaper editors to make a fight within the National Student Association (NSA) for a strong civil rights commitment. The first time I came to the 21st Street house, I was greeted by Al Haber, a resident and also then the head of SDS. Characteristically, he was drenched in mimeograph ink. Mike Harrington was still regarded by the SDS, in late spring 1962, as the closest thing to a mentor. Hayden, who lived in the apartment with his wife, Casey, was, like Harrington, a middle-class Midwesterner of Irish Catholic background. Like Harrington, he exemplified the adage "you can take the boy out of the church but you can't take the church out of the boy." Each was a fervent exponent of the politics of compassion—that we are all responsible for the fate of the poor—and derived inspiration, even if unacknowledged, from the encyclicals of Leo XIII as much as from Karl Marx or, in Hayden's case, C. Wright Mills.

Tom and Al were then preparing for the first national conference of this relatively new and very small organization. It was to be held in June at Port Huron, Michigan. Tom was responsible for writing the organization's political manifesto. He had returned recently from a trip to the South where he had gotten a fairly well publicized beating during a civil rights demonstration. This had established his credentials as one who would put his body on the line, one of the crucial bona fides of the era. As the first SDS president, he was clearly its best known and probably its most influential leader, but by no means the only one. He embodied the spiritual and intellectual energy of this small movement of no more than two hundred members, most of whom could be found on major campuses like Michigan, Harvard and Chicago, but had few adherents on the West Coast. SDS held national meetings at Christmas and in the summer. The rest of the time people kept in touch by mail, telephone, and through campus visits by the two national leaders. The SDS became highly visible because some of its members were also key activists in the then powerful NSA, and some were leading politicians and editors on some very important campuses. Despite its numerical insignificance, SDS thus organized an effective caucus for civil rights at the 1961 and 1962 NSA conventions. It became a veritable tribune for the growing movement for university reform, particularly the fight for a student voice in campus policy-making. It was also a catalyst in the student peace movement, helping to found the Student Peace Union.

I may have misunderstood the Democratic reform movement at the time, but I could not have mistaken the primacy of the *moral* in SDS. It was the most articulate expression of what became the leading theme of the ideology of the 60s: the attempt to infuse life with a secular spiritual and moral content, to fill the quotidian with personal meaning and purpose through social action.

The reform Democrats and SDS shared the belief that they themselves were the new historical subjects. They were equally dismayed by the deterioration of representative democracy. But, the similarity ends there. The doctrines of the

student as "nigger" or as a new oppressed class were merely clumsy ways for the most radical of this generation to separate itself from the old labor metaphysic, to declare itself competent to name the system that oppressed humanity. The *Port Huron Statement*, written by Hayden but collected from many sources, retained the outline of a liberal argument: its pages resound with the rhetoric of economic and social justice. But the subtext concerned the generation after Ginsberg's, a generation which not only prided itself on having the best minds but also claimed its own historicality. Hayden and his friends all but declared themselves ready for leadership.

By June, I was practically living on 21st Street with Evelyn and the SDS staff. They came home from their office on East 19th Street and I from my union job at the Amalgamated Clothing Workers, and we would immediately plunge into long discussions about the labor movement, civil rights, the Democratic Party, and the Kennedy administration. As a relatively weak political movement, they recognized the need to find allies in all of these arenas. Hayden was trying to pry some money from Walter Reuther and the UAW and went to Detroit to meet with him. Yet, despite playing "student organization" for the adult counterparts, Hayden, Haber, Todd Gitlin from Harvard, Bob Ross, and others did not ingratiate themselves with trade union and liberal leaders, since they believed that the labor-liberal coalition had no future in American politics. They were indeed deeply convinced that these were people of the past. While making compromises and seeking temporary alliances, they were actually looking for an alternative formula with which to transform the United States into a democratic utopia.

In this sense, the *Port Huron Statement* was remarkable for its continuity with traditional American ideas of popular self-government, egalitarian ethics, and social justice. As if to declare its independence and originality, it refused socialist discourse. It broke with the socialist tradition by ignoring entirely the questions that had preoccupied the Old Left of all persuasions: the Soviet Union, Marxism, and communism. Not since CP General Secretary Earl Browder's slogan "Communism is twentieth-century Americanism" in the 30s had there been such an attempt to invent an indigenous radical discourse. There were no invocations of "socialism," "revolution," or "workers' control" here, but of "participatory democracy" instead. In the tradition of Mills and Thorstein Veblen, they refused explicitly Marxist categories.

It was not the Cold War alone which had brought this about. It was the passion to make a fundamental break with the sectarian debates, "foreign" subcultures and sterile programs. The communist and socialist past was not repugnant, it was just irrelevant for contemporary purposes. A new language to forge group solidarity was therefore necessary—and Tom Hayden and his friends understood that.

Historians of this "new left" have frequently mocked the SDS for spending the first half of any meeting adopting the agenda and defining the rules of debate,

and even sympathetic observers have sometimes ascribed this strange ritual to inexperience or to the absence of a viable political culture. This criticism misunderstands the nature of the New Left, summarized in a single word: process. It signalled an almost religious return to *experience* and a converse retreat from the abstractions of the red politics of yesterday. One worked out personal and procedural issues in great and often exhausting detail as a way of fusing the personal with the political, of creating a community not primarily of interest (political rationalism) but of *feeling*. So in some respects a national meeting of the SDS was an orgy of incantations. Rhetorical repetition, procedural debate, and moral invocations to kindness and equality were all part of the process of community building, a psychopolitical experience in which the very length of the sessions was a purgative for transforming traditional political interactions into what was described as "movement behavior." This style drove many left and liberal politicos to distraction but it was intrinsic to the movement, just as Roberts Rules was the marker of traditional liberal organizations.

From 1962 to 1965 I attended these meetings, having been coopted along with several others as an advisor. This job actually began on 21st Street, but my interest, combined with other commitments, then was not strong enough to bring me to SDS meetings. I was drawn in by the unfortunate aftermath of the *Port Huron Statement*. A CP-led youth group, the DuBois Club, had sent an observer to the conference. He was a rather timid fellow and was regarded by the SDS people as harmless. But when the word reached the LID that a bona fide communist had been permitted to observe the SDS convention, the roof fell in on the students. During a meeting that has become part of the lore of the New Left, Harrington and other board members excoriated the SDS leaders for political naiveté: having had the bitter experience of Communist hegemony on the American left during the 30s and 40s, as staunch anti-Stalinists the board concluded that the CP was not merely wrong on a variety of political questions but that its presence was actually detrimental to the task of rebuilding the democratic left. It was not a question of political differences but of whether democracy and dictatorship, as they saw it, could coexist. While many, including Harrington, defended the party's legality and separated themselves from the more virulent forms of anticommunism, they had effectively read the Communists out of the socialist movement.

The incident would have blown over had the SDS leaders simply agreed to bar Communists from future meetings, since there was never any proposal to admit them into the ranks, but SDS instead chose to treat the whole thing as a major issue between the Old and New Left and, perhaps more to the point, a test of their autonomy. For the elders, the refusal of Hayden, Haber, and others to subordinate themselves to the principles of the movement was a departure from the tradition according to which the "youth" were regarded as apprentice socialists. After this confrontation, SDS looked for other possible sources of contact

with the mainstream of the labor and liberal communities. Ray Brown, a former union organizer and then an economist for the Federal Reserve Bank, myself, and others, were asked to give talks at national meetings, hold workshops and be available for consultation because they still felt the need for historical memory, even if not those of the Communists or anticommunists. I was twenty-nine years old at the time, Ray a little older. Most of the "students"—many were already in graduate school or working full time for some liberal or peace organization—were only between five and eight years younger, but had grown up under very different circumstances. We helped them because we shared their belief that the new movement would die if shackled to the old past. We sought to provide a new past that would be compatible with their present.

I was convinced, like SDS, that the CP was little more than a nuisance, and I was also persuaded that anticommunism had been the scourge of the 50s, that the labor and progressive movements had been seriously crippled by their preoccupation with issues like the Soviet Union. With C. Wright Mills, James Weinstein, William Appleman Williams, and others of the leading New Left journal of the period, *Studies on the Left*, I shared the belief that a genuinely American movement could arise only by adopting the stance of leftist isolationism.

SDS had no sympathy for the American Communist Party or the Soviet Union, but it was part of a generation which had just emerged from the dark days of political repression and intellectual censorship. With liberal dissenters, SDS believed that the American CP was being persecuted not so much for its ties with the Soviet Union as for its opposition to the main drift of American foreign policy. In this way, SDS became an important repository of "anti" anticommunism: it held that the Cold War was responsible for the destruction of participatory possibilities, that it was a mask for central control and management of everyday life, a metaphor for the reduction of the American dream to rituals of conformity. In the pursuit of a new democratic ideal, of political redemption from the McCarthy terror, SDS was thus obliged to defend the rights of the CP. It also argued that the CP itself was no threat to democratic institutions, for the party was weak and in fact had to uphold these institutions and the American tradition of civil liberties in order to survive at all.

However, the new movement was determined to resist the examples of its elders. It chose neither the path of Marxist science as the historical equivalent of moral redemption after the capitulation by its political progenitors during the McCarthy era, nor the Cold War liberalism of the disillusioned radical intellectuals of the 30s. Instead, SDS was the first organized expression of the post-scarcity generation's new nationalism. Their idea was directed principally to the renewal of the atrophied institutions of American democracy, or more precisely, to the creation of new institutions of popular participation to replace existing bureaucratic structures. The problem was how to utilize the subversive possibilities that already existed in popular political culture. For the New Left, the

question of the Soviet legacy was simply irrelevant except negatively; the obsession among the various groups of the Old Left with the character of actually existing socialisms was regarded as a central reason for the demise of the left in American life.

At the same time, the New Left was deeply concerned with issues of race and third-world revolutions, regarding the civil rights and independence movements as correlates to democratic renewal, the support of which could assist the moral regeneration of the middle class. The freedom rides and sit-ins gave many white students hope for change, but also suggested the how politics needed to be done in the new era: forget the tactic of pleading to higher authorities; don't depend on the wheels of justice to grind; don't rely on the legislatures or the government to provide. Direct action, civil disobedience, mass demonstrations were the only weapons that did not concede power to others.

Much of the New Left was guilty of a kind of collective amnesia, having rejected the idea that historical knowledge and living traditions could prevent repetition of past errors. Action/experience was to take precedence over history and memory. In this respect, one cannot but be impressed by the naiveté of the widely disseminated notion, "Don't trust anybody over thirty," the proposition that older people are somehow a priori plagued by memories, beliefs, and habits of thought and action that ought to be buried. Furthermore, there was an almost paranoid fear of what Sartre called the *practico-inert*. To admit, in other words, the limits of action was to court defeat. Undoubtedly, this delusion produced a series of disasters and near-disasters. So it was with the ill-fated community organizing efforts of SDS's Economic Research and Action Program (ERAP), an intervention in the black ghettoes and white "underclass" slums which generated much publicity but little benefit for the residents.

Hayden and Carl Whitman, a Swathmore College graduate from Paramus, New Jersey, had written a strategy paper in 1965 called *Toward an Interracial Movement of the Poor?*, in which they argued for a multiracial alliance combining the research and organizing skills of students and other middle-class types with the authentic anticapitalist needs and demands of the poor, a "class" the authors believed to be distinct from the working class (big labor). With the help of an organization I formed, The National Committee for Full Employment, dedicated to bringing research and policy experts to the movement, these ideas were put into practice in the summer of 1964. Even as SNCC field secretary Bob Moses was feverishly recruiting college students for the Mississippi Summer voter registration project, ERAP organizers were attracting a smaller number for work in the Northern ghettoes and slum communities. ERAP chose eight cities including Chester, Pennsylvania; Cleveland; Newark; Baltimore; Chicago; and Hazard, Kentucky (where Hamish Sinclair and I had started an organizing project among disenfranchised miners). There were also the less self-consciously radical but equally inspired efforts of the Northern Student Movement, which

conducted literacy programs for black kids and played a major role in organizing the Harlem rent strikes in the winter of 1964–65. However, the concept advanced in Hayden and Wittman's paper was that whites could redeem themselves only by helping blacks to become free. It was the adoption of the concept of responsibility which is as old in the American tradition as abolitionism. Community organizing, voter registration (primarily by the black Student Non-Violent Coordinating Committee [SNCC] in the South) and education projects challenged the liberal state and the institutions that supported it to live up to their own precepts, thus providing an opening for mass participation. For student radicals the struggle for decent housing, for jobs and income, against rats and roaches, pointed clearly towards the authoritarian side of liberal democracy since nearly all Northern cities were dominated by liberal Democratic administrations which had, since the Depression, effectively abandoned the black and white poor even as they proclaimed themselves the party of compassion.

Most of these projects folded within a few years but produced some interesting lessons. Take the Newark project, for instance. I had played a fairly active role in helping ERAP get moving because, having been until 1962 the vice-chair for organizing of the Clinton Hill Neighborhood Council in Newark, I was in a position to bring the groups together. The Neighborhood Council was dedicated to preserving the interracial character of the community by improving community life and especially its amenities. It took seriously the reasons whites gave for leaving the city rather than condemning the migration as yet another instance of racism. So, it fought overcrowded classrooms, for better garbage collection, and for more street lights and police patrols to make the neighborhood safer.

From its inception in 1955, the Council distinguished itself by waging successful struggles against federally sponsored urban renewal, a project heralded by corporations and liberals alike as the key to the development of the decrepit inner cities. Although the Council nearly became a political power in this rapidly changing city and was able to slow down the process of what we called "people removal," we were resisting large demographic and economic forces that proved too strong to withstand.

When SDS decided to make a commitment to off-campus organizing, they turned to me, among others, for information as to what to do. In my talks to the National Council meetings, I stressed the importance of addressing economic issues as well as Rights. I argued that because the unions had all but abandoned the "community," SDS could make a contribution to working class and poor empowerment through organizing in the cities. Subsequently, I arranged for SDS to be invited to assist the Council; this was a match not made in heaven.

The SDS group called itself the Newark Community Union Project (NCUP) and formed its base in the city's South Ward, of which Clinton Hill was a major part. Conflicts soon arose between the student organizers and the Council, who

counted among its members many black and white homeowners interested in code enforcement and other ways of preserving neighborhood and property values. Animated by a new poverty metaphysic to replace the shopworn labor metaphysic, the SDS group regarded these objectives as both limited and hopelessly middle-class and soon broke with the Council, moving its territorial claims to the lower part of the Hill, where the people were poorer and the homes more dilapidated. Thereby they had not only defined a turf but also an ideological difference, arguing that poor and working-class residents often had divergent needs and demands. The working-class homeowners wanted to make the neighborhood safe, the schools better, and the streets cleaner and better lit. They were prepared to compromise with established political powers on these demands.

In the view of NCUP (SDS) organizers, the working poor and welfare recipients of the dilapidated areas had lost confidence in the institutions of representative democracy. They wanted political power in order to improve their conditions, but would fight with the tactics of the Southern civil rights movement rather than those of the petition and the ballot. A "union" rather than a council was therefore the appropriate form for this desperate constituency. Analogously, while the Council was mired in electoral politics, NCUP favored direct action, especially since most of its members were not registered to vote. It was not a question, then, of finding the least common denominator which could unite the greatest number of residents (the policy of the Council), but of sharpening the differences between the poor and the wealthy, the people and the state. Later NCUP was nonetheless forced to defend its gains through electoral politics, and entered conventional coalitions around specific issues, candidates, and programs. But the group had defined a new politics of community organizing that went beyond single issue coalitions. A union was no longer conceived in terms of "trade" or "craft" but as "community," a site of popular fashion formed apart from, and in opposition to, the established interests.

This innovation was remarkable both for its sectarianism and its political originality. We need not linger, in this context, on Hayden's role—by 1964 he had become the leader of NCUP—and its unfortunate tendency to factionalism and personal power politics. What made NCUP interesting, on the contrary, was its creative fusion of traditional symbols such as "community" and "union," and the recognition of the need for self-representation among the poor. Even more important, in retrospect, was the fact that SDS, SNCC, and other movements of this generation provided a model for others to challenge the prevailing modes of political and social representation. It was not the organizations they built that defined the New Left in American politics, but the deconstruction of the common conflations of aggregation and democracy, of interest and community, of voting and participation, a deconstruction which indeed created an ideological space for the multilayered movements of the late 1960s.

These were movements of a generation, not of a class, a race, or specific interests or issues (about which more in the next chapter). It was a generation shaped by its parental predecesssor, by the postwar migration to the suburbs and professional communities adjacent to the big cities, where happiness had become synonymous with economic security and maximum consumption. As a reaction, the new generation tried to create more than a different sort of politics; it tried to create a utopian community, and indeed one may argue that the new politics was a product of this communitarian impulse. Some sought this community in southern rural slums and others in the ghettoes of northern cities. A small but important segment created a counterculture within the core cities—such as New York's East Village or San Francisco's North Beach; communities based around agriculture in Virginia, California, and Vermont; craft in Minnesota and upstate New York. These avant-garde movements were not notable so much for their formal innovations as for their conviction that efforts to reform the system were doomed to be absorbed by systemic antagonists. Hence the critique of liberal society took the forms it did, from the attempt to sustain an alternate economy based upon subsistence farming and small-scale production to that of finding the link between art and life in the combination of working, living and sexual space.

It might be objected that communitarian movements were naive, that their success depended on the longstanding affluence of the United States in general and the economic buoyancy generated by three wars in particular. And surely the notions of "participatory democracy," of the beloved community, of the counterculture are overdetermined and historically specific. However, to reduce their character to class origin, or to dismiss their social and political significance as narcissism or something worse is to see the whole thing from the perspective of social conservatism.

There were really two countercultures in the 60s. My connection was mainly to the political counterculture, those who engaged in the politics of direct democracy, who organized traditional constituencies in new ways. The second were the cultural radicals, the artists, writers, and, above all, the rock musicians and their audience, for whom the erotic revolution was a political movement. It is important to recognize the differences between these two tendencies. Even though there was some overlap, there was also considerable hostility between them. The cultural radicals believed the struggle within the state and its institutions hopeless and beside the point. For them the important question was freedom to be different, in political terms, freedom from the state. For them building communities in the present would prefigure the new society. This doctrine did not foreclose political action, but its forms were different: smoke-ins and be-ins in Central Park and other places where ostensible law-breaking could visibly show defiance; building art and cultural communities on the Lower East Side, in the Haight in San Francisco, and in other cities; coffee houses where

poetry and stories were recited; new dress codes, new sexual norms, concerts where dope was passed around in an otherwise dark stadium or club.

It does not matter that such slogans as "sex, drugs, and rock and roll" failed to encompass the many layers of social reality of the 60s, or that most economic countercultures, communes, and various other communities ultimately succumbed to interpersonal squabbles, external economic pressures, or the provocations of government agents and the like. What survives in memory is not the vast quantities of megalomania and its twin, paranoia, of this generation, which mistook its demographic proliferation for political power, nor the arrogance of those who invested themselves with magical powers; these excesses were merely symptoms of the affliction of historical amnesia. America's past is as mystified and weighs as heavily on the living as that of any other country. The difference is the widespread perception that only the glorious part constitutes our legacy and that to be American is to overcome all adversity.

The New Left was thus American in a double sense: it tried to invent a new past that served the present rather than the "truth" of the past, and, in a sort of Nietzschean way, it proclaimed the triumph of the will, its limitless capacity to shape the future in its own images. This magical quality marked the cultural politics of the 60s and distinguishes it from virtually every European counterpart except the French, where the slogans "Be Realistic, Demand the Impossible" and "All Power to the Imagination" replaced, for a brief instant, every traditional concern.

At the time, many older friends of the student and youth movements were amazed by the hubris of the new activists. We attributed their disregard for political and social boundaries to their inexperience, arrogance or, to be more kind, excessive exuberance. Of course, much of this was accurate. Hayden was impervious to, even contemptuous of, criticism; Carl Wittman, the person who really started the Newark project, was moralistic to the point of absurdity; and others were similarly afflicted with delusions about the omnipotence of their movement. These very qualities were the source of antagonism between SDS and other movements, like SNCC, the West Coast free-speech and antiwar activists, and the Northern Student Movement, let alone their local collaborators.

On the other hand, the same confidence and sense of purpose brought about results, among them the magnificent SDS March on Washington in April 1965 against the Vietnam War. After all, by winter 1964 SDS had grown to only a thousand members. The decision to resist entreaties from liberal "friends" not to embarrass President Johnson who had just scored a stunning victory over arch-conservative Barry Goldwater was motivated as much by the organization's remarkable self-confidence as it was by the war.

Nevertheless, it was symptomatic that the national organization did not follow up on this event, which had been so skeptically regarded by an assortment of social democrats and radicals on the outside. Instead, others like A.J. Muste,

Staughton Lynd, Jerry Rubin, and myself had to provide the links between the April demonstration and the growing antiwar movement. Astonishingly, the SDS leadership was still convinced that the future lay in local organizing among the poor and marginal groups. The chief promulgator of this view was Tom Hayden, later to become a very public antiwar activist.

~Sometime in 1964 Jim Weinstein brought himself and the four-year-old *Studies on the Left* to New York from its birthplace in Madison, Wisconsin. The journal was started by students under the auspices of William Appleman Williams, a Wisconsin history professor who is now generally credited with having spearheaded the school of American historical writing called "revisionism." Williams, together with C. Wright Mills, openly urged the generation of young intellectuals and political activists to break with all of the codes of traditional radicalism, especially the doctrines according to which the working class was anointed with sacred historical powers, and the Bolshevik Revolution was the transcendentally significant event for the fate of the American left.

In the late 50s Williams collected a large coterie of students, some of whom were refugees from the youth sections of the Communist Party. Among these were Jim Weinstein, Dave Eakins, Marty Sklar, Michael Leibowitz, and Ron Radosh. He added some of the more promising younger historians, many of them too young to have been part of the organized left in the 50s yet sympathetic to radical politics. Taken as a whole, this was probably the most resourceful and brilliant cohort that any American university possessed in that period. *Studies* was founded to provide the intellectual grist for the development of a new left. In its first issue, which appeared at the dawn of the new decade, it ran Mills's *Letter to the New Left*, a short document which served as the manifesto of this *intellectual* vanguard (but nonmovement) until the *Port Huron Statement*.[4] It was Mills who first systematically laid out the doctrine of the American New Left: abandon the labor metaphysic, don't get bogged down politically and emotionally in the controversies regarding the Soviet Union, China, or anyplace besides the United States; rediscover American traditions, particularly the promise of a democratic society, equality, and community; oppose the domination of large corporations over all aspects of American life; support national liberation movements abroad, but avoid endorsing their particular form of government—these were the succinct imperatives, and they became the creed of *Studies*.

The project throughout its seven-year history thus became a concrete investigation of American history and contemporary politics from the outlined perspective. Weinstein assumed the leadership, partly because he raised almost all of the necessary money for the journal and partly because he among the many

editors was the most dedicated to the major principles prescribed by Williams and Mills. In his own field, the history of American socialism, he applied these ideas to the issues that united and divided the historical left: electoral versus direct action, the question of the Soviet Union, class versus sectoral politics, socialist campaigns versus reform struggles within the Democratic Party, the mass party versus the vanguard party. Despite his communist past, or perhaps because of it, Weinstein came down squarely on the side of the old prewar Socialists, finding that the betrayal of Debs's party by both its left, which irresponsibly defected to the Communist International, and its right, which opportunistically supported U.S. entrance into World War One, led to the demise of the American left.[5] Indeed, from its inception, *Studies* aimed to reconstruct a multitendency socialist movement in the United States, one that could successfully contest electoral offices, provide room for education and cultural development, and play an important part in the peace, civil rights, and other social movements of the day. In the context of the 60s, when the American left divided between those wanting simply to resurrect and humanize Leninism and those who thought socialism archaic and wished to replace it with "democracy" pure and simple, the Williams-Mills-Weinstein position seemed to be a serious and reasonable alternative.

In the early issues of the journal, Marty Sklar wrote some wonderful papers on the Wilson era in which he traced the origins of what became known as "corporate liberalism." Sklar argued that such "reforms" as regulation of corporate economic activities were anything but expressions of popular power over capital, their being on the contrary signs of a new integration of state and big business. The Interstate Commerce Commission, railroad commissions, and other governmental agencies developed by all national administrations after the 1890s, were means to rationalize competition, to accelerate the process of monopolization of leading sectors, and resulted not in more popular power over government, but in less.[6]

Writers like Williams, Gabriel Kolko, and Weinstein (whose 1966 book *The Corporate Ideal and the Liberal State* extended Sklar's argument to social welfare policy), shaped a new vision of the twentieth century in America; "corporate liberalism" became probably the most influential doctrine of American historiography in the 1960s and 1970s.[7] In the bargain, twentieth-century populist, trade union, social liberal, and other movements were dismissed as either objectively corporatist, regardless of intention, or as grievously misguided in their refusal to choose an explicitly socialist alternative to corporate power. By showing that the corporations themselves wanted reform—though this has since proved somewhat of an exaggeration—the New Left historians also hoped to demonstrate the futility of Popular Front politics according to which the Democratic Party was regarded by many on the left as the most viable political arena

for socialists. For if the New Deal, for instance, was little more than a brilliant and effective way of derailing radicalism, then the success of the Communist Party in the 30s was merely the left face of corporate liberalism.[8]

Sklar and Williams provided a powerful counterweight to the conventional left wisdom that the CP was a heroic and strong force for social progress until the Cold War destroyed it or, as in the anticommunist left version, until the CP was mortally wounded by Stalinism. They argued that even the Communist contribution to the building of industrial unions could be criticized, if it were true that industrial unionism, whatever its benefits from the point of view of the workers, was irrelevant from a socialist perspective. *Studies* did not go as far as to denounce the labor metaphysic, since most of its editors still believed in the leading role of the working class. But it did hold that American trade unions were part of the corporate/liberal consensus and not its opponent, regardless of the frequent strikes and disputes with individual employers.

Because many of the editors remained in Wisconsin or scattered to various American and Canadian universities when Weinstein moved east, he, Lee Baxandall, and Helen Kramer began to look for some new editors. Shortly after they arrived, *Studies* held a party to which I was invited. I had known Weinstein from my days as a high school organizer in New York in the late 1940s. At the time of the party, I had just moved from the Clothing Workers to the Oil, Chemical, and Atomic Workers as an organizer based in the northeast region. Weinstein asked me to join the *Studies* board and I agreed. For the next three years, until its demise, I was an active member of the board. Gene Genovese was also recruited, and within a year so was Norm Fruchter, an American writer who had been on the editorial committee of the *New Left Review* while living in England; Alan Cheuse, Fruchter's college friend and also a writer and a critic; Tom Hayden, now ensconced in Newark; and historian Staughton Lynd, who was ending his controversial career at Yale.

The board divided along ideological lines from the start. It would be excessive to see the split as one between intellectuals and activists, but every meeting after 1965 reflected some aspect of this sort of dispute. Most salient was the issue of how important the new social movements of the decade were, and how they should be treated. Weinstein and Genovese could barely disguise their contempt for the mindlessness of the student, countercultural, and, to a lesser extent, civil rights movements. At best these were to be regarded with benevolent condescension. The main task was to provide consistent socialist analysis of the main political struggles of the time and an evaluation of the American past from the point of view of an undogmatic but incisive Marxism. I generally sided with the Weinstein faction concerning the politics of the journal, insisting that socialism was the determinate negation of corporate capitalism and that the journal had to place itself within a specifically socialist ideological tradition of American radicalism. At the same time, as a participant in

many of the new movements, I was fearful that Genovese's Old Leftism would destroy the journal's receptivity to their originality. Unfortunately, as with many other debates on the American left, the controversies were too often framed as antinomies: either the new social movements *or* ideological politics (albeit one sharply critical of old leftist positions).

In the end, it was agreed to subject the movements to critical reportage and inquiry. My only signed articles for *Studies* were pieces on the labor movement and community organizing, written from the perspective of the corporate liberal theme: the idea was always to show the reformist nature of apparently radical organizations and movements which did not adopt an explicitly socialist or even anticorporate view. Lynd and Hayden, often supported by Fruchter, argued that the movements were everything. Though Lynd had been a Trotskyist in the 1950s and came from a distinguished left-wing academic family, he was deeply influenced by A. J. Muste's version of radical pacifism. It is worthwhile to review some of Muste's activities in the 1950s and early 60s since the importance of his ideas, and of the groups he guided, has been strangely underestimated by historians.

In his early career, Muste had been a Methodist minister of the social-gospel variety. He was a leading spirit in the formation of the Amalgamated Textile Workers in the 1920s and, after its demise, started perhaps the most famous labor education program in American history, Brookwood Labor College. Opened in 1927, Brookwood became one of the more important meeting places for labor radicals until, a decade later, under pressure of bankrupcy, it was forced to shut its doors. Forced out of Brookwood for his increasingly sharp criticism of the AFL leadership, Muste became a revolutionary Marxist and, in 1933, organized the American Workers Party. This group played a key role in the famous Toledo auto strike of 1934, one of the three struggles that paved the way for the CIO. After a disastrous and sobering experience attempting to merge with the Trotskyists, Muste took a half-step back towards the religious left. From the late 1930s to his death in 1968, he organized and presided over a series of pacifist groups, most notably the Fellowship on Reconciliation, the War Resisters League, and the Congress of Racial Equality (CORE). During World War II he advised conscientious objection to some draftees, including Dave Dellinger, who was later to become his successor at the helm of the pacifist wing of the peace movement. In the 1950s and 60s he helped to articulate the aims of the nuclear disarmament campaigns and the resistance to the draft. Shortly before his death, he was fighting to establish the principle of nonexclusion within the antiwar coalitions so that communists, Trotskyists and other radicals could work with independent leftists, liberals and even some social democrats: no one was to be excluded in principle.

By the 50s, Muste had become a kind of Christian socialist but he was also a radical organizer of unusual ability. His vision was fundamentally at variance

with that of both the communists and democratic-socialists. Although he respected and worked with progressive legislators on specific issues, he worked hardest on promoting direct, nonviolent resistance as the best and most morally defensible means to achieve social change. He was probably the preeminent exponent of Gandhism in the United States, but at the same time he adopted a unique, informal version of cadre-based interventions geared to the reality of radical American politics.[9]

Muste employed vanguardism exclusively as an organizational device. On the surface, Muste ran or advised a floating crap game of organizations that intervened on every major issue: peace, civil rights, African Freedom, religious and political liberty. He established informal relations with important figures of the developing movements on the strength of his personal stature: he had been a leading figure in various radical movements since World War One. His quiet, firm way of speaking, his obvious political sophistication and enormous intelligence drew younger people to him, especially radicals seeking alternatives to social-liberal and sectarian left politics. He spoke a different tongue from the tired leftism of the 50s. For him, direct action was not merely a dramatic tactic to achieve specific ends, it was a way of life. If you sat in at a lunch-counter, you were doing more than integrating a public facility and breaking Jim Crow practices; you were bearing witness to human inequality and, by your sacrifice, you were contributing to the possibility of creating the beloved community. Lynd was deeply influenced by Muste and so was I.

Muste had his own implicit theory of the student/middle-class professional as a historical agent. The working class had demonstrated its passion for both economic justice and social conformity, but almost none for fundamental social change. Muste was therefore always looking for the few good people who would be prepared to put themselves on the line and to initiate change through personal witness. Hence the middle-class nature of his entourage, some of whom became public figures—notably Dave Dellinger and Bayard Rustin. Most of his comrades, however, remained anonymous, creative apparatchiks willing to work long hours at low pay for idealistic reasons.

When Muste died, his coworkers scattered in different ideological directions. Bob Gilmore of Turn Toward Peace moved steadily to the right of the peace movement, became increasingly anticommunist and, under the influence of ex-radical Robert Pickus, became mainstream both in style and aspiration. After brilliantly organizing the March on Washington together with Martin Luther King and a group of New York radicals, Bayard Rustin became President of the A. Phillip Randolph Institute, which, as time went by, came to oppose the militant wing of the black freedom movement. Rustin was always torn between his radical pacifism and his fierce loyalty to a neo-Trotskyist version of the United Front which in the end led him to a strong alliance with the mainstream labor unions. Dellinger stayed on the left and modified his pacifist beliefs in the wake

of the national liberation movements of the 1960s. He succeeded Muste as the leading pacifist activist but lacked the latter's authority and talent for compromise, both necessary qualities to keep an ideologically diverse group together. At the same time, he had a remarkable ability to keep legions of warring factions from destroying the antiwar movement, no mean acheivement.

I had first met Muste in 1963 when I was chair of the Committee for Miners. I was seeking "notables" for our effort to defend some Kentucky miners who were on trial for conspiracy, having staged a wildcat strike against both the companies and their own corrupt union. A respected figure in some religious circles, Muste agreed to help reach others, including former minister and Socialist Party leader Norman Thomas, who was by then a fairly crotchety old warrior. While Erich Fromm, Harvey Swados, Kenneth Boulding, and other leading radical intellectuals accepted my invitation to join the board, Thomas demurred because, in the Socialist tradition, he was committed to working with the official labor leaders. Thomas even asked me what Tony Boyle, the notoriously corrupt president of the United Mine Workers, thought of the Hazard movement. Politely, I took my leave.

However, not until the early days of the antiwar movement did I get to know Muste well. We sat together on coordinating committees that began to gain momentum in the summer of 1965, following the SDS March on Washington. We lived in the same Upper West Side neighborhood, so I frequently drove him home to his west 90s apartment after meetings. I learned that the popular image of a saintly yet slightly irascible fighter was only part of the truth. Muste was a strategic thinker. By the last year of his life, he was absolutely convinced that the struggle against the American intervention was the key to mass radicalization and urged that view upon me.

Subsequently, I become part of the Labor for Peace network that Sid Lens, Tony Mazzocchi, and David Livingston of District 65 were organizing under the benign sponsorship of Pat Gorman of the Meatcutters, Frank Rosenblum of the Clothing Workers, and Emil Mazey of the UAW. Later elected secretary-treasurer of the union, Mazzocchi, then a rank-and-file member of the board of the Oil and Chemical Workers, was clearly the most talented rank-and-file activist in labor's wing of the antiwar movement. I was critical at the time of his cautious, even conservative approach to the war, but he had his ear to the ground. Given the deep-seated anticommunism of American workers, their conviction that war work was needed for full employment and George Meany's open hostility to any criticism of U.S. foreign policy from within the AFL-CIO, Mazzocchi stepped just far enough out on the limb to keep his legs intact. I almost got mine cut off because by 1966 I had gone public in my antiwar activities inside and outside the trade unions. When columnist Victor Reisel named me as part of a left-wing conspiracy inside the labor movement, a group of union leaders—some of whom where close to government security agencies such as

the CIA—vocally pressed for my dismissal. Without Tony's intervention with the president of the International Union, I would have lost my job.

Muste clearly perceived that the vacuum left by SDS's failure to spearhead a national antiwar movement required a new initiative. Under Muste's influence, Lynd organized a conference in Washington in August 1965 for the purpose of providing a forum for the many new movements which were trying to mobilize poor people, students, and blacks. The Congress of Unrepresented People, as it was called, was intended as a protest against the hypocrisy of representative government, and a demonstration that direct action rather than traditional political participation was the only way to achieve justice.

Prior to the Congress, Jerry Rubin appeared in my Washington Heights apartment. Agitated, pacing my livingroom, Jerry had come to persuade me that we needed a national coordinating body to expand the antiwar movement. He argued that SDS, despite its crucial role in giving a national existence to the movement, had shifted most of its resources to community organizing and would not lead the antiwar effort. I was one of his targets because I had played an important role in the New York Committee to End the War in Vietnam, an SDS project developed in late 1964 simultaneously with the March. It was a summer organizing project spurred by Columbia students, among them Rick Wolff and David Gilbert, but also involved some older neighborhood-based peace groups, especially on the Lower East Side of Manhattan and the Upper West Side. But students—many of whom were already residents of New York communities—organized committees in Washington Heights, the Columbia area, in South Brooklyn, and Queens. Rubin had been a leading figure in the Berkeley Vietnam Day Committee. He had already won the support of Frank Emspak, an activist in Madison who had already done some dramatic and nationally reported antiwar activities.

One of the by-products of the Congress was the first national coordinating committee for the new antiwar movement, a committee put together by Rubin, Emspak and myself. The coordination was established in Madison under Frank's direction. This committee lasted a few years and provided the first really national face to the movement. It was replaced within a year by the Mobilization Against the War in Vietnam that Dellinger and a few others close to Muste led.

Lynd and Hayden disagreed with the Old Left less on the specific issues than on the reliance of the latter on state action, legislative methods, bureaucratic organization, and the like. Furthermore, like many other new radicals, they were more interested in humanizing cultural and social relations than in reorganizing the principle of economic ownership as such. In this, they were early proponents of political and economic decentralization, the creation of nonbureaucratic forms which would "let the people decide" the questions affecting their lives, and the substitution of "community" for "society" (thus following Ferdinand Tönnies's famous distinction). The state was regarded not as an instru-

ment of social justice and equality, but as an arena in which community, peace, and other issues of the "people" could be fought out. The ultimate object, however, was to dismantle as much of the state's power as possible.

The *Studies* board in 1965–66 was not split along personality lines—though Lynd's slow, pacific and moral discourse was sometimes maddening to the New Yorkers—but on deeply rooted divergences on the question of what the basis of a new left was supposed to be. Weinstein and Genovese may have broken with the Communist Party on political grounds, but they were, root and branch, socialists of the Second and Third Internationals, respectively. Hayden and Lynd, on the other hand, had a proto-religious conception of the "movement." Their argument that *Studies* should report the activities of the emerging social movements was well received by other board members. The battle ensued over the problem of whether the journal had the right and responsibility to provide an interpretation and critique of these movements. Hayden was particularly insistent that intellectuals on the outside should confine themselves to publicity for such movements, at the very most asserting their centrality to contemporary political discourse and situating them in the general liberation movement.

This cut to the heart of the role of the journal. In these years, *Studies* was perhaps the most influential and widely read of the growing band of New Left periodicals. Despite its relatively modest circulation, its articles were widely discussed. Its editors were national figures in the movement, and its ideas were considered advanced. Weinstein, Genovese, and I saw the journal as a theoretical organ of a putative new socialist party that would gradually gain hegemony among the key activists in the movements. Abandoning the Old Left organizations did not for us signify the absence of any hope for a mass socialist party, which could run its own candidates for public office, constitute the leading cadre of the movements, and eventually find means of building influence within the trade unions and other working-class organizations. Hayden, Lynd, and Fruchter argued that these perspectives were far removed from reality. They, and the new radical generation, did not aspire to act within the confines of mainstream politics. They were searching, on the contrary, for a way to authenticate their own social and personal existence through action, for a way to construct a new moral order based on popular democracy as the antithesis of representation.

One can see in these debates the germ of what was to become the cause of the breakup of the movement in the later 1960s. Weinstein argued that movements without a political vehicle would inevitably collapse. But his often accurate criticisms failed to come to grips with the fundamental assumptions of Hayden and Lynd. For them, the issues had to be fought in order to build the movement, which was by no means intended to change the existing society but to presage an alternative one. Weinstein had replaced the palpably erroneous economic determinism of the Old Left with the primacy of the political; Hayden and Lynd

challenged politics itself as a form of domination infinitely more oppressive than economic exploitation.

We socialists on the board also missed a second principle of the new radicalism: the aspiration to absolute sovereignty for the individual, whose power had been systematically undercut by representative government, trade union bureaucracies, and large impersonal institutions. The New Left intended to restore power to the *person* (which is not to be confused, as it often was, with "power to the people," a formulation of the black civil rights movement where the individual was subordinated to group interest). Hayden and Lynd were, in this respect, early critics of what Gilles Deleuze and Félix Guattari were later to castigate as aggregative politics. Against the traditional macropolitics evinced by Weinstein, Genovese, and me, Hayden and Lynd advocated a micropolitics of liberation.

Weinstein was finally also involved in the politics of *interest*, the underpinning of such notions as class struggle, corporate liberalism, and conventional conceptions of socialist revolution. Lynd, while not adopting Muste's reconciliatory stance, was less interested at this point in the political strategies deriving from rationalist assumptions, i.e., alliances, coalitions, and blocs, than he was in movements stemming from individuality, spiritual renewal and love. The revolution would restore our humanity, bring us back to ourselves, and in Marx's words, recreate our "species-being." The movement had to be founded on the dignity of its subjects or it would inevitably degenerate into traditional interest group politics. The inspiration here was the early Marx and the left traditions of Protestant humanism, not revolutionary Marxism. Lynd's fundamental view was expressed in a book he wrote later with Alice Lynd, *Rank and File*, in which workers spoke for themselves about their work, their struggles, and their hopes for the future.

The differences within the board were too wide. Lynd, Hayden, and Fruchter finally resigned when they understood the intractability of Weinstein's position. Weinstein then disbanded the journal in 1967 and moved to the West where, three years later, he founded *Socialist Revolution* (now *Socialist Review*), a political journal seeking a new socialist party. In 1972, Lynd and Weinstein came together again to form the New American Movement, a democratic-socialist organization which embodied the principles of both the communitarian and the traditional radical politics.

Lynd and Hayden, like Weinstein and Genovese, were serious intellectuals. Both groups were profoundly persuaded that the left had to be, in the first place, an *American* movement. This left isolationism did not affect their shared hatred of imperialism and global American corporate interests, or their admiration for national liberation movements abroad. The idea was to build the movement on American traditions. Lynd admired Thoreau and Hayden wrote his master's thesis at Michigan on C. Wright Mills (it was subtitled "Radical Nomad").

Although Weinstein drew much from Mills's *Power Elite* and followed his political writings with interest, he was more of a Marxist. As for Genovese, he remained an unreconstructed Leninist of the Italian variety, which meant that he believed in a polycentric world communist movement, admired Gramsci, but was also interested in building an American Marxist party that could one day contest state power. In 1964, he became a national figure by declaring, while still a junior history professor at Rutgers, that he favored victory for the National Liberation Front in Vietnam. After the collapse of the Soviet Union, Genovese's Marxism also collapsed.

However, Lynd and Hayden became, as the 60s wore on, more political activists than intellectuals. Like so many others, they were unable to break down the growing division between the two aspects of the radical movement, and ultimately came close to sharing the pervasive anti-intellectualism of the period. We, on the other side, increasingly defined the issue in terms of the need for *"theory."* For Hayden, theory was a devaluation of concrete experience. On the other hand, what we meant by theory was not clear. Weinstein was hardly a theorist and Genovese's idea of theoretical discourse was mostly too traditional to be taken seriously by the other side. In fact, most of the writers of *Studies* were empirical historians. The journal did publish genuine contributions to theory. James O'Connor's two articles on community unions as a new form of social struggle advanced our collective understanding of the processes at hand very considerably;[10] Harold Cruse produced a brilliant, historical critique of the role of the CP among blacks, later expanded to a celebrated book, *The Crisis of the Negro Intellectual*; and Martin Sklar, though no longer involved in the daily activities of the journal, succeeded in his few contributions in expanding the historical perspective on corporate liberalism.

~The antiwar struggle, in its first years an important but still sectoral movement, gradually came to consume almost the entire New Left, including Hayden, Lynd, and for a time myself. This transformation was due mainly to the escalation in the war and the attention it drew in American political life. As the 1968 election approached and the size of the movement increased, antiwar leaders like Hayden, Dellinger, Rubin, and Abbie Hoffman inevitably turned their attention to the Democratic Party Convention in Chicago that summer. Many of them could not have cared less about who got the actual nomination, though others certainly were attracted to electoral politics after seeing how profoundly the protests had shaken the Democratic Party. Yet the coordinators of the movement, the majority of them either Muste's offspring, old SDS leaders like Rennie Davis, or cultural radicals such as Hoffman, were still guided by communitarian ideas. Protest and confrontation would purge the sins of our culture: the antiwar movement was yet another occasion to exercise the popular will, to

expose the sham of electoral representation, to mobilize the millions for control over their lives. Only a minority perceived the moment as a means to change power relations within the state or to create new alliances against imperialism.

The way, then, was seen largely as a symptom of the degeneration of our civilization, of the futility of bourgeois rationality, which had become the same as technological rationality. Antiwar protest, direct confrontation, was a way to redeem a corrupted nation by bringing it back to its moral roots. However, even as thousands of young people were battling with police in Chicago, the youth movement was beginning to fall apart. SDS, now a mass student organization with thousands of members all over the country, was beset by sectarian squabbles, squabbles which had begun in 1967 with the entry of a Maoist sect, Progressive Labor, into the movement. PL was formed in 1960 as a late spinoff from the Communist Party, partly as a product of the Sino-Soviet split, partly because the dissenters considered the CP hopelessly reformist. By the mid-60s, PL had discovered that the student movement was more than an amusement for upper-middle-class kids and indeed worthy of political intervention.

Progressive Labor forced the usually laconic SDS leadership into intense ideological struggle. For the first time, members were forced to declare their "politics" beyond the ordinary combination of vague democratic radicalism and strong antiwar position. PL pushed its own, fully worked-out Marxist-Leninist perspective, from which it was never prepared to deviate, upon an organization that was somewhat of an ideological vacuum at the time. For SDS had grown much faster than its political and administrative resources could handle. A good number of the first generation of student activists had already graduated into antiwar work, trade union, and community organizing, academia or, occasionally, "mainstream" liberal politics and the professions. Many of the old New Leftists had gone to the media. It was a new leadership, then, that had to come up with a response to PL. For a time, they tried to rework the implicit ideology of their predecessors: "youth" became a class, a historical subject and the vanguard agent of change.

By 1967, having abandoned their bold assertions of sovereignty, SDS leaders no longer saw their generation as historical subject, but were self-proclaimed "organizers," meaning they were to facilitate the agency of the people. For them it was always "the people," the poor, the blacks—in short, someone else. They had rejected the Old Left, but hesitated to go further than arguing for an anti-mass, anti-elite, antistate position. Their successors had no choice but to engage in ideological combat, faced as they were with a competent and determined PL cadre. In addition one could not deny the importance of Maoism and the Cuban Revolution in the context of mobilizing the political opposition. Maoism, as distinct from the actual achievements of the Chinese revolution, deeply influenced feminism and radicalized many youth, especially blacks. It also became a refuge for the multitude of radicals who abjured reformism but could not bear

to support the Soviet Union, which they viewed as the mirror image of the United States.

The debate within SDS epitomized what was going on everywhere: it was just more visible because the discussion was open, had immediate organizational consequences and took place in the most highly respected New Left outfit. The Trotskyist Socialist Workers Party, which had made a substantial contribution to the antiwar movement since 1965, was now challenging it to limit itself to minimalist slogans and leave broad ideological politics to the Leninist vanguard (like themselves)—a policy, incidentally, directly opposite that of the European Trotskyists. Other sects intervened too. By the end of the decade, the entire independent left was debating whether to transform its various organizations into preparty formations, and, if so, what one ought to do next. SDS split into four major factions, corresponding to the wider splits in the radical movement.

The first tendency, the Revolutionary Youth Movement (RYM), immediately became two. One faction, RYM I (which was later to metamorphose into the Weather Underground, Prairie Fire, etc.), argued that the United States was in a pre-revolutionary situation, an old concept designating imminent armed struggle for political power. The perceived agents of this revolutionary upsurge were the oppressed black masses and the alienated, already countercultural youth. This alliance, forged through exemplary acts of violence against the symbols of white ruling-class power, would thus eventually topple the system. Now, critics have often labeled the Weather movement as nihilistic, juvenile, irresponsible and paranoid; it has also been blamed in pulp magazines for sexual experimentation, elitism, and general zaniness. Yet one should be aware that the Weather people were an extension of the communitarian anarchic impulses of their entire generation. They misread American politics and the depth of the cultural rebellion. Like other isolated groups, they overestimated the repressive side of the state and of the large corporations, prophesying for a time the advent of fascism. As a result they engaged in some dubious acts of symbolic violence to show the vulnerability of the system and their own power. Yet these sometimes grotesque actions were not out of sync with the ideal of a total reconstruction of the human community: these "action critiques" of an apparently closed universe of liberal discourse can be defended if one accepts the premise that pluralism is simply another authoritarian form.

A total critique of the existing society, one which finds nothing redeeming in it, requires a broad political consensus in the population at large. Such was the case in Chiang's China, Batista's Cuba, Somoza's Nicaragua. The tragedy of the Weather Underground did not consist so much in the nature of its deeds as in the complete misunderstanding that the United States was another one of these cases. The question, then, is how they could fall into such an egregious error. Part of the answer lies in the nature of community building. Like other sects,

they created a discourse for themselves which reinforced the self-imposed demand that political work necessarily had to be a "family" expression. Just as the family generates a series of behavioral rules, values and assumptions, so the Weather people insisted that its members endure rituals of initiation, tight security as to their comings and goings, and a strict system in which loyalty to the family was everything. The community in effect created a new reality to fit the mode of intervention. The Weather Underground inherited the hubris of the New Left and added their own form of solipsism. Their feelings, perceptions and ideas were not represented to others as their own. They had become tribunes of the masses of revolutionary youth waiting in the high schools and the streets for the detonator to set them off in struggle—the new Weather vanguard. All others, especially leftists, were hopelessly mired in the culture and politics of liberal reform, inherently unable to make a real contribution to history because they had been coopted. The violence of the Weather faction was most acute in its language rather than its isolated revolutionary deeds such as bank bombings. These capers were informed by a deep sense of righteousness. After a while, it was reinforced by blatant substitutionism. The masses had yielded to their masters and the Weather family had to awaken their revolutionary temper by the deed.

The other RYM faction was, in some ways, a throwback to the 1930s. The notion of youth as the vanguard was supplanted with an emphasis on working-class and black youth. Led by SDS vicepresident Carl Davidson, Michael Klonsky and Bob Avakian, this group renounced the American perspective of the New Left, replacing it with the figures of Mao and/or Stalin and the policies of the Third Period of the Communist International, that is to say, confrontation with social democrats and left liberals. The party form of organization followed its course. It was the complete antithesis of the early New Left and the mirror image of PL. There was nothing libertarian or anarchist about it; it was deliberately mundane, glorifying the plodding and dogmatic style of the Old Left. For a time we witnessed a remake of an old film, but like all replays it suffered from having lost its original context.

The second tendency to emerge from SDS, the "mainstreamers," already in existence by the time of the split in 1969, gradually reverted to left liberal politics through they retained its new left ideology, at first. These were the community organizers: Mike Ansara, who was later to form MASS Fair Share; Paul and Heather Booth, who founded the Midwest Academy as a training institute for community and "citizens action" organizers; and policy oriented activists like Lee Webb, a leader in the Vermont Citizens Action Network and later the founder of the Conference for Alternative State and Local Politics; and, of course, Hayden himself.

Seen historically, this group was Old Left in the sense of the Popular Front. Their task was to bring new constituents like environmentalists and working-

class neighborhood movements into the faltering labor-liberal coalition and to put new issues on the national political agenda. One of the latter, the struggle for safe, clean, and cheap energy, became a central focus for coalition politics in the 1970s under Heather Booth's direction. The Citizens' Labor Energy Coalition (CLEC) is perhaps the quintessential formation of this mainstream tendency. It combined energy and utility organizations, trade unions, and citizens' groups in anti-corporate campaigns against big utilities that are responsible for advocating and producing nuclear energy, raising gas and electric rates to pay for it and pressuring legislatures to give in. CLEC was a locally and nationally based model for this new citizens movement that pretty much denied any specific ideological politics except the anticorporate rubric. In recent years, citizens' action networks and coalitions have reentered local Democratic politics in behalf of liberal candidates and have reproduced the older orientation of progressive politics of the 30s and 40s. Yet at the outset, electoral politics had been subordinate to extraparliamentary legislative and street activity. Although the mainstreamers came out of the 60s, they have left them behind, taking their place in the left wing of the Democratic Party.

The third and perhaps most important tendency was the formation of the new feminist movement, about which much substantive has been said. Here I wish to emphasize that the socialist-feminist wing and a major segment of the radical feminists formed in opposition to the sexism of the male New Left. SDs, antiwar organizations and countercultural movements of various kinds shared one major characteristic: women were mimeo-operators, coffee- and meal-makers and convenient bedmates for male leaders. I cannot recall a single major woman figure in the early SDs, although women comprised a large proportion of the membership. When the movement entered community organizing or mass antiwar activity, women assumed responsible roles in the actual work, but were rarely, if ever, considered leaders. Upon reflection, I remember the exceptions: Casey Hayden in Chicago's North Side, organizing white welfare mothers; Betty Garman on the West Coast, Sharon Jeffries in Cleveland, and Jill Hamburg in Newark. I am sure there were more women leaders in the mid-60s, but I am equally certain that they took a great deal of abuse and suffered humiliation. We were, simply, a male elite, on the *Studies* board, the leading antiwar coalitions, the counterculture affinity groups. The feminist movement became more than the property of a generation; it represented, mobilized, and embodied a large fraction of women, regardless of age and experience.

The fourth tendency was a small but not unimportant group of intellectuals who through their involvement with various journals maintained the deep-seated beliefs of the New Left, i.e., its reverence for decentralization, communitarian goals and democratic renovation of American society. Jeremy Brecher, Bruce and Kathy Brown (who for a time were mainstays of *Liberation*), Paul Breines (an editor of *Telos*), Paul Buhle (long-time editor of *Radical America*), Stu and

Liz Ewen, and many others became writers and publicists of a new type of libertarian socialism, which was not exactly anarchist in ideological orientation but certainly was antistatist and antibureaucratic. At the end of the 60s, it was my tendency. For us the twin tragedy of the New Left was the Leninist intervention and the left-liberal cooptation.

For the most part, we went back to the Marxism of Georg Lukács, Rosa Luxemburg, Karl Korsch, or the later Sartre—a Marxism without the sterile party politics and dogmatism of the new communist movement. At the same time, we tried to preserve the antiparliamentary or at least extraparliamentary perspective of the workers' councils. Brecher and I joined with a group to found a short-lived magazine, *Root and Branch*, which celebrated the wildcat strikes of the late 60s in Italy and derived much inspiration from the May 1968 events in France, and from U.S. labor struggles such as the 1970–71 national Postal strike and the wildcat walkout at GM's Lordstown, Ohio plant.[11]

This tendency was not a movement, but many of the new journals shared the general perspective. Some local organizing efforts were informed by it. Eventually, this neo-Marxism also helped spur a major Marxist revival in the universities. The "tendency" faded but survives as a current of cultural Marxism among radicals within a wide spectrum of activities today.

~I left the trade unions in the 1960s determined to break with my own political and occupational past. My activities in formal New Left organizations terminated with enforced exile to Puerto Rico in 1966, when I was accused of being a leader of the "communist antiwar conspiracy in the labor movement." While sympathetic in the main, the President of the Oil, Chemical, and Atomic Workers Union Al Grospiron responded to right-wing pressure by sending me off on an organizing assignment in the Caribbean, thus avoiding having to dismiss me. Eventually, I took a leave of absence to write *False Promises*, and then, while I was on a trip back to the mainland, Russ Nixon, a Columbia professor, advised me to see some people in the New York City antipoverty program. I was hired subsequently by Bob Schrank, a former trade unionist and machinist, who had become assistant commissioner of the city's job agency. I welcomed this. I was tired of traveling and living in motels, tired of trade union routine. Although the unions remained for me an important part of any possible movement for social transformation, the life of a labor functionary was not for me anymore.

After a year as program developer, I became director of a Lower East Side jobs program, spending the next two years as a community activist and administrator. My road was an alternate one to that of those radicals enamored of party or union building. The Lower East Side could not be organized along the same lines as Citizens' Actions, most of which had been formed among white middle-

and working-class constituencies. When we fought David Rockefeller's lower Manhattan expressway, when we tried to start coop housing movements in the slums and battled police in one of the several hot summers in the late 60s, when we struggled to obtain more jobs for youth than the city or the federal government were willing to yield: then the movement was based on poor and working-class Puerto Ricans in alliance with the remaining Italians. The organizers were recruited from the many social agencies that dotted the community. For these were the golden years of community action, the time that prompted Daniel Patrick Moynihan to address the problem of disruption and underclass organizing by devising for Nixon a guaranteed-income program for the poor as an alternative to the sprawling activities that marked Johnson's antipoverty crusade.

Moynihan's *Maximum Feasible Misunderstanding* referred to a panel at the Socialist Scholars Conference in 1970 where Michael Harrington and I participated in a debate about the value of the antipoverty program. I had asserted somewhat casually that its best feature was the employment of some good organizers, and Moynihan took this as evidence that the program was hopelessly misdirected. In retrospect, I think the hodgepodge of programs directed to the needs of the poor was one of the most interesting features of the entire decade. These programs provided support for SDS community organizing, and for the first welfare rights movements since the Depression, helped stop urban "renewal" dead in its tracks, and, equally important, trained a generation of organizers who together with some in the civil rights, antiwar, and student movements came close to revitalizing the labor movement through farm workers' struggles and the still unfinished organization of the public sector.

These community organizers avoided the Maoist and Trotskyist alternatives for two reasons. First, both positions struck them, and me, as authoritarian ideologies opposed to the ideas of a self-managed society. Second, to many of us, Marxism was the necessary but insufficient condition for understanding our situation, while Leninism, despite the major contributions of Lenin himself, was not at all appropriate to the building of our movement: we believed that an American socialism had to be internationalist, especially in regard to national liberation struggles in the third world, but we were even more convinced that it had to build on specifically American traditions. While we were among the most active opponents of the war and fully grasped the danger of isolationist populism, we were more impressed by the perils of trying to relive the history of the American communists.

The "new communists" invaded the factories to constitute a workers' vanguard. Most of the time they fell on their faces, though locally they made intermittent gains.[12] They produced weighty manifestoes proclaiming the imminence of the socialist revolution and elaborated strategies for defeating the liberals and social democrats (read ourselves) who would, just as in 1919, betray the work-

ers at the brink of revolution. They talked the language of violence as much to purge themselves of their deep-rooted pacific feelings as to symbolically annihilate the enemy.

The various Trotskyist sects were considerably more sensible. For one thing, they refused violence and did not prophesy imminent fascism or revolutionary socialism. But they were no less workerist and vanguardist. Their trade union work was more successful because they supported the "most progressive" rank-and-file insurgencies in the Teamsters, Steelworkers, and Communication Workers' unions, and kept their leftism in the background. Yet they found themselves in reform struggles against the most conservative bureaucrats along with other militants who were not socialist and for whom an honest contract and a democratic union was the limit; and that also tended to be the limit of this kind of entryism as such.

In the 1970s, as the young radical unionists tended to merge into the labor movement, an important fraction of the left "disappeared" into neighborhood activism, fights about nuclear power and opposition to the utilities which controlled it, feminist struggles for social autonomy and economic equality, and, of course, into the academy where Marxism had secured some beachheads in various disciplines—notably English, Economics, and Sociology. Often, we lost our distinct political identity as radicals, an identity that was now constituted by the sects, by the leftist journals, and by the several socialist schools that survived the breakup of the New Left. Many independent radicals felt that the time had passed when national movements were possible or even desirable. They adopted the perspective "Think globally, act locally." Nor did the left constitute a definite ideological tendency; it had become a subculture, a strain of American life that still resonated among intellectuals and activists but had lost its specific constituency elsewhere.

I had become, in the late 60s, a columnist for the *Guardian*, which, after two decades on the periphery of the communist movement and some painful internal disputes had metamorphosed into the leading New Left weekly. The paper became the place where activists and intellectuals debated radical strategies. It was clear to me that the task was to broaden the left public sphere created by the mass movements and that the press was probably the best way to do it. I wrote two kinds of pieces: analyses of current politics and labor developments, and a series that tried to bring a sense of history and social theory to my readers. I wrote on Marcuse's philosophy, the debate about fascism, the fate of the trade unions, the state of the American left and so on. I remained active, meanwhile, in the fight for urban space on the Lower East Side.

For me, the 60s ended when a group of Guardian staffers seized the means of production in protest against the stance of the paper on one of the factions of the new communist movement, RYM 2. The insurgents were a coalition of sympathizers of the Weather Underground and anti-authoritarian independents. I

abandoned my column in March 1970 with a piece in the *Liberated Guardian*, the shortlived alternative paper set up by the rank-and-file movement; I condemned both factions for sectarianism and that was for me the end of the New Left.

By spring 1970, I was part of a project to start an alternative public high school in East Harlem, perhaps the first major institutionalization of the free school movement. We tried taking the long march through the bureaucracies, fighting for space inside the structure of prevailing power, waiting perhaps for the next conjuncture. Those dizzy years of building an institution would not erase the sense that this was a defensive struggle. We were now engaged in preserving our gains of the 60s in bits and pieces. I knew it was going to get worse before it would get better.

The Depression of the 1930s would certainly not have produced a mass popular left if Capital had not reneged on its promise of the good life to both immigrant and native youth. The American dream was synonymous with economic security. Capital had thus broken the social contract by closing the frontier of economic opportunity. Of course, young workers fared better than their older comrades, who were consigned to the bread lines and Hoovervilles. But if one was lucky to have a job it did not mean dignity: wage labor in these times was self-evident humiliation. By 1933, mass organizing among the unskilled and semiskilled, most of them young, brought millions into both new industrial unions and old AFL craft unions.

The 60s revolt was caused by another kind of broken contract, one generated by the very success of the system during the New Deal in reconstituting the American dream. The generation born around 1940 and after never experienced the culture of economic deprivation and this opened the possibility of seeing the injustice of American foreign policy, racial discrimination, and poverty as signs of the moral decay of late capitalism. These concerns were in fact mirror images of the middle-class discomfort with the banality of everyday life in the suburbs. Consumer society obliged its white, middle-class beneficiaries to accept the end of history as the price of economic security. For the new historical subjects this was too steep a price to pay: a euphoria grounded in mediocrity.

The end of the Vietnam War removed the one universal, popular left issue from the public eye. The era had ended when activists were forced back into other single issue, often locally based, movements, or were forced into trying to recapture the initiative by forming national organizations that substituted somebody else's revolution for our own.

Some years ago, Peter Clecak told me that the enduring achievement of the 60s was the cultural changes it brought about, particularly the codification of a new morality in sex, gender, and race. The strategic failure of the left to create new institutions of conventional political power can be forgiven. There was a time when the movement could have created a viable independent electorate in

many states, though not on the national level. These formations would surely have cut the losses we have sustained during the recent conservative onslaught. Yet, despite the right-wing victories in the 1980s, the betrayal by a whole generation of liberals of their most cherished beliefs, the disintegration of the progressive coalition within the Democratic Party, imagination had succeeded in creating both institutional and ideological practices resistant to reversal. Certainly, as Brecht wrote referring to the rise of fascism, we live in dark ages; our justice system is once more suffused with the doctrine of retribution. Panic has replaced compassion in the polity, revealing that public generosity was the product of long-term economic growth. In an era of economic contraction, this society has lost its tolerance.

Perhaps the real test is whether workers will accept a permanently lower living standard, whether the middle strata will remain oriented to career aspirations despite its steady retreat into economic and social contingency and whether the minorities and the women will agree that they have been permanently defeated. Perhaps the other worlds that remain the indisputable legacy of the 60s will fade from memory like childhood itself. But the new social movements persist in our own decade, reminding us that, contrary to the best efforts of reactionaries and to the most pessimistic prognoses of social theory, the future is not dead. It is just resting.

The New Left

An Analysis

The Contract with America worked because it had ideas.
— Newt Gingrich, January 20, 1995

~For the moment, forget whether upon assuming office House Speaker Newt Gingrich spoke in good faith when he proposed to devolve the federal government by consolidating many programs into a few block grants to the states and eliminating chunks of the executive branch, especially cabinet-level federal agencies such as Energy, Housing and Urban Development, Commerce and Education. Was he really interested in "small is beautiful" or was he merely completing deregulation of business and accelerating the war on the poor, a cornerstone of conservative social policy for two decades? Ignore doubts about whether he, or any of the other conservative cadres whose faces and testimonies littered the media in spring,1995 (following the November 1994 Republican victories in both houses of Congress) *meant* what they said (a middle-class tax cut, smaller government) or whether by skewing the tax cut upward they merely wished to rob our pockets and transfer resources to the large corporations and their wealthy executives, the military, prisons, and police forces. Suspend judgment about the sincerity behind the rhetoric of popular empowerment which fueled the Republican long march to political power beginning in 1964. Forget, for a moment the cynicism of many who celebrate free enterprise as they dismantle the one-hundred-year-old regulatory system generated, ironically, by precisely those corporate interests who now scorn them.

Listen, instead, to how these evocations managed, if only for a brief historical moment, to plumb the depths of the political subconscious, to reach down to the unfulfilled popular yearning for freedom from government-imposed burdens of all sorts. For, in the last instance, from the perspective of political understanding rather than morality, whether they were sincere or not really does not matter. What counts is that some of the old distinctions between populism and conservatism blurred as Gingrich reversed field and claimed the libertarian-revolutionary legacy of Thomas Jefferson. In contrast, liberal Democrats appeared

to follow the Hamiltonian prescriptions of strong central government and a system of checks to the power of the House of Representatives, which, throughout American history, has been an uncouth and rowdy bunch because it is a more middle-class, populist chamber than the Senate, the resting place of established money and power.

Bill Clinton was, himself, a leader of the party faction that urged the Democrats to turn towards one of the more conservative anti-New Deal passions, modern antifederalism, especially in economic and regulatory policy; he was more openly allied with corporate interests than most of his Democratic predecessors; and, perhaps most crucial, since the 1970s, Democrats, including Clinton, have adopted the conservative budget-balancing religion, a faith that became a hallmark of Reaganomics and Gingrichism. In the short spring of right-wing power this economic policy shifted tens of billions from the poor, the working class and the middle class to the wealthy. The major differences between the two parties seem to be how fast this reverse redistributive program should go, not whether it should become government policy.

One of the major reasons for Republican dominance of national politics since the 1970s is the deep-rooted suspicion and even antagonism among large sections of the electorate of Government, a Democratic tool, especially its self-perpetuating bureaucracies and the failure in recent years of the mostly Democratic-controlled Congress to improve the quality of their lives. Instead, many believe that as taxes go up, public services deteriorate. The politically active population despairs of any serious change in and through government and. at least since 1980, has been prepared to suspend its own disbelief that any politicians will do better in these hard times. They have chosen instead to follow the pied piper out of Hamelin in order to gain tax relief, even if it means drowning. On this premise, some were able to muster enthusiasm for a return to more state and local control over tax revenues where, presumably, their voices could be more clearly heard.

"Now what you've got in this city [Washington] is a simple principle. I am a genuine revolutionary; they [the Democrats and the Bureaucrats] are the genuine reactionaries; we are going to change their world, they will do anything to stop us, they will use any tool, there is no grotesquerie, no distortion, no dishonesty, too great for them to come after us."[1] Who said this? Some paranoid New Leftist, fresh from harvesting sugar in the fields of Cuba's Oriente province or giving an English lesson in a Sandinista classroom? No, the voice belongs to House Speaker Newt Gingrich, the radical leader of the Republican party.

Since the New Deal, a coalition of political professionals and the core Democratic Party electorate of trade unionists, blacks, women, and many people who work in the "helping professions" of health, ,education and welfare have presented themselves as unremitting defenders of the proposition that those unable to care for themselves require the intervention of a compassionate state. The

commitment of these advocates to the dominant role of the federal government and especially its agents—the bureaucracies that administer the myriad of social and economic "entitlements" and distribute funds such as welfare payments and veterans benefits—is rarely as passionate as it is compassionate. And, despite the fact that they directly benefit from government programs, for many who voted for the Reagan Revolution and the Gingrich thermidor, the rhetoric of freedom, expressed in the promise of reduced middle-class taxes, and "getting the government off our backs," proved more powerful than a restricted definition of self-interest. Given their perception that government simply no longer works *for them*, no matter what the alleged benefit, many would prefer to have more money in their pocket with which to purchase from private sources the services currently dispensed by the government.

Indeed, like the movement that resulted in the end of Russian-style state socialism, the Reagan Revolution would not have been possible without the support of those reared and nourished by the Welfare State: union members in industry, commerce, and public employment; some of the women who gained abortion rights in the last of the mostly liberal Supreme Courts that expired in the late 1970s; and some affirmative action babies, especially black and women intellectuals who today rail against the hand that fed them handsomely.

The political choices of these once ardent Democratic constituencies reveal the complexity of political loyalty and refute, at least to some extent, vulgar economic determinism. For Reagan's own deployment of the New Left's "New Morning" slogan ("it's morning in America"); his adroit invocation of the rhetoric of freedom; his brazen reverse redistributive policies in behalf of the rich and powerful; and, of course, his bold, debt-laden program of remilitarization in pursuit of the Evil Soviet Empire, were contradictory, but extremely effective, tactics on the road to reversing a half-century of liberal hegemony.

That Reagan's military Keynesianism made all, except Lyndon Johnson, of his post-war predecessors' interventionist policies appear mild, went almost unnoticed in the media and among the electorate. Despite steep tax rises for the proverbial middle class and massive giveaways to the rich, Reagan's administration presented itself, successfully, as the embodiment of populist antigovernment sentiment. His rhetoric was that of a prudent fiscal conservative, but he turned out to be one of the champion "tax and spend" presidents of the twentieth century. Hardly anyone noticed because the President's rhetoric never wavered; even as the debt ballooned to dangerous levels, and the family farm all but disappeared from the rural landscape, Reagan was leading the country toward a revival of the rural and small-town values of self-sufficiency and free enterprise. In fact, he embodied these values. That he was obliged, for good political reasons, to back away from his revolutionary promise to phase out Social Security and Medicare caused his budget director, David Stockman, to complain of betrayal, a calumny that Gingrich sought to correct after the 1994

congressional elections. Yet, make no mistake, the Reagan Revolution prepared the *ideological* ground for Gingrich's success.

Surely, many of the crossover voters who abandoned the Democrats for the Gipper and his successors have already suffered, materially, the results of the Reagan Revolution. As federal health programs were cut and states failed to pick up many of the costs, deductibles on prepaid health insurance have risen, and fee schedules have, either by inflation or by dollar reductions, been slashed; federal and state education funds have been reduced causing, in effect, many schools to partially privatize or curtail the school day or school year. In suburban districts, schools depend more than ever on voluntary labor, not only in the classroom, but also for the provision of the basic material tools of learning. Parent financial contributions for pens and pencils, books, computers, and trips are a vital component of the school functions, but even as their state-supplied budgets shrink, schools suffer from the bolt of millions of women from uneasy domesticity to paid labor. Yet, many of those who bemoan the loss of services preferred to send "revolutionaries" to Congress rather than return the tepid, backsliding, status quo liberals. Some say they voted Republican even though they disagree with many of their policies because, in contrast to Democrats, they appear decisive.

This raises the crucial question of whether people vote their economic interests in an era where both political parties seem to represent the same large corporate interests. Surely, no discerning observer could accuse the post-New Deal Democrats of being a party of workers, blacks and women. Still, even as they agonize over the next necessary compromise to reduce social services and increase the government's policing functions to address the resultant fallout, the Democrats are unable to shake the images inherited from the Great Society era. In short, the Republicans win because they are unabashedly in favor of their program, while the Democrats never lose an opportunity to retreat from their own.

As we shall see, the New Left shared many reservations concerning big, bureaucratic government. The movement was Jeffersonian not Hamiltonian, populist not progressive, communitarian not associational, pacifist not patriotic. These broad sentiments emerged, however, from an underlying libertarian ethos which, suprisingly, they found absent in their liberal heroes.

~Reinventing the Left

Having rejected the discredited communist and socialist movements but also the lessons of their demise, the young radicals of the early 1960s often imagined they were reinventing the left. However, whether by intellectual means or by a still present political culture, populism and antifederalism remained living traditions. The survival of the populist tradition was abetted by what may be termed the "politics of compassion" that was kept alive during the postwar era

by the religious left, mainly Protestant but also including some elements of the U.S. Catholic hierarchy (which regularly rails against poverty amid plenty while, simultaneously, it condemns women to the slavery of enforced marriage and childbirth).

Many, perhaps most, political and cultural radicals of the 1960s were exiles from the 1950s version of class- and race-segregated enclaves: suburbs, private schools, country clubs, and other exclusionary institutions. They rejected what they perceived to be the emptiness of their parents' lives for which suburbanization signified the good life. Many students came to believe that the elite universities to which they were proudly and invidiously sent by their parents, often at great sacrifice, were, as Paul Goodman told them, places of mis-education.[2]

Even if reserved for the few, the elite universities under pressures to produce a new scientific and administrative technocratic class, were rapidly moving towards mass education. The generation of students who entered them in the last half of the 1950s shared the perception that the postwar era was marked by their elders' loss of commitment to democratic ideals and the political will to achieve social justice. In classrooms as much as in the dorms, many students became increasingly critical of the society and culture that, after all, offered them a widely approved, commodity-suffused version of the good life. Instead of partaking in what C. Wright Mills termed the *American Celebration*, they proclaimed American representative government to be by and for the few, and demanded a new era of *participatory* democracy which signified a "revolution" of everyday life as well as radical transformation of government institutions. In more contemporary terms they wanted to shift the ground of governmentality itself from the bureaucracies and the corporations to the "people."

This shift entailed decentralization of control over basic government services so that their recipients (clients, in social work parlance), especially those otherwise excluded from government, could participate in decision-making. The generation born between around 1940 and 1950 (Gingrich's) were the last critics before the current crop of conservatively coded antifederal radicals to demand decentralized government power. This chapter is about this generation.

I began with Gingrich because he is *of* this generation; his rhetoric and style is redolent of 1960s in-your-face radicalism. His appeal is to the same Unconscious that responded massively to 1960s slogans such as "let the people decide" and "community control" slogans which, despite the complexity of their accompanying political interventions, define the originality of the New Left against such positions as opposition to U.S. military intervention abroad and the struggle for social justice that were adopted by the conventional left. Moreover, Gingrich's ability to capture the press and television resembles the media genius of the New Left and is closely linked to his adroit *appropriation* of some radical traditions, notably the idea that in politics laying cards on the table, seeming to say what you mean, is superior to political sleight of hand, a characteristic of

politics as usual and one of the crucial components of permanent government. Ironically, precisely at the moment when the left hunkers down and, in some quarters, declares itself as relentlessly constitutionalist—especially with respect to the doctrine of checks and balances which removes from popular control many political choices—it is a militant rightist who recalls most vividly the underlying message of the New Left, the imperative of unfettered popular power.

~THE NEW LEFT WORKED

The New Left worked—that is, became a political force and gripped the imagination of an entire generation—because unlike the conventional postwar New Deal left that busied itself with system maintenance, it had *ideas*. It possessed the political will to try to make them part of political culture. Of course, like most new ideas, they owed some of their persuasive power to a definite series of *traditions*, which, in the American grain, were not necessarily internally coherent, but gained currency because they were disseminated in the contemporary vernacular and uniquely conjoined with the zeitgeist of post-1950s political scepticism.

The tradition to which the New Left owed much of its influence, no less than the radical right of the Gingrichs, was antifederalism. For it was the antifederalism of the American Revolution, revived by post civil war populism that first enunciated the deep antipathy of small farmers and business people to Big Government run by bureaucracies who were not accountable to the "people." Of course, the notion of the "people" is ambiguous.

Who are the people? Clearly, the term means different things in different historical periods. The antifederalists of the American Revolution were drawn from several social groups, but were united in their opposition to the very rich of their time, especially the large mercantile interests and the nascent political and intellectual class to which the larger merchants and planters were closely tied. In turn, the people were diverse: at their "legitimate" core were the farmers and the smaller merchants linked to them; master artisans who might have employed a few journeymen and laborers; and a scattering of intellectuals, drawn from the propertied classes as much as from more modest origins. The intellectuals were extremely influential because as a people dominated by yeoman farmers and artisans, the colonies were a literate culture.[3]

The second layer of the people was the "crowd" of permanently employed or casual laborers and independent, often self-employed artisans. They distinguished themselves from the other segment of the people by opposition to an independent judicial system that emerged in wake of the revolution and made demands for economic justice, specifically, if occasionally, raising the "social question" by demanding income from the state. The state, for many other Democrats, was not the proper concern of the polity.

In other contexts, the "people" connotes "the community"—usually situated in the countryside and composed of independent, yeoman farmers and the small merchants who supply them. In rural areas, agrarian laborers, many of whom were migrants or seasonally employed, were not considered part of the community. Indeed, in modern representations such as John Steinbeck's *Of Mice and Men* or the character Judd in *Oklahoma* as well as in everyday existence, the farm worker is considered a dangerous class that threatens "the people": for smallholders, the migrant or casual laborer is unstable, utterly unreliable and given to vices of the flesh.

Or, "the people" might designate a religious, ethnic, racial, or industrial group that predominates in a given social/economic space. In the Know-Nothing era of the 1840s and again in the 1880s, immigrants were constituted as the classical "outsiders." In fact, the early Irish Catholic migrants suffered both religious and a kind of racialized discrimination. They were poor, they owed their allegiance to the Pope and not to the American flag and, in the jungles of the emerging industrial and commercial cities of the Northeast such as New York, Philadelphia, and Boston, they were prone to riot, especially during the Civil War when the Lincoln administration imposed a draft.

Lawrence Goodwyn has convincingly argued that the turn-of-the-century populists were a popular movement which, in the main, consisted of poor farmers interested in the "social question."[4] Even if, as the revisionist historians of the New Left claim, the movement's militant struggle for railroad regulation and other forms of government intervention into the market unwittingly helped the large corporations in transportation and processing rationalize destructive competition by regulating themselves, its class aspects have, in these histories, been overlooked.[5] But populism may also be understood as a communitarian movement which, like nearly all other quests for community, had a strong exclusionary aspect. The "we" of the people may be national, regional or sectoral, but the "they" could also be religious, racial and ethnic. Thus, the absorption of the Farmers Alliance into the conservative Grange and the Farm Bureau signified the end of the glorious era of the interracial movement of the poor to one based on "farm" against "worker" interests, white against black farmers and so forth.

For the populists among the New Left—by no means a majority during the early 1960s—"the people," or more commonly the "community," referred to two disparate groups united by their perceived exclusion from the dominant economy and politics: the student generation born between around 1940 and 1950; and the black and white poor, urban and rural. The notion of the community and its constituents was to be intentional, the realization of a new political will which recognized the existential unity of these apparently opposed groups.[6] But, as we shall see below, the true subject of this communitarianism was the student generation itself, unable to forge its agency in terms of its own demands. The poor remained mostly symbolic through the community organizing period.

In the context of the deformation and reduction of the New Deal into a series of bureaucracies which virtually defined social justice after World War Two not as a series of rights but as one of obligations to the "deserving" poor of compassionate public power, the idea of "participatory" democracy resonated with a felt powerlessness shared by an entire generation in the face of a political culture that privileged "consensus" over conflict and economic security over freedom. The Cold War, according to bipartisan wisdom, demanded national unity. But the New Left set itself the daunting task of breaking the consensus. Perhaps equally important, the generation born around 1940—the first "baby boomers"—revealed, through their discontent, the limits of consumerism as a mechanism for consent.

That many activists projected their own struggles to others, particularly to the blacks and the multi-racial poor, was due, in a large measure, to the absence of a legitimating discourse of middle-class discontent in the immediate postwar era. Many in power—conservatives as well as liberals—acknowledged that the poor, broadly conceived to include a significant segment of the working class, had legitimate grievances. They were excluded from the benefits associated with the prevailing prosperity of the postwar era: first and foremost, they were excluded from having the money to buy many food items. Nor could the working poor and a substantial segment of the stable industrial and service sector working class, let alone the unemployed, acquire amenities such as credit of all sorts: banks would not make loans to them; they could not qualify for credit cards; and since racial discrimination prevented millions of blacks from entering the work force and the majority who did were consigned to the poorest paying and mostly dead-end jobs, their ability to buy a house, own a car or other appliances was severely limited by the widespread practice of bank redlining. Blacks were largely excluded from apprenticeships and other training programs for the skilled trades. When they possessed skills in the building trades, for example, most still could not obtain union cards from white-only craft unions, so they were relegated to poorly paid, nonunion work in rehabilitation or in noncommercial housing developments where the unions had been broken or failed to organize.

Despite their relative privileges, the middle-class blacks of the pre-affirmative action era—small shopkeepers, ministers, attorneys, and physicians—were denied access to southern, white-only colleges and had limited access to the Ivy Leagues and other elite universities. Access was denied to public accommodations which, more than the grinding poverty of many in black communities, elicited widespread sympathy and generated political will among many in the commanding heights of power. As the saying goes, the poor will always be with us, but to deny amenities to paying customers is a fundamental violation of the American creed that anyone who can pay should be served.

However, there was little public sympathy for those white-coded young peo-

ple whose dissent was chiefly cultural and political. To a society propelled, more than that of any European country, by the ideology of economic determinism, middle-class youth disaffection expressed in spiritual as much as material terms appeared to dominant opinion as little more than the fulminations of spoiled, selfish and overprivileged crybabies.

Consistent with another hallowed American tradition, only the most abject had the right to complain and only the deserving among them could expect a just measure of restitution. Since abjectness was invariably defined in economic and racial terms, students simply did not qualify for protest. Their victim status was severely contested, not only by those in power but also by other victims. Their task, according to elders, was to respect the authority of their parents, their teachers, and their benevolent employers. Students were told that their powerlessness was, above all, a demographic condition. They were admonished to make it in that uniquely American way: climb the corporate, small business, professional or government ladder. More, as among the privileged minority of the population they were obliged to set an example for less fortunate others rather than display their narcissistic anger.[7]

Yet, despite their relative isolation from prevailing cultural sentiment that placed enormous value on acquiring cultural capital (education) as the path to career success, the most dynamic segment of the incipient student movement of the early 1960s focused protest on the contradictions of the higher education system to which they were subjected. True, they were the last generation in American society which, on the whole, could look forward to doing as well or better, in purely occupational and monetary terms, than their parents. At the same time, they understood that even if their career chances remained relatively good, the career itself was less worth having because most professions were undergoing occupational degradation.

By the 1960s, the salariat was rapidly replacing the independent entrepreneur at the center of the professions. That is, the typical, newly graduated attorney or physician could not expect to own her/his own practice. Instead, perhaps a substantial majority would become employees at relatively high salaries. Yet, as employees, their degree of control over their work would be circumscribed by decisions made by supervisors. By the middle of the twentieth century, nurses, teachers, social workers, and engineers were almost fully transformed from the self-employed into hired professionals. The old middle-class expectation of owning your own business and, therefore, commanding much of your own time was vanishing with the small town and the countryside.[8]

Still, if they kept their noses clean and close to the grindstone students could acquire the credentials and other markers of cultural capital which qualified them for good professional and technical jobs. They would be in a position to enjoy the dominant conception of the Good Life which had been outlined by Herbert Hoover in 1928 and became, tragically, the measure of success for all

subsequent national administrations: "a chicken in every pot and car in every garage" (which implied everyone would own a house), a metaphor for the advent of post-scarcity consumer society.

By the end of the war the Good Life was almost entirely defined by the images and the means of consumption. The shift from the idea that work was a vocation informed by transcendent social and cultural value was not entirely eclipsed by consumer society and the degradation of labor, but the expectation that these values dominated paid labor had been severely attentuated by the subsumption of intellectual and manual labor under the rationalizing practices of Taylorism and Fordism and the growth of large scale organizations which were dedicated to restricting the creativity and the autonomy of their employees.

Even for professionals, the idea of teaching, the law, or medicine as a vocation in the proto-religious sense of the term had been significantly sullied. Students pursued the credentials and training required by law, custom, and professional organizations, but, despite initial enthusiasm for the intellectual content of the profession, gradually learned to expect little gratification from the work itself. They may have consoled themselves by the knowledge that their efforts were important in larger social contexts, but they were also increasingly subject to conditions of labor directed from above. Mingled in the social justice rhetoric of the burgeoning movement was the bitter speech of disappointment. The perception that free space within the university was shrinking was only the prelude to much grimmer life prospects as an employee of a school system, a large law firm, or a corporate medical practice. These occupational choices were framed by the widespread antipathy of many of this generation to the corporate world.

But the generation that reached its maturity in the 1960s was also the first to question the terms of social and economic mobility. For them, the "multiversity"—Berkeley Chancellor Clark Kerr's felicitous phrase for the conglomerate of academic and technical programs subsumed under a single name—was the epitome of a new authoritarian corporate order. Mobilized by capital, the truly remarkable productivity of U.S. labor enabled a considerable part of the underlying population to enjoy the pleasures of mass consumption but could not offer even the college educated "meaningful work," that is, work that was both socially useful and self-managed. No matter how skilled the new professional, management ideology decreed that s(he) had to be supervised lest the organization lose control over its own resources.

The multiversity, of which the University of California-Berkeley was, perhaps, the model, was likened by Berkeley student Mario Savio to a "machine," the product of which was the "trained" brain worker.[9] So, in keeping with Cold War practice and the tradition which viewed undergraduates as unweaned infants, the UC-Berkeley administration barred political groups from engaging in public activity on campus, such as recruiting members and holding meetings and rallies on nonacademic political issues. Students, many of whom were not

members of the unsanctioned organizations, conducted a prolonged, and ultimately victorous, protest.

The Berkeley Free Speech Movement condensed the many grievances of the 1960s generation, not the least of which was that the bureaucracy had deprived them of academic citizenship. Students were not only legally disenfranchised of political speech and assembly, but were unable to control the conditions of their own education. The curriculum was in the hands of the professors and the administration. By the university rules, students were powerless to thwart the technocratic intention of the administration and the authoritarian classroom dominated by the professoriate. Consequently, from the demand for free political speech about questions such as war and peace and civil rights for blacks, the movement spread rapidly to considerations of whether students were moral *subjects*, whether they could have a significant voice in determining their own education—its curricula, pedagogy, modes of evaluation.

At the heart of this controversial demand to participate in determining the quality and direction of their education was the emergence of a *generation* which occupied a unique social location that propelled new, hitherto uncontested issues into the public sphere with a force that was unique in twentieth century. Although it finally embraced the broad goals of social justice, it was the first social movement of the epoch of *post-scarcity*. Its demands presupposed what the history of humankind had striven for and could only anticipate material plenty—at least for a significant portion of the population. This generation could have fulfilled the dreams of political philosophy since Plato's *Republic* for a community in which political discourse was logically distinct from the social question and could, for this reason, address what democracy actually means, and what are the responsibilities and obligations of members of the community to each other. Put another way, the student generation of the 1960s was engaged in a profound exploration of the clichéd term "citizenship" in the context of what they thought of as an increasingly massified culture.

Despite the fact that the generation of the 1960s was slated to become the chief beneficiary of U.S. postwar dominance of world economic and political affairs, it was profoundly at odds, and often at war, with the prevailing culture and the system of artificial scarcity that undergirded it. The core of its emergence as a political force was the "impossible" demand for the Good Life defined by spiritual and political rather than material goods. In sum, this generation questioned those institutions most responsible for providing the social glue that undergirds any social system—family, work and education.

The critique of the family was perhaps the motive force behind the modern feminist movement, which burst upon the scene on the heels of the the New Left's inability to recognize the autonomous women's movement. The implications of equal employment rights for women—which has been mistakenly interpreted as a mild, liberal request—for abortion on demand, and the demand that

men share childrearing and other domestic tasks constitute a veritable thought-experiment in the destruction of the patriarchal family. And the contestation of the culture of conventional higher education can only be fully understood as a critique of its function in the accumulation of cultural capital: acquistion of the credentials, behavioral rituals, knowledges, and internalized culture of the professional and technical workplace.

~ The popular 1960s slogan "turn on, tune in, drop out" may be interpreted as *both* a mantra of the counterculture, which refused to shape itself in the images of the *Man in the Gray Flannel Suit*, and a rejection of the conventional work imperative.[10] If higher education was after the war no longer a place where a young person could locate her or himself in the world and discover the dimensions of the self through explorations of literature and art, philosophy, science, and social theory; no longer an interregenum between the martial discipline of high school and the equally authoritarian workworld—then the rejection of the instrumental values of the multiversity in favor of a self-directed life is a commentary on the fate of the relatively privileged young under late capitalism.

The two countercultures of the 1960s—the New Left and the cultural radicals (which included feminists and people who explored alternative ways of working and living)—were the most visible expressions of this generation.

By "generation" I mean not the life cycle, what Dan Levinson has termed the "seasons" of bio-social development in an individual's life.[11] A generation *as a social movement* entails chronological synchronicity, and common social location, but also other preconditions. The conjunction of these conditions may or may not produce the unique phenomenon of a generational movement. What is required is the dissemination and broad adoption of a series of cultural and philosophical ideas and practices that congeal in a prism through which the world is experienced in a particular way and, for many, constitutes an alternative or oppositional sensibility that tends to have ideological and political implications.[12] Since most people, except for very brief periods, do not define themselves as activists or representative figures, a generational movement embraces even those who may never consider themselves as activists but, nevertheless tend to share the *worldview* of its most articulate, politicized fractions.

A generational movement shares with other genuine social movements both a profound dissatisfaction with the existing state of affairs and a *structure of feeling* that may or may not be articulated in clear political or other programmatic alternatives.[13] In the 1960s, the counter-*political* culture was fairly slow in exploring the implications of what had already become plain to many: that we had entered a postwork phase of the United States if not the global economy. That perception was expressed in the often inchoate feeling of this generation that people could begin to live their lives on the basis of the presumption of

post-scarcity and, for this reason, relieve themselves of the guilt associated with pleasure and happiness— which would no longer be a vanishing horizon relegated the future, but, at least as an objective possibility, would infuse the living present. Young people began to envision self-directed, decommodified work that overlapped with what in current terms may be classified as "play," "hobbies," or avocation.

Needless to say, a generational movement does not preclude others from identifying with its worldview or its politics. Indeed, for example, C. Wright Mills, Herbert Marcuse, Paul Goodman, William Appleman Williams, and most of their students were older than the generation that came into its own during the 1960s. Marcuse was born at the turn of the twentieth century, two generations earlier; Goodman and Mills were of the next generation—born before U.S. entrance into the first World War—but did not experience it as young adults. And James Weinstein, the editor of *Studies on the Left*, and Gabriel Kolko were more than ten years older than the most senior founders of SDS and the Free Speech Movement.

Their ideas would have remained iconoclastically brilliant but entirely marginal to politics had their work not been assimilated and reworked by the New Left generation. They would have remained prophets without a following and, in some cases, without academic jobs. Herbert Marcuse's *Eros and Civilization*, Wilhelm Reich's *The Function of the Orgasm*, C. Wright Mills's *Power Elite* and Paul Goodman's *Growing Up Absurd* were certainly widely read but, more to the point, their ideas and categories were disseminated throughout American universities, out of as well as in classrooms, and were picked up by many students who never read their texts.

Eventually, some of their phrases—Marcuse's "One Dimensionality," Mills's "Power Elite" for example—found a way into the culture. Some of Reich's intellectual progeny such as Alexander Lowen and Arthur Janov became prophets of pop psychology, and Goodman's libertarian educational ideas helped give birth to a new free school movement. These popular emanations are ultimate tests of influence: most people who used these phrases and repeated some of the ideas never heard of or read a single word of their authors.

However, in various ways, these texts provided a conceptual and moral framework for the new student politics. Mills spoke to the experienced powerlessness of middle-class students by enunciating the theory that American economic and political power was increasingly concentrated in, and dominated by, three elite institutional orders: the corporations, the military, and the top politicos. Marcuse and Reich asserted the right to pleasure against the prevailing dogma that the meaning of human existence resided in paid labor, for them a residue of eighteenth- and nineteenth-century Calvinism which, nevertheless, remains today a powerful moral precept. However anachronistic in the age of consumerism, the Nazi doctrine that "arbeit macht frei" ("work makes us free") has never been far

from the lips of any American liberal—and many a radical—ideologist. And Goodman's blistering critique of American education was, perhaps, the most widely read radical tract of this period.[14]

Marcuse exposed liberal doctrines such as those of the necessity of work, the naturalness of the free market and of competition as forms of "surplus repression," surplus because capitalism and its technological revolution had *objectively* freed humankind from the shackles of necessity. Only the reproduction and introjection of scarcity through the imposition of the moral imperatives of work, family, and community prevented the mass of humanity from entering the realm of freedom. Marcuse suggested that Freud's *Civilization and Its Discontents*, hitherto regarded as a conservative invocation to the repression of eros in the service of civilization, be read as an argument for the liberation of eros on the condition that the forces of material production be fully developed so as to vitiate the requirement that work dominate our lives. Where Freud could not envision a world without the dominance of alienated labor, Marcuse identified the persistence of this world with repression. Although not impressed by the moral virtues of work, Freud could not imagine the abolition of material scarcity that could be separated from the human compulsion toward domination. In this case, there is no question of separating the material from the political.

Imbued with the virtues of a fair day's pay for a fair day's work, most of the old ideological and popular left scoff at these ideas, believing them to be hopelessly utopian and inimical to the interest of class justice. But the New Left enthusiastically embraced them and, in the form of slacker culture, still does. Paul Goodman's rant against authoritarian education touched those who Kenneth Kemiston called "alienated" youth most directly and helped transform them into "Young Radicals," the title of Kenniston's 1960s update.[15] And in the late 1960s Theodore Roszak, among many others, proposed shifting social life away from the imperatives of the market whose social analogue was the nuclear family, the career and consumer society, to ecologically sustainable intentional communities.

More than thirty years after most of these works first appeared, in the midst of a massive conservative counterattack, it is too easy to dismiss their conclusions as the works of irresponsible, out of touch intellectuals. But it was precisely their plausibility in the face of postwar prosperity and the degree to which they seemed to accurately grasp the emptiness of everyday existence that made these ideas so attractive and ultimately influential. Even though the ideas of post-scarcity and postwork live a semi-underground existence towards the millenium largely because the forces of the past have succeeded in reintroducing material and moral elements of scarcity in the wake of overwhelming evidence of its supersession, they continue to inform the political discourse of the right and the everyday lives of youth. The right assumes a post-scarcity economy.

How else to explain its confident proposals to shrink the welfare state and its equally strong assertion that the free market can achieve full employment and prosperity for all? The practices of young people, particularly the refusal of many to work except under duress and their resistance to the socially conservative imposition of repressive sexual morality, have become the leading "social issues" of our polity.

Most powerfully, the common thread to the radical tracts was that they affirmed the moral agency of youth and women who were inclined to turn away from careers in favor of making a revolution in everyday life. Even though the word "revolution" has not yet impinged on the vocabulary of the new post-work generation of the 1990s, designated as "*x*" by the pundits, their action-critique—the refusal to value paid work as an end, and their affirmation of pleasure—lies behind the ferocious attack on welfare and teenage sexuality in the current era.

The most stunning and, from a national perspective, controversial contribution of the early New Left was to have punctured the thick skin of liberal complacency about liberal democracy. The critique of the exclusion of blacks from voting rights; the paucity of participation by workers and the poor in elections and in local institutions such as school boards and planning boards; and the attack on the vaunted welfare state as an insensitive bureaucracy which was often opposed to the poor as it was rendering assistance, marked the New Left's alternative of participatory democracy. For a brief moment, it became a contender to the hegemonic view that America was the best of all possible worlds except for a few glitches such as racial injustice.

But, the "innocent" demand for new forms of popular participation was revolutionary in the context of the political practice of American representative democracy which had been severely compromised by McCarthyism, antiblack Southern terror and the meekness of the liberal establishment. SDS, the Free Speech movement, and other young radical movements proposed to transfer political power from the "power elite" to the "people." SDS was the leading organization in a much broader movement which spanned the entire 1960's. It became the most influential section of the white movement, especially before 1967, precisely because of its intellectual ambition to displace the politics and ideology of the Old Left no less than of modern liberalism with a new radicalism. Unlike the "single-issue" movements such as the anti-Vietnam War coalitions, housing, education, and others that focused their energies within a single institution or domain, SDS tirelessly educated its membership and its putative constituencies toward a multi-issue, radical perspective. For this reason, SDS was, warts and all, the most dangerous of the new social movements prior to 1968 when, flush with real influence, but no power, frustrated factions of the organization elected to self-destruct by creating a series of delusional revolutionary-cadre organizations.

~Black Activists and the New Left

Although by no means ideologically identical with the white student radicals, SNCC and the rejuvenated Congress of Racial Equality (CORE) (originally an outpost of the small, but active pacifist movement led by A. J. Muste) were clearly part of the New Left and shared many of its ideological precepts. The main difference was that the *context* of the civil rights movement obliged any organization which sought to become a player to confine its intervention to disputes about the strategy and tactics for achieving the common goals of breaking down segregation in public accommodations such as schools and retail establishments and achieving the long-deferred goal of democratic rights for black Americans. Under the influence of Bayard Rustin and James Lawson, SNCC and CORE became eloquent voices for militancy and direct nonviolent action, a perspective shared, in part, by King and other influential leaders of the Southern black Church.

But the young black radicals were much less free than SDS to experiment ideologically and politically. After all, SNCC and CORE were part of a much larger movement dominated by long-standing moderate organizations, particularly the highly esteemed NAACP, which had distinguished itself in the legal fight to end school segregation. Moreover, while industrial unions like the Autoworkers were perfectly happy to throw a spare five thousand dollars to SDS, they were officially affiliated with the NAACP and, by extension, to the moderate wing of the civil rights movement. Some unions might support SNCC's voter registration activities, but were dubious, when not hostile, toward activities that might embarrass the Democratic White House or, in the case of trade union racism, themselves. Until 1964, although frequently embroiled in an internal dialogue with King's SCLC on matters of tactics, SNCC was careful to refrain from posing class issues, questions of political independence from the liberal Establishment and a more precise definition of black power.[16]

We can see in the policy of the most radical wing of the civil rights movement in this period an interesting parallel to the line of the 1930s Communist Party and other forces within the Popular Front. The modern civil rights movement adopted a tacit two-stage strategy for achieving black freedom. The first was the completion of the democratic revolution thwarted by the betrayal of Reconstruction. The SNCC staff, especially Northerners like Jim Forman, expressed their personal frustration at the need to defer more ambitious political goals. Yet, when he was leading SNCC, he and the field workers, especially those from the South like Courtney Cox, James Bevel, Lawson, and others, restrained themselves from entering into a more antagonistic relationship with the major civil rights leadership, especially King.

It was enough of an affront to have organized and mobilized for the challenge of an alternative Mississippi delegation to the 1964 Democratic convention in Atlantic City. Led by SNCC, many student activists joined a large Southern

contingent of civil rights workers and black, mostly rural citizens in attempting to unseat the old-line legatees of the 1930s and 1940s machine that had been built by the arch-racist Theodore Bilbo. Then, Vice President Hubert Humphrey, Arthur Schlesinger, and the newly converted Rustin (whose close ties to the trade union and civil rights mainstream had been forged during his role as chief organizer of the 1963 March on Washington but also by his strategic commitment to Harrington's and Max Schachtman's theory of political realignment), opposed the Mississippi black delegation's effort to unseat the regular delegation.

Schachtman was during the 1960s a powerful influence on the Socialist Party's secret civil rights caucus, forged during the March on Washington to stave off communist influence. Some of its members included Norman and Velma Hill, associates of A. Phillip Randolph; Tom Kahn, close to Rustin and later to become an advisor to Lane Kirkland; and Rochelle Horowitz. These people worked hard to persuade the alternate delegation led by Lawrence Guyot and Fannie Lou Hamer and their supporters to abandon the unseating effort in the interests of insuring Johnson's reelection in the wake of the most conservative challenge to a sitting liberal president since 1936.

SNCC and the Mississippi Freedom Democratic Party resisted the threats and blandishments of the liberals, and rejected the argument that a split in the party would likely elect the arch-conservative Barry Goldwater to the presidency. In the end, the movement lost the battle—the convention seated the regular delegation—but by the late 1960s, won the war when the party leadership determined that unless it won heavily in the increasingly black cities, it could not hope to retain the White House in 1968. But, in 1964, the South was still solidly Democratic, and, despite their status as a congressional "third party," the coalition that Roosevelt had built with Southern conservatives and racist populists was intact as an electoral force, if not in legislation.

It was only after the Nixon victory in 1968, which depended heavily on his own Southern strategy to crack the Democrats' monopoly in the region, that Democrats shifted their hopes to urban centers in which black and latino concerns received pride of place in domestic policy, even though by doing so the Democrats alienated their traditional hold on the white working class. By the mid-1960s, the long postwar working-class suburban exodus was so far advanced that blacks were able to pose a political threat to the existing Democratic machine that controlled city hall. As the urban machine lost its base, it began to disintegrate. In some places, community-organizing student radicals played a small, but vigorous role hastening its demise.

But none of this was apparent in 1964. From the perspective of the young radicals, Johnson and the party's liberals had been unmoved because they adopted a relatively benign hands-off policy toward Southern states and cooperated with conservatives as long as they could deliver the region to the party's nation-

al ticket. Yet, the achievement of full citizenship rights and access to schools and other public facilities required that the civil rights groups tread gingerly. Above all, the leadership determined it could not afford to walk away from the Democratic Coalition. This was precisely the consequence of taking on one of the sacred cornerstones of U.S. government foreign policy, the policy of containment. When it became apparent to the Kennedy administration that the Vietnamese Communists and their southern allies the Vietcong were seeking to unite the country under their rule, and that the South Vietnamese government was unable, on its own, to militarily thwart this objective, Kennedy, like Eisenhower before him, began to slowly escalate U.S. military presence in the country and in the region. According to the domino theory, Vietnam was the first line of defense to preserve U.S. influence in southeast Asia, for similar movements were growing next door in Cambodia and Laos.

Shortly before his assassination, Kennedy is reported to have reconsidered the terms of Cold War policy. Whether he was prepared to seek a rapprochment with the Soviet Union, if not China, a policy shift which would have also forced a reassessment of U.S. policy in Vietnam, remains a matter of speculation. In any case, Johnson showed no signs that he had been apprised of these plans or, indeed, had agreed with a new direction. Instead, even as SDS and other radicals wore buttons saying "Part of the Way with LBJ," his administration demonstrably turned up the juice in the summer of 1964 by sending thousands of advisors to Southeast Asia, while on the campaign trail Democrats attacked Goldwater for favoring full scale war.

Given their harsh and potentially dangerous confrontations with the liberal and the Johnson wings of the party, not only at the convention but also in the field, neither King nor SNCC and CORE were willing to support SDS's bold decision, first enunciated at the winter 1964 national council meeting, to organize a national march on Washington in the spring of 1965 against U.S. military pursuit of the Vietnam War. Needless to say, SDS's liberal friends were frantically trying to head off the young radicals at the pass and, more than incidentally, sending a clear message to King (who was personally opposed to the war and an ideological pacifist) and other civil rights workers to stay away from the war issue. But, after the Democratic convention and Johnson's subsequent duplicitous policies, SDS was not to be dissuaded. The unexpectedly successful event in April attracted more than twenty-five thousand marchers which for a Cold War issue was, until that time, astronomical. While individual SNCC and CORE activists joined the protest, the organizations demurred from sponsorship, or from addressing the war issue in voter registration drives and other aspects of the civil rights struggle.

Despite their fervent belief that single issue protest movements were counterproductive to social change, most SDS activists were not critical of SNCC's caution in the wake of the enormous liberal counter-offensive following the MFDP

struggle. After all, King had shown his willingness to play hardball politics by marginalizing Rustin and firing Stanley Levison (a fund-raiser for SCLC and close personal friend and advisor) when it became known to the Kennedys that Levison had been a Communist. SNCC suffered the wrath of Lyndon Johnson when it insisted on assisting the Mississippi movement to conduct an intensive voter registration campaign in the wake of the administration-crafted agreement with the civil rights establishment to desist from antagonizing the President's Southern Democratic base. But SDS had to face the same obstacles in order to mount the war protest. Taken together, events of 1964–1965 were to mortally alter the relationship between the movement and the liberal Democrats.

~Ideologically, the New Left was formed, spectacularly, by a series of confrontations with liberals around the important phenomenon of the modern incarnation of Know-Nothingism—McCarthyism. For all their later denials, many intellectuals—liberals and former radicals—such as James Burnham, Arthur Schlesinger Jr., Max Eastman, and, despite his personal contempt for the Wisconsin Senator, Sidney Hook, became collaborators with his programs. Throughout the 1950s, most liberals, especially those who had been radicals in the earlier days, stood by with embarrassed or approving silence as Communists, fellow travellers, and many innocents were hauled off to jail, condemned to unemployment, or driven out the country. Liberals such as Schlesinger focused their disapproval on McCarthy himself as a ridiculous and venal character. But despite their civil libertarian professions and sporadic denunciations of the Wisconsin Senator, they did not truly protest the unconstitutional persecution and virtual illegalization of the Communists.

In his manifesto of anti communist liberalism *The Vital Center*, Schlesinger had, in fact, approved of the notorious Attorney General's list of subversive organizations, objecting only to its inclusion of the Workers' Party, a neo-Trotskyist group. Like Hook, he was entirely convinced that, owing to its allegiance to Soviet Russia, the Communist Party should not be treated as a legitimate political organization.[17] Therefore, while mindful of the need to protect individual liberties for noncommunist radicals, he saw little merit in the loud cries of libertarians that freedom had been placed under siege by government repression of Communists.

New Left activists, many of whom shared anticommunist sentiments with the liberals, were, nevertheless, repelled by their apparent complicity with political repression. They saw the enthusiasm for anticommunist repression in some quarters as a sign that liberals had, perhaps irrevocably, surrendered to the right. In Berkeley and elsewhere, the New Left tacitly repudiated both the liberals and the more cautious anticommunist radicals like Michael Harrington by joining with students and faculty to protest hearings conducted by the House Un-

American Activities Committee (formally known as the House Committee on Un-American Activies) and parallel events by the Senate Internal Security Sub-committee, which carried into the 1960s the red-hunting tradition.

Despite the considerable loss of prestige suffered by anticommunists of the virulent stripe such as McCarthy, in the 1960s the Cold War was still very much alive. Ex-Communists who left the party after the Khruschev revelations but refused to recant still had difficulty getting or keeping jobs; the unions seemed not to notice that the Supreme Court had relegalized the party; and the stigma of pro-Soviet or pro-Chinese sentiments was enough to mark an individual as politically tainted. The cardinal sin of the New Left, according to liberal and radical anticommunists alike, was that it refused to recognize the Communist danger. For although socialists like Harrington disdained the denial of civil liberties to the party and its institutions, they recoiled at the New Left's willingness to work with some people who were in or close to the Communist Party. The de facto collaboration between the New Left and the Communists and their sympathizers in the civil rights movement and on civil liberties issues seemed, to the many liberals and independent leftists of the older generation, to be evidence of naivete at best and perfidy at worst.

There were, of course, outstanding exceptions to embarrassed silence in the face of repression among noncommunist leftists: the journalist I. F. Stone; some distinguished scientists such as Albert Einstein, Phillip Morrison, Linus Pauling, and Leo Szilard; *The Nation* and *New Republic*; educators such as A. Whitney Griswold of Yale Law School and William Kilpatrick of Teachers College; the small but influential Independent Socialist League to which some prominent intellectuals belonged, such as the critic Irving Howe, sociologist Lewis Coser, novelist Harvey Swados, and, of course, Michael Harrington. Although ISL was, through a misunderstanding, on the Attorney General's list of subversive, i.e. Communist organizations, it vigorously denounced the persecution of the Communist Party's leaders.

These were courageous but relatively faint voices, but they helped inspire the tiny band of student leaders who, by the late 50s, knew all too well that official liberalism had abandoned its own precepts of civil liberties. As we shall see, it is significant that when the student movement was reborn after a quarter century of quiescence, they knew that no major liberal organization such as the Americans For Democratic Action, which counted Schlesinger among its leaders, would provide a haven for dissent in a hostile and conformist world.

Not the least of the sources of their knowledge about the fate of liberalism was the National Student Association (NSA), the coordinating body for student governments, later revealed to have been heavily infiltrated by the FBI and CIA in the 1950s and 1960s. The NSA was closely allied with the liberal wing of the Democratic Party, whose congressional leader, Hubert Humphrey had, at the height of the antiradical hysteria, introduced the bill to outlaw the Communist

Party. The Humphrey Bill ratified what had already been achieved by administrative fiat and juridical persecution. (Humphrey's rationale for this measure echoed that of the red-hunters during the Truman administration: if the liberals did not initiate "moderate" anticommunist measures, the right would propose even more extreme repression.)

In the 1950s and early 1960s, NSA leaders red-baited some student governments and organizations, and engaged in their own witch hunts. Equally important, they subordinated their policies to those of the Democratic Party on the crucial issue of whether to support the civil rights movement's demand for federal action to speed the pace and scope of desegregation and for voting rights in the South. For students on their way to radicalism, by 1960 NSA had become little more than a mouthpiece for the Establishment. But, for student newspaper editors such as Tom Hayden, who had confronted NSA over civil rights, the battles within NSA provided an invaluable verification of their own suspicions and a training ground for politics.

In many respects the peculiarly American variety of anticommunism which converted ideological difference to conspiracy played an important role in slowing and otherwise thwarting the completion of the liberal economic and social agenda. Perhaps the most dramatic failures were the refusal of Congress to enact federal legislation to enlarge the social wage to include universal health care and the extension of full civil rights to blacks, a promise which, despite some gestures, had been deferred by liberals such as Roosevelt and Truman.[18] During the Cold War, even though the Democrats mostly held majorities in both houses of Congress, and controlled the White House for all but eight years until 1968, they were unable to enact a *substantial* program of social reform, except Medicare and Medicaid. This failure is compounded by the fact that after World War Two nearly a third of the work force was organized in unions and, by the mid-1950s, the Communists had been driven from most unions and other mainstream social justice organizations.

The AFL-CIO, united in 1955, seemed more concerned with keeping a tight rein on its affiliates than in mounting an aggressive campaign to repeal the Taft-Hartley amendments to the Labor Relations Act, in aggressively organizing the massively nonunion South, or in mobilizing its membership to enlarge the social wage through legislation. Despite Truman's veto, the Taft-Hartley amendments were enacted by the Republican-dominated eightieth Congress as part of the emerging Cold War government policies, but also were the cornerstone of the employer offensive against labor's postwar militancy. One amendment barred Communists from holding union office; another provided for an eighty day "cooling off period" before strikes could be staged in industries considered vital to the national interest. In the face of a severely intimidated Congress and a hostile administration, most unions preferred to avoid, at all costs, confrontation with the government and to win elements of the social wage such as health ben-

efits and pensions through collective bargaining with employers, rather than risk being charged with giving aid and comfort to the Communist conspiracy (Wasn't National Health Insurance a socialist measure?).

As we have seen, the Communists were no less active in the civil rights struggles. Throughout the 1930s and 1940s the communist and independent socialist left played a prominent role in the emerging civil rights movement. Armed with historical memory, many liberals became suspicious when, in 1960, Southern black students, mostly at Negro colleges, and their white allies, began to employ civil disobedience and other direct action tactics in the pursuit of black political freedoms. After all, they argued, wasn't the legal and lobbying approach of the NAACP sufficient to the task of achieving racial equality? Although committed to using legislative and judicial measures to win civil rights for blacks, many in the unions, liberal intellectuals, as well as the Democratic Party were persuaded that the sit-ins, freedom rides, and mass demonstrations that the more militant wing of the movement preferred to the older tactics of lobbying and court cases were somehow the work of left-wing subversives, even though the Communists were clearly on the margins of most of these actions.

Since many of the radicals, notably pacifist and socialist Bayard Rustin, A. J. Muste, attorneys William Kuntsler and Arthur Kinoy, and even some who were or had been Communists, gathered around Rev. Martin Luther King Jr., the Montogmery, Ala. minister was himself subject to FBI surveillance and liberal reticence, if not denunciation.[19] Behind the scenes NAACP secretary Roy Wilkins, Senator Humphrey, and Auto Workers president Walter Reuther were among leading figures who expressed reservations about King's Southern Christian Leadership Conference, which after the Montgomery Bus Boycott became, with considerable internal tension, more militant, and were suspicious of the Student Non-Violent Coordinating Committee. Among those close to SNCC were Ella Baker and Anne and Carl Braden, activists whose affiliation with the Southern Conference for Human Welfare and its successor, the Southern Conference Education Fund (SCEF) subjected the organization to more than the ordinary scrutiny by public agencies and the liberal establishment.

These liberals took seriously allegations that some key organizers of these groups were in, or close to, the Communist Party or, as in the case of the anti-communist Rustin, had been a member of the Young Communist League and perhaps more egregiously was a known homosexual. According to a leading historian of the movement, Rustin "was a pioneer in the shadows"; he remained a close King advisor, but was unable to assume public positions of leadership in a movement whose early development he did so much to nurture.[20] Perhaps due to these harrassments, after collaborating with the left during the Freedom Rides and sit-ins and with key leftists in the civil rights movement to set the scaffolding for the March on Washington for Jobs and Freedom, Rustin decisively broke from these relationships after the 1964 Democratic Convention,

where he played a key role in the effort to persuade SNCC and the Mississippi Freedom Democratic Party to accept a compromise which would perpetuate the standing of the regular state delegation. In the last decades of his life Rustin and his sponsor A. Phillip Randolph allied themselves with the Cold War liberals in the labor movement and the Democratic Party, even as his old mentor A.J. Muste remained in alliance with the left.

~How SDS Began

In the late 1950s, in contrast to the Republican White House which, reluctantly, was obliged to to enforce the Supreme Court decision for integrating public schools but did little to encourage the desegregation of other public accommodations, Democratic liberals in and out of the legislatures experienced considerable ambivalence: the South was still heavily Democratic and its substantial, high seniority congressional delegation played a major role in congressional affairs, especially for the enactment of key elements of the liberal legislative agenda such as Medicare and aid to the growing legion of depressed areas. Lacking an alternative such as a massive voter turnout among the working class and poor blacks and whites in major Northeastern and Midwestern states, many of which were controlled by Republicans, no Democratic national administration could hope to achieve its priorities without the support of the Southern bloc. President Kennedy was acutely aware of this conundrum and until late 1962 played a major constraining role on the movement even as he became the first President to have more than a formal relationship with it.

NSA as the major player "representing" the first baby boomers, who were rapidly becoming an important voting bloc, functioned in a large measure as an arm of U.S. Cold War foreign policy and was, in effect, one of the (junior) members of the liberal coalition that aspired to regain power when the ever popular Dwight D. Eisenhower left office in 1960. Of the leading contenders for their party's nomination neither John F. Kennedy nor Lyndon Johnson was anxious to provoke a party crisis by staunchly supporting the emerging civil rights struggle. Nor, it must be added, could they openly oppose it. Instead, before the freedom rides and sit-ins, the voter registration campaigns, and the emergence of a mass New Left of black and white activists, the Democratic leadership presented an ambivalent face to the mainstream civil rights groups, liberal intellectuals and the progressive wing of the trade unions. Always sensitive to the political winds, particularly the congressional Democrats, NSA also remained officially reticent about civil rights during the 1950s. When a substantial group of editors and other student leaders began agitating for the organization to take an aggressively affirmative stand on behalf of the urgent demands of the Southern freedom movement, the stage was set for confrontation. NSA's 1959 and 1960 meetings were cauldrons of controversy and, perhaps more to the point, the sites for the emergence of a new student movement. To forestall taking a stand, the organi-

zation's leaders rebuffed demands from the several dozen editors and student government officers who offered resolutions supporting direct action against segregation. More egregiously, NSA leaders engaged in open red-baiting, a tactic that had been used earlier in the decade by NSA leaders such as Immanuel Wallerstein (who later recanted), to defeat similar demands from delegates from the NAACP Youth Councils to the National Assembly of Youth, a federation of youth and student divisions of church, student, and civil rights groups.

Student liberals who had become deeply committed to civil rights after the Supreme Court's desegregation rulings and especially the stunning 1955 Montgomery Bus Boycott were increasingly disillusioned by the apathy and even the resistance of the liberal Establishment to supporting militant action to enforce federal edicts. Even if most, including activists, were anticommunist and agnostic about socialist and marxist ideas, it seemed to many of them that, while an alliance with mainstream liberal and labor groups was absolutely crucial to civil rights and class justice victories, there was something *structurally* wrong with both the ideology and the politics of liberalism. Consequently, when University of Michigan students Al Haber and Tom Hayden and others fresh from efforts to persuade the National Student Association to join the civil rights struggle sought a protective umbrella under which to create an independent student organization, they turned to the Socialists, the last remaining "official" opposition to the Cold War consensus.

Now, the Socialist Party was all but moribund, especially after most of its trade union and intellectual members bolted to Roosevelt and the New Deal in 1936. The infusion of the remnants of the fiercely anti-Stalinist and more organizationally and intellectually sophisticated ISL into the party in 1958 did little to revive it. Although the ISL cadres added younger, energetic people to weary and thinned Socialist ranks, the seriously decimated party of the aging, battle-scarred ex-minister Norman Thomas held little attraction for student radicals. Nor, with the exception of the 32-year-old Harrington, whose biography resembled that of Hayden, did the marxists among them make more of an impression. After all, they were still obsessed with the "Russian question" a concern which led them to anticommunist paranoia.

Rather, despite serious reservations, they saw in the reenergized Democratic Party of John F. Kennedy and his coterie of reform-minded technocratic liberals a more viable arena for social transformation. In fact, Hayden, if not Haber, was already convinced by fellow Midwesterner Harrington of this proposition. They agreed to organize a student affiliate of one of the party's front organizations, the League for Industrial Democracy(LID), largely on the strength of the fact that Harrington had recently replaced the veteran Harry Laidler as chairman. Although these young people had few, if any, illusions about the Socialist Party or LID, which by 1960 was reduced to an annual dinner and sporadic publication of pamphlets, they were attracted to its still extensive contacts with

labor and liberal communities and especially its access to money.

Throughout his leadership of the Students for a Democratic Society, Hayden was careful to cultivate, and remain friendly with, union and liberal leaders, including Reuther and Humphrey and, most notoriously, the Kennedys. Ever the realist, Hayden's radicalism never blinded him to the practical realities of organizational survival. Student groups, especially those like SDS whose early 1960s membership never exceeded a few hundred, could not hope to be financially or politically self-sufficient. The organization, whose activities chronically exceeded its resources, required substantial financial contributions and political protection from people who did not necessarily share their political commitments, especially an already fervent anti-anticommunism.

Hayden knew that Cold War liberals, hoping to avoid political oblivion, would support SDS on condition it did not (often) bite the hand that fed it. Even after, in one of the more celebrated controversies of its early history, SDS separated from LID and from Harrington's patronage, many among its leadership worked hard to retain liberal contacts and, with some exceptions, succeeded, at least until the fateful Days of Rage at the 1968 Democratic convention, which signalled a final parting of the ways of the two movements (but not for individuals like Hayden, who found his way back to the Democratic party in the 1970s). In retrospect, the antiwar demonstrations at the Democratic Convention marked the end of New Left influence in mainstream American politics, although many of its ideas remain at the core of current cultural debates.

~THE RUSSIAN QUESTION

Although the sensibility of radical intellectuals such as Marcuse, Mills, and Goodman resonated with the New Left, chronological, even generational differences were telling on certain points. No left political intellectual born between 1870 and 1930 could have failed to be deeply influenced, not to say interpellated, by the Bolshevik Revolution and its aftermath. Just as the French Revolution set the path for the development of liberal and socialist thought of the nineteenth century, the "Russian Question" defined the political imagination of the first half of the twentieth century, not the least in the United States. This implied that for many the course of the Soviet Union in the Stalin era was a defining moment in their political identity. They could not say that what happened during the Moscow Trials, the Jewish Doctors' "plot," and persistent reports of famine, labor camps, and other infamies were peripheral to their politics or, in supremely isolationist discourse, a purely internal affair of the Soviets. Since socialism and communism as political ideologies were ineluctably internationalist, what happened in the only society that, unequivocally, called itself both revolutionary and socialist was a matter of urgent concern for all who counted themselves on the left. As a consequence, at least until the removal of Nikita Khruschev in 1964 and beyond, what the Soviet government and Communist

Party did and said was, in fact, the frame of reference for the world left, pro and anti alike.

The complex history of world communism after the war, let alone the inter-war calumnies, failed to impress an essentially antihistorical and profoundly parochial new student movement. In the main, leaders like Hayden and Haber heeded too enthusiastically Mills' advice not to shape their politics on the basis of the old sectarian wars nor by the traditional labor metaphysic—the privileg-ing of the working class in the process of social change—that was endemic to marxist parties. By eliding the Russian question, the New Left was able to avoid the anticommunism that had infected the entire independent American left, but only temporarily. In its first five or six years, SDS remained outside the often vituperative battles over this question that had previously split the labor and lib-eral movements. Student activists tolerated the more ideological of their peers, whether social-democrat or communist—and were even condescendingly friendly to the older radicals, some of whom were barely thirty and who they recruited as allies, even if the Russian question remained uppermost or at least visible in their minds and hearts.

However, precisely in the midst of the 1960s phase of the Cold War—the rise of movements of national, anticolonial liberation and of Great Power mili-tary and political intervention to save Latin American, African, and Asian coun-tries from sinking into the orbit of the Evil Empire (the words are Reagan's but the sentiments were clearly bipartisan), at first the major groups of the New Left not only refused to take sides, but, save for a fairly small contingent of peace activists whose purview was after all international, disdained the debate itself. Rather, the focus of the early student movement was the conditions of their everyday lives. Clearly, taken individually, many of the most articulate among the student activists had strong opinions about everything, including U.S. foreign policy. But, by almost unspoken agreement, the Great Debate of the twentieth century received little attention in SDS and other local student groups and, for this reason, was conducted elsewhere.

In 1968, many of SDS's most effective leaders who, previously, were the most vocally insistent upon a radical politics rooted in U.S. conditions, were openly espousing the priority of anti-imperialist politics over issues of class, gender, and generation (race still occupied a special place in the pantheon of New Left commitments); and the old slogans of participatory democracy were all but shelved. In short, the New Left, together with a large segment of the Commu-nist and noncommunist Old Left tended to transmogrify into the American branch of the national liberation movements. Their political *identity* was no longer defined by the cleavages that had propelled the movement in the earlier 1960s and, for this reason, some saw little reason not to join the parties of the Old Left (primarily the CP and SWP) or, more typically, to form generationally based caricatures of revolutionary communist parties of their own.

At first, these groups felt obliged to acknowledge the generational ideology of the origins of the New Left. They began by calling themselves Revolutionary Youth Movements proclaiming, in turn, the priority of working class and/or third world youth in the class struggle. For some youth were a class, for others the vanguard. Within a few years, these trappings were shed and the various groups settled down into a sectlike existence, and emulated some of the most egregious mistakes of their communist forebears.

In retrospect, it is clear that, unlike the current postmodern political activists, the New Left disdained neither the social question in general nor the class question in particular. The participation of thousands of young people in the civil rights movement, the desire of a considerable coterie of activists to link up with the unions and their organizing efforts, especially among the poor, stemmed from a conviction that genuine democratic institutions could not be constructed on the swamp of class as well as racialized inequalities. In the end, the social question, particularly civil rights and the rights of the poor, and the renunciation of their own political subjectivity dominated New Left politics, prompting feminists, ecologists, and the counterculture to take another road from the specifically *left* movement. But, for a shining moment, it was the early New Left that provided a glimpse into a politics that remains to be recovered.

~THE BIRTH OF IDENTITY POLITICS

Strategic considerations aside, one of the New Left's most significant political innovations was to have given birth to identity politics. Identity politics, in this context, means that a politics derives from the ways in which a specific group of people define themselves—and are defined—within the polity. The famous generationally suffused warning "don't trust anyone over thirty" was a statement of the identity of a youth generation that found itself profoundly at odds with a culture formed by adults. These adults enjoyed a stable relationship to society manifested first by their integration into the job culture, for which individual advancement within an established hierarchy was the chief professional goal, and by a system of consumption that, itself, was a cultural norm.

The motto embodied more than a general social critique. It was a reference to the culture and ideology of their own class and, more specifically, to their parents. Later Anthony Lukas' popular book *Don't Shoot We Are Your Children* spoke to the deep mutual suspicion that appeared to separate the younger generation from its elders. More to the point, the generational movement signified the emergence of a self-defined identity defined by its refusal of available alternatives provided by the mainstream. What made generational identity "radical" was that lived experience rather than "issues" and "problems" formed the core of a new politics. While mainstream culture was prepared to accept racialized political identities because, almost explicitly, there was a wide, if not universal recognition among whites that blacks were effectively excluded from citizenship—

North as well as South—the forging of a youth and student identity among white, middle-class kids, appeared far more dangerous since it threatened the very grammars and vocabularies of American ideology. Even today, liberal and conservative thought prefers to believe that America is all right for the majority, in which case racism may be safely tucked under the category of a "problem."

The social and cultural weight of this movement is demonstrated by the variety of sub-identities that were sprung from the generational. Virtually written out of SDS history as early as 1965—two years before the emergence of such organizations as Redstockings and New York Radical Women—women, most of whom had been politically marginalized within the New Left and the civil rights movement, began a long struggle to find a separate voice within the recesses of SDS, the free speech movement, and the Southern civil rights movement.

In part, the development of feminism as an autonomous political identity occurred in the context of the movement's sexism: SNCC leader Stokely Carmichael's infamous remark "The only position of women in the movement is prone" became a kind of negative flag and object lesson for women beginning to recognize that, despite its doctrine of participatory democracy, the New Left was a closed elite of male leaders. When women complained, among them the community organizer and SDS veteran Casey Hayden, men became contrite or contemptuous, but there was little political will to change until young women, en masse, bolted the movement's organizations. Even when they supported the antiwar struggle, women began to define their participation through groups such as Womens Strike for Peace and feminist antiwar groups at the local level.

The presupposition for the development of these new political identities was the reemergence of popular radicalism and a New Left which became its ideological wing. But identity politics was inherent in the *style* of the new radicalism itself. As the New Left developed the notion of *generation* alongside the universalistic ideology of radical democracy as markers of difference within the left, it proposed a crucial ethical criterion of exclusion—those who were complicit with the sins of the past. Second, and perhaps more important, the New Left accepted the underlying socio-logic of the Great Society programs: that public goods such as federal transfer payments to the unemployed or the "unemployable" were "entitlements" reserved for those unable to negotiate the job market successfully, either because of racial discrimination or class. If in the 1960s sociologists and policy analysts invented the term "underclass" to describe a melange of working poor, permanent unemployed, and handicapped persons, its political roots were in the income criteria established under antipoverty legislation for eligibility and the facile characterization of industrial and clerical workers as part of the American middle class.

Even as they voiced general support for broader working-class demands and for the labor movement, SDS's theorists accepted the idea, even the term

"underclass." From the 1960s to the present in the literature and organizing strategies of many organizing projects sprung from the New Left and/or its political culture, the working class was sharply segregated from the poor: in housing, working, and living conditions and, from the political standpoint, by a host of public amenities such as education, job training, housing subsidies, and other measures.

Hence, reflecting the powerful role mainstream sociological thought played in forming the American New Left, in SDS lexicon industrial and service workers were merged with the "middle class" by income (consumption) criteria, even where their cultural capital (accumulation of education credentials and the experience of submission to intellectual authority) was divergent from professionals who might earn no more than a well-paid factory worker.

Many accepted one of Mills's most dubious and ultimately refuted theses: that the constituency of Big Labor, the industrial and craft workers were in Tom Hayden's terms "part of the establishment." Writing in 1948, Mills viewed the unions as *integrated* into the system, a player in the big power games, the social basis was the "bourgeois worker."[21] There was, of course, plenty of common sense as well theoretical support for this position, enunciated more precisely by British sociologist David Lockwood as the "embourgeoisification" of the postwar working class.[22] The credit system made possible a new pattern of private ownership of vital consumer durable goods such as homes, cars, and appliances. Higher education was no longer a barrier for the upper crust of the working class. The dominance of apartment dwelling gave way to the single-family home; both by necessity and choice, workers owned cars and were no longer bound to mass transportation; and the university student of working-class origin was no longer a rarity. More to the point, consumerism appeared to be the chief mechanism for tying workers to the capitalist system.

Of course, those New Leftists who were refugees from the Old Left, particularly the group around *Studies on the Left* and a substantial number of "red diaper" children of socialists and communists, were not moved by the Johnson and Kennedy administrations' discovery of poverty. For them the poor were understood as a fraction of the working class and the unemployed, a "reserve army" awaiting the next phase of capitalist expansion to enter the workforce.

For a brief period, some SDSers groped to bring into being the conditions for the reinvention of agency for the young intellectuals who, they perceived, were rapidly becoming absorbed by the ideology of otherness. For example, a small group of SDS antiwar activists in New York began to experiment with the idea of Serge Mallet and André Gorz that, owing to the predominance of knowledge in late capitalist production, technical and professionally trained employees were on the way to constituting a "new" working class.[23] The main contradiction of the new regime of knowledge production manifested in automation and computerization was between the proletarianization of its new subjects, the knowl-

edge workers, and their effective technical control of the new labor process. In 1966, Columbia University students David Gilbert (later a Weatherman), Gerry Tenney, and Bob Gottlieb circulated a paper called ironically *The Port Authority Statement* which outlined the Gorz-Mallet thesis and called for new emphasis on organizing college-educated knowledge workers on the campus, in the workplace and in the community.[24]

The writers became among the organizers of a new postgraduate organization, Movement for a Democratic Society (MDS). A few chapters of this SDS-related group were formed, more papers circulated and, within a year, several MDS groups were organized in academic disciplines, social work, and among teachers. Lacking organizational resources and requisite political will, MDS itself faded out of existence, but its legacy remained in the caucus movement which, by 1969, had merged in the professions with other independent radicals. These caucuses had varying effectiveness. Especially important were the groups in academic English, Economics, Political Science, and Sociology. Among the professions, computer people, physicians, scientists, teachers, and engineers formed groups for peace, against the war and for "social responsibility," some which became players in their field's professional associations while others remain, to this day, networks of individuals whose interventions are more occasional. Around 1970, these groups produced a significant number of new journals, many of which have outlived or become independent of the caucuses that spawned them. In many ways, the journals have substituted for the movement or party that was unable to sustain itself. Among these, the *URPE Journal* (Union of Radical Political Economists), *Catalyst*, a journal of radical social workers, *New Political Science*, and *The Insurgent Sociologist* enjoyed longevity.

For SDS's Economic Research and Action Project (ERAP), the organization's major attempt to intervene off-campus politically, the poor possessed special qualities that transcended conditions of class and race. For the hundreds of student-organizers in ERAP the poor, white as well as black, had deep moral significance. In a letter to Junius Williams, Newark Community Union organizer Tom Hayden put it succinctly. After reporting some of the project's activities— mobilizing hundreds of people to fight the landlords for heat, hot water, and repairs and the city for better garbage collection Hayden discusses the long-term objective to "change the balance of power" in poor neighborhoods in the cities. Then Hayden addresses the "needs" of students in relation to the project of organizing the poor:

> Students, especially, ought to consider whether their own needs are satisfied by life in the universities and professions as now constituted, or whether they must find an alternative to staleness by taking sides, risky as it must be, with the movement of a truly democratic society we are trying to build. For those who want to take sides, I believe the time is at hand when real vocations exist through which we can realize our values and realize ourselves. Organizing—and many, many differ-

ent skills are needed in organizing—can be a way of life, if only we make it so. We ask that people join us, down here.[25]

These remarks reflected the strategy to which, after 1963, many of the key SDS leaders began to commit themselves and the organization:

> At the core of the ERAP program is community organizing in poor areas (of eight cities). It rests on the assumption that "organizers," that is, people who devote full time to the task of talking with people about personal and community problems, can generate social and political change, can break down the isolation of ghetto life, and can open new alternatives to people who are wedded to lives of despair.[26]

To this catalytic objective, one should add Hayden's plea for self-realization. The student cum organizer could realize the self only through the Other. And otherness was defined as the more abject, "those who are wedded to lives of despair," a phrase which implies a high degree of introjection of poverty as a central element of the self.

In their pamphlet *An Interracial Movement of the Poor?* (1965) Hayden and the main organizer of the Newark Community Union Project (ERAP), Carl Wittman, revealed the full import of community organizing for student radicals. It was a way to implement the strategy of achieving "social change" by addressing the needs and the demands of the most oppressed social group in American society, the poor, especially the black poor. These were the classic unrepresented people in the political process, their everyday lives "wedded" to despair. But, it was also a way for students to address their own interests. What were these interests?

In this text, largely devoted to a detailed sociological description of depressed areas of the United States in the mid-1960s, mostly mining, urban industrial, and rural communities suffering deindustrialization, Hayden and Wittman turn to a "definition of our role" in building an interrracial movement of the poor.

> The student base of our movement must remain solid, and must increase greatly in scope and quality. *Our primary concern is not with the immediate value of students to the Negro and economic movements although students today are among the main catalysts of change. We are concerned with improving our quality of work and making opportunities for radical life vocations.*[27] [emphasis added]

In this text the term "catalyst" understates their self-evaluation. Here there is clear indication that the purpose of the organizing links with a much larger strategy and reflects an ambition that tends to be glossed over but was clearly part of the reason-for-being of the entire project. The authors understand that their contribution is to bring the poor into the mainstream of the liberal-left coalition of labor, intellectuals, and middle-class professionals. But organizing is also seen

as a "radical life vocation" in opposition to the professional life that their educations have indicated.

This theme is repeated in other ERAP literature, especially in the 1964 *Program*. Student radicals are eager to find work that engages their entire lives, that constitutes a "vocation" rather than merely a career or a job. I believe the term "vocation" signified, for ERAP organizers, a religious calling that was not far from that of Christianity's expectations of its priests or of Lenin's call for a party composed of professional *fulltime* revolutionaries. Richard Rothstein, an organizer for Chicago's JOIN (Jobs or Income Now) which focused on white poor on the North Side wrote:

> Students for a Democratic Society began about four years ago to question the nature of "democracy"; what it meant for men to take part in the decisions that affect their lives. After three years of the theorizing, we decided that intellectuals could not make democracy for anyone, that democracy has to have roots in heretofore apolitical American man. . . . I don't know if we will stimulate some democracy in American cities or will help to build an interracial movement of the poor. We can succeed only if a great influx of student organizers join our ranks, only if hundreds of new people leave the security of middle-income America to share a life with poor people as organizers and leaders.[28]

The intellectuals, secure middle-income liberals and progressive trade unionists are viewed as potential allies for a new leadership that can awaken the conscience of America through the mass mobilization of its most oppressed. In this strategic formulation, ERAP writers are playing on a recurrent theme of this period: poverty amid the plenty generated by technologies such as automation. SDS accepted the idea that the only barriers to inclusion of millions of poverty stricken people into the general U.S. prosperity were class and racial injustice. Although organizers were too sophisticated to believe that either the students or their clients among the poor could effect social change by themselves, they were convinced that this combination constituted something of an ethical and a political vanguard. Two years later, Hayden and many others who had (temporarily) abandoned secure middle-income comfort to share a life with poor people threw themselves wholeheartedly in the anti-war struggle. If a tiny minority stayed the course in the ghettoes and big-city white slums, others, such as Rothstein, realized that organizing as a vocation was possible only in the labor movement and other institutions with more stable funding. Still others returned to graduate school to serve the movement as academics and intellectuals.

It may be argued that the New Left was destroyed by the sectarian new Old Left of recently minted Marxist-Leninist Maoists. During its heyday, 1962–1968, there were many discussions within SDS and other groups about the tendency to organize around single issues rather than a broad program of social change. Recognizing the limitations both of workplace based trade unionism and of single

issue organizing, James O'Connor proposed a model of *community unions* whose task was to bridge the gulf between the shop floor and the neighborhood, between single economic issues and broader social and cultural concerns.[29] These articles were fairly widely discussed among New Leftists, including ERAP organizers. However, lacking a broader framework for politics, not only a multifaceted movement (party) but also historical and social theory including that of the American polity, the New Left was fated to repeat many of the errors of the past. Since the founding premise, the Generation, entailed a refusal to recover historical memory or to affiliate itself with tradition(s), it became likely that, when the New Left's diverse constituents sought to recover their own subjectivity and their own agency, it would take the form of identity politics.

Of course, feminism is a much larger and more multifaceted movement than that suggested by gender identity. Its theoretical development exceeds that of the New Left, which apart from its truly groundbreaking idea of participatory democracy, was, with few exceptions, truly anti-intellectual. Nevertheless, radical feminism inherited many of the best and the worst features of the New Left, especially its penchant for issue based political interventions which are (were) largely justified on ethical grounds. At the same time, like the New Left, feminism has appealed to the discourses of rights and interests to undergird its demands. In susequent chapters we shall return to the question of how to refound a radical politics outside the framework of rights and interests.

Unlike the socialist left which arose as a wing of the labor movement at the turn of the twentieth century, the New Left was a youth movement, most of which was middle class. It succeeded in attracting hundred of thousands of activists and supporters, in part because it kept its distance from the old sectarian wars, even though a considerable fraction of its leaders were sons and daughters of Old Left families. With the exception of the early Students for a Democratic Society and some younger disafffected Communists and socialists, the new movements were resolutely anti-ideological, except for their adherence to radical democracy as a kind of tacit value underlying their political activism. They limited their intervention to the fights against the war and racism and for social reform and refused to debate the virtues of socialist theory and policy or align themselves with either the Soviet or Chinese orbits.

Thus, despite the vast radical upsurge which by the mid-1960s had reached into the military and among younger workers as well as schools, left contingents remained, on the whole, steadfastly opposed to party formations, to the intricacies of ideological disputation except in the movement's own lexicon, or, indeed, to coherent organizational forms. For the democrats and liberatarians, the concept of *organization* of an ideological character was identified with Stalinism. Rather, when confronted at the end of the 1960s with three challenges—those of the Maoists, feminists, and the nationalist insurgency within the black freedom movement—the New Left dissolved its independent, democratic orga-

nizations, abandoned most of its regional and local organizing projects among the workers and the poor, and was unable to maintain the substantial peace movement that it led during the earlier years of Vietnam War. In the 1970s, the peace movement reverted to its pacifist roots and, as a result, was unable to offer effective resistance to the Reagan and Bush adventures in the 1980s in Granada, Panama, and the Persian Gulf.

Henceforth, especially after the McGovern defeat of 1972, the "left" was hopelessly dispersed into four segments: the dwindling base of the Old Left parties; the "new" social movements especially feminism, black nationalism, and ecology; the various institutions of electoralism, especially the liberal wing of the Democratic party; and "solidarity" organizations to support the Cuban, Salvadoran, South African, and other revolutionary insurgencies. In the 1970s, except on issues of U.S. interrvention in the third world, the public face of the left was manifested only in newspapers, magazines, and journals, including the established liberal weeklies and monthlies which had been somewhat radicalized during the 1960s. And, as we shall see in chapter three, efforts to resuscitate a democratic socialist left after the demise of the New Left have achieved little more than keep the name alive.

More to the point, the New Left was the last oppositional and alternative movement which, even when it gave birth to identity politics, partially transcended their partial totalizations. Its doctrine of participatory democracy captured the collective imagination, not only of its generation, but of a considerable portion of post- and anti-Stalinist radicals who had been mired in disputes around the Russian question for decades. The New Left's boldness—even arrogance—in face of the overwhelming power of giant corporations and the liberal establishment managed to galvanize a good segment of the popular imagination and produced the greatest outburst of popular resistance in thirty years. And, perhaps more important, for the first time ever on a world scale, millions of people, and hundreds of thousands in the United States, caught a glimpse of the possibilities of a radically different future in which the struggle for existence would not dominate their lives. It was this, rather than the specific resistances, that mortified those in power.

3~

The Situation of the Left in the United States

~PROLOGUE

"We live in dark times," began a Nazi-era Bertolt Brecht poem. The times in which we live might better be described as "gray times," since the tacit agreements by which the world turned after World War Two have been cancelled. As Ulrich Beck has pointed out, from the welfare state with all of its certainties, we have entered the era, perhaps the epoch, of a "risk" society.[1] Between the ecological crisis, a worldwide unemployment and underemployment rate of about 30 percent, and the progressive shrinking of public amenities, the world, as in seventeenth-century England, is turned upside down.

The Cold War was no fun, but it provided clearly delineated boundaries. For example, the New Left was once prone to criticize the welfare state as a bureaucratic nightmare, but in the wake of its dismantling, by Democrats as much as Republicans, the left—new as well as old—hastens to shore it up. Radicals called the trade union leaders to task for failing to defend workers' rights and for being suppliants of the aggressive U.S. foreign policy but are appalled by the free fall of unions in a new era of post-Fordist, "disorganized" world capitalism.[2] And, worst of all, the left falls in line behind a Democratic Party which, imbued with the religion of the balanced budget, has absolutely no intention of fulfilling even the bare bones of labor's traditional social justice agenda.

The more it follows the slippery slope of neoliberal compromise, the more the left is utterly shut out of public debate, for the brute fact is that, after the Cold War, and in the wake of the incredible shift to the Right of American politics, there is little to distinguish the U.S. left from yesterday's everyday social welfare liberalism. But however necessary are some aspects of the welfare state, the left's fervent and unconditional defense of it seems increasingly anachronistic. Most appalling, we live in a time when the left has run out of ideas which, in the absence of popular movements, sustained it as a force of *influence* even when bereft of a shred of political power.

~WHERE WE HAVE BEEN

For the vast majority of the New Left which, as a matter of principle, was polit-
ically and ideologically independent of the countries of what became known as
"actually existing" socialism, the 1970s had been years of retrenchment and
shifts of political focus. From a radical movement which proclaimed its aim to
be the fundamental transformation of society—in its economic structure, polit-
ical institutions, culture and personal relations—the decade was marked by five
distinct directions. Having refused to learn from the history of the Old Left, a
considerable fraction of activists was doomed to relive it. As we have seen, they
formed new revolutionary communist parties or democratic socialist formations
which, like the much bigger Communist Party of the 1930s and 1940s, failed
to attract a popular constituency, because they could break neither from the
basic liberal assumptions embodied in the political program of the New Deal
and its successors nor the dogma of Leninist voluntarism.

The organizations of democratic socialism rightly rejected Soviet-style com-
munism but without exception lacked the political will to forge a new path from
that dictated by the terms of the Great Compromise that formed the core of the
New Deal coalition. On the other side the newly minted revolutionary "van-
guards," which, as we saw, emerged from and helped make a shambles of the
"old" New Left of participatory democrats, became politically delusional and
squandered much of the considerable political capital of the New Left in a series
of absurdly self-destructive adventures which, in the final accounting, helped
set the entire left back for at least a generation.

Since the New Left was, in the main, a movement of students and young fac-
ulty, many entered mainstream professions and became leaders of their associ-
ations and formed radical caucuses, not only in academia but also in social work,
medicine, education, engineering, computers, and science. Former antiwar and
civil rights activists helped build the burgeoning ecology movement and public
interest organizations, some of which, notably in New York and Ohio, have
been effective in specific, largely environmental fights: against New York's West-
way which would have displaced thousands of residents and posed a significant
ecological challenge; against building incinerators in one of New York's poorest
neighborhoods, Williamsburg; and, fighting against runaway shops in Cleve-
land, Akron, and other large Ohio cities.

A fourth group entered mainstream or community based politics. The main-
streamers worked as organizers and staff members for trade unions and liberal
organizations or became activists in the Democratic Party where some, like Tom
Hayden, for example, ran for and won elective office—primarily in local and
state legislatures. Armed with an unarticulated egalitarian ideology, but without
global reach, community activists operating as advocates as much as organizers
spurred tenant, neighborhood renewal, homeless, and antipoverty movements.

Finally, even before the 1989 collapse, a significant number of erstwhile left

intellectuals were already steadily moving rightward into the liberal or neo-conservative camps. Some, like historian Eugene Genovese, whose marxist orthodoxy he never failed to announce, claimed to have learned of the failure of the Bolshevik Revolution only in the 1990s. Lesser lights like Ronald Radosh and others whose ideological training was, essentially, forged in the late 1950s and 1960s and who were never caught in the Stalinist web, "discovered" left authoritarianism and duplicity in the wake of the wars in Central America. Radosh and, later, Harvey Klehr learned from KGB files and elsewhere the "shocking" revelation that some American Communists, notably the Rosenbergs, may have actually engaged in espionage, a piece of news that was as fresh as a week old bagel.

For others such as Fred Siegel and Michael Lerner, the path to liberalism was cleared by the ample evidence of complicity of the left with anti-Semitism or at least tolerance for it exhibited in the rabid left pro-Palestinian position during the Middle Eastern debate and the hesitance of many radicals to condemn black anti-Semitism, most notoriously that of Jesse Jackson. Some had defected from the New Left during the Six Day War in 1967, but it was not until the post-Vietnam war 1970s and early 1980s that, in the face of the declining left presence in national politics, many felt they could slip into liberalism without facing the scorn of friends and former comrades, some of whom had taken the same road or retired prematurely from politics.

I would not want to minimize the significance of these factors or the legitimacy of the complaints against what had become automatic leftist support for all varieties of third world struggles, many of which revealed themselves to hold democratic and libertarian ideals in contempt let alone respect the emancipation of women from religiously based patriarchal bondage. For intellectuals who had remained unreconstructed New Leftists during the vanguardist phase of the late 1960s radical movement, there was no more important principle than that of democracy and respect for difference. Trampling upon these ideas was simply unacceptable.

I want to suggest that there was another, perhaps more salient, reason for the defections. As we have seen the demise of the New Left as an organized movement was the occasion for the emergence of what became known as "new" social movements based upon the assertion of new subjectivities and new political agency. Among them, none was more ubiquitous than feminism. Between around 1968 and the mid-1980s feminist ideas were fiercely debated among left intellectuals. Within the groups, women demanded nothing less than shared power. In the home they were asking their partners to share child rearing; they returned to school to gain professional credentials; and finally left men who refused to recognize that emancipation from domination, not equal pay for equal work, was the heart of the women's movement. More to the point, women marched out of the left groups *en masse* to form their own groups, fight their

own grievances, especially abortion and other reproductive rights, created their own journals and magazines, and wrote books. In short, they entered the once exclusive club of (male) activity, the life of the mind.

Suddenly, in their homes and in their workplaces, male left intellectuals, no less than many other professionals, were confronted with their own social conservatism. Christopher Lasch's long public rant against cultural radicalism was once considered marginal. By the 1980s, his social conservatism proved to be in the vanguard of a long march to the right by hundreds of others. By the 1990s "left" social conservatives were finding prominent berths in some mainstream media: Siegel writes for the *New York Post,* Christopher Hitchens is a *Nation* columnist, and Jim Sleeper, a founding member of the Democratic Socialists, writes a column for the *New York Daily News.* Political theorist Alan Wolfe, whose early work *The Seamy Side of Democracy* debunked the claim that liberal democracy was the best of all possible political worlds, writes in the neoliberal *New Republic* and his most recent books are culturally conservative, communitarian tracts.

As we shall see, without the totalizing ideology of the Old Left, the post-New Left did what most radicals have done throughout the twentieth century. Tacitly recognizing that they could not create a "party," either of the Leninist or liberal types nor were they capable of contesting the main elective institutions of the liberal state, they could intervene in a wide range of what Louis Althusser has termed the state's "ideological apparatuses," including the unions. For the most part, in contrast to the Old Left's heavy emphasis on the industrial sector, New Left union work was integral to their professional identities rather than, as in the vanguards, an expression of an ideological position. Union work, especially in the "basic industries" of the industrializing era—auto, steel, transportation, communications, to name the most prominent of leftist interventions—was a priority because the capital goods industries were considered the "most decisive" section of the economy and where the potentially most revolutionary part of the working class was located.

Perhaps more important, as we have seen, the New Left partially spawned the emergence of what later became known as "identity" politics. Rather than proclaiming the point of politics to be *universal* emancipation, many who had mounted the barricades of antiwar and civil rights struggles which, in a large measure, were conducted in behalf of the universal values of peace and human rights and in behalf of "others," wearied of the deferral of agency demanded by the established Left, and rediscovered their own identities, interests, needs. The discovery of what Beverly Harrison calls *moral agency* among many who had been fervent practitioners of a politics of compassion signaled a new era in which all issues were recoded from the *standpoint* of ecology, gender, sexuality, and race.

The very idea of *general* emancipation was seen by many activists in these "new" social movements as a ruse perpetuated by White Men to suppress dif-

ferences which might threaten their power and privileges. Or, more theoreti-
cally, general emancipation was designated "reductionist" since the concept was
linked to a version of Marxism for which the working class and, more general-
ly, economic relations occupied a privileged space in the social structure. Each
modality of identity politics cultivated its own theorists who, among other
moves, conducted a relentless polemic against left universalisms, deploying Karl
Popper's category of "essentialism" to beat down ideological opponents who
might suggest that identity politics was a necessary, but not sufficient condition
for achieving the stated goals of the movement.[3]

That there was considerable justice in these allegations is self-evident. The
arrogance of the New Left leaderships of the 1960s was legend. In this period,
to found a movement that departed from the analysis and the focus of the anti-
war and civil rights struggles could be condemned as trivial when not down-
right disruptive of the great historical mission of liberating third world peoples
by staying the hand of American imperialism and racism. Infinitely tolerant,
even obsequious in the face of rising black nationalism in the late 1960s, the
leaders of the male New Left viewed feminism with emotions varying from
indifference to alarm, because they tacitly recognized that women would achieve
gains at the expense of white men. In this respect, the rise of what became
known as "second wave" feminism (the first wave was the movement for voting
and social rights founded in 1848 at Seneca Falls and ended with the enactment
of the Twenty-first Amendment) foreshadowed the social conservative back-
lash of the 1980s which helped the right gain political power.

By 1973, the New Left, by far the largest contingent of the diverse U.S. rad-
icalism, was all but dead. It was replaced by two new organizations—the Demo-
cratic Socialist Organizing Committee (DSOC), a 1972 splitoff from the already
disintegrated Socialist Party, led by Michael Harrington; and a smaller, but more
activist group, the New American Movement (NAM), perhaps the sole organi-
zation that could claim direct lineage to SDS and other New Left contingents.

NAM was initiated in 1974 by James Weinstein and Staughton Lynd, both of
whom soon abandoned the organization they created because the new organi-
zation was still too culturally radical. When the two groups merged nearly ten
years later, the new organization Democratic Socialists of America (DSA) claimed
no more than five thousand dues payers, but apart from DSOC's impressive list
of notables such as Gloria Steinem, U.S. representatives Ron Dellums and Major
Owens, critic Irving Howe, Machinist Union president William Wipinsinger,
and assorted mid-level labor leaders, the group had almost no influence at the
national level for its own program because, with almost no exception, there was
no discursive field for a distinctly *socialist* politics. Nor, did DSA seek to offer an
independent radical ideology and program aimed at attracting a popular con-
stituency; as an organization committed to the informal "progressive coalition"
within the Democratic party, the DSA rejected this strategy from the start.

DSA's trajectory is a contemporary example of Marx's famous aphorism "Hegel says somewhere that history always repeats itself. What he forgot to add, the first time as tragedy, the second as farce."[4] Harrington used to say that he was trying to achieve Browderism but without Stalinism.[5] By this aphorism he meant to emulate the Communists during their moment of greatest influence, the era of the Popular Front. For Harrington, as for Browder, radicalism, let alone revolutionary socialism, was not on the political agenda. The task Harrington set before DSA was to broaden the popular left umbrella to include all who wanted to expand the compassionate state by supporting the most "progressive" elements of the Democratic Party and the unions.

Apart from international affairs, in every respect DSA has emulated the experience of the old CP, except the older organization's organizing flair. It allies with the progressive wing of the unions; works within the Democratic Party; works from the top and brooks no support for rank and file insurgencies within the unions or the main organizations of the liberal coalition such as the NAACP and the local Democratic clubs. But, the farcical aspect to these positions is that DSA has no real ideological coherence nor a large enough group of cadres to become a player in almost any arena it has entered. On the whole, DSA is an annual socialist scholars conference and sporadically conducts electoral and legislative campaigns in behalf of the more liberal of the Democrats' candidates and programs.

~THE POPULAR LEFT AT BAY

Recent historiography has revealed what was hidden from our view in the heyday of the civil rights struggle: that the major goals of the civil rights movement were unstable and contested throughout the nineteenth and twentieth centuries. Proponents of black autonomy disdained the "rights" which could be conferred by a generally hostile liberal state and preferred to build black economic power and community solidarity within the segregated cities and towns. Some black intellectuals of the antebellum and post-Civil War era like Alexander Crummell and Martin Delany yearned for a black homeland; at the turn of the century, some were deeply influenced by Theodore Herzl's call to Jews to end their diaspora and create a homeland. In the twentieth century, W. E. B. Du Bois, the theoretician of the integrationist civil rights movement, became convinced of the urgent need for a Pan African movement to unite blacks on a global scale. Marcus Garvey, flying the flag of nationalism, organized the United Negro Improvement Association as an alternative to the integrationist NAACP, which after World War One attracted tens of thousands of adherents until scandal disrupted his quest.

The civil rights movement, the most enduring of all, focused, in the main, on the struggle to establish the victim status of blacks in the larger polity in order to force recognition of the justice of their demands for equality of opportunity and, in education, special consideration. This more or less tacit strategy was hid-

den within the specific goal of ending discrimination in employment, housing, education, and voting. It was not enough to prove discrimination, however. For if blacks were naturally inferior because of genetic or cultural characteristics associated with their race, the argument for special consideration was somewhat vitiated. On the other hand, if blacks were ordinary human beings stigmatized and victimized by the living legacy of slavery as much as the color of their skin, then constitutional and legal measures could achieve equality of *opportunity* to make it within the larger society.

The presumption in this request was that blacks required no special treatment to achieve economic niches and social status within the predominantly white society except the rigorous enforcement of the law. By insisting that the position of blacks was due neither to cultural deprivation nor to genetic deficits, the proponents of black freedom were obliged to seek the removal of barriers, not an affirmative program to secure specific positions. Nor did the nationalist demand for black power amd independent black economic development within ghetto communities receive much approbation from the civil rights leadership until the late 1960s. But only the nationalists have been able to mobilize the black working class in significant numbers; the middle-class black organizations may attract black trade union leaders but their program has been perceived by the "masses" as too narrowly focused on its own needs. This, more than any other factor, may account for the enormous success of the Million Man March organized by Muslim leader Louis Farrakhan in the Fall of 1995. Although the March was not billed as a protest against the systematic reversal after 1973 of black gains, its appeal was precisely to those who had lost the most in the past twenty years.

Note that the struggle for victim status has encountered considerable opposition since the betrayal of Black Reconstruction by Northern capital and the Republican party in the 1870s. On one hand, we are in the midst of a revival of phrenological thought, the more sophisticated versions of which are the claims of psychometricians such as Richard Hernnstein and Charles Murray that blacks are simply less intelligent than whites.[6] The pseudoscience backing this claim has been deployed by many conservatives to abolish affirmative action programs in employment and education.

On the other hand, the far more insidious and widely accepted theory of the culture of poverty, whose leading proponents are Daniel Patrick Moynihan and Nathan Glazer, has had enormous influence among liberals and liberal policymakers.[7] The heart of the theory is to ascribe *social* rather than genetic deficits to the legacy of slavery, migration, and urbanization. In this view blacks have been victimized by these historical trends, but more urgently they contend that the black family, to which has been assigned, no less than in other groups, the cornerstone of social organization, is in crisis. They argue that widespread incidence of single female parenthood, welfare dependency, drug and alchohol abuse,

and crime among blacks may be traced to cultural factors inherent in the condition of blacks, rather than to other systemic forces such as racial discrimination and class stratification.

Moynihan has been a prime mover in the shock therapy approach to black poverty: force able bodied welfare recipients to work on pain of losing their benefits; penalize women who have children out of wedlock; reward premarital sexual abstinence among youth. The ruse inherent in this argument is, that in the name of a social and cultural theory of black poverty, neoliberals such as Moynihan propose to punish its victims since they, and not the System, are mostly to blame. In this respect, the policies proposed by neoliberals to address poverty resemble EST therapies of the late 1960s: like the self-indulgent neurotics that EST wants to rehabilitate by external and self-inflicted punishment, "workfare" and similar policies want to change behavior through the sadistic rituals of coercion. Thus, far from emancipatory ends, the chief task of the civil rights movement has been to overcome ideologies, such as the new phrenology and the culture of poverty, that would strip blacks of their victim status.

~The Prison House of Welfarism

For modern liberalism politics is both logically and historically independent of economic relations. It has always been ambivalent regarding the *emancipatory* demands of the disenfranchised, which include the demand for freedom from alienated labor and popular power over the institutions that affect everyday life as well as a significant measure of economic redistribution. Liberalism has confined its most passionate advocacy to securing juridical justice and civil liberties, especially the right to organize, demonstrate, and speak dissent freely. American Liberals generally favor civil liberties, but, before the New Deal and after the demise of the Great Society, they have become increasingly divided over issues of redistributive justice. At the level of economic policy they tend to favor growth as an alternative to the imperatives of class struggle in which the discursively prohibited zero-sum game prevails. In the American rhetoric of justice there are no losers and the growth strategy fulfills this goal. When growth substitutes for redistribution and genuine popular power in decision-making, more equality might not be achieved, living standards could rise.

And many who favor the features of a mature welfare state such as educational, health and transfer payments for the poor and unemployed accept the division between the "deserving" and the "undeserving" poor. While the welfare liberals distinguish themselves from market liberals, coded in the United States as "conservatives," because they approve transfer payments for poor children and unemployed adults, many disapprove of willful sloth on both moral and economic grounds. Under the sign of puritanism, they accept the old adage, "She who does not work and persists in sexual promiscuity, neither shall she eat." Some, imbued with the sanctity of the work ethic, fear that if slacker culture

spreads too far beyond the welfare cheats, criminal class, and then the lumpen elements, the moral fibre of the nation, let alone economic growth, may be impeded.

In consideration of growth policies, liberals have tended to compromise their traditional view that welfare costs should be financed through the rigorous enforcement of a progressive tax, which puts the greater burden on those able to pay more. Now many compassionate social liberals have become economic liberals as well. Since the fiscal crises of the 1970s when banks and other bondholders went on capital strike until cities and states reduced their commitment to welfare, they have increasingly abjured the progressive tax as a brake on growth. And, politically, they have, even if reluctantly, joined the right on the argument that the "left"(read redistributive liberals) threatens to plunge the economy in crisis by means of a bloated debt.

These shifts constitute a massive split on the left. For if modern liberalism, born at the turn of the twentieth century, can be demarcated by the recognition by a segment of the corporate capitalists and the state bureaucracy of the urgent necessity of breaking with the precepts of economic liberalism (for which the market, not the state was the appropriate arbiter of social justice), the past twenty years may be characterized by a massive return to nineteenth-century neoliberal economics. Retrospectively, we can now see clearly that the New Deal and other Keynesian solutions to the political effects of the Great Depression relied primarily on debt accumulation rather than redistributive justice to cushion the effects of mass unemployment and economic insecurity.

The experience of popular movements has been that the redistribution in decision-making and economic goods cannot be delivered by others "on high" but derives, principally, from their own power for among other reasons, that those in power rarely concede it to others. For, except for a relatively small contingent of genuine libertarians, liberals are hopelessly tied to the goal of attaining *order* through state control. They are, almost invariably, Hobbesians. The preponderant thought among modern liberals no less than Hobbes himself is that in the state of nature, some humans are essentially aggressive, amoral and therefore undeserving of full citizenship within the human community. For this reason, while many liberals favor economic justice, they are equally convinced of the need for a strong, repressive state. Presented with these goals as conflictual, they have often chosen to support the latter.[8]

Moreover, the liberal conception according to which the market is the best guarantee of individuality, self-fulfillment and freedom has steadily gained ground in the postcommunist era. Ignoring the overwhelming evidence adduced by economic historians (Karl Polanyi and Louis Hacker, among others) that there never was a market free of state intervention and monopoly control, neoliberals militantly oppose state regulation of banks, food, medications, transportation, and other public goods.[9] Since the late 1970s, it was the liberals, not the

conservatives who led the effort to legislate deregulation which, in the cases of banks and transportation, have resulted in more capital concentration, not less.

The labor movement all but abandoned the struggle for expanding the scope of the welfare state in the 1950s. This left blacks, women, and other excluded groups to wage the fight to preserve its most important elements with only an assist from labor's extensive lobby network but not from its millions of rank-and-file members. The problem was and remains that most unions were unwilling—or, to tell the truth, unable—to mobilize their members to fight for the welfare state, except for medical care for retirees which companies were no longer willing to pay for.

Thus, antipoverty programs established by the Johnson administration in the wake of the Vietnam War and the widespread perception of a war at home, especially in impoverished black communities, now segmented by race as well as income, quickly lost favor among the organized sectors of the working class and among the middle class as well. By 1970, owing both to Richard Nixon's victory and to the demobilization of the civil rights movement by the growing chasm between separatists and integrationists, the reduced antipoverty programs in job training, day care and education helped fewer poor people but abetted the formation of a fairly large black middle class.

This class consists of many of the managers of these programs; a substantial professional-managerial group in staff positions and middle levels of power in large corporations; and a black component to the political "class" which was poised to take over the severely deindustrialized and deteriorating large cities. By the early 1970s the black political class was already climbing to high political and bureaucratic office in most of America's largest cities. Figures such as Carl Stokes, Cleveland's mayor, broke the mold of white-only city halls. He was followed by Detroit mayor Coleman Young, a former left-wing UAW local leader, Los Angeles police officer Tom Bradley, and Chicago's Harold Washington, a congressman who fought a successful campaign to become the first black mayor of what had been assumed to be a majority white city.

Some of the new politicians came from the left: Major Owens, Brooklyn rent strike leader, holds a seat in Congress; Ron Dellums, an avowed socialist, is a U.S. representative from Northern California; Charles Hayes, a former Packinghouse Workers Union official, succeeded Harold Washington in Congress; John Lewis, who was chair of the Student Non-Violent Coordinating Committee (SNCC), captured an Atlanta congressional seat in a bitterly contested primary against his old colleague, SNCC staffer Julian Bond; SNCC field worker Marion Barry is, despite previous scandals, once again Mayor of Washington, D.C. and Ivanhoe Donaldson was an elected official and a key operative in his administration until tarred with the brush of corruption.

These instances reproduced, on an expanded scale, the experience of civil rights leaders of a previous generation, notably New York's once lone black con-

gressperson Adam Clayton Powell Jr. And they illustrate a cardinal feature of the American tradition: in the absence of an independent electoral vehicle, the ideological left, the labor and the civil rights movements become, as perhaps their main socially integrative function, training grounds for liberal leadership. For, it cannot be said that any of these officials, with the exceptions of Powell and Washington, were in a position to succesfully implement the justice agenda of the black freedom movement. Their national role has been, at best, to slow the inexorable drift of the liberal wing of the Democratic Party to the right, which is no mean achievement, but hardly a powerfully affirmative program.

However, not all black and Latino civil rights and community organizers and intellectuals entered electoral politics or middle management. By the late 1960s, it had become abundantly evident to many of the most experienced activists that the substitution of mobility for a relatively small elite and the achievement of formal rights through legislation may have been necessary, but these gains constituted the sufficient conditions neither for liberation nor for economic and political equality. Nor, did they believe that the individual "rights" framework within which issues of oppression had been framed by political liberalism could make a real difference in reversing institutional racism. Moreover, there was considerable doubt that *integration*, the farthest horizon of the liberal wing of the black freedom movement, could deliver emancipation for the black and Latino working class and the poor.

In 1967, at a New Politics conference in Chicago, SNCC chair Stokely Carmichael raised the stakes with his announcement that, rather than seek integration into a racist society, the movement's goal was "black power." Whereas, the struggle for civil rights had been conducted by white as well as black participants, and envisioned the gradual disappearance of social differences based on race, Carmichael invited whites to leave the black freedom movement and go back to their communities to organize "their own people." In the same year, Harold Cruse published *The Crisis of the Negro Intellectual*, a blistering condemnation of the white left as much as the black leadership of the civil rights movement.

In different ways, Cruse's and Carmichael's interventions—and the parallel formation of black revolutionary parties and unions, especially the Black Panthers in Oakland, Chicago and other cities, the League of Revolutionary Black Workers (LRBW) in Detroit—were emblematic of a new nationalist direction for the black freedom movement. Influenced by the earlier pan-African writings of George Padmore, C. L. R. James and W. E. B. Du Bois and the more contemporary nationalism propounded by the earlier writings of Malcolm X, a spectrum of new movements developed fairly quickly at the end of the 1960s which, in various ways, criticized the middle-class objectives and leadership of the civil rights movement and were constituted by, or spoke for, the black working class and militant black youth. While many of these movements were not

ideologically separatist, they were almost all revolutionary *nationalist*, especially in their organizational culture.

What was impressive about the development of the black radical movements of the late 1960s and 1970s was the variety of their ideological and political expressions. LRBW was formed directly from the shop floors of a half-dozen auto plants in the Detroit area. Perhaps the strongest of them, the Dodge Revolutionary Union Movement (DRUM), challenged both the company and the union to lower the color barrier to promotions, especially to the skilled trades and line management. Equally important, DRUM fought everyday racism on the shop floor. In one of the most militant actions of this entire period, DRUM staged a strike against these practices which antagonized the union leadership as well as the company. For, by the late 1960s, many of Detroit's booming auto plants had black majorities; in most of the rest, there were substantial black minorities.[10]

In retrospect, the slow deindustrialization of the Motor City may, in part, be ascribed to the growing power of black workers in the auto industry, in the union and in the political life of the city. While relocated plants in the rural areas of the South and Southwest were still under union contract, they presented far fewer discipline and political problems for the union leaders and the companies. Even though the union won relocation rights for its displaced members, many did not move to remote rural areas with the plant, preferring to remain in urban areas with substantial black populations.

The Black Panthers were similarly oriented to local action. Drawn in part from street gangs such as Chicago's Blackstone Rangers, the Panthers combined social work—they ran successful breakfast programs for kids—with political demands such as community control of the police and other institutions in black neighborhoods. Eventually the Panthers, who built close ties with some black churches and local businesses as well as youth, became a force in Oakland city politics. In Newark, Amiri Baraka helped organize a black political party which eventually extended to some other cities. And locally based militant nationalist groups sprung up in Cleveland, Los Angeles, and Baltimore. These efforts were frequently met by police violence and legal persecution, most notoriously in the 1969 murder of Fred Hampton, a Chicago Panther leader, in his own bed, and the arrest of key national Panther leaders. It may be said that the demise of the Panthers was as much the result of an FBI-coordinated national campaign of police violence as it was of its own internal divisions.

The formation of the Young Lords in 1968 in New York's El Barrio (East Harlem) was probably the most dramatic event in the emergence of a new radicalism within East Coast Latino communities. The Lords resembled the Panthers in their dual strategy of militant street action and community service; in other ways they were somewhat different. For example, the Lords were a multiclass organization, including intellectuals. It had a fairly extensive interest in

building cultural as well as political institutions in New York's East Harlem and Lower East Side where it was strongest.

But the organization was relatively short-lived. The Lords eventually adopted the demands of the Puerto Rican independence movement which had always attracted a considerable number of intellectuals. By the early 1970s, many of its activists joined the growing Puerto Rican Socialist Party (PSP) which, building on the Movement for Puerto Rican Independence (MPI), became, for brief period, an important force in New York as well as Island Puerto Rican politics. Unfortunately, having adopted a distinctly independentista ideology, PSP's leadership in Puerto Rico, the controlling center, proved less interested in the local interventions that had marked the early years of the Lords than in mobilizing within the diaspora for Puerto Rican independence. Often, these interests were viewed by leaders in Puerto Rico as well as New York as conflictual, if not contradictory.

The PSP, which has been considerably weakened since the late 1970s, has extensive ties to the Cuban government and its Communist Party, and the LRBW evolved into Marxist-Leninist political parties. Their Leninism was expressed in both the cadre character of their organizations (they were not "mass" parties) and in the nationalist component of their Marxism. The Marxist-Leninist political parties had extremely limited influence among African American intellectuals, let alone black workers, except in their home bases, such as Newark and on the West Coast where the Chicano organization La Raza achieved some constituency.

Of these groups, perhaps the PSP came closest to attracting a substantial layer of intellectuals within the Puerto Rican community who responded to the long-deferred dream of independence. But the party was hampered within the United States by its indecision with respect to the question of the the relation between the independence aims of the party and the urgent economic and social problems of Puerto Ricans in the diaspora, a question that has plagued the left among other national groups, including Chicanos, Dominicans, and Jews. For, by 1960, the Puerto Rican diaspora—much of it occupying positions of the working poor—had reached such proportions that the national liberation context of the movement no longer corresponded to the earlier migration which was composed of a considerable coterie of intellectuals, including the future Governor, Munoz Marin. Yet, in theory as much as practice, diasporic perspectives remain to this day curiously lacking among radicals working within immigrant communities, especially those who have rejected the assimilationist ethos of the dominant culture. There are, of course, exceptions, notably in the New York Chinese community where the Chinatown History Project and then the labor organizing of activists in the Chinatown Staff and Workers Association has begun a long range labor organizing program among restaurant workers.

On the one hand, as Partha Chatterjee has argued, marxist theory, with the

exception of Gramsci's work on the so-called "Southern Question" in Italy, failed to recognize nationalist ideology as a relatively autonomous discourse which cannot be entirely comprehended within the framework of class functionalism, especially in the colonial context.[11] On the whole, especially in recent years of ethnic cleansing, postcolonial nationalism has revealed a virulent side. Although the U.S. situation is not an exact parallel to colonial societies, black and Latino nationalism remain important discourses of ideological and political mobilization, although, lacking an approach to economic justice issues, they have in recent years been subsumed under culturalist hegemony.

On the other hand, whatever their family ties or national loyalties, the vast majority of those who have entered the United States from Latin America and the Caribbean have, for the most part, no intention of returning to their country of origin, except in retirement. To the extent they build their lives within the United States or Europe, they face specific problems such as language, access to labor and educational opportunities and other forms of discrimination, as well as share the general class, gender, and racialized identities of other subaltern communities. In a phrase, like everyone else, they have multiple identities of which the national is not necessarily dominant.

In contrast to the first three quarters of this century when the ideological left enjoyed enormous influence in major African American communities, especially New York, Chicago, and Detroit, African American and Latino radicals have almost no presence among any substantial fraction of the general populations of these communities, a statement which cannot be made for academic and intellectual circles, where the black and Latino lefts exert considerable influence. At the same time, nationalism appears alive and well as a major *cultural* force with, as yet, little or no impact on social movements except perhaps in the growing Dominican communities of New York, and in the border regions of Texas and California. Puerto Ricans in New York have independence *in their hearts* but this sentiment has little practical significance in a debate dominated by whether statehood or semi-colonialism are the real alternatives.

One of the new developments is the appearance of a small group of African—Americans as public intellectuals. Henry Louis Gates, Houston Baker, Cornel West, Manning Marable, bell hooks, and a number of novelists and poets such as Nobel Prize winner Toni Morrison, Alice Walker, and Gloria Naylor have gained genuine public platforms from which to express views concerning the declining economic and social condition of large sections of black America. Their voices are only *putatively* independent since, in the absence of a genuine radical presence in the public sphere or a left public sphere outside the universities, they are cast in the discursive positions of the civil rights movement, the left wing of the Democratic Party and liberal academia. Moreover, with the partial exception of Gates, they are publicly constituted exclusively in terms of their gender and racial identities and are, for this reason, put in a fairly restricted perspective.

A few white women are afforded opportunities to enter public debate—notably Betty Friedan, Catharine MacKinnon, and Susan Faludi—but only on "women's issues." There are virtually no Latinos with comparable media and other forms of mass public access, Richard Rodriguez excepted. In short, identity politics—but only for *some* identities—defines the limits of critical involvement in public debate for anyone who asserts the primacy or even the salience of the social question as opposed to the achievement of "rights" for oppressed minorities.

As a result, the entire economic debate is framed within neoliberal categories, and class is raised publicly, but stridently within a context of attacks by social conservatives on cultural radicalism and the social movements. The discourse about class takes odd forms within the established discourse: newly minted phrases such as the "working middle class" are invoked by conservatives seeking to win popular support for tax cut proposals and to oppose social gains such as abortion. In the bargain, the working class comes alive, but only as an object; its status as moral and political agent is categorically denied, by both identity movements and the right.

It must be admitted that, with the important exception of the initial stages in the development of some of the new social movements, the past thirty years have witnessed the incorporation of most of these and the older movements of the popular left into the framework of liberal democracy. From deep scepticism according to which the law and the state were seen as instruments of class, gender, and racial power, the leading organizations of the popular left have made a more or less explicit alliance with the Democratic Party, within which they have received some recognition at the commanding heights and middle levels of power. In some cases—the AFL-CIO, civil rights, and liberal feminist organizations—they have obtained seats at the high and middle councils of party governance. In turn, the ideological left—including the black and Latino radicals—having proven unable to build a popular following and, for this and other reasons, are shut out of the public debate.

Yet, the results of the mass civil rights and women's movements were by no means confined by their electoral experience. These movements have effected nothing less than a revolution in the moral economy of the United States, changing social and cultural practices in incalculable ways. The most dramatic *material* consequence of the direct action strategy *against* the law and the state was to accelerate the creation of the aforementioned large black middle class and to facilitate some job mobility among women into professional and managerial positions. In the face of an overwhelming conservative hegemony in the 1980s the movements have, respectively, saved the civil rights law and abortion rights. But, the end of the "confrontation" phase of the struggle (which did not prevent the right from taking on the characteristics of a direct action movement) and their failure to develop a specific class agenda, witnessed a slow, steady, and

largely uncontested deterioration in the economic situation of women and the black and Latino working class.

The 1980s marked the end of the forward march of working women, which has been demonstrated in the stagnation of the proportion of women's wages to those of men at around 79 percent and stagnation in the unionization of the service sector. For example, while most public sector clerical workers in major cities and states are organized, unionization is almost nil among clerical workers in the private sector—head offices of large and medium sized corporations, financial services, insurance companies. The wholesale and retail trades in several large cities are unionized, particularly supermarkets and warehouses, but beyond the large metropolitan areas of the North and Midwest, union organization is appallingly low.

Nevertheless, there can be no doubt that the color line has been thrust to the fore of American politics, if not without extremely painful aspects. It is no longer possible to marginalize gender issues or questions of sexuality. Indeed, the right has gained new strength from this phenomenon, particularly in the large cities where, as the results of the Los Angeles and New York mayoralty elections showed, the growth of impoverished black and Latino populations has conjured the most virulent racial backlash since the 1960s. Yet, who can deny that these are times when virtually no public issue can be raised unless the issues of *social* if not economic equity are addressed? Politics has been irreversibly shaped by the identity movements and the economic-justice left is obliged, often against its will, to acknowledge the changes.

~New Social Movements and the Left

As we have seen, many of the social movements, including contemporary feminism and the movement for sexual freedom, were formed, in part, as a protest against the sexism and homophobia of the New Left which, like the ideological and economic-justice lefts regarded these issues as marginal to the struggle for more equality and against imperialism and colonialism. Many in these movements bitterly resented their treatment by the New and Old ideological lefts and by leaderships of the labor and civil rights movements. Of course, the cultural radicals of the feminist and gay and lesbian movements were not able to find a way to prevent bureaucratization, the formation of their own elites or avoid endless bickering. If the social movements have tended to reproduce some the sins of the Old Left, it is less a testament to their moral turpitude than to the contradictions of institutionalization. In this respect, there is some truth in the proposition that the diseases associated with bureaucratic organization transcend the traditional division between left and right.

Moreover, some ecological theorists insisted long before the collapse of the Soviet Union that the old distinctions of left and right had been surpassed by the *universal* interest to save the planet. They argue, saliently, in my opinion,

that the ecological crisis realigns old ideologies. For example, the so-called social-ist countries of Eastern Europe were among the worst polluters and the capitalist West is not far behind. Both state socialist and liberal economic ideologies are committed to policies which promote rapid economic growth; they view eco-logical demands for "zero-growth" as inimical to the task of achieving social justice. Ecologists are persuaded that the interest of saving the planet supersedes class interest in an age of global warming and life-threatening pollution. The traditional reliance by the social-justice left on policies of economic growth has been rendered arcane by the ecological crisis. Indeed, what has come to be called ecologically *sustainable* economies might renounce growth. Under such cir-cumstances, the "left" program of solving justice problems completely collaps-es. Now the zero-sum game defines social and ecological politics.

Despite these objections to defining social movements as part of the "left" (the European social movements are less wary of this designation), the actual political history of the past twenty years more than justifies this designation, especially in the public debates about abortion, economic development, and rights for gays and lesbians. With the exception of a relatively small group of libertarians, the free market right has lined up with social and cultural authori-tarians even more definitively than the state socialist left. Who can deny that the major opponents of abortion rights, sexual freedom, and ecological protec-tions such as conservation, water and air regulations are virtually identical with those who would drastically curtail welfare state expenditures and abridge labor's rights? Or, that many thousands of economic-justice leftists have supported cul-tural freedom in the Reagan era, even if they have refused to *theorize* the link-age between the social and cultural questions.

Apart from the fact that social movements and the economic justice move-ments have common enemies, the main reason for treating them as two wings of the left is that both challenge traditional power arrangements. Both have, in a word, attempted to break aspects of bourgeois domination. The deepest aspi-ration of any economic-justice left worthy of the name is to separate citizen-ship—economic as much as political—from the possession of private property in means of production. This proposal does not necessarily entail ending the private ownership of the means of production, but does challenge the presumed entitlements of private property, *control* over state priorities as much as indus-try and commerce.

Of course, the idea of economic citizenship is the basis of social as opposed to business unionism. In the early days of industrial unionism, workers laid claim to prerogatives traditionally reserved to management. Their demands were *radically* democratic insofar as they addressed work rules as much as wages and benefits. In tendency workers wanted *industrial* as well as political citizenship, that is, to control the conditions of their labor, if not its product. Worker control, in theory, requires that *all* production decisions be transferred or at least shared

with the producers. These decisions included *what* is to be produced, by what labor process, the deployment of technologies, assignment of tasks and the working conditions such as health and safety. In short, the project of workers control entails self-management and contests the concept of unilateral management prerogatives over production decisions.

As opposed to liberal manifestations, radicals in the social movements challenge the taken-for-granted presupposition of patriarchal, heterosexual privilege in everyday life. The radical core of feminism and of sexual freedom is put into sharp relief by their challenge to the patriarchal family, which rests, in large measure, on the moral superiority of heterosexuality and the "natural" authority of the father. Since in U.S. society the family, with its implication that childbearing and child-rearing is the way women may perform God's work, has assumed a privileged space in the pantheon of ethical life, the subversive ramifications of abortion on demand have not been lost on cultural conservatives, even if the left persists in treating abortion as a civil liberties issue. For it is not the right to privacy which causes tremors in the hearts of moral gatekeepers, it is the threat abortion poses to social discipline, which depends, crucially, on women remaining "nice" girls and gay men being willing to curb their sexual impulses or to have the decency to hide them in order to reproduce the patriarchal order.

Despite historical evidence that the "Woman Question" was accorded a place in both the social-democratic and the communist movements at different moments throughout this century and the well-known fact that Frederick Engels and the German Social-Democratic leader August Bebel were close students of women's oppression and wrote pioneering books defending sexual freedom for women, the instances of conflict between feminists and male-dominated socialist and labor organizations are far more numerous and ultimately persuasive.[12] At both the theoretical and strategic levels the economic justice left has, at least historically, insisted on the subordination of social and cultural demands to the exigencies of the "class struggle," forcing feminists, particularly sexual radicals such as Margaret Sanger, Alexandra Kollontai, and many others to leave the socialist movement or retire to its margins.[13]

The tension and acrimony between intellectuals and activists in the black freedom movement and the organized left in the twentieth century is legendary. In the first decades of this century, the Socialists invited blacks into "their" movement but their leading public figure, Eugene Debs, warned they had nothing "special" to offer blacks besides an opportunity to participate in the movement for class emancipation, a warning repeated by many socialists right up to the civil rights explosion of the 1960s. Despite the fact that communists, both in and out of the party, recognized the extraordinary character of the color line in American life (indeed, toward the end of his life in recognition of the CP's grasp of the "Negro question as a special question" Du Bois joined the Communist

Party; and C. L. R. James, a collaborator in the pan-Africanist movement, had been a leading Trotskyist in the United States) and were virtually alone among whites in supporting the demands of the civil rights movement until the Second World War, the narrative of black/communist relations is not without considerable evidence of rancor. Harold Cruse, Richard Wright, Chester Himes, and Ralph Ellison wrote eloquent condemnations of the gap between the party's theoretical fealty to black liberation and the vagaries of its practices.

Some of the earliest gay and lesbian groups were formed *within* the Communist Party but were obliged to live a secret existence because of official party hostility. And, there are well-known ecological intellectuals and activists such as Barry Commoner and Murray Bookchin whose earliest political experiences were within the comunist movement, when ecological thought was (and, to some extent, still is) labelled "romantic" and "petty bourgeois" by significant sections of the marxist left.

In addition to critical intellectuals who had been associated with the communist movements, the early New Left was constituted, in a large measure, by the radicalization of white civil rights activists in the early 1960s. For it was the callous response of liberal democracy, let alone the Democratic officials of Southern governments, to the sit-ins and freedom rides, the beatings—and killings— of civil rights workers by Southern officials that, in addition to the writings of critics such as Mills and Marcuse, inspired SDS and other student groups to conclude that liberalism was fatally flawed. Certainly, some, like Tom Hayden, were attracted to the Kennedys and tended to minimize nagging evidence that they were hard-boiled, Cold War politicians more concerned with rolling back communism than forging a democratic future.

Of course, the economic-justice and the cultural lefts are by no means identical. Neither Marxism nor progressivism has been willing or able to articulate class issues with those of gender; even the ample literature on race in which class is considered, lacks clear articulation. Moreover, homophobia has been rampant on the left, even if not to the same degree as among the general population. Nevertheless, there are diverse, inconclusive, traditions on the left that have tried to make the theoretical connections. The works of Wilhelm Reich, Otto Fenichel, Geza Roheim, Theodor Adorno, and Herbert Marcuse attempted to link character structure with social structure and Michel Foucault showed that sexuality is linked to power.

For example, contrary to received Communist wisdom, which ascribed Hitler's rise to power to the discontented middle class, in a careful investigation of election returns psychoanalyst Wilhelm Reich found considerable German working-class support for the Nazis. Following Freudian premises, he explained these suprising results by reference to Hitler's appearance of omnipotence, which penetrated the *desire* of the masses for an authoritarian father to tell them what to think and what to do. Reich argued that what he called the "sex-

ual misery of the masses" was an underlying factor in Hitler's dominance of German politics after 1930.

The attempt to integrate psychoanalysis with Marxism was not popular either in Communist or in psychoanalytic circles. For the notion of Marxist "orthodoxy," which helps account for the sectarianism of much of the left, is defined precisely by its refusal to depart from the categories of political economy for analysis or political strategy. As many have noticed, with some exceptions, Marxism holds that problems of subjectivity require no separate theoretical or practical treatment; class consciousness results from the experience of exploitation and oppression combined with the power of the rational program of the revolutionary party. From the Marxist viewpoint, Reich's sin was to have used the ideas of a "bourgeois" thinker, Freud, to help understand what Marxist theory had excluded a priori—that a large fraction of the working class could support fascism—since, at best, psychoanalytic categories applied only to the middle class. Ironically, in order to remain relatively faithful to the prevailing Marxist framework, he invoked Freud's concept of sexual economy. Derived from the neo-liberal notion that economic activity arises from *scarcity*, and from the idea that sexual need is, in the last analysis, indestructible, but can only be, through repression, displaced or sublimated, Freud sought to explain "group psychology," specifically the activity of the "mob" or "crowd" (euphemisms for mass action by the "lower orders") as displaced Oedipal relationships and the identification of child and father.[14]

What Reich added was that under conditions of severe economic crisis, lacking a multi-dimensional approach by the left to the cultural and psychological as much as the economic issues, mass yearning for solutions "from above," either by an omnipotent state or, more likely, a charismatic leader would carry the day.[15] When Reich called attention to the "sexual misery of the masses" as a significant attribute of the rise of fascism and authoritarianism in the 1930s, he was either villified or ignored by the left, much to its detriment. We may observe that while psychoanalysis receives favorable treatment among the literary left today, chiefly in its Lacanian incarnation, and was at one time fiercely contested among communist intellectuals, it is ignored in almost any other political circle. Psychoanalysis is definitely *not politically correct*.

We can observe a similar antipathy towards psychoanalysis in contemporary feminist thought, largely on the basis of aspects of Freud's work that revealed his considerable confusion, if not hostility, toward women. Although writers like Jessica Benjamin and Nancy Chodorow have refused the summary condemnation of psychoanalytic thought within feminist ranks and have creatively worked with its categories to understand dimensions of women's oppression, these remain minority voices.[16] The louder voices are those of most feminist theorists who insist that Freud offers nothing of value to the movement.[17]

And, after its apex in the 1940s when social psychologists and novelists

explored the interior as well as the political and economic dimensions of racism, the psychological and the cultural dimensions of racial oppression are today accorded little, if any, systematic treatment. Of course, there are a few writers like Joel Kovel who have written of white racism from a psychoanalytic perspective.[18] But the left, including the black left, has been so persuaded by conservative uses of psychological categories (to reproduce black subordination by blaming the victims of discrimination) that more nuanced discussions of internalized oppression such as those of psychiatrist Franz Fanon and Albert Memmi have tended to be ignored. Fanon is read narrowly as a tribune of African protest against colonialism. But few really take seriously his and Memmi's profound discussions of the colonial mentality among blacks themselves.

In this connection, I want to call attention to one of the hangovers from Marxist orthodoxy and other rationalist political discourses that continue to hobble a creative and original response to understanding gender and racial oppression and their relation to the discourses of power. Contemporary social theory—Marxist and non-Marxist—is, in the main, still tied to the concept of *interest*, or put more directly, suffers from the limitations of *rationalism*.

For example, white working-class antipathy to blacks has been explained as a rational outgrowth of the emergence of ethnic labor monopolies at the end of the last century. According to this theory, white racism is rooted in the development of a kind of caste system within the mainstream of major U.S. industries where whites have made the best occupations a *job property right* and have ruthlessly excluded blacks.[19]

While the work of writers such as Alexander Saxton, Michael Omi, Manning Marable, Howard Winant, and Herbert Hill have made substantial contributions to a new and more sophisticated theory of "racial formation" by calling attention to the social construction of racial categories, these perspectives remain incomplete to the degree that cultural aspects are occluded when not entirely ignored.[20] For the question of racial formation is *overdetermined* by its discursive elements, which incorporate but also transcend the realm of rational economic interest. Or, to put it more theoretically, the question of racial formation requires an understanding of the extent to which the category of interest is interpellated by ideology. And, any theory of ideology must plumb its unconscious components, which are outside the realm of the ordinary meaning of the phrase rational interest. These desires, which are often experienced as needs, are neither irrational nor nonlogical; they simply do not obey the rule according to which one must restrain pleasure (or rage) in the pursuit of success or survival.[21]

The slogan "Black and white, unite and fight" expresses the precisely opposite view: white working-class racism is opposed to the class interest of workers, those coded as "white" as well as those seared by the designation "black." In the history of the labor movement, strikes were frequently broken when blacks, largely excluded from membership in the striking unions, were recruited by

employers. Until the 1930s, black workers had little reason to trust those unions which barred them from membership and, hence, from employment, and which fought antidiscrimination legislation. And white workers whose strikes were sometimes lost on the employer's successful recruitment of blacks to replace them, reified these events by "forgetting" that the willingness of blacks to take their jobs was a result of exclusionary policies of their own unions.

It was not until the industrial unions, under pressure from federal laws barring discrimination, adopted integration as their official policy in the 1940s and 1950s that blacks joined unions in large numbers. Black union membership was also spurred by union shop agreements that required maintenance of membership as a condition of employment. Blacks hired in industrial plants, shipyards and other labor-starved businesses during World War Two were able to retain their jobs, but also their union membership.

Still, the skilled trades, especially but not exclusively in construction, remained closed. Black workers got construction jobs only in the nonunion sector until the federal government forced some unions—under protest—to open their membership rolls. The construction industry is a good example of a white labor monopoly, but this theory applies only imperfectly to industrial plants. How to explain racial exclusion from the skilled trades even during periods of relative labor shortages? Was it mere "economic fear"—that is, that blacks would take away opportunities from their sons—which caused many workers to circle the wagons around their jobs? Is "racial formation"—the coding of caste on the basis of skin color—a question of rational white interest? What is the role of culture, of sexual anxiety? Is racial exclusion a displacement of powerlessness? While these questions cannot be explored here in depth, suffice it to say that they have rarely, if ever been posed within the various movements of the popular and ideological left. In the main, the effort to introduce a discourse about race and gender that departs from the imperative of practical interest and explores other possibilities for explaining what people do, is confined to academic and literary research. Practical political discourse simply has no way to address power/domination without the crutch of interest or its antinomy, morality.

One of the conditions for the emergence of a new politics that can adequately address these issues is the adopting of a new theoretical paradigm in which elements of the Marxist analysis of capitalist social relations would be integrated into a larger framework. What has popularly been termed "ideology" is grasped as a key category without the class reductionism that usually accompanies its employment. This means, among other things, abandoning the notion of "false" consciousness, except by taking the unconscious seriously and liberating sexuality from its imprisonment by individual psychology. This framework would have to acknowledge that psychoanalysis and various philosophical traditions (phenomenology, poststructuralism, non-Marxist materialism) are helpful ways

to understand the political world we inhabit. In which case, the concept of "left" would have to be severed from its Marxist and socialist straitjackets and might be better jettisoned in favor of the designation "radical." More on this below.

With the collapse of the Soviet Union and Eastern European Communism, the crisis produced by the calamitous decline of the Old Left in the 1950s and the disappearance of the New Left two decades later was superseded by a death rattle. On the one hand, Marxism, while it asks important questions about class and the state and offers valuable, even indispensable categories for understanding the ideology and practices of economic life, can no longer be a master discourse of emancipation. On the other hand, socialism as the ideology of the determinate supersession of capitalism has been fatally weakened by the record of the countries of "actually existing" socialism. It won't do to say, as many have done, that socialism in its historical forms was never tried, that given advanced industrial societies, socialism would demonstrate its capacity to solve most of the problems generated by capitalism.

It won't do because historical experience cannot be elided or relegated to the realm of the exotic or the tragic. What has happened in the countries of actually existing socialism is part of the left's own history because the national context of politics is only *relatively* autonomous. While local politics are inextricably linked to specific economic and cultural conditions, the Bolshevik Revolution and its achievement, the formation and maintenance of a powerful rival state to world capitalism, set the boundary conditions for U.S. politics, not only with respect to foreign policy, but also with respect to the realm of the politically possible. For one thing, the arms race was directly linked to the Cold War and a huge military budget has been taken as a "given" since the late 1940s not only for reasons of national security but, perhaps equally important, for reasons of investment, profit, and employment. Consequently, a struggle for social reform such as universal health care has been obliged to contend with the limits imposed by the enormous military budget, in addition to the immense power of the insurance companies to shape the program and, like it or not, the identification of social reforms which enlarge the powers of the federal government with authoritarian state collectivism.

Even if it is true that red-baiting has always been the blunt instrument of rightist and Cold War liberal ideology, these factors have constituted a rational kernel that resonated with many people who would have otherwise preferred arms cuts and a national health plan. Absent the military imperative and cursed with a powerful left, the European liberal states were able to strike a compromise with the workers' movements to greatly expand the welfare state, even as the enlargement of public goods in the United States seemed permanently stymied.

But the tentative end of the Cold War produced and coincided with a major restructuring of world economic and political power that has effectively foreclosed the chance of social reform within national states. The whole left—pop-

ular as well as ideological—remains perplexed and disoriented in the wake of these new conditions. For those who relied on the eventuality of disarmament to lift the gridlock around the broad issues tied to the social wage, the 1990s have been years of dissappointment and left disarray. In the last chapters of this book, I shall try to indicate what the prospects for a rebirth of radicalism might be.

~THE LEFT AND FOREIGN POLICY

In the United States and, increasingly, throughout Western Europe, socialism as an alternative to global capitalist power, let alone as a *determinate supersession of capitalism* is dead or dying. Global economic restructuring and the rise of conservative ideologies have thwarted the social-liberal and social-democratic programs of social reform, which made substantial gains after World War Two (a little earlier in the United States). In the 1980s, the Reagan-Thatcher revolution succeeded in halting the slow, incremental gains of Labor by largely deregulating state controls over business practices and labor relations as well as by making direct assaults on all sorts of transfer payments to the working class and the poor. Reagan invoked images of the market as a domain of *freedom* and his privatization and deregulation policies were coded as an invitation to eros. In the 1980s, when not mired in a rhetoric of interest, the left's appeals remained tied to the politics of specific interests, *guilt*, and *moral piety.*

Even more important, the ideological U.S. left remained a presence in U.S. politics even after the New Left disappeared only because of the salience of its foreign policy interventions. With the rightward drift of American politics, and the virtual obscurity of the traditional socialist movement the American left was unprepared for what has been perhaps the final devastating blow: the breakup of the Soviet Union. For seventy years, perhaps no national left has been so dependent—for and against—on the Soviet example.

Even before the fall of the Berlin wall in 1989, the left foreign policy consensus, which was forged during the Vietnam War and which had sustained the left's public relevance, had begun to fragment. Although Central American solidarity work was almost universally supported by various left groups, sectarianism dictated that the Americans should support only those guerrilla and political formations in El Salvador which corresponded to their own political positions. In turn, democratic socialists became increasingly ambivalent about the Sandinistas for accepting weapons and other aid from Cuba, an alliance that many suspected contributed to frequent lapses in Sandinista respect for human rights, particularly political dissent. On the other hand, many on the left supported the concept of revolutionary dictatorship in Nicaragua as a necessary expedient in the wake of aggressive external military and economic forces, just as they had justified similar practices by Soviet, Chinese, and Cuban Communists.

But perhaps its response to the emergence of the Polish Solidarity movement

in 1980–81 revealed the confusion of the left during the long winter of the Cold War. While democratic socialists were generally enthusiastic about the formation of the Solidarity Labor Union, the mass strikes in the Gdansk shipyard and for other oppositional movements in Eastern Europe, and its independence from Government control, most of the rest of the official left remained suspicious, even hostile to them. Wasn't Lech Walesa a devout Catholic, antisocialist, and befriended by the anticommunist leaders of the AFL-CIO? Were these movements sponsored by the CIA? Even if they were not, didn't they *objectively* strengthen the U.S. government's containment policy which was widely perceived on the left as dangerous and reactionary?

In short, the main line left was, for the most part, bitterly silent as the reform movements in Eastern Europe grew in the 1980s. Even Gorbachev was viewed by many with considerable trepidation. Wasn't he letting down his guard in the face of a West that was poised to take advantage of any weakness in the "socialist camp"? If the United States honored his plea for substantial loans to rebuild the Soviet economy wouldn't the International Monetary Fund and the World Bank exact a steeper price—the return of capitalism? Not a few veterans of the antiwar movement muttered half in jest "bring back Brezhnev." Repressed during the Vietnam war era, residual Stalinism within the American left surfaced yet another time. Some even acknowledged that the appearance of a mass workers' movement in Poland exposed the near fatal weakness of the regime but were not prepared to embrace a movement for democratization lest it become a trojan horse for counterrevolution. Indeed, the events since 1989 may justify scepticism. Yet, the left discredits itself when it cannot separate its legitimate fears of a New Right in Eastern Europe from the inescapable judgment that democracy, as risky as it has proven to be, is still better than a tyranny which offers a steady paycheck even if it can buy only the barest necessities of life.

A striking symptom of the decline is that the ideological left has been rendered invisible in public debate. The left's media invisibility is the result of its political weakness, ideological confusion, especially about the importance of the public sphere as a site of political contestation, but also of the collapse of Communism. The left's influence in the United States has never been proportional to its political weight within the electoral system. Neither the labor movement nor the ideological left has been successful building a *sustained* voting constituency, even when it was able to set much of the agenda for a vast program of social reform. From the 1930s to the post-World War Two era, the ideological left—Stalinist and anti-Stalinist alike—was taken seriously, not principally for its fairly modest mobilizing ability around social justice issues such as better living standards for workers and the poor, but because of its relationship to a powerful international movement. During the 1930s, the left mounted the major agitation against fascism in Europe and Asia, especially in Spain, and then, in the postwar era it led the fight against colonialism, a fight which was sus-

tained by the presence of the Soviet Union as the most powerful anticolonial power.

Even before the emergence of the anti-Vietnam War movement to popular proportions in the late 1960s, the left enjoyed de facto the status of the official opposition to the interventionism which, during the postwar era, was the linchpin of U.S. foreign policy. This position was retained through the 1980s with respect to Central America and ended only when the Soviet Union decreased its support to Nicaragua and the Salvadorian and Guatamalan insurgencies, and Yeltsin's Russian government finally withdrew aid from Cuba, the Sandinistas, and the Salvadoran rebels. The collapse of Communism bore a direct relation to the cessation of armed struggle in El Salvador, the Sandinistas' electoral defeat and Cuba's desperate efforts to forestall complete collapse by expanding diplomatic and trade relations, especially with the United States. These developments deprived the U.S. left of its traditional voice in U.S. foreign policy. For it must be admitted that, in the absence of popular resistance against U.S. policies in that region, the left's views mattered on Caribbean and Central American issues only so long as it was perceived by those in power as the domestic voice of an international movement.

The phrase "post-Cold War" signifies the disappearance of the main opposition to the agenda of global capitalism. For while the Soviet leadership was, to say the least, far from a force for human freedom, its foreign policy in Latin America and much of the third world was impelled by a reflexive anticolonialism and opposition to U.S. intervention that, nevertheless, provided the material and political resources which enabled many movements such as the PLO and the Angolan and Mozambique "liberation" forces, to wage a determined struggle for national independence. Over the past thirty years, a substantial fraction of the U.S. left has defined itself in relation to these movements. For this "third worldist" tendency, politics *was* the anticolonial struggle and the United States was deemed the main enemy of national independence. In the mind-set of the third world left, any struggle for national independence against the leading imperial powers, except the Soviet Union, was worthy of support, irrespective of whether it was democratic.[22]

For example, though the majority of war protesters simply favored an end to U.S. military intervention, a minority of the anti-Vietnam War movement marched under the slogan "victory for the National Liberation Front," and remained unfazed by ample evidence that, following common practice in the "socialist" world, the Vietnamese Communists repressed civil liberties for dissidents of the left and the right alike. Similarly, during the Sandinista rule in Nicaragua, the regime's U.S. supporters remained hostile to critics on the left who deplored its suppression of the indigenous peoples, workers' strikes, and the political opposition. Except for the Mesquito Indians, they even denied that such suppression was possible, much less had occurred. Ten years after the rev-

olution, the left regarded these criticisms as counterrevolutionary, even though the Sandinistas were, at best, a national liberation movement with no particular democratic political aims. And, of course, we should not forget the open-throated left consensus in favor of the Iranian revolution of 1979, which ushered in a theocracy that proved to be among the most brutal and repressive in the world, including against the left. While many individuals have been self-critical in the wake of the horrendous record of that "revolutionary" regime, especially after the death threats to novelist and critic Salman Rushdie, there was little, if any, discussion of the implications of the virtually uncritical left support for national independence.

The "new phase" of negotiations and electoral struggle throughout Latin America and the Middle East, imposed by the withdrawal of Russia and its resources from the anticolonial camp, has partially washed away the political basis of the virulent anti-Americanism that once sustained the left. But, during the post-Cold War era when nationalism has revealed its ugly and fractious side, the left has not be able to respond with a new evaluation in part because of its historic complicity with regimes whose nationalism was no less despicable than that of the Serbs and Croats in the former Yugoslavia, and in the republics of the former Soviet Union. The precondition for such a voice would be the left's capacity for a searching reexamination which, with a few exceptions, has not been forthcoming. Many still support the Cuban Communist regime without carefully separating the legitimate position that calls for the end of the U.S. embargo, for normalization of diplomatic and trade relations and cultural exchanges, including tourism, from one that still apologizes for this one-party system, its occasional jailings of dissidents and its policy of censorship and control.

The left was no more pertinent in its criticisms of other recent events involving U.S. foreign policy, such as the successful October 1993 coup by the Yeltsin forces in Russia, conducted, ostensibly, in behalf of democracy and the free market (uttered in the same breath). Crack government troops mobilized against the resistance of what was labelled by his government, as well as the majority of U.S. press, as a cabal of Stalinists, nationalists, anti-Semites, and thugs. As with other issues, with a few exceptions the left was silent or silenced.

In any case, it would be unseemly to support either side with the fervor one would want to reserve for genuine democratic movements. We should have known better during the long history of the Soviet Union to commit ourselves to tyranny of any sort. One would hope we are wiser now. The left could have made these interventions, but was afforded no opportunity to do so for the simple reason that, lacking either substantial mobilizing power or ideas, there are no clear justifications for seeking its views. In turn, it must be admitted that the press, radio and TV news might have difficulty identifying consensual left-wing voices because most of its institutions—especially those that had thrived on

Cold War analysis and anti-interventionism—have gone out of business. More-over, on the current international hot spots—Bosnia, Somalia, and the Middle East, where the Palestinians are themselves divided on the peace settlement—it is by no means certain that the left has anything distinctive to say. Certainly ini-tially, most of the European left did not dissent from the do-nothing policies of European governments regarding the situation in Bosnia, policies that in effect supported the Serbian and Croatian governments in the quest for territorial expansion at the expense of Bosnia. Here and abroad there were, until 1995, few, if any, large-scale protests calling on the European Economic Community and the United States to lift the arms embargo to Bosnia, much less demands to send UN troops to protect Bosnian sovereignty. Nor, indeed, did anyone except some of the leftist sects protest U.S. and UN intervention into Somalia, even though it was directed not merely to humanitarian aid but also to what has been euphemistically termed "nation building," a goal which entails the elim-ination of the armies and political influence of "warlords." We have not seen this kind of frank imperial intervention since the U.S. invasion of Grenada and, historically, since the gunboat diplomacy of the 1920s and the 1930s in China and Central America.

The Somalia intervention was truncated for, among other reasons, that the United States public has no taste for losing American lives for unspecified ends. The withdrawal of U.S. troops from that country in 1994 and the government's long hesitation before it finally intervened in the Yugoslav crisis raises the ques-tion of whether the United States has been assigned, by the world relationship of powers, to sovereignty in Latin America and the Middle East and seems will-ing to contest influence in East Asia, but has *de facto* backed off from the role of world policeman unless it can obtain UN, NATO or European Union cover.

More to the point, large segments of a putative U.S. left does not know, col-lectively, what it thinks about these issues since, in at least in the cases of Bosnia and Haiti, it would have to reexamine its own tradition of reflexive anti-inter-ventionism, (especially to interventions by advanced capitalist powers) which, for most of the Cold War, was the staple of its politics. For there might have been reason to support the Clinton administration's actions in Haiti and its final decision to send troops to Bosnia.

Nor has the left anything coherent to say about the situation in the rest of Eastern Europe. For example, whereas the French *Le Monde* and Italian *Il Man-ifesto* greeted the results of the September 1993 Polish election, in which "left" parties (many of which were Communists-turned-social-democratic) achieved a near-majority of the votes, as a sign of the "return of the left," apart from a few individual journalists, there was virtually no public analysis from the U.S. left of the significance of these results. What is its attitude toward the return to power of a coalition in Eastern Europe led by former Communists? What, for example, would the left think of a possible democratically elected Communist

president of Russia and a parliament dominated by the CP?

While some might take comfort in the persistence of resistance to the privatization policies of the right, what do we know about the political ideas and complexion of the new coalition governments in Hungary and Poland? Was there any far-ranging significance for Eastern Europe to the results of the 1993 Polish elections? In quick succession, parties calling themselves Democratic Socialists, but dominated by former Communists came to power in Hungary and began to show considerable strength in Russia. Having, like the rest of the country, turned inward, out of embarrassment or ignorance, the U.S. left has given scant attention to these developments.

Part of the reason for the silence immediately following these events is the absence of a left-wing press with the ability to send correspondents to the hotspots or at least to use the services of like-minded European journalists. Apart from individual correspondents such as Daniel Singer, who writes in *The Nation*, there is today no semireliable public (as opposed to specialist) source of news from the postcolonial world or Eastern Europe. But beyond the lack of resources—no small matter—the absence of a debate about these international issues may be better explained by fragmentation and demoralization but, more saliently, by the fundamental ideological and political shift that has taken place within the left since the early 1980s.

Abetted by the advertising industry, free market ideology wrapped itself in the shroud of "empowerment," "choice," and "freedom," all of which had been battle cries of both redistributive and cultural movements. The deft appropriation of New Left slogans and its conflation of direct democracy with market participation and consumption were perhaps the greatest ideological triumphs of the right during the 1980s. These Orwellian inversions played upon deep-seated distrust of central authorities (except the large corporations) and penetrated well beyond the borders of the United States to become the chief political weapon of the Reaganite foreign policy. On the occasion of the collapse of the Soviet Union in 1991, Bush's crow "We won" was ritualistically dismissed by the left; we knew that Communism crumbled beneath the weight of its own contradictions.

To deny Western capitalism's achievement of relatively high living standards for most of its underlying population, even if the popular struggle was among its vital components, is to engage in an egregious and self-serving form of forgetting. For, while a minority of Eastern European dissidents marched under the flags of political freedom, the call to reestablish "civil society," and relief from the oppressive powers of the authoritarian state and its bureaucracy, the larger populations of the Communist countries who approved the work of these democratic vanguards hoped for a better life in fairly mundane terms. They were, undoubtedly, attracted by *consumer society*, perhaps the most subversive attribute of late capitalism. That only a tiny minority has, thus far, been able to taste its delights

has produced widespread disillusionment, which at the political level has desta-
bilized many of the newly constituted free-market regimes, even helped fuel a
revival of the left.

~THE FALL OF THE LEFT

The power of the practices and ideology subsumed under consumerism has dis-
armed the social-democratic and labor parties in Europe and Canada, which
like the Democrats in the United States have accepted conservative free-mar-
ket ideology. According to this ideology, labor, like any other commodity, must
be put in competition with itself in order to save the economy. In consequence,
the privatization of public goods, economic patriotism and nativism are no
longer proscribed, but are often openly embraced or tolerated by large segments
of the traditional left. Lacking an alternative within the framework of existing
social relations, the popular left is caught between an opportunism which jumps
on the nationalist and nativist bandwagons and belated resistance to the most
reactionary expression of these doctrines, such as the remarkable campaign
against the North American Free Trade Agreement waged by organized labor in
the United States. Meanwhile, the right preys on the economic and racial anxi-
eties of many working-class and lower-middle-class voters.

While the leaderships of the unions, civil rights and liberal feminist organi-
zations deplore these developments, they seem powerless to launch an effective
counteroffensive, not only because their armies have been diminished and in
some cases decimated but also because they, too, sense the hollowness of tra-
ditional social reform ideology in a period when the welfare state in being dis-
mantled in the name of budget-balancing. As long as they refuse to challenge
the budget-balancing imperative and the huge military establishment, they can-
not wage a struggle for redstributive justice such as might be effected by a sin-
gle-payer health care plan.

More to the point, this surgery is accompanied by the traditional values of
work, family and community that cultural conservatives on the left have always
embraced. The popular left lacks a bold approach that links the struggle for
redistributive justice with the critique of authoritarian social institutions such as
the capitalist workplace and the family, and a trenchant analysis of the global
economic and political situation. This approach would require a fairly explicit
renunciation of its current collaborationist strategy with the Democratic Party.
Rather, most organizations of the popular left have opted, with almost no excep-
tions, for circling the wagons around past gains and protecting, as best as is pos-
sible, a constantly diminishing constituency. Nevertheless, the powerful coali-
tion that emerged to oppose NAFTA reveals the considerable latent power of the
left and brought to the surface considerable hostility to the rightward drift of the
Democratic Party's national leadership.

The end of the social reform phase of U.S. economic and political life is not

unexpected. For the bare truth is that the social compact that sustained both the labor and black freedom movements for a half-century has been broken by, among other developments, the emergence of global debt and a global metastate. In the atmosphere created by such developments, the nationally based welfare expenditures and government regulations of the New Deal era are seen as obstacles to financial responsibility, expansion, and, for some, corporate survival. Whereas in the postwar framework of seemingly unlimited expansion, high wages, and transfer payments within the framework of the national state were heralded, even by segments of Capital, as an *economic* safety net, in the current period of consolidation, retrenchment, and restructuring, even the concept of the *social* safety net is under siege.

The organizations of economic justice that form the core of the popular left have been on the defensive for at least twenty years. They have sustained many lost strikes and legislative struggles and have concluded that they are obliged to go along with the urgent demands of their political allies and enemies alike that reducing the $4 trillion national debt supersedes all other considerations. Consequently, the socialist (ideological) left, whose condition of development and influence has historically been the growth and vitality of the labor movement—not only trade unions but also movements for various forms of justice (housing, health, welfare and social security, racial equality, for examples) has reached a dead end.

~The Left at Bay

Protest and resistance, the major strategy of the left since the early 1960s, neither captures the imagination of a public yearning for *alternatives* to current policies nor of the media, unless the action involves the struggle for gay and lesbian or women's rights, which strike to the heart of the dominant conservative social ideology. In the midst of a veritable international consensus in the higher circles as well as in considerable sections of the disoriented popular left around the economic doctrines of Adam Smith, the so-called "social" issues remain deeply divisive and for this reason are worthy of media attention. In contrast, a national 1993 Mineworkers' strike competes with the obituary columns for space on the back pages of the daily press, and other labor struggles are relegated to the Business section, when they are covered at all. We know that the poor portray themselves as victims to mask their sloth for, as the erstwhile liberal and current neoconservative guru of welfare policy Lawrence Mead reminds us, all questions of poverty may be understood as the expression of a mass psychology of "incompetence" by the poor themselves.[23] While thirty years ago, the Establishment was gearing up for a war on poverty, these times are marked by a war on the poor dressed up in the rhetoric of reform. And, perhaps most egregiously, reports of corporate job cuts elicit little or no public comment from the left, let alone from mainstream politicians and official sages. Given the vacuum

on the left, most of the anticorporate thunder comes from the populist right. The announcement that a leading corporation intends to chop its workforce is, almost inevitably, the occasion for a rise in the price of its stocks. The tough-minded manager has become the new culture hero of business and of the media.

Meanwhile, erstwhile liberal public officials compete with conservatives in the game of ragging the poor. Democratic mayors and governors race to cut welfare benefits by introducing the principle of work or starve. "Workfare" requires adult recipients of public assistance to accept often useless or onerous jobs as a condition of eligibility, whether daycare services are available or not. Simultaneously, drastic cuts in basic benefits and a torrent of new claims from newly impoverished workers and professionals owing that the permanent economic crisis, and acinine proposals to offer displaced workers "job retraining" in order to alleviate their misery, are the leading ideological tools of an administration and its professional coterie that refuses to acknowledge the coming of the post-work or unwork society.[24] Rather than risk the emnity of the seemingly omnipotent corporate capitalist class, the unions and their Democratic allies have steadfastly resisted opting for laws and contract provisions for shorter working hours and sharp limits in overtime work; National and state child care legislation languishes in committee; and capital flight, addressed by a fairly weak notification bill passed during the Bush presidency, needs urgent action.

Perhaps with the single exception of the AFL-CIO's suprisingly effective opposition to the proposed North American Free Trade Agreement with Mexico, organized labor was, prior to the election of an insurgent slate to AFL-CIO leadership, despite some rumbling, prone to "me-too" the Clinton Administration, thus continuing a long tradition in U.S. and British politics of moderating its demands when the party in power is perceived to be on its side. Having a "friend" in the White House has proven more important than labor's legislative agenda. The AFL-CIO seemed prepared to wait in line for its replacement-worker bill to get to the floor of Congress until, at its 1995 winter meeting, the rumbling surfaced in veiled demands for union president Lane Kirkland's prompt retirement. Ever grateful for Kirkland's service to the administration and fearing a more militant alternative from the nascent opposition, President Clinton, now faced with a hostile Republican Congress, issued an executive order barring replacement workers in companies receiving federal government contracts.

Since the early 1970s, the left in America has been a movement with no name. When the *ideological* left speaks it is in the name of others. These others include the major organizations of the *popular* left: the labor movement, the liberal wing of the Democratic Party, feminist, civil rights, gay and lesbian, and ecology organizations. Although many of the militants of these groups were initially politicized and trained by the organizations of the New Left, they act *as if* these "origins" are unimportant to their own activity since there is no left movement to keep their feet to the fire. What they received from the ideological left was an

orientation toward social justice issues, a set of organizing and administrative skills, and, perhaps equally important, networks that are very useful to their respective movements.

Since the American left—ideological or popular—has failed to articulate an *alternative* politics for several generations, the many thousands of labor, feminist, and community activists as well as writers and artists who were trained within the ranks of socialist, communist, and the New Left organizations and helped build social movements organized around various identities are publicly indistinguishable from the liberal wing of the Democratic Party, even as they retain socialism "in their heart(s)." Thus, when the media use the term "left" they refer to the modern liberals, including the unions and the melange of single-issue and identity movements that have coalesced around the Democrats, not the invisible socialists, let alone radicals.

Almost alone of the broad ideological and identity "lefts," the historical role of socialist ideas and critiques was to never let the liberals forget that inequality is rooted, in part, in the capitalist system of ownership and control of production. But to attempt to revive socialism *in its present form* would be an exercise in futility, especially after the rise of the social movements. As I shall suggest in chapter six, the living tradition of the socialist movement consists in its determination to secure economic justice for workers and the poor, and in its exquisite understanding of the need for institutional forms of struggle such as parties and organizations. (The latter stands against the tendency of communitarians and many social movement activists to ignore or, more egregiously, to oppose these dimensions.) A new radical paradigm will ignore the contribution of the socialist tradition at its own peril.

Against the Liberal State

ACT-UP and the Emergence
of Postmodern Politics

~The election of Rudolph Giuliani in 1993 as New York City's first Republican mayor in more than twenty years challenged a number of political assumptions that had solidified into myths in the city's political culture. Among them, none was more significant than the idea (vigorously promoted by the person he defeated, Mayor David Dinkins) that, despite Staten Island and Queens' fabled conservatism, New York remained, indeed, a gorgeous mosaic of different ethnicities, races, and sexual orientations the sum of which added up to one of the last liberal outposts in the midst of an increasingly rightward drift of the national polity. Even though Giuliani was a Republican and a militant champion of the now powerful doctrine that the chief role of government was to insure law and order by pursuing an unrelenting war on crime, his other political priorities were carefully disguised during the 1993 mayoral campaign as they had been in his unsuccessful bid of 1989. The political spin-doctors assured us after his narrow victory over Dinkins—the city's first African American mayor—that beneath his conservative exterior Giuliani was really a "Rockefeller" Republican, a designation that marked him as a softie, committed to the provision of social welfare and public goods even as he might be tough on crime. After all, who could deny that Rockefeller's administration of New York State government followed the broad pattern established by welfare liberalism during the 1930s and 1940s? Nelson Rockefeller's one great crime initiative, mandatory sentencing for drug dealers and drug users and his order to brutally supress the famous Attica uprising of 1969 were not, in any case, partisan political gestures. Indeed, by the 1970s organized scepticism about the criminal justice system had been dissipated by a series of media-manufactured crime waves built on the rapidly shifting racial and ethnic composition of large cities. No big city administration, whether Democratic or Republican, could afford to ignore the mounting public clamor for law and order. According to some, Giuliani was merely following a script written by most other big city mayors, including many Democrats.

Thus, for many, including some Giuliani supporters, it came as something of a surprise and, for liberals and the majority black and Latino communities, a calumny that the new mayor fully intended to carry out at the municipal level many of the elements of the national conservative project to "downsize" government and privatize public goods. Among them none was more provocative than Giuliani's intention to abolish or otherwise shrink services to the homeless and to victims of AIDS. Shortly after his election victory, the press was informed that the mayor-elect would offer a plan to close an inherited $2.5 billion budget gap by cutting municipal services—in the first place by eliminating fifteen thousand jobs; privatizing part of the vast municipal hospital system and paring such basic health services as pest control; selling the licenses of the municipal radio and TV stations; and, despite an official rate of youth unemployment of some 38 percent, reducing youth programs, including summer employment. As a visible sign of his serious intent to shrink the government's role in positively addressing social need, he would close some shelters for the homeless and eliminate the Department of Aids Services (DAS).

Having run as a law-and-order candidate, Giuliani pledged not to cut the uniformed employees of the police and fire departments, although sanitation would not be spared. In fact, he indicated garbage collection might be privatized—that is, services to apartment dwellers and small homeowners would be contracted out to private haulers, a measure that might not cut costs since most garbage collectors in the private sector were unionized. But, it would please some free market ideologues and large campaign contributors among the hauling companies. Further, since, responding to its long-standing feud with the Dinkins administration, the 60,000-strong teachers union broke precedent by remaining "neutral" during the campaign, the new mayor rewarded this discretion by promising not to lay off teachers, although Board of Education administrative and clerical employees (who are represented by a union that formed one of the key elements of the Dinkins coalition) would face draconian reductions. This final measure Giuliani trumpeted as a way to puncture the Board's fabled bloated bureaucracy.

Within his first hundred days of elective office, the new mayor tossed many balls in the air. Faced with armageddon, with scarcely a whimper the union leadership of the two-hundred thousand nonuniformed city workers threw in the towel and averted a potentially embarrassing confrontation with the mayor by quickly making a deal. In order to save the face of the union leaders Giuliani agreed to grant employees who elected to leave municipal employment modest lump sum payments of up to $25,000, depending on length of service. But he made clear the administration's resolve to proceed with layoffs if the unions rejected these terms. With an official 11 percent jobless rate in New York (compared to an official national rate of 6 percent), many low-level employees had little chance of landing another job, but the much anticipated head-to-head

battle between the conservative mayor and the liberal labor movement was avert-
ed by a compromise that reproduced some of the conditions of the 1975–76
fiscal crisis, which ultimately resulted in 50,000 layoffs, mostly of the working
poor.

In the main, despite grumbling by African American and Latino political
leaders, in his first months Giuliani largely had his way. He did not succeed in
his plan to sell the municipal radio stations—which are listener supported NPR
affiliates—or his plan to abolish DAS. The management of the stations mobilized
their considerable white middle-class membership to pledge more money to
make up for anticipated lost revenue that would result from the City's with-
drawal of some $1.7 million in subsidies and the radio's corporation bought the
operating license from the city government. Given Giuliani's considerable back-
ing among white liberals who had been herded into his camp by their growing
fear of crime and other signs of urban mayhem, the mayor backed down from his
plan to sell off the stations' licenses to a commercial station.

And the leading AIDS activist movement, ACT-UP, swung into action against
the proposed shutdown of DAS. Activists staged a series of confrontations with
the mayor: noisy demonstrations at public events, including some where the
mayor was delivering speeches; a lie-in across the Brooklyn Bridge; deploying
the more conventional tactics of letter-writing and rallies. After four months of
press attention and relentless disruptions promulgated by a small group of tire-
less activists, the city administration quietly dropped its proposal. When the
new budget was finally issued in early May 1994, DAS had been preserved.
Where unions repesenting tens of thousands of municipal employees had failed,
a relatively small but highly vocal social movement succeeded in staying the
administration's hand.

ACT-UP's victory illustrates the relative decline of the numbers game in con-
temporary local politics. ACT-UP represents neither most lesbian and gay voters
who, in any case, were heavily in the Dinkins column, nor by itself has a "con-
stituency" which could make a significant electoral difference. (At the nearly
one million-strong New York parade commemorating the twenty-fifth anniver-
sary of the Stonewall confrontation, ACT-UP's alternative demonstration for AIDS
action drew a comparatively small crowd of some six thousand). Moreover, the
establishment lesbian and gay organizations have been careful to keep their dis-
tance from ACT-UP's confrontational tactics and relatively uncompromising posi-
tions on several aspects of AIDS policy. As I want to argue, ACT-UP certainly
engaged itself in the struggle for power, but its capacity to win battles, enjoy
influence in AIDS policy, and unsettle hegemonic political forces rested, in part,
on the complexity of the contemporary political system, in which majoritarian
ideologies have lost some of their moral force because of the partial breakdown
of the legitimacy of the liberal state, where "liberal" connotes not so much the
dominance of political parties of modern social welfarism but a system where

"representation" is considered an adequate measure of legitimate power.

The crisis of the U.S. state is overdetermined by economic, political, and ideological developments: the loss of the state's sovereignty in the wake of the intensification of economic globalization which, concomitantly, has increased the power of international capital and the newer power centers—Germany, at the head of a new Western European alliance and Japan—over many of the crucial decisions once made routinely by the president and his administration. In effect, the U.S. political system is faced with many of the same problems once reserved for Europe and developing countries. For the first time in more than a hundred years the painful fact is that its autonomy is severely constrained from without.

Yet substantial sections of the electorate persist in disbelief in the ability or political will of the political class to deliver policies that benefit the majority. Only slightly more than half of the eligible voters cast ballots in the 1992 presidential election, and this proportion represented a slight advance over the previous elections. At the state and local levels, the percentages are much lower. While Ronald Reagan was elected by some 29 percent of eligible voters in the 1984 election, many governors and mayors are selected by even smaller proportions. Contrary to liberal explanations which assert the problem is voter "apathy," one may argue with equal credibility that the U.S. state suffers legitimation problems, especially among economically and socially disaffected groups who cannot see themselves in the processes of representative government. We may observe similar dissatisfactions with the mainstream Catholic and Protestant churches, even as membership and activism among religious fundamentalists and formerly tiny sects has exploded. The political parties suffer from a palpable loss of activists, while the insurgent presidential candidacy of Ross Perot in the 1992 elections succeeded in recruiting tens of thousands of volunteers.

The liberal state is losing its sovereignty even though its sovereign powers are insured by laws which, among other things, give governments the unconditional right to dispose of private property for public purposes. In addition, while the legislature retains the legal right to impose and differentiate the burden of taxes, "outside" influences such as corporate political action committees," special interest" lobbies and, perhaps equally powerfully, the press and electronic media have effectively blocked and in many respects reversed the progressive principle of distributing the tax burden on the basis of the ability to pay.

To be sure, progressive taxation, a carryover of Wilson's New Freedom and especially of the wartime policies of the Roosevelt administration, remains official doctrine to which until recently even the most rabid conservatives were obliged to pay tribute. However, since World War Two, Democratic and Republican administrations and legislatures have undermined the progressive tax by consistently enacting legislation that flattens the percentages of tax to income between affluent and relatively hard-pressed taxpayers. Among these measures are regressive taxes on sales, fees, property, road use, tolls, and lotteries, all of

which fall disproportionately on poor and lower-middle-class people. And in the Clinton era, there is a new campaign to institute a "flat" income tax which would merely fine tune the Reagan-Bush tax "reforms" of the 1980s.

ACT-UP, at least in its heyday from 1988 to 1992, was the quintessential social movement for the era of postmodern politics represented by the just-decribed developments. In contrast to the leading premise of modern politics, namely that the legitimacy of the liberal state is guaranteed by electoral majorities, ACT-UP tacitly challenges the *ethical* legitimacy of the majority just as business interests have buried the majority interest in areas such as tax policy, national health care, and environmental protections. Although ACT-UP eschews doctrinal pronouncements, it insists on and actively seeks to impose a *substantive* rather than procedural criterion upon claims to representation. If the majority accepts or otherwise acquiesces to the institutionalized homophobia of the state and its apparatuses (including large sections of the church), citizens are under no obligation to obey the law and rules of conduct prescribed in its name. Although this gesture appears at first glance to follow Alisdair Macintyre's call for a return to substantive justice in the mode of Aristotle's ethics, in the context of the canon of procedural rationality that governs modern politics, ACT-UP operates from "post" modern premises.[1]

Now, it may be claimed that Giuliani could afford to bow to ACT-UP's resistance because the financial stakes were much lower than the anticipated savings on the wages and benefits for fifteen thousand employees. In any case, we may never know what effect labor union resistance might have had on the government's policies. What we do know is that the numbers game, the staple of modern electoral politics, may no longer regulate policy struggles and their outcomes, (if they ever did) except in terms of the "bottom line" issue of who may claim the right to rule. In terms of the pragmatics of governance, electoral majorities have little effectivity in the day-to day political struggles which constitute what we mean by political power. Even Giuliani knew that having won the election by a slim margin he could not legitimately claim a mandate for a determinate set of policies. Thus, he adapted the well-known Eastern European strategy of "shock" therapy to New York. He administered a torrent of changes to an unsuspecting public in the hope that the patient would be too stunned to offer resistance. In this respect, Giuliani's strategy paralleled that of economist Jeffrey Sachs, whose advice to the Polish reform government was to act swiftly to privatize state-owned enterprises and radically reduce welfare spending before the underlying population had a chance to express its displeasure. In the subsequent election the voters decisively rejected the policies of the privatizers and returned a reformed Communist Party to power. But, of course, the changes were by then sufficiently entrenched so that the new government was unable to renounce, let alone reverse them.

In any case, postmodernity in our era of political rule consists, in a large

measure, in the indeterminacy of the relation between electoral outcomes and public policy. Just as the Polish voters were largely unsuspecting about Sachs's prescriptions for their economy, what the government actually does is the result of a series of struggles over discursive hegemony, in other words who sets the framework for the debate, how decisions are to be configured, what the constructed "public" perceives to be the case.[2]

For example, the influence of business interests on local tax, urban redevelopment, and social welfare policies is rooted not in their ability to deliver large quantities of votes, or even in the substantial campaign contributions real estate, banking and other commercial groups bestow on both major political parties (although such a judgment would be rejected by those who follow conspiracy or economic determinist perspectives). The power of capital resides, principally, in the public perception that in the absence of an alternative economic discourse and plan corporations such as those engaged in financial services hold the economic strings; that they—and not the production companies—are indispensable for the lifeblood of the cities. Almost everybody who counts in political terms accepts the idea that no fiscal program can be *perceived* to hurt business.

The consequences of antibusiness public finance extend beyond general perceptions. As the New York fiscal crisis of 1976 demonstrates, public policy bears on such matters as the city's bond rating and, concomitantly, whether investors (notably the banks, pension and mutual funds, and insurance companies) will purchase municipal bonds (and at what interest rates) to pay the city government's ongoing expenses. In 1975–76, labor unions, education, health, and social welfare organizations were informed that unless they agreed to substantial cuts in employment and *therefore* services, investors would undertake a capital strike against New York City.[3] During this crisis, many were impressed by the simple formula that the business of government was, in the first place, business and that any violation of that principle risked disaster. Recall that this was a period when the Democrats had occupied City Hall for all but eight of the previous thirty years, so there was no question of an ideologically determined partisan contest over public finance. When faced with demands by a now well-organized financial sector that the size of government be substantially reduced, the Democratic mayor obliged by proposing to lay off fifty thousand city workers, a fifth of the labor force. The unions, which by the mid-1970s represented all of the city's manual and clerical employees and most nonsupervisory professionals, felt constrained to go along with the program, fearing the reaction of investors more than their own rank and file.

Since the Great Depression, most U.S. municipal administrations have awarded tax abatements and other types of subsidies to employers who threaten to remove plants and offices to greener union-free and tax-free environments. In many of these cases, the specter of capital flight is enough to send civic and labor organizations, let alone city officials, scurrying. Politicians have been

intimidated by the threat of job losses much more than the consequent withdrawal of campaign funds from corporate political action committees, currently the life-blood of politicking in the United States. When business threatens to relocate to the suburbs, rural areas, or overseas (or even in rare instances when local government fails for whatever reasons to grant a lucrative package of tax breaks and subsidies) the news inevitably gets around, especially to the media. Politicians hasten to accommodate business demands lest they be accused of im-poverishing their city or town.

Despite the democratic palaver that regularly litters the linguistic landscape, public debate about probusiness government policies at the local level remains a rare occurrence, even when by granting concessions the tax burden inevitably shifts to small business and the working class. Under these circumstances, services such as education, health and transportation suffer from consequent budget cuts since the main source of local revenue—taxes on real property—fall disproportionately on small holders. Since the decimation of the cities by deindustrializing capital flight in the 1970s and 1980s, many municipal administrations have become little more than adjuncts of the remaining corporations. The assumption is that when large employers threaten to move, political opposition to granting them concessions must collapse. At the same time, if these concessions result in substantial reduction of tax revenues to pay for programs such as AIDS services, the role of concessions in preserving jobs takes precedence.

Thus, the fight in New York to save city services in the wake of the consequently narrowing local tax base resulting from business migration and massive government concessions to those that remain takes a distinctly postmodern turn. Rather than being fought *primarily* at the ballot box, which in the eyes of most activists is stuffed by the de facto one-party system, the battle must be joined in the new public sphere: the visual images emanating from TV's eleven o'clock news of intransigent protesters conducting in-your-face politics, street actions that embarrass public officials through exposure, and other disruptions. Publicity is the movement's crucial strategic weapon, embarrassment its major tactic. ACT-UP's tacit strategy was to force on public officials, church, and business leaders their most horrific nightmare: exposure by means of actions that signify disrespect. By presenting itself as an "out-of-control" intransigent melange of queers and misfits, it reveals a capacity to opt out of what is expected of a "responsible" civic organization: to play by the rules. From the perspective of the Establishment's code, to refuse these rules in to engage in the politics of *terror*.

In this respect, ACT-UP figuratively highjacks the rituals of respectability. When, in 1991 it disrupted the Cardinal's conduct of a service at Saint Patrick's Cathedral, it demonstrated a seriousness from which even the most radical civil rights and antiwar demonstrators had carefully refrained in the 1960s and early 1970s—despite ACT-UP's debt to the philosophy and politics of civil disobedi-

ence. As with all who hold up substantive justice to the vagaries of the proce-durality of the liberal state, the AIDS movement has suffered the charge that it has violated the fundamental freedoms of its adversaries by disrupting the most sacred rituals of the Catholic faith, and has destroyed the ability of public figures to engage, with security, in dispassionate public discourse.[4]

Despite the slowly growing number of openly gay and lesbian public offi-cials, most AIDS activists take little comfort from these gains, at least in compar-ison to the spreading AIDS and homophobia epidemics. In the long tradition of radical movements—anarchists, communists, feminists, and militant pacifists—ACT-UP may be regarded as the latest tribune of the idea that the greviances of the oppressed cannot be submitted for adjudication to the oppressor without fac-toring in a moral equivalent of power. Put another way, neither public officials nor civic leaders may be held as adequate to *represent* the needs of those afflicted with AIDS, especially under conditions where determined and, more to the point, principled opponents exercise equal or greater force in the opposite direction. [5]

For example, ACT-UP is no match for perhaps the leading opponent of rights for gays and lesbians, the Catholic Church, either with respect to institutional power (which manifests not least in the Church's moral and doctrinal hold on sitting legislators and other public officials who are among its parishoners), or with respect to its status as an electoral force. Like the active core of pro-abor-tion activist women who are practicing Catholics, the Catholics in ACT-UP are in a unique position to understand how formidable is the Church as a political influence and how daunting is the task of undermining this influence in the larg-er public sphere. Given the lopsided power equation, ACT-UP has effectively played the postmodern concatenation of outrageous confrontation with adroit media politics to help level the playing field.[6] Likewise, as we shall see, the movement has played the institutional game by a combination of inside negoti-ation and outside agitation: as a moving target it is hard to ensnare.

~ What ACT-UP grasped during its decade-long existence is that the styles appropriate to modernist political combat *do not apply* to issues of sexuality and its viscissitudes. (The question here is whether they still apply to any other kinds of struggles?) Having determined that the political arena is suffused with homophobic responses to the urgency of the AIDS epidemic, of which benign neglect and determined denial constitute perhaps the most egregious manifes-tations the pressures on elected officials to soft-pedal public funding of AIDS research and care programs preclude AIDS becoming a major political priority by bureaucratic means.

For these reasons the movement has disdained relying primarily on legislative and electoral niceties.[7] The fight to win publicly financed AIDS services such as outpatient care, hospital care and hospices and to expand research has, tacitly,

elided the rules of prevailing definitions of political "reason." That is, AIDS activists have refused to accept the necessity of subordinating the urgent need for services to overarching conceptions of economic rationality or political expediency in which private interests are considered prior to the provision of public goods. Nor do they accept the liberal politician's need to placate homophobic and racist opposition to providing extensive care as well as expanding research as a reasonable barrier to moving swiftly to provide what is needed.

ACT-UP's working assumption is that the prevailing economic and political rationality is a mask for homophobia, a judgment that prompts the movement to ignore or otherwise deride appeals to fiscal responsibility. Like its attitude toward civil virtue, ACT-UP shows little or no respect for the problems of the money managers.

In contrast, steeped in the presupposition that fiscal austerity corresponds to the given economic "facts," other movements and organizations such as labor unions, health advocacy groups—among them the Cancer society and the Heart Association, whose constituents are at least as victimized by scarce resources for research and care as those endangered by, or suffering from, AIDS—have generally gone along with cuts despite trepidation. At the level of policy if not individual belief, they accept as credible the doctrine that expanded health care and other social needs depends on private sector growth. This perception is, of course, simply another way of expressing the utter subordination of the remnants of the liberal welfare coalition to the exigencies of "free market" economic policy. Its naiveté consists not so much in the tie to economics, but in the belief that if the resources were available for social spending, there would be no ideological barriers to more bountiful resources for dealing with dread diseases, unemployment, hunger, and homelessness.[8]

To this ideological passivity one may add the degree to which nearly all erstwhile social movements have been integrated into the Democratic Party as "pressure groups," a transformation that constrains both their power base and their organizational configuration. From democratic anarchy, the internal life of the movements tends to become *normalized* in two ways: by adopting variants of Roberts Rules of Order and other means of bureaucratic management and by entering the "contract state."[9] As metaphor, Roberts Rules assure orderly meetings and "rational" decision-making, while the emergence of an organizational bureaucracy to replace the more or less anarchic and free-wheeling "movement" decision-making process in which *all* members have a voice, facilitates its integration into the state system as one of its appparatuses of control.

One of the key mechanisms for transforming social movements from independent adversaries of the state to collaborators is the *service contract*. In the 1960s, under pressure from the federal requirement to dispense services with the "maximum feasible participation" of the recipients of these services—especially the poor—state and local governments have contracted out large chunks

of service delivery to community-based organizations (CBOS) and maintained a relatively small central staff to provide oversight, chiefly of fiscal responsibility. For example, New York City contracts some AIDS services to the Gay Men's Health Crisis (GMHC) and other locally based groups rather than reserving administration and delivery to itself. GMHC is perhaps only the most prominent of a series of once militant groups which find themselves caught in the contradictions of the welfare state. Having been formed initially to fight for state and private support for AIDS services to an alarmingly growing community of HIV infected gay men, it gradually, and somewhat reluctantly, became a health provider and its movement character receded in favor of service delivery and public policy "advocacy." By the late 1980s GMHC had become an adjunct of state and local governments seeking to enhance their own legitimacy among the now considerable "out of the closet" gay and lesbian community. On the one hand, with the rise of identity politics in the gay and lesbian community, GMHC may have been perceived as a more reliable advocate and sympathetic provider than the City. On the other hand, like antipoverty groups and other community organizations since the 1960s, it had been effectively demobilized by these relationships.

The predicament of GMHC signifies the complexity of the relationships between social movements and the political/administrative system of power. Can they or any other social movement maintain autonomy in the wake of the crumbling of the service-delivery capacity of governments which, understandably, seems to cry out for intervention by "community" groups to assure that victims actually get help? The evolution of GMHC helps explain the emergence of ACT-UP as the "outside" bad cop in AIDS crisis politics. Since the terms of becoming a de facto agent of government are increasingly rigid in the wake of numerous media-hyped examples of welfare fraud, the politics of management replaces the politics of protest for most of these erstwhile movements.

Under these conditions, the movement is often seriously constrained from taking direct action to reverse budget cuts or waging a public fight for expanded funding and services. In time, many of the erstwhile movements, now reformed as organizations, acquire elaborate staffs to lobby for grants and other funds, write and manage grants, as well as administer and deliver services. Specialists are employed in all of these areas and, even if the organization retains a membership, the expert bureaucracy tends to become its life-blood.

What, beyond creative protest and organized disrespect, distinguishes ACT-UP from traditional liberal organizations and advocacy groups? I believe the answer may be found in its different conception of *citizenship* emanating from its "ultrademocratic" style of organization which, tacitly, oppose traditional statist notions of "leadership."[10] The key point is this: for "good" historical reasons determined by the discourse of responsible public behavior, most social movements and advocacy groups dedicated to welfare and other aspects of social justice have

subsumed their notions of citizenship under the general interest signified by the exigencies of the liberal state. Unions, groups devoted to expanding education and health services, and civil rights organizations, for example, may express their interests in forms such as legislative pressure, collective bargaining and the like but, at the end of the day, their exercise of popular citizenship, which may be best materialized in forms such as shared decision-making, is constrained by the tacit rule that loyalty to the rules of representation governs political action. The advocate petitions the legislature and the executive for redress; the social movement demands, by direct action, shared power because it does not trust procedural democracy.

In a time of economic stagnation and decline, deregulation and fiscal austerity, the *universal* interest is said to be identical with a weakened public sector. Fueled by their service functions, the social movement-turned-organization's bureaucracy, members of which are frequently recruited from the ranks of government because of their expertise in "government relations" including grants acquisition, take a larger role in policy formation, even if they remain formally subject to membership review and consent. Or, as in the case of the crisis of the New York City municipally owned media enterprises, many organizations have accepted the principal of voluntarism and a skewed conception of self-help as the moral equivalent of public responsibility.

For example, saving New York's public radio stations was achieved by accepting the terms imposed by the Giuliani administration. What had increasingly been de facto privatization after the concept of preponderant listener-sponsorship replaced municipal control twenty years ago became de jure. In the future, the largely upper-middle-class audience for the classical top forty offered by the FM station and for a refined version of liberal talk radio on the AM band will pay more for their entertainment and for their social and political enlightenment. "Public" radio connotes little more than commercial-free programming except for the week-long quarterly hectoring of listeners during fund drives. Like the huge deductibles many Americans are forced to accept in order to maintain their health insurance, or the ever rising tolls to pay for urban highways, as listener-sponsored radio loses its government subsidy the price of even the shell of independence retained by these stations will be borne by its constituents or they will pass into the annals of nostalgia, together with old union songs and memories of the "movement."

Similarly, even though cancer and heart disease remain the leading killers in the United States, public funds continue to dry up for research and treatment. Consequently, a larger portion of the costs of dealing with these diseases is borne by users and corporate givers in the forms of prepaid health insurance plans, and private charitable contributions extracted, in the main, from employees during special corporate-sponsored fund drives.

And, of course, the pharmaceutical industry has stepped up its collaboration

with university sponsored research. In return for financial support for research many, if not most scientists engaged in medical research have agreed to sell or otherwise transfer the patents for their discoveries to drug, genetic engineering and other private companies. As a result, and despite vehement denials by providers, access to knowledge as well as full treatment for these diseases remains restricted. Secrecy, a prime characteristic of the emerging national security state, penetrates the veil of scientific disinterest.[11]

The efforts of advocacy groups to win federal and local support for care and research have been successful only in periods of relative national affluence. For the last twenty years under the austerity regimes begun by the Nixon administration, raised to the level of a virtue by the Reagan/Bush administrations, but fostered by two Democratic administrations as well, advocates have experienced increasing difficulty obtaining enough funds to meet the burgeoning demand resulting from the veritable cancer epidemic that has afflicted the country.

ACT-UP is fairly unique among social movements, including those of mainstream feminism and racial justice insofar as it has rejected the economic determinist framework of contemporary political discourse, insisting that the AIDS epidemic, rather than fiscal constraint *is* the definition of the crisis. The movement flourishes on its refusal of conventional definitions of responsible social and political behavior whose underpinning is loyalty to the state and to the business priorities that increasingly drive its policies. I will argue in the next section that this turn away from the rules of conventional political action within the liberal state results not from an explicit radical antistatist ideology such as that which has motivated movements like the Industrial Workers of the World (IWW) (but not the socialist and communist parties, which were supremely statist) earlier in the twentieth century, but from radical democratic practices which are inspired by the early radical feminist movement and the civil rights movement, each of which perfected in-your-face politics.

With some exceptions, ACT-UP has rejected the core practices of modernist movements as well as mainstream politics—centralized, bureaucratic control over decision-making which, in many social movements, has subverted their ostensible political intention. The practical effect of this rejection is that control over ACT-UP policy was, at the moment of its greatest effectiveness, displaced from a putative center occupied by a swollen bureaucracy to autonomous voluntary committees which, frequently, vigorously disagree with each other, but are unable to veto the proposals of those with whom they disagree. Put another way, precisely because ACT-UP has no significant service function and hence no bureaucracy and, perhaps more important, no overarching political ideology it has been able to mitigate, if not entirely avoid, the contradiction between opposition and integration that inhere in the underlying organizational logic of liberal movements and groups. Once sanctioned by a vote of the organization's membership assembly, the committee acts according to its own delib-

erations; the membership retains power over expenditures from the treasury over $1,000, a prerogative that retains a vestige of oversight. In turn, many committees raise their own money in part to maintain their independence.

While it is both premature and excessive to claim that we are witnessing the beginning of the end of the era of state economic interventionism (after all, the federal budget is still almost a trillion and a half dollars) one cannot fail to observe radical shifts in the chief functions of government, and the relationship of citizens to a seriously weakened national state. Although the term "national security state" predates the current era, having been coined to describe U.S. government policies during the rapid military build-up of the Johnson and Reagan administrations, we can observe, in the guise of the quest for personal security in the face of an increasingly dangerous world, the triumph of law and order ideology and, particularly, the near hegemony of retributive justice. In this respect, the law and order imperative is not only a response to the changing racial and ethnic composition of cities or the rise in violent crimes, but also a symptom of the shared sense that the environment has become more perilous, that human action is fraught with increased risk.

Poll data show that Americans are increasingly reluctant to become involved in risky foreign policy adventures such as those manifested in the early 1990s: Bosnia, Somalia, Haiti, and Rwanda. Under intense conservative pressure we cannot avoid the risk entailed by seeking power over our own environment. Fighting crime concentrates and allays many of the fears that seem out of control on other fronts. In fact, "retributive" has largely replaced the adjective "social" in the very definition of justice. "Perpetrator" and "victim," once technical terms of police work, have, under the disseminating power of television and popular film, become commonplace in ordinary conversation. The term "victim" is no longer defined chiefly in its socio-economic connotations or in terms of discrimination on the basis of race, sexual orientation, or gender, for example. Now, victimization means simply those individuals who have been mugged, raped, or killed. In the conservative conception of justice, redressing the harm caused by violent criminals by sending them to prison or the gas chamber/electric chair is coincident with its definition. In the process, the invocation of crime is *always* preceded by the modifier *violent*.

Thus, when an employer fails to provide healthful and safe working conditions and, as a result, workplace accidents rise; and women suffer employment discrimination or something other than aggressive physical sexual harassment on the job; African Americans are subject to hate speech; or when those afflicted with AIDS are victimized by the "benign" neglect of governments, the invocation of these "crimes" of negligence by activists and intellectuals is dismissed as political correctness. "Real" crime appears on the police blotter and happens exclusively to individuals.

For the Giuliani administration and many other big city governments the

charge that they are transforming themselves into a police state is by no means an extremist epithet. The new conservatism waxes proud of its pared down mission to mete out swift and sure justice against those who would tear at the "social fabric" of the Community by preying on its unprotected citizens. Although not lacking compassion for the halt, the sick, and the lame (while at the same time condemning these categories to near penury in social-Darwinist terms) conservatism vigorously denies government a crucial role in providing them with more than the most minimum level of subsistence.

Compassion may itself be a substitute for justice. As Hannah Arendt reminds us, compassion always already signifies inequality.[13] The compassionate intend not justice, for justice might disrupt current power arrangements. Rather, the concern evinced by those in power for victims of AIDS, handicap, poverty, and social diseases may be the occasion for a black tie charity dinner, even as the charity diners, in their roles as corporate chiefs and professional politicians cut public funds to the bone. Surely, conservatives believe that the middle class can fend for itself when it comes to education and health. In the case of modern conservative administrations, this faith in privatization and voluntarism extends to the provision of pure water. While not (yet) renouncing its responsibility to provide water that is relatively free of toxins and harmful bacteria, conservatives have been so emboldened as to declare the commodification of water, if not air, a perfectly defensible position in a free (market) economy. (In this respect, perhaps the most significant distinction between New York's recently defeated Democratic governor and its Republican mayor is that the former still believes in environmental protection. In contrast, Giuliani has declared recycling to be a luxury incompatible with the higher aims of privatization and budget-balancing, an economy which could, in time, reduce New York's water quality to the level of the rest of the country.)

Needless to say, while the law and order doctrine has been with us for many years before the current crisis of the modernist liberal state, it increasingly occupies center stage. In this sense the postmodern state exhibits two contrary tendencies: its lumbering bureaucracies are under attack for being redundant in a time when the state does less, except in criminal detention and prosecution (misnamed criminal "justice"); at the same time, as its security functions proliferate, the police commissioner becomes, as much as the mayor, the central governmental figure: dialing 911 is the most effective way to reach city hall.

This is the vortex in which ACT-UP's practice of "no respect" plays itself out. Unwilling to follow the pattern established by the old modernist movements to fret, compromise and ultimately disappear from the public fray (a choice which despite these movements' proliferating advocacy functions tacitly accepts the new definition of the state as minimalist), ACT-UP nevertheless rejects the prevailing definition that citizens should be loyal to repressive civilization. Nor, on the other side, can the AIDS movement afford to adopt a contemporary ver-

sion of Marcuse's pure refusal, according to which the notion of citizenship has itself been sundered by the authority of executive powers and any participation in the affairs of the state is tantamount to complicity with domination. Faced with the dread disease, to focus on self-help as some have done is to foreclose hope, except for the relatively small number of its victims who can be made more comfortable in their descent. Thus, entering into intense dialogue with the liberal state is a strategy borne of the insight that the remedial practices of noblesse oblige, self-help, and voluntarism are no match for an epidemic. Thus, ACT-UP chose to fight for the provision of solid, institutionalized tax-levy money to pay for publicly administered services.

The dilemma of AIDS activists is that they must struggle within as well as against the remnants of the liberal state, assert citizenship but avoid giving their loyalty to its current definition. This strategy entails a process of constant testing of the liberal state's capacity to respond to every form of oppositional intervention, from engaging in protest to offering alternative policy proposals to negotiating and monitoring their implementation. For it is increasingly evident that legislative or administrative mandates are no assurance that a given policy will be put into effect. It is not only a question of institutional homophobia but of its fiscal variant, austerity. The budgets of many agencies charged with responsibility for dealing with AIDS were cut to the bone during the 1980s and early 1990s but not (yet) restored to operational strength during the Clinton administration. For this reason no serious social movement can afford to remain entirely on the outside of the policy framework of the provision of health, education and other social services, an imperative, as I have previously noted, which produces severe conflicts *within the movement*. It cannot be a movement in "radical chains" in, but not of, society. It must enter society as a player, but try to retain its adversarial position. This tightrope few movements have been able or willing to walk. ACT-UP's frequent crises are produced by the strains of this journey.

As Gilbert Elbaz has shown, contrary to widespread perception, ACT-UP is not principally a protest movement of the usual type, seeking more resources on terms dictated by the scientific and technological establishment to fight AIDS; nor is it an "interest group" with a limited agenda. It has concentrated its energies on sexually-transmitted AIDS and avoided forming alliances with black and Latino communities where the AIDS epidemic has taken different forms. Nor has ACT-UP joined coalitions to fight for broader aims such as, for instance, universal health care, homelessness, or hunger. One of Elbaz' central arguments is that New York ACT-UP is at once two movements: a cultural movement of (primarily) gay activists seeking a democratic *community* within which their identity may be freely expressed; and an organization of heterosexual and homosexual men and women dedicated to addressing the AIDS crisis through direct action, independent research and policy interventions.[14]

ACT-UP's radical democratic pluralism has led to important innovations in the style and scope of social movement activity. Perhaps most significant has been its ability to intervene in science policy. Confronting the Food and Drug Administration's slow approval process that regulates the pace of introduction of new drugs on the market, the movement has been able to speed up the process, now by confrontational tactics, now by carefully wrought arguments delivered at agency and legislative hearings.

Even more dramatic, members of an ACT-UP committee were able to offer an affirmative research program that partially altered the priorities of the key federal medical research institution, the National Institutes of Health (NIH). While *Science* and other journals of medical and scientific research consistently white-out ACT-UP's role in deciding such policy questions as budget levels or whether new vaccine trials amd approvals should be accelerated, and while these journals present the debates as *internal* to the scientific community—say, between the Federal Environmental Protection Administration (EPA), FDA, and NIH's Centers for Disease Control—there is no question that ACT-UP has made important interventions, chiefly through direct action at these agency headquarters as well as through critiques and testimony before congressional committees and scientific conferences.

The hubris of AIDS activism has been to set its face against the conventional view that scientific knowledge is the intellectual property of the professional/business/scientific community. Activists have insisted that as "laypersons" they have the right and, perhaps more to the point, the capacity to participate in making crucial policy decisions. Of course, armed with the ideology that science is independent of state and private intervention, scientists and science administrators at first vehemently tried to deny activists access to information and a place at the negotiating table. ACT-UP had to overcome more than homophobic prejudice, it was obliged to challenge the neutrality of science. In the process, and for many against their own predilections to accept the sacredness of scientific knowledge, it had to address a whole range of questions that bear on the applicability of democratic participation: elitism, professionalism, expertise—in short, the contradiction between the power/knowledge model and that of grassroots democratic citizenship.

Even though a crucial part of its strategy entailed winning over a critical mass of scientists to recognize the urgency of the AIDS epidemic, the energy for change came from the movement, not chiefly from the scientific circles whose priorities often elided the AIDS epidemic (a) by not recognizing it and (b) by invoking fiscal austerity after being forced to recognize the epidemic.

~ACT-UP's extraordinary history may be distinguished from all previous health movements by several crucial features: it is a movement *of* and by the victims,

not merely *for* them. It was born in the struggle against the decision of the Gay Men's Health Crisis (GMHC), the oldest AIDS advocacy organization, to become an arm of the State and, specifically, the refusal of a critical group of activists to define the AIDS crisis in terms of issues of service provision rather than sexual politics. ACT-UP's organizational style may be described as one of *radical democracy* as opposed to the liberal service/advocacy modes characteristic of rest of the health movement. When, by marginalizing and otherwise excluding dissonant voices, ACT-UP exhibited some of the authoritarian characteristics of the liberal organizations, it experienced some fairly profound splits, especially the formation of two women's AIDS activist groups, the largest of which was the Womens Health Action Mobilization (WHAM). Although these groups were disaffected from ACT-UP's sexist practices, they departed neither from its organizational model nor from its reliance on direct action as a strategic principle, behind which lay a largely unarticulated critique of the liberal state and its model of subordination, accommodation and incremental change.

That ACT-UP has experienced deep fissures should come as no surprise because it is, at the end of the day, not exempt from the enormous pressures of what may be described as the politics of "risk." In a moment in which the environment is increasingly unstable—a fact which makes folly of the strategy of playing by the rules—ACT-UP has to define an internal/external boundary in order to secure its own position. The internal is the community of activists, but particularly gay men, and those afflicted with AIDS. The external is coterminous with the environment within which the group exists. Consequently, it would be surprising if ACT-UP did not develop an us/them mentality which in this case placed women on the outside.[15] In the wake of the breakup of the old progressivist hegemonies there is simply no available worldview to hold different factions together within a single framework. After all, as a movement principally of and for Gay Men, which has disdained the messy ideological debates which would have had to accompany a significant address to gender, class, and race issues, its relationship to male patriarchal politics is ambiguous but nevertheless complicit. What is remarkable is that its model—the tactical arsenal which it largely borrowed from the militant wing of the civil rights and antiwar movements—has succeeded in remaining a fairly coherent alternative within the lesbian and gay movement and, more generally, in the wider sphere of sexual politics of which anti-abortion activism is an unwelcome adherent. The key issue is whether the presuppositions of ACT-UP's interventions will spread more widely to form oppositions in other spheres.

~John Judis purports to detect, after years of retreat and decline, a new insurgency in the labor movement at the grass roots. Although he acknowledges the advanced sclerotic state of the AFL-CIO top leadership, he adduces evidence of

some recently won strikes among miners, teamsters, and airline employees as well as new organizing efforts among Washington D.C. janitors.[16] The major strike activity may be ascribed to successful efforts to stem the employer offensive on past gains. What impresses, for example, is a Service Employees Union Project, Janitors for Justice, an organizing drive among Washington area janitors. In a departure from the traditional modern union strategy of organizing workers in a particular firm for the purpose of gaining a union contract, the SEIU, following the earlier example of the Farm Workers effort of the 1970s, has focused on recruiting janitors regardless of whether their employers are under union contract or whether the union has enough support to demand collective bargaining status.

It is too early to tell whether these sporadic instances of labor insurgency signify the possibility, let alone the imminence, of the transformation of the unions from a series of bureaucratic fiefdoms and insurance companies into a revived social movement. Such an eventuality would presuppose that at least a considerable fraction of workers, as well as rank-and-file and middle-level unionists, recognize themselves as a distinct social group, but that alliances should be built with the likes of ACT-UP, feminists and race and ethnic activists rather than the liberal establishment and the state, even though in the history of the last three decades these movements see little reason to ally with a hostile trade union establishment.

If our major thesis is right that the moment has passed for liberal hegemony, this modernist program has been, for better or worse, profoundly displaced. The conditions for modern liberal hegemony, the interventionist state led by a political directorate capable, simultaneously, of popular mobilization and influence among and over fairly large segment of corporate capital, no longer obtains. Moreover, the limits of the national state as a vehicle for the achievement of social justice are all too apparent in the an era when it has been weakened, perhaps mortally, by the emergence of a global *metastate* which increasingly demands of the national state that it shed more and more of its welfare functions.

Of course, the appearance of a postmodern politics may be ascribed to a multiplicity of developments that signify a major shift in the cultural and intellectual presuppositions of political life. Chief among these is that the category of "reason" proposed by modernity as an unimpeachable standard against which politics and culture may be measured has become a contested category. Recall, that for the enlightenment there was only one science, that of the ratio, and the determination of truth was reserved to those qualified to judge it. Although modernity never succeeded in making politics into a science, it claims the theoretical possibility that a polity of individuals may be formed which obey rules, largely procedural, that relegate the disposition of common resources to technical solutions.

The postmodern polity is defined precisely by the fact that it recognizes no universal and reductionist principle that governs resource allocations. The new

social movements must act *as if* the the government is a relatively autonomous system and that the disposition of public funds, for example, is always subject to partisan evaluation of the relative merits of specific proposals. In this *as if* understanding, neither legislatures nor courts may be relied upon to adjudicate difference since only the dead are neutral. Thus, there are no "higher" powers invested by reason to displace religion with the right to supercede the judgment of those most directly affected by a given harm. Consequently, in the postmodern turn, under conditions of imposed scarcity, there is no uncontestable way to evaluate the relative merits of providing funds for cancer research and treatment in comparison to AIDS.

Under these circumstances, ACT-UP as a practitioner of postmodern politics remains remorseless in the pursuit of its own ends and is constitutionally sceptical of the priorities set by official bodies. Since these bodies are deemed both institutionally homophobic and bureaucratically repressive, no presumption of unencumbrance may be made concerning their social policies. Needless to say, it was these assumptions that drove some in ACT-UP to examine the most hallowed of discourses, science, hallowed because notwithstanding Nietzsche's aphoristic declaration about the death of God, it was natural science which quickly assumed the mantle of the deity. Whereas, most social movements and civil organizations in the health field are constrained by their wholehearted acceptance of the algorithms of modern science and the results of research medicine, ACT-UP has asked some questions of AIDS science, including those of *verification* considered to be the heart of scientific versimilitude, and backs up its claims for changes with rule-breaking public demonstrations. No greater threat to modern claims that scientific decisions conform to the canons of reason could be posed. For ACT-UP insists upon its own passion against the presumption of dispassion explicit in scientific method.

Of course, ACT-UP's decision to build a noninstitution with only a minimum appparatus and to disdain the formation of bureaucracies to sustain its organization during periods of ebbing activity is fraught with the same weaknesses that have befallen previous movements. The anti-institutional bias of SDS, the Student Non-Violent Coordinating Committee, the radical wing of the civil rights movement, and the groups of early radical feminism such as Redstockings and New York Radical Women steadfastly resisted insistent demands *from within* that they stabilize their organizations, join coalitions, and form electoral parties. In the face of the almost inevitable tendency of activists to burn out, form factions, and undergo splits, these movements disappeared; what remained of the broader movements were the mainstream organizations: NOW, NAACP, and the National Student Association.

The wager of postmodern social movements is that they can maintain their strength by hewing to the thin line between oppositional independence to and troubled participation in the institutions of state policy, if not the legislative and

executive branches of government. More to the point, ACT-UP is a movement without utopias, bereft of illusions, and in consequence has eschewed ideological flags, thus abandoning the core religiosity that has sustained the historical opposition. This wager is crucial for any possible postmodern politics. Will the pattern of which the integration of GMHC is only the most recent example in a long line of modernist victories prevail? Or is informed scepticism enough to sustain the passion for caring which has propelled the AIDS movement?

5~

Toward a Politics of Alternatives

Part One

~A Revolution Betrayed

Even before the collapse of communism, the term "utopia"—once the horizon of Hope, the end of the long journey, and the content of emancipation—had become associated with tyranny. Although not at all the same or even similar economic or political systems, fascist and communist regimes shared an important commonality: armed with a totalistic ideology, they aimed at nothing less than a revolution in every aspect of social life as much as they sought to utterly transform the meaning of politics and the polity. And, a distinguishing characteristic of the Bolshevik revolution was the intention of many of its leaders to obliterate, by force if necessary, the private sphere which, according to the dictatorships, was a potential if not an actual site of resistance to their rule. Hence, the "cultural revolution" that accompanied the political and economic upheaval in Russia, while not an artifice of the new state power, gradually became an aspect of its will to total domination. In the 1920s, the cultural revolution signified a new beginning; by the 1930s, it became an excuse for the surveillance and selective jailing and execution of intellectuals and political dissenters.

The early Bolshevik regime was as dedicated to supporting innovation in the arts and in the sphere of private life as it was politically rigid. The description of Bolshevism as a great experiment was by no means entirely hyperbolic. The Soviets passed laws granting women sexual freedom, including the right to divorce. Prominent Communists like Anatoli Lunacharsky, Mikhail Kalinin, and Vladimir Lenin wrote about the need to reform education, an effort which, together with the vast expansion of health facilities, enjoyed a high state priority.[1] Contrary to later repressive practices which established a party line in aesthetics, the arts were as diverse as they were generally well-funded.

To be sure, the first decade of Soviet power was by no means lacking in elements of repression that later became characteristic of the Stalin regime. But it was, among other things, a veritable cornucopia of literature, music, theatre, and

the visual arts, most famously the emergence of a first-class film industry. The state supported, even privileged science but, more importantly, the 1920s was a decade of enormous creativity. Physics, biology, and chemistry took precedence for reasons having to do with the imperative of finding ways to a nondependent industrial development in a period when the Western powers had imposed a virtual blockade on the country. But the Soviets were also among the world's leaders in cosmology, psychology, and linguistics, whose practical applications were far less clear. During the early years, state surveillance, control, and ideological restraint was only sparingly exercised.

In the wake of the identification of the whole of Soviet history with Stalinism, this remarkable episode was erased from memory, both of the Soviet people and of the West. We have only recently become aware of the breadth of the cultural revolution which, in comparison to the Chinese, was relatively non-repressive. Surely, even before Stalin's final triumph in 1930, the poet Vladimir Mayakovsky and the composer Dmitri Shostakovitch were criticized by the party and some less famous intellectuals were deprived of their livelihoods. But, there was no public display of scorn against intellectuals as a class.

Lenin and Trotsky were ambivalent about the cultural revolution on a number of grounds. Trotsky polemicized against contemporary avant garde cultural movements, especially the proletarian cultural movement (prolecult) which, in his view, was antithetical to the great socialist task of raising the general level of culture.[2] For Trotsky, the masses still had to assimilate the best of "high culture," much less attempt to understand an ill-begotten effort to create what Marxist theory deemed impossible: an artificial proletarian culture within an inevitably short-lived transitional society. While favoring sexual and artistic freedom *in principle* Lenin was concerned that, by the early 1920s, cultural freedom had careened out of control. He was especially critical of constructivism and other avant garde art movements but made no effort to suppress them. On the other hand, free sexuality, according to Lenin, was producing some unintended burdens on the state—most visibly a fair number of parentless children.

After the defeats of the post-World War One German and Hungarian revolutions and the failure of the workers in the advanced capitalist world to make their own revolutions, Lenin argued that, to defend its own revolution, the Soviet Union would, necessarily, require a prolonged period of controlled capitalist development. The slogan "enrich yourselves" was an invitation to private capital, at home and abroad, to participate in the further modernization of the Soviet economy. To which Nicolai Bukharin added that the regime should not hasten to collectivize agriculture; for the foreseeable future, agricultural production should rest, primarily, in the hands of small holders.[3] But after Lenin's death in 1924 this "new economic policy" gave way to Stalin's program of relentless statification of virtually all economic activity, including forced collectivisation and, eventually, the establishment of state farms. In any case, by the early 1930s, the

period of experimentation in art, economics and social life was definitively over.

Stalin and his minions never tired of denying that the goal of the revolution was socialism, for this term signified merely the transfer of ownership and control of the means of production from private hands to the state. In their penchant for theories of historical *stages*, Soviet ideologists announced socialism as the first stage in the long march towards the second stage of the revolution, communism. Communism in the Marxist/Leninist lexicon has several characteristics: production for use and need replaces production for profit or accumulation; since the productive forces of society have become fully developed and scarcity has, finally, been overcome, the state withers away because its repressive function under socialism is directly linked to the still underdeveloped technical means to assure abundance; and perhaps most controversially, *all* relations, in personal life and culture as well as in society—would be radically transformed and subject to new norms. In the 1930s, Soviet ideologists proclaimed the "new man" as the cultural mission of the regime. The new man was exemplified by the figure of a coal miner named Stakhanov: in contrast to the traditional worker for whom labor was to be avoided at all costs, he was productive and loyal and was heralded as the norm against which workers would be measured.

After World War Two Stalin had a penchant for declaring that the Soviets had already reached some these long-range goals. Like his successor Khruschev, he anticipated catching up with and overtaking Western capitalism in less than a generation. Unlike Khruschev, who was committed to some openness in the public sphere, Stalin's vision was, indeed, a perversion of the hegelian totality. For the sake of total control, the state apparatuses of politics, which was conflated with *policing*, and culture certainly blurred the line between private and public so that everyday life was, itself, politicized.

For many of its subjects the most egregious aspect of the regime was not its thwarting of private economic initiative, although in the countryside the policy of forced collectivization and then state farms proved to be nothing short of a disaster. Soviet citizens could tolerate, even support state ownership of the decisive means of production; what they could not tolerate was the state's drive to politicize every itch and scratch of everyday existence. After the revelations of Stalin's crimes, among the more popular reforms of the Khruschev and Brezhnev regimes was to loosen, to some extent, the relentless chains of totalitarian rule.[4]

In the Stalin era, Western intellectuals were horrified to witness the spectacle of the Soviet state's intervention into scientific, literary, and religious affairs as well as evidence that dissenters were subject to exile, imprisonment, or worse. The Lysenko controversy, over this scientist's attempt to reassert the old Lamarckian theory of the inheritance of acquired characteristics, which established a state-sponsored biological science, also ruined the careers of hundreds of geneticists who questioned, let alone challenged, either Lysenko's theoretical premises or the validity of the results of his empirical investigations;

the official censures of prominent Soviet composers, especially of Shostakovich, Khatchaturian, and Prokofiev; the internal exile of writers, artists and scientists who refused to admit their errors, notably Pasternak and Sakharov; and the disappearance of many less famous intellectuals such as Isaac Babel and the Marxist scholar I.I. Rubin in Soviet labor camps, led many in the West to insist on a sharp separation of socialism, indeed, social reform itself from the taint of communism.

After the Moscow trials, many intellectuals saw communism as a form of tyranny, because it envisioned total control by the party and the state of virtually all human affairs, leaving little or no room for difference and its most reliable site, privacy. Indeed, at times in the three quarters of a century of Soviet history, the state regulated—with varying degrees of success—sexuality, marriage, the intellect, work, as well as culture. After 1930, no political debate was permitted, except behind closed doors among the highest levels of party and state elites. There were one-sided culture wars, Stalin himself intervened in linguistics, and Andrei Zhdanov's opinions on art became cultural law.[5]

Some scientific debates were permitted, particularly in physics, whose applications to technology were deemed essential to Soviet military and economic development. These were relatively unregulated because the bureaucracy recognized that the close relation of scientific to technical knowledge required some latitude for its bearers even on issues that bore on Marxist philosophy. At the risk of debilitating defections, a society that wished to advance the development of the productive forces had to grant some freedoms to scientists, but this was a practical, not a principled decision.

~THE LIMITS OF LIBERATION

In contrast to Marx and Engels's appropriation of utopian ideas, especially the dream of the "full development of the individual" in a putative post-scarcity communism, turn-of-the-century German and Austrian social-democrats developed a more restricted idea of revolutionary aims. The attainment of individual liberty and collective workers' rights, the separation of the franchise from property qualifications, and the sovereignty of representative parliamentary institutions had been a principal goal of the movement's reform struggles between 1870 and the turn of the twentieth century. During these battles, many socialists became deeply committed to liberal democratic conceptions of politics and staunchly defended a position of public neutrality with respect to culture, except science which, like the parliamentary state, was regarded as a *universal* good.

Far from the "vision of the whole man" proposed by Marx, socialism was conceived by many of the leading theoreticians of the German and Austrian Social Democratic parties in terms of the Kantian antinomies: it satisfied the demand that the irrationality of capitalist relations of *production*, in the narrow meaning of the phrase, be replaced by a new *economic* system which would be

fully consistent with the institutions of individual freedom and parliamentary democracy. As the notion of revolution became, in the interwar period, more firmly connected with communist ideology, socialists increasingly favored a "mixed" economy in which forms of public, if not social ownership of highly concentrated basic industries—steel, machine tools, and mining—and transportation and communications, would coexist with private property in small enterprises such as agriculture, artisanal production, and services. Indeed, this conception came to prevail in many post-World War Two labor, socialist and even conservative governments. The giant French car maker Renault, the Italian oil refining industry, and British mining were government owned and virtually no public utilities, rail and bus transportation, or radio and television communications were privately held. Combined with the vast postwar expansion of the European welfare state, it might be argued that from a modern socialist perspective, Eduard Bernstein's vision of socialism by incremental change had been largely realized, at least for western Europe.

From the turn of the century, the socialists of the Second International adopted a position of official agnosticism concerning issues of art, insisted upon the sanctity of the private sphere, and, despite August Bebel's Engelsian feminist critique of the family and bourgeois morality, accepted the family as a naturalized institution.

Until the 1950s, most socialist parties declared Marxism the science of history, capable, like any natural science, of predicting social processes. Individual Marxists like the Russian George Plekhanov, the German Karl Kautsky, and the Austrian Max Adler might express differing ideas concerning literature and art, psychology and philosophy just as had Marx and Engels themselves, but these questions could never become issues subject to *political* debate within the party. All questions of science and culture, including Marxism, had purely intellectual or scientific interest; politics was considered in its purely legal-juridical meaning and was consigned to a logically different sphere.

These precepts mark post-Marx socialism as a specifically *modernist* ideology since it accepts the separation of the private and the public (in contemporary parlance, the personal from the political), especially in terms of the raging issues, then and now, of church and state and culture and politics. That many turn-of-the-century European Marxists, like Adler, Rudolph Hilferding and Karl Renner were influenced by neo-Kantian thought may be ascribed, in addition to specifically intellectual influences, to the particular circumstances of the struggle for and achievement of *legality* of the socialist and workers movements in these countries. In the absence of a liberal bourgeoisie which, in Western Europe had led the fight against the old regime, socialist movements were obliged to participate in, and even lead the struggle against the absolutism of the semi-feudal monarchies of Central Europe.

The liberalization of the Prussian and Imperial Austrian states in the late

nineteenth century, made space for the gradual spread of socialist and labor influence in the enterprises, in the public sphere and within the parliaments. The left wing of the parties—preeminently Rosa Luxemburg and the Austrian Otto Bauer—maintained that fundamental social transformation would, inevitably, require mass revolutionary action because the bourgeoisie would never concede power without a fight. But a considerable fraction of the parties, including many leading theoreticians such as Adler and Hilferding, foresaw that the cumulative effects of social reform within the new framework of *organized* capitalism might render the traditional vision of mass uprising obsolete. Revolution as an image of social change gradually receded into the background of the day-to-day fight. By World War One, much of socialist ideology posited a gradualist as well as a limited vision of the new society.

In the 1920s, it was the Communists who, under Lenin's influence, retrieved the old "dream of the whole man" associated with the utopian socialists and the earlier works of Marx and Engels. In Berlin, the cultural capital of the new communist movements in the west, debates on art, science and philosophy were conjoined with political debates. The abject failures of Social-Democratic-led governments in Germany, Austria, and Britain to effectively stem the hyperinflation and mass unemployment of the 1920s and 1930s and the simultaneous rise of fascism in Germany and Italy and fascist movements throughout Europe and America, persuaded many radicals that unless capitalism was overturned, root and branch—its system of government and its commodified culture as much as its class system—no revolution could survive. Like the right-wing political theorist Carl Schmitt, many Communists held its institutions in contempt, as the stalemate of liberal democracy appeared immutable as the 1920s wore on. The example of the October revolution seemed to verify the metaphor that all birth is ineluctably linked to pain and violence was regarded as the midwife of history.[6]

The Communists of the late 1920s, as much as the arch-conservatives and fascists, propagated the doctrine that bourgeois society from top to bottom was irretrievably corrupt. What cultural intellectuals found attractive in the Bolshevik Revolution was the regime's apparent political will to act boldly against every manifestation of capitalism and bourgeois culture. However brutal the methods of destruction under Stalin, many Bolsheviks seemed determined to create a genuinely new society in which every aspect of life would be subject to the criterion of political correctness.

The French surrealists including André Breton and Louis Aragon; expressionist writers Bertolt Brecht and Alfred Döblin and artists Kathe Kollwitz and Georg Grosz; and many American writers and artists saw in communism a way to break the grip of conventional aesthetics which, in their view, reproduced bourgeois domination and constrained freedom. For them, politics was cultural politics as much as anything else. Having abandoned the rhetoric as much as

the strategy of human emancipation, the socialists seemed to be operating *within* the limitations of a liberal state and were rendered by their commitment to its rules powerless to reverse the economic and spiritual catastrophe of the postwar era. The Communists were not only leading mass protests against unemployment and hunger but were, according to these artists, forging a new sensibility in which the brutality of capitalist culture was fully confronted. The alternatives were not restricted to demands for social justice, but for an end to the historical *alienation* of the public and private, art and politics, science and society, knowledge and social transformation.

These optimistic judgments were, for many, cruelly sundered by the coming to power of fascism and the Moscow trials of the late 1930s. The calumnies of the Soviet and, later, the Chinese communist system no less than the fascist terror have been, with little discrimination, identified in the Western mind with *totalitarianism*. For the newly formed anticommunist left, parliamentary democracy became the best possible framework for social change. Political liberties were now conflated with the idea of freedom itself.

In contradistinction to the ambitions of the communist vision of emancipation, liberalism, of which the socialists were an important component, declared even more emphatically than before its own limits and the limits of social change.[7] Indeed, following the European catastrophe the more restricted idea of freedom proposed by liberal and socialist theorists in the late nineteenth and early twentieth centuries became extremely influential in the late 1930s and 1940s. Now "progress" was coded in terms of the welfare state plus civil liberties, especially the "right" to dissent, and organize unions and political associations without state interference.

After the war, some noncommunist leftists entered a short period of "third camp" militancy: their slogan was "neither Soviet Communism nor liberal capitalism" but revolutionary democratic socialism. For a time they attempted to create an international movement, primarily among intellectuals, that would elaborate the leading precepts toward an independent left.[8] But with the definitive division of the world into two camps led by the superpowers, combined with Jean-Paul Sartre's turn toward the communists, hopes for a *mass* independent left seemed indefinitely postponed. Most of the independent left felt constrained to "choose the West" as the shooting war was replaced by a prolonged war of containment in which the Soviet Union was portrayed as compulsively expansionist and the West reliably, if not consistently, committed to a limited version of freedom.[9] Under the odd slogan "better dead than red," the American left intellectuals grouped around the magazine *Partisan Review*—and many Europeans such as the writers Stephen Spender, Ignazio Silone, former Sartre associate Raymond Aron, Nicola Chiaramonte, and Arthur Koestler—battened down the hatches and prepared for the worst. For Dwight Macdonald and Irving Howe no less than the more shrill voices of Sidney Hook and Arthur

Schlesinger Jr., the choices boiled down to the freedom associated with the liberal democratic state or tyranny.

In the wake of the apparently undeniable fact that fascism and Communism ruled by terror but also on the basis of the tyranny of majorities, a state of affairs condemned by classic liberal thinkers such as Benjamin Constant, Alexis de Toqueville, and John Stuart Mill, it was not a long step from the view that to achieve the "good life" required adopting the minimalist position that, since the good had no *objectivity*, especially since the betrayals of the 1930s, the main task of the left was to secure individual liberty and collective "rights."

Individual liberty is, according to Isaiah Berlin, constituted by establishing stringent boundaries beyond which public authority cannot step. This assures the noninterference of the state in the right of individuals to peacefully join together to redress grievances and promote their interests without suffering the injunctions of law or custom.

Some former revolutionary Marxists like Irving Howe might still identify with the interests of the workers and those victimized by racial and other oppressions and allow that a socialist reorganization of the economy would be a more rational means of achieving rough distributive justice. But for the postwar generation of democratic socialists, the concept of a "science" of history or even the idea that "theory" could be a guide to action evoked too many images of the nefarious practices of regimes in which Marxist "science" enjoyed the status of official doctrine. Socialism was elevated (relegated) to an ethical ideal or, in its more political formulation, the indeterminate result of a series of incremental reforms which would, at the same time, result in new power over state institutions for workers organizations. In effect, democratic socialism abandoned the older concept of the state as a series of *class* dominated institutions and accepted the liberal idea of its essential neutrality.

When confronted with the tyranny of "really existing" communism and the national liberation movements it supported, democratic socialists were constrained to support the the limited goals of modern liberalism. Renouncing the search for political "truth," most erstwhile radicals contented themselves with a politics that sought the achievement of "more" equality and a greater measure of economic justice for the minorities excluded from postwar prosperity. Justice entailed preserving the gains of the welfare state, which, albeit imperfect, remained a relatively adequate mechanism for securing social justice for the individual and for enacting laws that protected individual freedom and associational rights; such gains could also enlarge the participation by excluded groups through electoral reform.

Democratic socialism holds to a sharply attenuated conception of positive freedom. But Berlin, always sensitive to critics, defends negative freedom as the crucial marker of liberty:

> It may be that the ideal of freedom to choose ends without claiming eternal valid-
> ity for them, and the pluralism of values connected with this, is only the last fruit
> of our declining capitalist civilization; an ideal which remote ages and primitive
> societies have not recognized and one which posterity will regard with curiousi-
> ty, even sympathy, but little comprehension. This may be so but no sceptical con-
> clusions seem to me to follow. Principles are no less sacred because their duration
> cannot be guaranteed.[10]

The implied interlocutor of this still influential restatement of modern lib-
eralism is the revolutionary New Left which, as we have seen, had criticized
rights-based discourse as an inadequate response to the blatant economic
inequalities of late capitalism and embraced the politics of liberation as the suf-
ficient condition of freedom. Writing in the 1960s, at the zenith of the New
Left's rediscovery of cultural radicalism and emancipatory Marxism, Berlin is at
pains to acknowledge the argument that severe economic deprivation, more than
Hobbes's concern with the vagaries of the cutthroat market, vitiates the ideal of
freedom. Moreover, Berlin grants that those who enjoy liberty, owing to their
relatively secure economic position, may have purchased it at the expense of
others for whom freedom remained a distant shore as long as they were con-
demned to devote nearly all of their energy to the struggle for existence. Still, he
vigorously argues that liberty is not a zero-sum game: even if, as the politics of
guilt was prone to urge, the haves give up their privileges in order to provide
the preconditions for others to enjoy freedoms that acquire meaning only after
the basic requirements of material comfort are broadly disseminated, there is
no necessary logic in this formula. Berlin claims, correctly I think, the haves
may surrender their freedom, the have-nots may or may not get what they need,
but freedom would be thereby diminished for all.

In the end, Berlin rejects what he represents as a Hegelian concept, that there
is a distinction between the autonomous self that has achieved a higher degree of
self-reflection and a lower self governed by the passions and prone to exploit
others for its own ends. On this account, public authority is sanctioned to
restrain the part of the self that interferes with others and, more to the point,
thwarts its own journey toward self-consciousness. The state as an instrument
for achieving positive freedom by fostering self-mastery or reason is, for Berlin,
only a thinly disguised version of tyranny.

Which helps explain why modern, rights-based liberalism has only an artic-
ulated conception of justice, but no ideal of the "good life." Given what Sartre
termed the "practico-inert" or the legacy of the ignominious past, liberal polit-
ical theory recoils at the idea that we can have a common "good" based on an
agreement on what constitutes the truth.[11] The *best* we can hope for is that the
state's interventions will be held to a limit so that liberty may, in a pluralistic
social universe, be preserved. Thus, only *negative* liberty is a reliable index of a
civilized society.

But while the binarial formulation of tyranny and freedom, most influentially elaborated by Hannah Arendt, agrees that, under prevailing conditions, "limited government" to safeguard the freedom of individuals for self-development and self-expression is more desireable than any form of absolutism, it does not entail an endorsement of the institutions of political modernity, especially the Kantian view that "rights" was the farthest horizon of freedom. On the contrary, Arendt argues for a conception of democracy in which consent, which in most liberal democracies has become *both* the maximum as well as minimum condition of sovereignty, is replaced by participation as its most reliable measure. In the political realm, she is quite sceptical of the liberal state. For her, *representation* by parties and bureaucracies can never substitute for the direct participation by individuals in processes of (self) governance.[12]

Arendt's remarkable essay on the revolutionary tradition, which gives pride of place to the soviets (workers councils) as spaces of freedom in the immediate postrevolutionary period *before* the Bolshevik seizure of power, endorses Rosa Luxemburg's vision, forged in the wake of the 1905 Russian revolution, of the soviets as institutions of *permanent* power, and rejects the instrumentalist conceptions of these councils developed by writers as diverse as Lenin, Trotsky, and Adler.[13] For Bolshevik and social-democratic leaders alike, councils run by workers and not by the parties were, at most, a transitional form of governmentality not suitable "under modern conditions" to be permanent institutions. While praising Lenin's slogan "All Power to the Soviets" Arendt also points out that the Bolshevik *Party* which he headed organized itself under the slogan of "seize state power," a slogan which heralded not a broadly based popular sovereignty but a prolonged period of rule, during the transition from capitalism to communism, by the party.

Just as in 1905, without the initiative of the parties who were struggling for a voice within the Tzarist duma, the workers councils sprung up all over Russia in 1917 and, in Lenin's words, constituted themselves as forms of "dual-power" to that of the liberal state whose legislature was composed of representatives chosen from among party lists. The central conflict between the Kerensky government and the soviets was over which institution was authorized to make laws. Before their cooptation and reduction to hollow organs by the Bolsheviks the councils were really associations of workers, soldiers, and peasants who came together to pursue the revolutionary aim of exercising power over their own affairs. Thus, the idea of self-management obliged them to assume the authority required to make laws that could bind them together in a more or less stable relationship. The parties—Menshevik, Social-Revolutionary, Cadet, Bolshevik—were struggling within the Soviets for relevance, let alone hegemony, and often failed to achieve it.

It was perhaps for this very reason that, after the Bolsheviks toppled the Kerensky government, the question was once again raised of "who has the

authority to govern, the newly installed party dictatorship or the soviets?" The answer came in a series of events beginning in 1918, when, faced with starvation and economic collapse, the Bolsheviks rescinded soviet power, initially under the sign of "war" communism, presumably a temporary emergency measure. But, this decision proved permanent. It was reaffirmed in 1921 when a group of revolutionary sailors at Kronstadt demanded that the power and authority of the soviets be restored. The reply came swiftly: War Commissar Trotsky assigned a military battalion to crush the rebellion that followed Bolshevik refusal. While the term "Soviet" was retained by the new regime, the actual soviets became legislative rubber stamps for the party's policies at the local and national levels.

Arendt notes a fundamental difference between the American and European revolutions. On her interpretation, the American Revolution *followed* the formation of popular associations such as clubs and societies. The revolution was fought over the right of the people to self-government, not merely for the right to consent to the rule of others. In contrast, the French and European revolutions corresponded, at least until the Paris Commune, to party/mass divisions characteristic of liberal democratic states in our own time. She ascribes the deformation, even degeneration of nearly all European revolutions to the absolutism of the *ancien regimes* as opposed to the American colonials' enjoyment of self-governance in many respects. According to Arendt, the American Revolution occurred to complete a process already underway for some two hundred years. Its crowning achievement, its most noble moment, was the writing of the constitution marking its intention to establish the "foundation of freedom": a *limited* government to replace the absolutism of the already secularized crown.

Arendt's reflections on current American attitudes toward revolution are instructive to the future of freedom. Having made, arguably, the most successful revolution in human history, America has become perhaps the most hostile Western power to revolution.

> In recent times, when revolution has become one of the most common occurrences in the political life of nearly all countries and continents, the failure to incorporate the American revolution into the revolutionary tradition has boomeranged upon the foreign policy of the United States, which begins to pay an exorbitant price for world-wide ignorance and for native oblivion. The point is unpleasantly driven home when even revolutions on the American continent speak and act as though they knew by heart the texts of the revolutions in France, in Russia, and in China but had never heard of such a thing as an American Revolution. Less specular perhaps, but certainly no less real, are the consequences of the American counterpart to the world's ignorance, her own failure to remember that a revolution gave birth to the United States and that the Republic was brought into existence by no ["historical necessity"] and no organic development but by a deliberate act: the foundation of freedom.... Fear of revolution has been the hidden leitmo-

tif of postwar American foreign policy in the desparate attempts at the stabilization of the status quo, with the result that American power and prestige were used and misused to support obsolete and corrupt political regimes that long since had become objects of hatred and contempt among its citizens.[14]

More than thirty years later and despite considerable historical and bio-graphical scholarship to reveal the hidden history of radicalism we remain vic-tims of the wall of resistance and the pervasive *public* silence on radical and rev-olutionary ideas, including those that originated in our own history. This silence extends from the ideas of the founders to the words and deeds of the abolition-ists, the great labor agitators and organizers such as Debs and Haywood, the tribunes of black freedom—Frederick Douglass, Martin Delany, W. E. B. Du Bois and the virtually unknown radical statements of Martin Luther King—and feminists such as Susan B. Anthony, Margaret Sanger, and many others.

Arendt's discourse is regrettably double-voiced: in the rhetoric of Cold War freedom, she speaks from the point of view of the American state when address-ing its global interests and against the *really existing* American state. When speaking, normatively, of freedom, her account of the conditions for genuine self-management of society—the creation of face-to-face institutions of peers to which delegates are directly accountable to a living association—corresponds to the defeated radical traditions which, in every country, oppose themselves to party/state systems of the liberal variety no less than the totalitarian one.

Mindful of the egregious fascist and communist regimes of the twentieth century, but also of the tyrannies of what is taken in electoral terms as the "majority" which are all too evident in our own time, Arendt's political philos-ophy is committed to the concept of *limited* government. Against utilitarian ideologies which proclaim the role of government to assure the greatest good for the greatest number or communitarianism for which freedom presupposes the social and historical context of the beliefs and values of the community (which, admit some communitarian theorists, might justify limiting some indi-vidual freedoms), for Arendt, government is constituted, in the first place, to assure negative freedom—the ability of individuals and groups to act in dissent from or opposition to limits imposed by the "community" on liberty. Then, against the liberal democratic doctrine of rights and responsibilities, the coun-cilist tradition insists that representatives must be directly accountable to a base of individuals who have delegated their power to others *on condition that they can be recalled at any time* if they fail to express the views of their constituents. This conception of the polity implies that "society" is not understood as an aggregation of individuals, but a complex of relatively small groups which engage in face-to-face decision-making on the basis of full discussion and debate about issues that are of mutual concern. Participation becomes an ethical good, and its absence a sign of undemocratic process.

Those who have disparaged this model of participatory democracy in favor of the more limited politics of consent have, in addition to the antimajoritarian cry of tyranny, frequently invoked the category of "complexity" to argue that liberal democratic institutions—in which politics has become a profession and relatively large government bureaucracies are run by professional managers—are the necessary price of efficiency. Defenders of the status quo acknowledge that the system may, with its minimalist concept of participation as a "right," thereby encourage the exercise of arbitrary power and tolerate, or collaborate with, the inordinate influence of powerful "interests" such as large corporations. Despite these abuses, they insist that a rights-based relatively uncoercive liberal democracy remains the best of all *possible* worlds. This "realist" perspective on governance presupposes the permanence of the complex but interdependent global economy, large metropolitan regions, and a privatized, mainly indifferent citizenry, except on issues deemed of personal or community interest.

Michael Sandel has argued that modern liberalism triumphed in its claim to have shown the superiority of a political "framework neutral among ends" and the substitution of a "rights-based" ethic over the utilitarian idea that the end of the good or secure life for the majority justifies restricting the rights of minorities who may disagree. But, according to Sandel, in their repudiation of a substantive idea of freedom, Mill's successors have merely substituted one set of values for another.[15]

Perhaps more saliently, rights-based liberalism assumed the "unencumbered" rather than the "situated" self. Alisdair MacIntyre, Selya Benhabib, and Charles Taylor have in different ways insisted that the "good life" is the appropriate criterion for ethical behavior, but individuals are hardly able to achieve it on their own.[16] The self, says MacInytre, is *situated* in its own narrative history. Drawing, but only implicitly, from Marx's formula "the individual is nothing but an ensemble of social relations," MacIntyre restricts the idea of situatedness to the entanglements of everyday life—family, friendships, neighbors, community; the "ensemble" encompasses something less than what Marx signified:

> A central thesis then begins to emerge: man is in his actions and practice as well as in his fictions, essentially a story-telling animal. He is not essentially, but becomes through his history, a teller of stories that aspire to truth. But the key question for men is not about their own authorship: I can only answer the question "What am I to do?" if I can answer the prior question "Of what story or stories do I find myself a part?"[19]

MacIntyre's "narrative concept of selfhood" is twofold: I am the subject of my own narrative which always entails a telos, an end which retrospectively explains to myself and others the story itself; but, while I am responsible for giving an *intelligible* account of my own story and its telos, "I am not only accountable, I am one who can ask others for an account." The essence of the

self is its situatedness which, ethically, implies mutual obligations; it presupposes that the self is constituted by its relationships as well as a relatively autonomous personal identity. Thus, for contemporary communitarian critics of liberalism, there is no appeal in political ethics to a pristine individual.

Taylor's critique of the conception of the individual as "solitary wanderer" is indebted, like MacIntyre's, to Marxist-oriented critiques of seventeenth- and eighteenth-century bourgeois culture: Ian Watt's cultural history and the political theory of possessive individualism explicated and deconstructed by C. B. MacPherson. Individualism, replete with its myth of man's origin, is a construct of early English bourgeois society. Taylor traces rights-based ethics to the idea that, reduced to a "state of nature," man (in Rousseau's opening lines to *The Social Contract*) was born free and unencumbered except, perhaps, by the slavery of nature.[18] Commercial civilization, in later commentaries, ties man to the market and fetters his freedom. On this account the object of ethical philosophy is to set forth the conditions of freedom for this naturally autonomous individual identity. The organization of social life on the basis of social contract theory owes its telos to the mistaken notion of the individual as solitary wanderer. Taylor and others point out that the individual who enters the wider world is *always already* encumbered by (his) history and his networks of obligations.

While acknowledging the power of deconstructive critiques of the morality of communal ends, particularly those of Nietzsche and Foucault, and those of feminists who demonstrate that morality often excludes women as subjects, Taylor opposes the prevailing secular, rights-based ethic as a tacit retreat from the quest for the telos of the Good Life. Like MacIntyre, he parts ways with Marxism because of what he views as its romantic view of "expressivism" derived from Rousseau and late-eighteenth-century philosophy's designation of nature as a source of truth, which leads to Marxism's ultimate appeal to history's dialectical spiral as a substitute for ethics. Taylor is constrained to reject the radical participatory democratic solution to growing alienation on the familiar ground of technical complexity and the substantive ground that in a society marked by increasing homogeneity of instrumental means and ends, participation may lead to more authoritarianism than in the current rights-based regime of governance.

Yet, however powerful their refutation of the limits of negative freedom and the uncertainties of a positive conception of freedom grounded in *mass* participation, neither Taylor nor MacIntyre go much further than an inconclusive appeal to community against individualism, mutuality of obligation, and a collective search for meaning and the Good in a society marked by the triumph of instrumental and formal rationalities. In both of their philosophies—which parallel Horkheimer and Adorno's dark ruminations about the Enlightenment's unintended consequences—the mood is one that seeks to constrain human action by asserting its imbeddedness in human communities rather than to nature.[19] Like Robert Bellah's and Christopher Lasch's more sociological wor-

ries about self-love and rampant individualism in modern culture, the new ethical philosophy would substitute for happiness and its concomitant, pleasure, a regime of moral austerity in which the subversive influences of consumerism and individualism—read the body—would be purged from the polity.[20]

In the wake of the rise of a new generation of cultural radicalism in the 1960s, a significant fraction of American left intellectuals, formed by a subtle mixture of neo-Marxist critical theory and bourgeois high culture, discovered their own ethical conservatism. The cultural left could readily dismiss the criticisms of others, notably Daniel Bell, Saul Bellow, and Irving Kristol, who had long since abandoned the socialist politics of their youth in favor of a forthright turn towards neoconservatism. Their repudiation of cultural radicalism preceded the more or less collective decision of the Cold War intellectual generation to "choose the West" in the 1950s in the wake of their belief that communist expansionism threatened freedom, and was reinforced by their revulsion at the ubiquity of the 1960s New Left and countercultures (although some like Bell still believed in some version of social-democratic economic arrangements.) The neoconservative attack on the New Left was as predictable as it was vituperative and was easily dismissed by most radicals. More disturbing has been the substantial trend among left intellectuals toward a parallel critique. For one of the consequences of the reemergence of cultural radicalism has been to focus on the degree to which the ethical foundation of the traditional left is an amendment to bourgeois morality to extend liberal democracy to the economic sphere rather than a *cultural* break with the past.

We have learned in the past two decades that for much of the ideological left, capitalism and cultural radicalism are both evils, and the relative weight of the threat they pose to human progress is a question that may be answered only in context. I want to briefly examine some of the critical work of one of the most articulate writers in this recent left cultural conservatism, Christopher Lasch. Not only is he a representative figure in this movement, but his work has eloquently articulated the repudiation of some characteristic cultural movements of the 1960s by left as well as liberal opinion.

In 1978, on the eve of the American economic debacle, Lasch published his gloomy analysis of our country and our culture. Built on Freud's investigation of individual pathologies of self-absorption, *The Culture of Narcissism* became, in Lasch's argument, a description of our times. Individualism had caused us to lose our sense of "historical continuity." According to Lasch "to live for the moment is the prevailing passion—to live for yourself, not for your predecessors or posterity."[21] Lasch's essay is a peculiar combination of ideas derived from the critical theory of the Frankfurt School (especially its condemnation of consumer society, which accompanies narcissism because its aim is to satisfy individual wants, which are perceived by the consumer as needs); and the old conservative lament about the decline and fall of authority, especially in the family.

Lasch's targets are not narrow: in his search for causes of our collective sense of "diminishing expectations" he reexamines permissiveness in child rearing and faults the entire anti-authoritarian tradition emanating from both psychotherapy and "progressive" pediatrics, especially the pervasive influence of Dr. Benjamin Spock whose advice literally dominated middle-class parenting after the Second World War. Citing psychological studies, Lasch condemns the tendency of recent therapies to encourage parental rights to the detriment of the child. Parental responsibility is further eroded by the rise of professionalism in child rearing in which expertise replaces tender, loving care. Like the older Phillip Rieff, Lasch simultaneously condemns America as a "therapeutic" society and lavishly employs psychoanalytic insights to buttress his arguments.[22]

Having discovered that our most urgent cultural problems stem from a collective incapacity to transcend self-interest and its twin value, personal autonomy, both of which, after all, are built into the fibres of American capitalism, Lasch can only issue a plaintive plea for a rebirth of moral discipline without which a new order cannot be built. Having offered a systemic critique of the normlessness of our culture, Lasch's prescription reduces to urging a collective act of will whose core constituency is the American middle-class mother. Until recently she has, however, failed to fulfill her historic function by indulging in the sin of self-awareness (read feminism).

Of course, *The Culture of Narcissism* cites the effect of the perennial absent father as a partner in the crimes of omission as well as commission against the helpless child. The father fails to enter the child's emotional life and thereby causes the child to be absorbed and dependent upon gaining his (absent) authority. But he is not, on Lasch's account, the primary culprit. It is the mother's "shallow, unpredictable" and ultimately inappropriate responses to her child's needs that produces what psychoanalyst Heinz Kohut calls "borderline" narcissistic pathology.

Lasch has no quarrel with patriarchal culture, only its lack of clout. Under circumstances of the death of the family women bear the primary responsibility for the reproduction of the culture as it plays itself out in the individual. Maternal childrearing, suffocated by mixed messages, has become the crucial site of cultural identity. Women are required to provide both motherly nurturance and fatherly rule-making, tasks which are well beyond her ability to perform. At times Lasch suggests that if only we could replace bureaucratic authority with selfless parental authority our diminished culture could be renewed. This would, of course, entail rededication by men and women to traditional family values, almost all of which are inimical to the prevailing values of narcissistic culture. But, since the absent father is profoundly rooted in our industrial and commercial system, the last chance for salvation is to persuade women to cease being "narcissistic mothers," to stop the seduction of their children by promising more than they intend to deliver. Rather, women should become more

attentive to their children and forswear their irresponsible self-absorption.

Anticipating later neoconservative critics of American education, notably Allan Bloom, by almost a decade, Lasch inveighs against pitfalls which mistake permissiveness for democratic pluralism.[23] His brief history of schooling, although linked to the rise of the industrial system, finally makes a point similar to his chapter on the family: the new social movements arising from the turbulent 1960s have distorted the meaning of citizens' rights and, in the bargain, have caused a serious decline in the public and private institutions of social order. As with the family, large social and historical developments appear to be the cuprit. But, in the end, we are led to fault the democrats, the left. For in Lasch's narrative, the real error of the 1960s decade and its aftermath has been to violate the human need for limits. In post-scarcity culture, the young, the blacks, the women have transgressed elemental conditions of human sociation; in the case of schools, in their urge to impose satisfaction they have wrought "stupefaction."

Now, Lasch is too embarrassed to walk the final mile, a journey Bloom is only too glad to make. That is, Lasch portrays mindlessness as an unintended consequence of the struggle for equality rather than holding, as Bloom does, that social movements were both intellectually trivial and politically venal. Yet there are telltale characterizations that Lasch is a precursor to the contemporary neoconservative attack on educational freedom. Lasch dismisses black studies, women's studies, and other new programs as merely means "to head off political discontent" that have no intrinsic worth. To Lasch's credit, he does not shrink before the charge of elitism. Citing courses in popular culture, which by the late 1970s were already displacing, to some degree, the conventional English curriculum, he argues boldly for a version of the old learning: foreign language instruction, basic skills of reading and writing, and, more broadly the revival of the great Judeo-Christian tradition (a reform enacted in the 1980s by both elite and plebian universities with no apparent short-term effect on our culture).

Like his literary mentors, Thorstein Veblen and a substantial fraction of the generation of European refugee intellectuals who emigrated to American shores in the 1930s and 1940s under the banners of critical theory, sociology, and especially Freudian psychoanalysis, Lasch infers there is virtually nothing to be redeemed in American popular culture. From Veblen, Lasch imbibes admiration for the "instinct" of workmanship and mourns its passing, while railing against leisure, which is wasted on assorted banal pleasures from sports to television; from the Europeans he derives a mode of sociological and pyschological criticism in which, notwithstanding its democratic, libertarian professions if not its ethos, the United States betrays unmistakable features of social and cultural decline.[24] These diseases are held to be manifest in the formation of personality types which are variously labelled "neurotic," "other-directed," "narcissistic."

Consequently, we live our mundane existences in the constant search for comfort obtained through pseudo-satisfactions, the exemplar of which is the

world of commodities. To this airconditioned nightmare—the term is Henry Miller's—Lasch counterposes the undemocratic although aesthetically defensible culture of some unnamed older civilization. Like his student Russell Jacoby, whose intellectual debt to the Europeans is even deeper, Lasch can see no way out into the future. Only the past provides the rudiments of a model, one which requires, nevertheless, that we abandon the quest for cultural equality.

What is at issue here is whether American culture and its contemporary simulacrae (or perhaps, more accurately, parodies) are, indeed, increasingly degraded in comparison to the European pasts, versions of which are regularly invoked as a benchmark for our times. In fairness to Lasch neither he nor other left critics of American culture joined Saul Bellow, his friend Allan Bloom, and their neo conservative colleagues in full-throated support for the traditional Cold War aims of U.S. foreign policy nor their fettered admiration for capitalism (only two cheers can be awarded) as the best representation of freedom in an ever more dangerous world. Nor have they abandoned their general support for social justice as it is conventionally defined by social democrats and American liberals: blacks and women should enjoy equal access with white males to compete for goods and jobs. However, by ascribing much of our cultural crisis to the power of movements the aims of which are to achieve cultural transformation, Lasch leaves the door open for the final disaffection from democratic ideals. He denies to democratic struggles the right to challenge either the part played by cultural elitism in maintaining economic and social inequality or its cultural effects on the oppressed.

To be more precise, this denial takes the form of distorting the radical critique of elitism. Lasch tries to show that conservative and radical education critics share the anti-intellectual bias which argues against educational standards. "Cultural Radicals," Lasch charges "take the same position [as conservatives who hold intellectual standards to be inherently elitist] but use it to justify lower standards as a step toward the cultural emancipation of the oppressed."[25] Cultural Conservatives never entertain the part played by these standards in maintaining the structure of class inequality, the degree to which workers and the poor experience the older curriculum as an assault. Lasch and Russell Jacoby are no exceptions. Their own class unconsciousness prevents them from understanding what Paul Willis has made unmistakably clear: seen from below, schools have never fostered Lasch's "art of reasoning...clarity of expression."[26]

On the contrary. Working-class kids get working-class jobs by rebelling against school authority and a curriculum which values only the willingness of kids to disengage their critical capacities by submitting to rote learning. The fact is, critical thinking in mass education has never been tried on a grand scale and public education has nothing to do with standards which might bear on any kind of intellectual rigor. The overwhelming majority of schools do not value the "art of reasoning," which, in any case, has no consensual definition.

The historical issue is, When did these values inform the public school (or the majority of private school) curricula and pedagogy? Lasch invokes as a cultural ideal a type of schooling which has never sunk deep roots in the United States and is increasingly remote from the actual practices of European education systems.

Lasch gets closer to the problem when he places the responsibility for our current literacy crisis on the tendencies of contemporary capitalism to render both work skills and citizenship abilities redundant. Approvingly, he cites literary critic R. P. Blackmur: "The crisis of our culture rises from the false belief that our society requires only enough mind to create and tend the machines together with enough of the new illiteracy for other machines—those of our mass media—to exploit."[27] Contemporary advanced industrial societies are facing burgeoning economic redundancy (disguised in the 1980s by the rise of the service economy which was fueled by enormous consumer, military, and foreign debt), and the growth of enforced leisure as a way of life for a larger chunk of our population. Times are bad for those who have been formed in the shadow of the eighteenth- and nineteenth-century cultural ideal that an informed citizenry is the foundation for democracy and that the model of education from which this citizenry is to be derived should be borrowed from what we believe prevailed in classical Athens.

The egregious parsimony in the development of Mind in our society is not, however, logically connected to machine culture, only to the prevailing interpretation of its consequences. Nor is leisure, itself, the void filled by banality and other sins. Lasch provides a solution to these problems. Although schools are not the culprit, edcucational reforms geared to the new industrial system resulted in the loss of the classical cultural ideal. But the practices of instrumental education which orient learning to a specific conception of occupational requirements are firmly entrenched in social, economic, and cultural inequality which predate classical antiquity. For the Greek public never made room for the slaves or artisans who did the work; citizenship was a privilege reserved for the few. It is no wonder that critics of mass culture, most of whom see themselves as heir to that fallen mythic tradition of the Greek polis, have reason to excoriate the present. Mass education, mass leisure, mass production, mass consumption signify the cultural triumph of the crowd.

~Ecology as a Radical and Conservative Philosophy

With the transformation of the old conservationism from a movement of thought aimed at creating, through political action as well as education, spheres of protection for nature against the unregulated incursion of industrial civilization, into ecology, which claims to be a fully elaborated natural and social philosophy, the stakes have been raised in the political discourse about the relation of humans to nature. For ecologists, "nature" is no longer merely the "toolbox" of indus-

trial society as in prevalent liberal theory or in some versions of Marxism, let alone the communitarian "other" of man. In what Taylor calls the "romantic" tradition ecologists claim that human history is part of natural history, and human life ineluctably linked to the place of our species in a complex of ecosystems, and that the price of attempting to subsume nature under human ends has been to create a catastrophe in social relations as well as in our collective relation to nature.[28]

Social ecology ascribes this crisis to social relations marked by human domination, of which the domination of nature is an entailment. Freedom, according to one of its leading theorists, Murray Bookchin, consists in attaining harmonious, nonopressive human relations as well as utterly reversing the domination of nature by humans. Bookchin:

> The notion that man is destined to dominate nature is by no means a universal feature of human culture. If anything, this notion is almost completely alien to the outlook of so-called primitive or pre-literate communities. I cannot emphasize too strongly that the concept emerged very gradually from a broader social development: the increasing domination of human by human.[29]

Reversing the domination of nature would require a fundamental reevaluation of the history and contemporary practices of hierarchical social arrangements: the scientifically based technologies of nature-domination as well as the social relations of production; how we relate to each other in social life, relations of sexual and racial domination and so forth. In short, social ecology proposes nothing less than the reconstruction of human communities on ecological principles.

The implications of a thorough-going ecological perspective on social relations illustrates the difficulties of addressing issues of governance from the viewpoint of purely negative freedom or from the perspective of communitarianism. To the rights-based presupposition that we must accept the current political system as the basis for environmental action, radical ecologists have replied that the situation demands a more far-reaching response. But, the responses have been quite different between and among radical ecologists and the liberal environmentalists who seek reform in the ways we treat the environment without challenging the regime of social relations that generated the crisis.

Both broad wings of the movement address the historical enslaving of nature which, as Horkheimer and Adorno pointed out more than fifty years ago, was undertaken by humans to relieve themselves from remaining nature's slaves.[30] The consequent domination of nature—the effort to be freed from its thrall—was manifested in the relentless drive to create a more elaborate built environment, through rationalization of the labor process, the universalization of the commodity-form in the production of life and, by the late nineteenth century, the mobilization of science to create labor-saving and nature-polluting tech-

nologies. The unintended consequences of unihibited industrialization were such catastrophes as pollution of the air and water and the thinning of the biosphere which have contributed to the veritable epidemic of cancer and other life-threatening diseases.

United States environmentalists have conducted a twenty-five-year struggle to enact a series of laws and government regulations such as the establishment of national water and clean air standards, and an ecological standard against which to measure the private use and industrial and commercial development of public lands. Environmentalism seeks not to transform the exercise of private domination of nature but to impose limits on it. The mainstream of the movement addresses not at all the *root* of the crisis, only its symptoms. It is a preeminently Hobbesian movement because it would impose restrictions on the few who are determined to exercise the prerogatives of property to endanger the community. According to environmental liberalism, where human survival is at stake, government must act as a constraint.

Even relatively limited restrictions have evoked an outcry from industrial corporations, developers, and landowners. These groups charge that regulation thwarts their individual "freedom." Tyranny is defined as the inteference of government in what should be private decisions. Environmentalists respond that if the situation is acknowledged to have reached "crisis" proportions these limitations overrule the unfettered rights of property.

In effect, environmentalism counterposes two sacred "rights" guaranteed by the liberal state: the ability of the individual to dispose of her/his property without external constraint—except when as in the case of highways, the public good demands other uses—and the right of citizens to seek government protection against the harm inflicted by the exercise of private sovereignty. But, this is not simply a case of rights in conflict. For instance, the celebrated Endangered Species, Wildnerness, and Clean Water Acts introduced an ostensibly nonethical consideration into the dispute: the authority of science to predict the consequences of the uncontrolled exercise of private interest. Ecologists of both liberal and radical persuasion appeal to the *universal* interest by invoking the quintessential Enlightenment institution, scientific knowledge, to oppose another equally important Enlightenment idea, private freedom as expressed in private property. The "community" of lumber corporations, labor unions, and individual landowners opposes the "state" which, until recently "imposed" ecological criteria to regulate the use of land, whether privately or publicly owned. "Conservative" politicians have joined these private interests to oppose the conservation of nature against its relatively unbridled exploitation.

Note well that the right is defending a rights-based as well as a communitarian ethic to foster real estate and industrial development against a "left," which, on grounds which assert our obligation to nature, supports the preservation of these lands for noncommercial uses such a protecting endangered species and

maintaining the pristine character of some areas. In this battle, not only the conservatives, but also the ecological forces are put in a curious position. Among the most compelling historical claims of ecological thought has been that scientifically based industrial technologies and their nearly universal dissemination, as one of the supreme "achievements" of enlightenment, are largely responsible for the ecological catastrophe before us. Some go further to argue that science is today techno-science; the distinction between science and technology has all but disappeared.[31] So, the separation of "pure" from "applied" science is no longer, if it ever was, tenable. Conseqeuently, if contemporary science is immanently technological, what is the status of invoking scientific investigation as justification for ecological policies? Is the science of "ecology" free of the presuppositions of instrumental rationality? So, even as conservatives use "liberal" political theory to justify turning back the clock on the relation of humans to nature, ecologists use the language and the results of science to argue for constraining its most powerful effects.

I do not invoke these paradoxical features of current environmental politics to debunk either conservatives or liberals. Like Aristotle's *Organon* from which it derived 2,500 years ago, scientificity, whose entailments—disenchantment, instrumental reason, the yearning for prediction and control of our environments—implies certainty in our knowledge of nature, society, and human nature, science and its methods have become naturalized so that even critics are imprisoned by its algorithms. Thus, even the critique of science and scientificity as an instance of the transvaluation of values, requires more than deconstructive power to sustain it. Does it require emancipation from the conditions that produced a science whose presupposition is domination?

Some radical ecologists have proposed a more sweeping economic and social alterative: bio-regionalization and other measures to otherwise reduce the scale and character of economic activity. This proposal contains a different kind of associational economics and politics: it presupposes one the basic precepts of communitarianism, a community of shared values, in this case those of ecology. It would impose some limits on individual prerogatives to dump toxic waste in wilderness areas or in oceans, lakes, and rivers, or to undertake private initiatives which violate its precepts.

Kirkpatrick Sale, for example, has proposed regionalization of agriculture as well as industrial production and services. The goal would be that each region supply the great majority, if not all, of its own needs. Interdependence between regions would be restricted to a common ecological standard, but the flow of goods between areas might be slowed to include only those necessities which the region could not self-supply. And the ecological standard of sustainability—practices which articulate with the homeostatic requirements of the ecosystem—would govern, to a considerable extent, the historical level of material culture, that is, considered as a cultural posit, what consumer goods are considered

"necessary" for the Good Life. "Development" would be limited according to this criterion. It would reconfigure consumption patterns; shape many aspects of individual preferences and especially whether we could act on them; and define the crucial, if elusive, notion of "harm."

From the traditional liberal perspective on individual liberties, this regime of production and distribution would not *necessarily* be objectionable. There could be ample space for disagreement on what constitutes harm and which practices may be construed in these terms. If, for example, property holders wish to dispose of their goods in ways that are deemed harmful to the "community" on the ground of sustainability, would their desires be construed as "rights" that have been trampled?

Further, if a crucial aspect of sustainability is limiting the size of population within the community, what about the problem that might arise from the question of human migration, which is among the more precious freedoms of the industrial era? Since, for a considerable time, the degree and level of development would vary from region to region, one could expect that some people from less developed regions would wish to enjoy the fruits of more ample development rather than suffer for a generation, or more, the risks and the vagaries of scarce resources. Even if one could imagine eventual rough equality on a global scale, the urge to move is not entirely economic. It is also cultural.

The position that the ecological crisis requires new spatial as well as social and economic arrangements confronts a past which may not be prepared to yield without a arduous, prolonged struggle. For quite distinct from the opposition of international capital, regulation of all sorts has been opposed by those deeply imbued with a privatized notion of their own liberty. But, perhaps equally important, ecologists and environmentalists have, in the United States if not in Western Europe, proven unsympathetic, not to say insensitive to the reservations and even the full-throated hostility of wage workers and small proprietors to ideas that, without practical alternatives, may threaten their economic livelihood, their communities, and their culture.

The widely publicized fight over the fate of the spotted owl brought to the surface conflicts between workers and ecologists in a time of global economic stagnation and decline. In the relatively prosperous 1970s, environmentally motivated regulation made enormous strides in state legislatures and in Congress. But, in the 1990s in the path of the displacement of millions from their jobs, ecological proposals have fallen on hard times. Every regulation is coded by employers and their political supplicants as a potential attack on profitability and *therefore* a threat to the business itself. While many unions favor environmental protections, their members, who experience the insecurity and uncertainties of a jobless future, tend to join with employers who seize every opportunity to fan the flames of anxiety.

Now, arguments for deregulating economic life go far beyond environmental

issues. Perhaps their most powerful idea is that freedom is linked ineluctably to the market, hence the odd phrase "free market." The right of an individual or corporation to dispose of its property at will, the right to put labor in competition with itself by "freeing" workers of union-imposed regulations are invoked by neoliberal economists and their political allies in the same context as the demand to eliminate or reduce environmental regulations. Lacking a vision of human freedom, the left has responded to libertarian market ideology by debunking its premise that there is a free market worthy of the name, and mocking the claim that conservatives really believe in protecting dissent or privacy.

But the most salient difference between left and right in contemporary political discourses is the left's counterposition of the language of "rights" to that of freedom. The left has joined progressive liberals in the faith that the state is the place where the struggle between labor and capital, the community and the pollutors, collective need and private property can and should be adjudicated. Since Eduard Bernstein in 1899 proclaimed socialism to be nothing but the gradual accumulation of reforms, which he read as victories that challenge the power of capital, and since the New Deal completely integrated the rhetoric of justice into its regulatory program, the left has become tied, hand and foot, to progressive-liberal political action.

The decline of the radicalism, as opposed to social-justice liberalism, signifies that a consensus exists concerning these closely related propositions:

- Capitalism is the de facto immutable framework for struggles for justice, which may or may not be redistributive.
- In Nicos Poulantzas's final statement, the state is an "arena of contestation," the outcome of which can result not only in significant concessions by capital in the form of transfer payments, but also a transfer of power from large corporations to the people. In the United States, this affirmative faith extended from labor relations to affirmative action programs and environmental protections.[32] Hence, the progressives' dominance of the Democratic Party, at least until 1968, was widely taken on the left as evidence of their own ascendency *within* the liberal state.
- The primary site of the struggle for redistributive justice is the state and the political system. Industrial action and local community struggles that address conditions of labor and efforts to transform everyday life are logically subordinate to political action.
- Consequently, the highest organizational vehicle of the social movement is the *party* and its representation of conflicting interests.

To statism and communitarianism, each of which seeks to corral the individual under the signs of benevolent or repressive conformity, I want to propose the alternative of a *radical democracy* whose underlying, conflictual ideas of negative and positive freedom require adumbration as well as explication.

6~

Toward a Politics of Alternatives
Part Two

~One of the major implications of the dissolution of the radical left has been the disappearance of systemic *alternatives*, both at the level of ideology and at the level of practical structural reforms. Whereas the generation of 1968 could credibly pose the slogan, "Be practical, demand the impossible," latter-day political thought asks in Michael Harrington's felicitous phrase, "What is the left wing of the possible?" To the discourse of utopian possibility, the retort is, "What do we do on Monday morning?" Some erstwhile radical intellectuals have rediscovered republicanism, with its focus on human rights, corruption-free, and transparent representative democracy; some have rediscovered the eighteenth-century idea of civil society and the democratic potential of market economies; and some have invented a "left" communitarianism which roughly corresponds to the nationalist program: redistributive economics and conservatism on the "social issues."

At the same time, these strands of a revived liberalism in their militant renunciation of the utopian tradition that has marked off radicalism from republicanism have, somewhat hastily, identified all references to a radically alternative future with the Stalinist legacy. As we have seen, given the relatively limited aims of liberalism, even the term "emanicipation" has been given a bad name. For the implication of an emancipatory project is that human dignity and human freedom are linked to, and perhaps dependent upon, the end of domination—of nature and of humans. Even if reforms may, however temporarily, impose constraints on capital, marxism's historical tendency to view the state as merely an efflux of the class struggle and recent socialist doctrine's view of it as a series of functions or apparatuses that are essentially *neutral* and whose tilt depends on the relations of power among contending forces, are historically surpassed doctrines.

As I have previously argued, the period of radical approbation with respect to the state corresponds to the period of *organized* capitalism, among whose fea-

tures was to integrate labor as well as capital into a system of regulation. From its conceptual birth to its practical demise, this period lasted almost a century. In its ascendent phase politics was recoded from a zero-sum to a win-win game, the presupposition of which was that the zero-sum could be *externalized* to the internally excluded and to other parts of the world.

In the past twenty years, under conservative and neoliberal pounding, the U.S. state has been systematically shorn of most of its benevolent aspects. Even as capital has been integrated *outside* the state system on a world scale, labor has been cut loose on a world scale in what some have described as "new enclosures." Even in the "social-democratic" societies of Western Europe, let alone the almost completely deregulated Eastern countries, the state increasingly tends to revert to its repressive character and a nationally based financial coordinator for international capital. Between the terrorism of the 1970s and the real and manufactured crime waves of the 1980s, the veritable cascade of tales of child abuse in single-parent homes as much as child-care centers, federal law enforcement officials raiding the headquarters of religious and right-wing sects in the 1990s, the visible state is linked to the floating panic that afflicts a considerable portion of the underlying population. It is not a question of the state "conspiracy" but of the extent to which the state has been stripped of most of the functions bestowed upon it by the reforms of the regulatory era as it loses its sovereignty to global capital.

And, since the franchise on social transformation was held by authoritarians for nearly all of this century, "emancipation" may be taken as a code for calumnies such as the gulag, for the atrocities in Tiananmen Square, for the Soviet tanks in Prague, and the brutality of the Pol Pot regime in Cambodia. The historical left's betrayal of pre-Bolshevik socialist/humanism suggests, for this tendency, that the interest of freedom requires that the entire legacy of Marxism—with its dream of cultural transformation and radical democratic participation be abandoned and political liberalism be installed as the farthest horizon of social thought and political practice.

The value of this polemic has been to revive some neglected ideas associated with liberal democratic theory which, with few exceptions, American radicals have ignored in recent years. The decline of civil society—the sphere of social life where individuals may openly debate issues of vital public concern, publish tracts and newspapers, engage in heated, but public-spirited discussions in public spaces—must be a significant blow for anyone interested in countering both the incredible de facto censorship of the press and electronic media (which results in the exclusion of alternative viewpoints) and the dismaying decline of the scope of public debates about burning issues.[1]

As important as it is in the struggle for democracy in Eastern Europe, the term and the concept "civil society" remains somewhat obscure in the U.S. context. From revolutionary times to the late twentieth century, there has always

been an important strain of radical democratic thought that insists upon "face to face" interaction as the core of participatory governance, in recent times notably in the writings of John Dewey and C. Wright Mills. Thus, the politics of federalism was opposed during the American Revolution by a combination of communitarians and libertarians who feared the centralism of the national government as it was outlined by Madison, Jay, and Hamilton. The notion of participatory democracy reappears throughout American history in the rank-and-file movements within trade unions, anarchist communities, and intellectual and political traditions during the late nineteenth century; left populism, which successfully voted in the electorate's right of initiative and recall during the first decades of the twentieth century; and finally in the New Left's declaration that representative democracy be substantially replaced by participatory democracy, not only in legislatures, but also in the institutions affecting everyday life, such as the family, the workplace, and the school.[2]

But, as Jürgen Habermas demonstrated in his study *The Structural Transformation of the Public Sphere*, the ideal of civil society has frequently been a mask for class domination, to which one might add, the justification for the privileged views of experts and other genres of intellectual elites as well. In order to make the concept useful for a resurgent popular democracy, it cannot remain an unelaborated liberal ideal; the social and political conditions for its development must be specified.

The same qualification should be placed upon the naturalized institutions of representative democracy. We know from cultural theory as well as political critiques that representation is an ambiguous term. The emergence of large cities and metropolitan areas as the characteristic territories of advanced industrial societies; the overly bureaucratized national and local states generated by a host of displacements, geographic and economic; and the profound divisions based upon class, color, and ethnicity have conspired, among other historical developments, to generate a *crisis of representation*. The historic task of representative government to homogenize the electorate presupposes centuries of common ground among the underlying populations of liberal democracies. That the modern history of the United States is marked by extreme heterogeneity has resulted in relative delegitimation for its system of governmentality. The decline of political participation has been exacerbated by the effective end of *national* capitalism

In the context of the electoral system where constituencies are extremely large and increasingly diverse (an American congressional district is drawn on the basis of five hundred thousand people and will be more as the population grows) geographic boundaries are determined by power and influence rather than criteria that would promote increased participation. And it must be acc-knowledged by the progressives that the two major parties have absolutely no interest in enacting reforms which could enlarge the major form of legitimate

participation, voting, from the current 37–50 percent to European norms of 70 percent or more.

A polity wishing to encourage greater participation in the limited system of representative democracy makes sure that elections are held at times when most voters are able to get to the polls. In most European countries, where the legitimacy of government has frequently been contested from the right as much as the left, voting takes place on Sunday, or spans several days. And in many countries people scheduled to work at voting times are paid for the period they go to and return from polling places. Equally important, where prior registration is required, opportunities are provided in many institutions, not merely official offices, for voters to enroll.

These reforms, whose provisions are well known, languish in the basements where dead congressional bills are filed: making election day a national paid holiday or holding elections on Sunday as in most of Europe; public financing of election campaigns and severe restrictions on, or abolition of, private donations to candidates; increasing the number of representatives on the basis of a formula of one to a hundred thousand for Congresspeople; tying voter registration to motor vehicle registration or to the execution of *any other public document*; drastic revision of state requirements for minor parties to gain permanent ballot status; and reducing the number of valid signatures required for recall of representatives.

In recent legal history, progressive liberals have attempted to use the judicial system to redress some of the deformations of the electoral system. They have brought suit against the practice of gerrymandering in which legislatures constructed districts to insure the continuity of one party rule or the reelection of a particular individual. In the legislative arena, Congress enacted the Voting Rights Act of 1965 designed to facilitate Southern black political participation, including the election of more black public officials. The warrant in these actions was that by reforms to enhance equitable participation, government itself would become more representative of traditionally excluded groups.

After thirty years of civil rights reform, formalists may regard the results as heartening. There are many more black elected officials at all levels of government, particularly at the local level. Many blacks have climbed government bureaucracies and some hold positions of genuine power. There is a growing black judiciary. And women have made even more strides in the governmental systems both in and out of legislative bodies. Even now, after more than a decade of backlash against affirmative action and black and women's power, the culture of redistributive justice is not easily displaced in either public or private employment.

But a recent Supreme Court decision calling into question racially determined district boundaries unless discrimination can be proved illustrates the vagaries of the issue. Under a fairly liberal interpretation of the Voting Rights Act, South-

ern state legislatures were instructed by a conservative attorney general to gerrymander in favor of black representation. A fair number of blacks went to Congress under this rule, leaving many Southern districts to the white conservatives of both parties. Now, some recently elected black lawmakers may lose their seats. If blacks voted heavily in previously white-dominated districts, would this be bad for black freedom? Is the content of black freedom the same as identity politics? True to form, many civil rights organizations have, incorrectly I believe, likened the court's decision to the betrayal of Reconstruction in 1876.

The decision was consistent with earlier court limitations imposed on affirmative action in employment, signalling the end of an era of juridically imposed civil rights law. But, lest historical memory be entirely wiped out, recall it was Richard Nixon who proposed to address discrimination in employment and education by affirmative action. In a period when military spending gobbled up much, if not most of the federal budget, which in any case was largely devoted to mandated spending such as veterans benefits and income support to the disadvantaged, the vast sums required to provide decent education and training programs for blacks and other minorities were, given the skewed tax system, simply beyond the capacity of the federal government.

In a word, Nixon fostered affirmative action because it was cheaper than spending billions for education, enacting a genuine guaranteed income program and work-sharing measures such as shorter working hours. And, in line with the results of the antipoverty program of the 1960s, its most socially important payoff was the creation of a new black job bourgeoisie that has proven itself, like its white counterpart, to be a bulwark of economic and social conservatism. Nixon's token moves could be expected. What is remarkable is how easily the civil rights movement, unions, and liberal feminist organizations adjusted their vision and strategy to define the fight against discrimination in terms of extending and protecting affirmative action as a model to fight discrimination. Why this adjustment? Could it have been due to the political *costs* of choosing a more confrontational strategy with capital and the war machine? In order to make a determined fight for real education and against job discrimination the organizations would have had to relegate their reliance on legal and legislative strategies for achieving their goals.

In the face of the congressional near-unanimity that military spending be maintained at or near its Cold War level and the ideological hegemony of fiscal restraint that have combined to thwart social reform since the 1960s, trade unions, civil rights, and women's organizations would have been obliged to turn back to direct action, and be prepared for the inevitable strain in the imperatives of consensual politics. That the alternative of going into the opposition was never seriously considered, even in the period of Jesse Jackson's 1980s insurgencies, testifies to the lingering pull of the liberal framework, even where its substantive power has been seriously eroded.

During the 1980s and 1990s, the popular left, including black and women's movements, have clung to an increasingly conservative affirmative action strategy to fight discrimination, maintained their loyalty to an increasingly conservative Democratic Party and, in the process, were rendered marginal to national politics. I want to raise the question, What are the substantive results of the struggle for more representation by women and minorities? Are blacks and women *as a whole* better off politically as well as economically since these gains? Or, can whatever gains that have been made, particularly in relation to more power and position, be ascribed to other influences?

The ebbing of the movements in the 1980s and 1990s, combined with general decline of economic opportunity except for a severely restricted upper-crust of managers and some professionals, has more than neutralized the possible effects of rights legislation and court decisions that awarded blacks and women compensatory benefits at the workplace, in legislatures, and in education. Even as affirmative action has produced a new black middle class since the 1970s, for black *workers* and the unemployed poor the past twenty years have been nothing short of a catastrophe. Mass unemployment in many black neighborhoods reached epidemic proportions in the 1990s. As city economies shrank and public goods were reduced to a minimum, whites accelerated their exodus and are now joined by substantial migrations of the black middle class.

Having won jobs and seniority in many decently paid goods-producing industries in World War Two and for the next twenty years, black industrial workers have been massively expelled from these niches since the mid-1970s by the restructuring and deterritorialization of industrial production. More than six million factory jobs were lost since 1980, most from the Northeast and Midwest where blacks had made deep inroads. Of course, most of these jobs were held by "white" workers but they represented a considerable measure of black economic progress.

For example, since World War Two in Detroit's auto plants, and in other auto assembly plants throughout the country, blacks comprised close to 50 percent of this highly paid labor force; blacks were in the majority in Chicago's packing plants and comprised 40 percent of the labor force in the area's steel mills, and held many steel jobs in secondary industrial centers such as Youngstown, Buffalo, and Cleveland. The containerization of the New York, Gulf Coast, and West Coast waterfronts, the computerization of warehouses and other service industries where blacks constituted a sizeable proportion of the work force and, more recently, the layoffs in the public sector and in the health care services where blacks have achieved considerable social weight has had the cumulative effect of devastating many of the key black communities in this country.

The march of millions of women into fulltime and *secure* parttime employment which began in the 1960s has been halted and reversed. Women are still entering the work world, but are offered, mostly, insecure parttime, "contin-

gent" and temporary employment carrying few, if any benefits and protected working conditions. Moreover, they have suffered disproportionately, in terms of joblessness, to white males from the attack on public services and the flight, overseas, of light industries such as the needle trades, electronics, and textiles. In the 1960's the early women's movement issued a button with the inscription fifty-nine cents, signifying that women earned less than three-fifths of male wages and salaries. After twenty years of affirmative action, antidiscrimination laws and court decisions, women in industrial plants and clerical jobs still earn only slightly more than 60 percent, a failure which can be fully attributed to the failure of the movement to vigorously fight for comparable worth, a program aimed at wage equalization through the reevaluation of women's jobs.[3]

Given the post-1968 resolve by international capital to divide and recompose the labor and the job "market" so that workers would have few options to taking significantly *less* as a condition of employment, the *weakness of unions and the movements for social justice* accounts for much of the economic and political defeat that the working class, including the salariat, has suffered. The social movements have been unable, and often unwilling, to come up with anything more than a defensive strategy geared to currying favor of increasingly neoliberal labor and socialist parties in Europe and the Democratic Party in the United States. In this country, the extreme craft, industrial, and especially race consciousness of large segments of the unionized white working class has constituted an added barrier to mounting effective resistance, let alone developing alternatives to the employer challenge, "Do it my way or there's the highway."

And, despite the vaunted adversarial relationship most experts believe is built into the U.S. system of industrial and labor relations, in the 1980s, under pressure from President Ronald Reagan's unceremonious firing of eleven thousand air traffic controllers for daring to strike to redress onerous working conditions, many workers felt impelled to give back many of their hard-won gains. The AFL-CIO leadership read Reagan's bold stroke as a signal to beg, hats in hand, for "fairness." Rights-based pleading proved no match for ideological politics. The union leaders left the White House empty-handed, but also bewildered about what had transpired. After all, even the arch-conservative Richard Nixon had not resorted to mass firing of postal workers who pulled a similar, illegal strike in 1970. Rather than call for a one-day walkout by all labor in protest and a determined fight for the controllers' reinstatement, the labor movement prepared to surrender some of its historical gains, particularly work rules and benefits for the elusive goal of job security. In the main, the concession bargaining of the subsequent five years yielded paltry results in the wake of sweeping restructuring of world capitalism. Mergers and acquisitions, but also computer-based technological change made many workers redundant and neither wage concessions nor corporate flexibility in changing work rules saved many jobs.[4]

Demobilization and disorientation has led to perhaps the most virulent and

complete corporate ideological and political hegemony since the 1920s. Neo-liberal and conservative discourse has become the new common sense of our times. It is not only the coercive threat of capital flight that constitutes this hegemony. Workers and their unions can no longer afford to make the distinction between economic necessity and the exercise of arbitrary power when an employer issues such a threat. They believe the risks of such judgment are simply too great to go out on the limb. As a result, where the historic compromise between European labor and capital has, despite twenty years of economic stagnation, generally held the line on wages and benefits, U.S. real wages have declined more or less steadily since 1973, a trend which has been slowed but not reversed by recent labor militancy.

The stark contrast between U.S. and European labor movements was dramatically evident in how New York public employees and French public employees have responded to their respective governments' proposals to eliminate jobs and curtail public expenditures for social services. When the Giuliani administration and the recently installed New York Republican governor George Pataki proposed deep cuts, unions tacitly agreed to permit extensive privatization of some municipal and state services, notably parts of the city hospital system, and have raised only faint voices against the practice of contracting to private agencies some functions historically performed by public employees.

The unions have settled for a shaky "job security" assurance; it remains in effect for the first three years of a five-year contract. In a startling reversal, the large teachers' union membership, by secret ballot, turned down a contract proposal negotiation between the city administration and their leaders, which would have frozen salaries for the first two years of the agreement. In District Council 37, which represents some one-hundred-forty thousand city employees, in the historical perspective of overwhelming support for the leadership, a similar deal passed by a relatively narrow margin.

The newly elected French government under President Jacques Chirac moved, in the fall of 1995, to implement its own version of Thatcherism. Under pressure from the European Union's drive to achieve a common currency (a euphemism for European-wide downsizing of the public sector as a prelude to cutting corporate taxes) Chirac proposed to reduce rail transportation and many other public sector jobs. Two of the three leading French unions, the General Confederation of Workers (CGT) and the Workers' Force (FO) sanctioned a strike in the transport sector which quickly spread to other employees. At its zenith, more than 75 percent of all public employees heeded the strike call whose key demand was that Chirac rescind his plan. After several weeks of spreading strike activity, the government withdrew its proposal for a limited time and the strikers returned to work.

Two remarkable features of the French events should be noted. Despite the fact that the two unions' memberships are relatively a small proportion of pub-

lic workers and an even smaller percentage of French labor than U.S. union representation of American workers, their *influence* among public employees is entirely out of proportion to their actual membership. And the traditional popular support for public goods remains strong. During the strike nearly 60 percent of the French public agreed with the strikers even though they had returned the right to power by a similar margin.

To be sure, neither the communist-led CGT nor the independent FO was able to advance an alternative program beyond resisting Chirac's plan. Nor is there any doubt that the resolution of the strike is likely to be short-term. Nevertheless, a weakened French labor movement was able to demonstrate its command of the national discussion and debate around issues which have confounded American workers and unions.

What was remarkable about the New York case is that the municipal and state unions represent an overwhelming majority of their respective constituencies, but utterly lack either the political will or the moral force to impose a different outcome to the efforts of conservatives to dismantle and otherwise destroy public goods. The explanation for the two divergent outcomes is chiefly ideological: U.S. unions do not see themselves in the context of the broad debate about public policy. They are not ideological actors, nor have they developed an alternative discourse to that of the large financial institutions and conservative ideologues who control City Hall and the State House.

Whatever their defects—and they are numerous—French unions are independent of Capital; they see themselves as forces of opposition, however much they have compromised this orientation. The differences are stunning.

Everyone who plays in the U.S. political arena accepts that the political priority of government in the 1990s is budget-balancing and removing the debt. In the face of this imperative, academic policy analysts no less than politicians acknowledge there is no alternative to subordinating public goods to the vicissitudes of the bond market. It is no longer an extreme left-wing harangue to say that government is dominated by large multi-national corporations and banks. This formerly contested claim is now accepted as fact, but with approbation by some and passive acknowledgment by others. That the business of government is business is no longer contested; it has become thoroughly naturalized.

The very idea of the possible expansion of redistributive measures such as universal publicly financed health care, shorter working hours at no pay reduction, guaranteed income to eliminate the brutal and retributive welfare system, the expansion of schooling opportunities and strict occupational health and safety codes, all of which could be financed through the reintroduction of a progressive income tax system which could reduce or eliminate most sales and user taxes, is, for political realists, considered nothing short of utopian. A new effort to mount an assault on inequality is branded nonsense and given absolutely no public hearing, in part because the official voice of labor, the AFL-CIO and its

affiliated unions, have been silent on these proposals. And, of course, the historic aim of taking labor out of competition with itself by building labor and union solidarity on a transnational basis was little more than a forlorn hope consigned to the trash can of nostalgic memorabilia alongside the Joe Hill Songbook.

~In the United States, the estrangement of voters from representative government is particularly severe. Liberal proponents tend to discount the fact that 50 percent of the electorate does not vote, attributing this phenomenon to social disorganization among the working classes and the newly dubbed "underclass." Yet, there is evidence of growing political disaffection among large sections of youth, blacks, and Latinos, and a considerable number of workers in all age groups, even those who have relatively "stable" families. While, unlike writers such as Jean Baudrillard, I do not glorify this abstention, not voting must be understood as a symptom of the crisis of liberal democratic institutions just as the refusal of workers to attend union meetings except to reject or ratify contracts is not a sign of satisfaction but a tacit critique of the oligarchical structure of the labor movement.[5]

Thus, the specifically democratic purpose of representation is structurally subverted. In most cases, the task of the elected official is to keep her/his constituents at bay in order to perform his service to the state. S/he runs things regardless of the party in power. One illustration: foreign policy, which, as Clinton quickly discovered, occupies the dominant space of federal politics. With the consultation of the president and his staff, the foreign policy and military Establishments choose the political appointees of state and defense departments from a fairly restricted list of possible nominees. As the secretaries of state in the post-World War Two era have shown, these appointees shuttle back and forth from corporate offices, universities, and corporate-financed think tanks to the federal government and are bipartisan. The President and his personal entourage make up only one voice in deciding who will run these spheres.

The permanent government is a product of a complex of historical influences, particularly the enormous power exercised by the "military-industrial complex" on the political class of both parties which seems to have lost none of its clout during the Clinton presidency. Further, American foreign and domestic policies are fatally constrained by the requirements of international financial markets and by an autonomous military which has been able to thwart any movement toward a post-Cold War defense policy.[6]

But the question of representation is not exhausted by the particular configuration of contemporary economic and political power. From a democratic perspective, representative government has been severely compromised not merely by the degree to which elected officials are beholden to private, mainly

corporate interests, but also by the *aggregative* character of politics. Election polling has effectively displaced serious discussion and debate of public issues. Politicians are not embarrassed to admit that they regularly take the pulse of their anonymous constituents on various public issues as a guide to their own positions. The "public" is heterogeneous, but the structure of the representation of the selective sampling by political parties and political camps of public opinion tends to exclude the plurality of concerns and interests of the electorate and to homogenize the rest. Moreover, new political identities have posed a challenge to the representativeness of the old political class which, with only some exceptions, holds the reins of government, if not the totality of political power.

So, the creation of a democratic public sphere which, in its classical formulation, consists of a civil society of individual participants rather than highly organized pressure groups, implies economic and social arrangements that are conducive to equality. For, as we know in our reading of history and contemporary politics, "one person, one vote" is a mask for the proposition that everyone is equal at the ballot box; but owing to their favorable access to economic power and/or bureaucratic position, some are more equal than others. Which did not prevent the labor and civil rights movements from demanding universal suffrage as the necessary precondition for achieving equality (according to Marx, the struggle for suffrage was the last great struggle within bourgeois society, but this judgment was made before the welfare state).

The recent discourse of civil society routinely ignores or occludes these considerations. Its referent is invariably the individual who is not presumed to bear class identity, much less social and cultural ties. In fact, the real aim of many of the arguments for the new post-Marxist liberalism is to leave the legacy of class politics far behind. Thus, in their haste to bury the old, many have resuscitated a sanitized old liberal political theory bereft of any trace of an alternative vision to the givens of current arrangements. No doubt, this emphasis on the imperative of public debate is overdetermined by the conformity of the media in late capitalist societies and by the grim legacy of repressive communism. Yet, in the quest for formal elegance and liberal purity, the civil society debate suspends the "social question" as if politics can safely dispense with the category of interest.[7]

Now, it is true that the projection of a socialist future, which promised to resolve most, if not all, social ills under the sign of the social ownership of the means of production, maintained the sharp separation of present and future and was employed to justify the most heinous crimes and corrupt practices of oligarchic states. The misuse of utopian thought contributed to the persistence of the binaries of pure refusal and accommodation that were hallmarks of the history of the twentieth-century socialist movement. Accordingly, we would not want to revive a utopian totality which may be the philosophical equivalent of

the total state. Instead, radical *alternatives* to the given state of affairs would embody a utopian *moment* insofar as it would attempt to transform the politics of consent into a politics of participation.

In fact, the proposal advanced by Habermas and his followers, for a new public sphere of free discourse in which agents resolve differences without resort to the violence of naked economic power and/or physical or psychological coercion and are able to substitute *communicative* action on the basis of presumed equality, is no less utopian. That is, the suggestion that social and political life submit to the criterion of rational discourse may seem far from realization in a world in which politicians boast of the funds they have raised from private interests and buy votes in a very prerepublican mode. Or, as in its European manifestation, a largely incorrupt political class determines that it is in the national interest to remain firmly tied to business interests.[8]

I have been at pains to defend the validity of the seeming utopianism of radical democracy in a time when democracy itself, even in its liberal forms, is under siege. But I want to argue that, despite its implausibility from the perspective of the utterly depraved quality of political life in America and elsewhere, participatory democracy is a political perspective which corresponds most closely to the conditions that have generated the current rebellion against political authority in the wake of the popular feeling that there is a crisis of representation. Moreover, liberal and "socialist" states have been rendered utterly powerless by the new global economic arrangements to perform the most basic legitimating services to their underlying populations. It is precisely these developments which have fueled the spread of the right's influence. For the left to defend liberal statism seems even more anachronistic than the proposal that only radical solutions are realistic.

I have claimed that the emergence of the new social movements of the late 1960s and 1970s was both a reaction to tendencies in the New Left and an overdue statement of the need for autonomous discourses which remained submerged under the redistributive programs of the ideological and economic-justice lefts. The result of the simultaneous disintegration of the ideological left and the growth of these movements was that socialist hegemony was decisively broken, but, in the process, the movements generally renounced universalism as well. That is, the possibility of a common *ideological* basis for alliances among these movements is denied, even when tactical alliances are considered. The particularity of the movements has led to two perspectives: some have claimed what might be termed a "partial totality." The particular, historically constructed identity claims that its own emancipation is not only a necessary component of general emancipation, it is identical with emancipation itself. This position is explicitly taken by many feminists and black nationalists in a farcical mimesis of the old Marxist dogma that the liberation of the working class was identical to

human freedom. As we have seen, some claim the mantle of redistributive justice, but subsume its demands under the rubric of identity politics.

Or, the very idea of universality is abjured on theoretical as well as practical grounds. I cannot here explore fully the philosophical objections to totality, objectivity, or universality. But, if one argues that universality always implies superordination as well as subordination as was the case in liberal or Marxist doctrine, there is reason for radical disaggregation of any claim to an overarching ideology. Further, if universality is a form of "essentialism" which tends to produce closure rather than maintaining open dialogue, one may deny any possibility of finding a common substantive ground beyond communication or, in political terms, tactical alliances among otherwise disparate groups.

Yet if the idea of *radical democracy* is rigorously pursued, we may discover that it is, potentially, a universal which meets some of these objections. First, radical democracy is hostile to the tendency of modern states to centralize authority as well as administration in the hands of bureaucracies whose accountability to any possible popular will is several levels removed. We know, for example, that the results of public opinion polls show that 70 percent of Americans favor socialized medicine. But, without a popular movement insisting on this alternative to the insurance company run health care system, it is not even included within the debate. Moreover, radical democracy entails limiting the power of representatives by requiring shorter terms and a simple system of recall. To the control by a bureaucratic/political class of leading institutions it opposes systems of genuine self-management. Third, radical democracy refuses the imperative of hierarchy and privilege based upon economic power, whether in the means of production or via professionalism. And, of course, radical democracy is inconsistent with patriarchy, heterosexism, and racism, for these doctrines and their practices overtly assert the superiority of white men over all others.[9]

These principles apply to social movements and to the institutions of redistributive justice as well as to the executive and legislative branches of government. As I have already indicated in chapter three, radical democratic theory insists that the movement's internal process be, as far as possible, prefigurative of the relationships we would want to bring into being, on the claim that the tendency of political theory to rigidly separate the present from the future is often employed as license for the formation of self-enclosed elites within an ostensibly emancipatory movement. In effect, in a radical democratic system, the present becomes as far as possible determined, at least ethically, by the future rather than by the past. Movements would have to adopt a *telos* from which day-to-day struggles would derive their significance as well as an accountable measure.

As we have learned from ecological, anarchist and left-libertarian thinking, a thorough-going radical democratic approach entails decentralization in the

control of economic and political institutions, and pluralism in the institutions of everyday life. This implies that there is no single way to produce things, no fixed way to learn and to teach, no immutable "rules" of adminstration or decision-making, except the invocation to inclusiveness, honesty and popular participation. Thus, in contrast to the institutions of representation of aggregated individuals which tend toward oligarchic power, radical democracy favors the restructuring of political and economic institutions in ways that permit broad *popular* control over them. Clearly, there are practical conditions for popular participation which, if they are won, would significantly shift the conduct of everyday life:

1) We are all familiar with the basic work-sharing argument for shorter hours in an era of decline and technological displacement. From the political perspective the workday and the workweek would be considerably shortened or, put another way, decision-making would cease to be an avocation and be considered part of work. Since decision-makers need information in order to validate their deliberations, study would be included in the workday, whether at home, factory or office. Adequate, free childcare would be provided so that all parents would be afforded the opportunity to take part in decision-making. Of course, there would still be managers and other representatives, but they would be elected and their work would be confined to administration of the determinations made by collective bodies meeting in face-to-face situations.

People could elect to decline participation in which case the shortened work obligation would permit a fuller individual development. But, in a genuinely post-scarcity society, the right to be "lazy," that is, to pursue one's own interests and pleasure, would be considered one of the sacred missions of the community and a legitimate consequence of shortening the time of labor obligation.

2) The size and scope of enterprises, schools, communications, and neighborhood institutions among others would be determined decisively by the goals of participation rather than making people adjust their expectations and range of powers to given institutions. Thus, particular forms of organization, which in many instances take on the appearance of a force of nature, and therefore are not subject to human intervention except by the God, Capital, would be honed to the collective will of producers and consumers. As we have seen, this argument has already been made by some ecologists who claim that large-scale organizations and centralized technologies disrupt ecosystems. Others, such as Arendt, have offered the insight that organizations which provide little opportunity for face-to-face interaction discourage participation. We do not yet know the possibilities for broadening the base for decision-making that electronic tech-

nologies might provide. If one accepts the view that there is a strong social dimension to decision-making, there are strong grounds for holding to the desirability of face to face interaction. However, with the possibility for linking geographically dispersed people provided by new forms of communications technology, to facilitate face-to-face discussion may not feasibly entail the affectivity of pressing the flesh.

3) Among other factors, technological development would be subject to the criterion of democratic participation. The criterion would refer both to the degree to which the technology enables broad participation in work of all kinds, not just commodity production; and whether its labor-saving aspects hurt or assist people to develop their own capacities, a consideration which depends, in the main, on how the labor process and consumption is controlled. Such questions as whether the technological innovation results in *debilitating* labor displacement would be considered crucial to its introduction. Popular control over technological innovation, a proposal which would entail the development of a new concept of scientific and technological citizenship, is perhaps one of the most important of the conditions for democracy.

4) As I have already indicated, proposals such as public or collective ownership of productive resources would be evaluated on democratic as well economic criteria, including the degree to which these forms of ownership would best meet human needs under existing conditions. For example, we know that huge state farms in the Soviet Union were not the best way to produce and distribute agricultural products. There is considerable evidence that small and medium farms—which share machinery, processing, distribution, and labor on cooperative basis—may be more "efficient" from the point of view of quality, price, and productivity than large state or corporate farms. American corporate farms use the tools of "scientific" farming—among them large earth moving machines, chemical fertilizers, and hormones—and, for this reason and the economies of scale, can produce very large quantities of food, but only at the expense of the environment, product quality. and consumer and worker health.

But beyond criteria linked to the quantity and quality of products and cost-efficient methods of production, smaller farms may be more conducive to broad democratic participation in ownership and decision-making. What Kirkpatrick Sale has called the "human scale" of economic production includes questions of control and management; from this perspective "small is beautiful" at a level beyond the scope of instrumental rationality. The question for agriculture, no less than for production industries and services, is, "What kind of relationships would alternative work regimes foster?" The *second* question is one of economies.

Similarly, in an age when knowledge has become the major productive

force, large-scale industrial enterprises have proven to be a disaster, and not only from an ecological perspective. They thwart initiative from below, tend to create and perpetuate narrow circles of power at the top whose decisions regarding technology, product development and organization are often disastrous for the enterprise, especially the employees, and for consumers. Radicals should be leaders in exploring new ways of organizing the labor process in goods production, service delivery as well as agriculture and for developing ideas of a more "human scale" of economic activity. In this connection, perhaps only the ecologists in recent years have offered concrete alternatives.

5) The struggle to democratize and make liveable everyday life is a crucial principle of radical democratic theory and practice. Increasingly, Liberal "social" ideology—which embraces most thought coded as "conservative" as well as neoliberal in the United States—extends the concept of the free market to all spheres and, in recent years, has systematically undermined its own defense of privacy. Its overarching ideology posits the metaphor of the market as the universal around which all life revolves.

Contrary to anticollectivist tirades, liberal social, and political theory argues, in effect, that the market is the homogenizing agency required to maintain social order and, contrawise, the road to freedom. Among other presuppositions, it assumes that freedom consists in the ability of atomized individuals to earn a living by competing in a free marketplace; that children should compete with their peers in school for better market access, especially for jobs; and that political life is both logically and ontologically distinct from questions of economic power. More than ideology, the new universal of late capitalism, the commodity form, exempts no nook or cranny of everyday existence. Business becomes the new ideal to which neighborhood life, work culture and friendship must subordinate itself. Thus, from the perspective of the commodity and its dissemination, cultural neutrality, privacy, pluralism are no less utopian than the revolution of everyday life proposed by radicals.[10]

In the model of the commodity-form everyday life is taken as a private sphere. The ideal family is a consumption-unit. Trying to live together in small, nuclear families, people are asked single-handedly to raise kids, fight with banks and landlords over living space, fight with and for schools and health care institutions—activities which are, for the most part, outside the public or market commonweal.

With its principles of popular sovereignty, intellectual and political pluralism, and individual freedom, radical democracy recognizes everyday life as integral to collective *political* life. Whether a single parent has access to affordable day care, schools that meet kids' needs, neighborhoods that

are safe and affordable, health care that is readily available, and adequate housing is experienced as a private problem, but as C. Wright Mills once argued, it is really a public issue which bears on freedom and equality.

In fact, these are questions which are at the intersection of class, gender and race issues. Since many of the concessions won by labor, the civil rights and feminist movements have been dismantled or severely weakened, and real income for most people has been sharply reduced, talk of the evils of "consumer society" must be sharply attenuated. We are in the midst of a new era of manufactured scarcity, a material, ideological and cultural transformation which has abruptly altered the expectations of nearly the entire generation that has "come of age" in the past fifteen years and a significant number of their parents. There is both *generalized* and generational austerity which manifests itself, as usual, in a new authoritarianism.

For example, we have been treated in recent years to a barrage of propaganda about child-abuse, much of which is artifically manufactured information that has failed to stand the test of indictments, jury trials, and imprisonment of its alleged perpetrators. Mark Fishman and Debbie Nathan showed in different periods that, respectively, a "crime wave" and an alleged epidemic of the sexual abuse of children in day care centers were conjured media campaigns, which is not to deny the everyday reality of crime, including the beating, raping, and even killing of children. What is at stake is these issues as symptoms of the concerted effort to displace and repress the increasing impoverishment of everyday life; the paralysis but also the complicity of government and social institutions in the progressive erosion of social and cultural freedom; the remonstrations administered by intellectuals and public officials to keep our collective noses to the grindstone; the attack against the cities not only by legislative and administrative starvation of public services but by ideological battering; and the creeping urbanization of the suburbs and exurbs, a testament to the historical tendency to close off avenues of escape.[11]

For the last two decades, these issues have not only divided the polity, they have split the left as well. The socially conservative left's defense of work, family, and community (which frequently spills into left anti-abortionism) has congealed into a full-fledged movement of liberal and "left" intellectuals toward a more socially repressive conception of freedom. From Christopher Lasch to Michael Lind we have witnessed a flourishing stream of thought which, preying on the legitimate point that identity politics has ignored the urgent class issues, proceeds to disdain struggles for abortion and sexual freedom as diversions from the "real" struggle for social justice. One suspects that class analysis in this con-

text is little more than a stalking horse for a nationalist politics which relies on the preservation of gender and sexual hierarchies to attract the "working middle class" to a populist economic agenda.[12]

Following left libertarian traditions, especially elements of the 1960s counterculture and those of anarchist vintage, radical democratic discourse openly proclaims its cultural radicalism because sexual freedom, especially the defense of the right to pleasure and of individuals to invent new ways of living and working together, is at the core of any possible free society. The counterculture, no less than the utopian claims of the technofreaks, prefigures a world made possible by the actual achievements of the scientifically based technology and may be considered "impossible" only if present political and social arrangements are considered normative and immutable.[13]

The last great effort to construct cultural radicalism as a living tradition was the much maligned and despised 1960s and 1970s counterculture. Among its leading precepts was that the we cannot wait for the future, but must bring it into being within the present. Despite its many serious problems, the counterculture was aware that the individualized basis of social existence generated by pervasive nuclearity was arcane. Small groups started collective farms, American style; rediscovered consumer cooperatives but integrated them into new life-styles (such as living communes which included cooperative child-rearing); set up child-care collectives in the context of community building; and began cultural collectives that produced music, art, and writing while living together or jointly operating small businesses such as cafes, coffee shops, and print shops.

One of the most important countercultural contributions to contemporary American life was the development of the health food industry. Its ideology, derived from ecological thinking, of respect for nature is expressed in technologies of "natural" pesticide-free agricultural production and preservative-free processing, claims which currently adorn the packages of a myriad of commercially mass marketed meat and chicken products, breakfast cereals, peanut butters, icecream, and breads to name a few. One could plausibly argue that the adoption by large corporate food processors of these methods is just another case of cooptation. Rather, it may be viewed as an illustration of the contradictions of the market and of consumer society. That nearly everything can be commodified is surely a triumph of capitalism; but consumerism is not a plague, it is a movement of desire. For those who have experienced the worst of standardized and homogenized food, the dissemination of the ethic of "natural" food should be viewed as a victory for the alliance of countercultural companies with consumers to force the food industry to, partially, change its ways.[14]

The major contribution of the counterculture, in addition to its almost single-handed revival of utopian thought, was to have called attention to the politics of everyday life. And, despite its many detractors, its influence remains and is, per-

haps, more enduring than that of the traditional lefts. It held before us a living vision of what a different, less stressed life might be like; it posed issues of equality in terms of the intimate details of daily living; and, together with the new social movements, established, incontrovertibly, the salience of the politics of culture.

The counterculture called attention to the value of nutrition in maintaining good health both by education and by starting health food production and retail businesses; pioneered in "health food" stores that sold chemical-free products made by cooperative enterprises run by members of producer and living communes; together with ecologists and radical medical professionals, waged public campaigns against chemical fertilizers, toxic preservatives in food, excessive food processing, and insisted that food production be environmentally sustainable; were among the earliest advocates of recycling; became a major influence in changing Food and Drug Administration regulations regarding labeling as well as content in the production and marketing of various products, especially food. And, perhaps equally important, the counterculture challenged conventional notions that alienated labor was the institution that conferred meaning to a spiritually impoverished life.

Much of the old New Left was hostile to the counterculture, ostensibly because it was deemed "non" or "anti" political. After attempting itself to create a movement that resembled the Beloved Community, the New Left of the late 1960s rejected the claim that building prefigurative communities was a political act or that collective cultural production not directed towards the immediate needs of the "movement" for social justice was an important expression of resistance to the dominant culture. Or, most controversially, that "sex, drugs, and rock 'n' roll" could be regarded as emblematic of the post-scarcity ethic without which the radical project itself cannot survive.

Indeed, the counterculture was given to excess, at least in terms of the prevailing culture. And, it brought out the latent conservatism of many leftists who had, tacitly, accepted the gulf between economics, politics, and culture. Daniel Bell's celebrated self-description, "socialist in economics, liberal in politics, and conservative in culture" became a formula which inspired the defection of a multitude of New Left intellectuals to liberalism and neoconservatism, helped consolidate the ressentiment of the old anti-Stalinist left around the theme of the alleged "scourge" of mass culture, and helped animate the political correctness controversy of the late 1980s.

~Radical strategy would address the politics of family, school, and neighborhood from the perspective of individual and collective *freedom*, not from the viewpoint of *control and reproduction* of processes of individual and generational development. This shift would transform interventions in all educational,

health and family institutions. It would pose *both* the *content* of education, including early childhood schools, health, transporation, and sanitation, and the issues of popular sovereignty in the administration of these institutions.

For example, the struggle over the multicultural curriculum in elementary, secondary and higher education is an intervention which seeks to reverse the exclusion of the stories of excluded groups, principally black, Latino and asian, by introducing a new pluralism in the teaching and learning of history, literature, and social studies. American history is no longer viewed as the history of white, male Americans or, indeed, as the story of Progress, Freedom, and American Values. Nor, as the social historians have argued, should history be viewed from above—that is, from the perspective of the elites which control the leading institutions of the state. Multicultural history is taught as the history of ordinary people whose struggles for a better life, culture, and resistance become part of the American story.

But multiculturalism is not only a supplement to a well-paved historiography. It offers a new story which, in conventional circles, is perceived correctly as an alternative, even opposing interpretation to that of the political historians. If resolutely followed it disrupts the nationalist consensus which is a vital component of American ideology, for it questions the degree to which "liberty and justice for all" have marked the past and present. Although a militant opponent such as Arthur Schlesinger does not object to an approach which would construe multiculturalism as a supplement, he has publicly bridled at the tacit antinationalism and antimodernity of multicultural discourse. Schlesinger, Michael Lind, and Norman Podhoretz have been in the forefront of writers who have attacked multiculturalism as a subversion of American, Enlightenment values that may be compared to the communist or consumerist subversions against which the high modernists of the left have always railed.[15]

For Schlesinger America is more than a nation-state, it is a community of free people whose problems of racism and economic inequality may safely be trusted to the slow, but sure processes of legislative and judicial redress. For many multiculturalists, tacitly more than explicitly, the story of America is the *failure* of these institutions of redress. But, within multiculturalism, three distinct tendencies may be discerned which vitiate the claim that the movement is an anti-American monolith:

— Mainstream multiculturalism, by far the most powerful in the schools and other cultural institutions, seeks a *supplement* whose objective is to facilitate the assimilation of the alienated, excluded minorities into the mainstream by offering individual empowerment through cultural identity, but is oriented to help the excluded to make it. Of course what this means in a society that increasingly narrows the opportunities for whites as well as blacks is never explored, since those in this camp accept the

myth that only blacks and other minorities suffer from narrow econom-
ic opportunities.

— Those who employ the movement as a sign for a new identity politics.
This wing of the movement generates several ideological elements: whether
by nature or culture, racial, ethnic, and sexual identities are fixed in the
world of male, white hegemony. Solidarity is constructed on the basis of
the recognition of the group's victim status and common fate regardless of
considerations of class or other forms of privilege. The history, literature,
and culture of "our people" is not merely the first step, it is also that last
step towards a communitarian politics in which exclusions as well as inclu-
sions are the basis of solidarity. Black and ethnic nationalism, religiously
animated communitarianism (most recently among some once secular
Jews) and cultural feminism have taken multiculturalism into a new ide-
ology of separatism and inverted racialized purity.

— Those who see multiculturalism in the context of a postmodern hybridi-
ty. While supporting the program of a new curriculum and pedagogy
which dredges the hidden history and culture of oppressed groups, mul-
ticultural pluralism recognizes the instability of identities and their
inevitable overlap. It adopts only what Gayatri Spivak has called a strate-
gic essentialism in order to assert group interests and needs—but recog-
nizes the concomitant need for a universalism of freedom which, howev-
er, respects the autonomy of social movements and group life. The politics
of hybridity is not a coalition of essential identities; it is the alliance of
mongrels. Far from glorifying "third world" societies whose tyrannies
are intolerable, it is prepared to join with the modernists in defending
"bourgeois" freedoms and would engage in debate and dialogue with them
over the question of whether western Capitalism fosters democracy.[16]

Regrettably most multiculturalists have only cursorily addressed the issue of
bureaucratic domination of the schools. One might speculate as to the reason
for this omission but it must be fairly obvious that to win a plural and democratic
curriculum within the framework of the old hierarchical structure tends
to undermine the victory. If power remains in the hands of those who have
opposed or otherwise resisted these innovations, they will subvert the best fea-
tures of the new curriculum by watering it down so that it is despised by its ini-
tiators and criticized by its opponents as educationally unsound. Similarly, the
development of cultural studies *within* traditional disciplines vitiates one of the
most important elements of the critique of the ways in which knowledge is pro-
duced and distributed.

To be sure, in the current political context in which conservatives have appro-
priated "choice" and "freedom" to mean the abrogation of the separation of
church and state and the right of parents to send their kids to private schools at

public expense, the intuitive response to words like "reform" is to say no. Since the right sets the agenda for the educational debate no less than the discussions of the economy or health care, even the minimal and mainstream discourse of multiculturalism—I'm OK, you're OK—is not protected. Multiculturalism is a term that covers a multitude of approaches. It covers the legitimate insistence that the cultural canon be inclusive and not be confined to the treasures of Western civilization, but also covers separatism and, increasingly is appropriated by corporations as a promotional gimmick. Under these circumstances, many leftists remain sceptical of educational reforms and prefer, instead, to defend the status quo against imperious administrators.

What is at issue here is the question of what the German New Left leader Rudi Dutschke once called the strategy of the "long march through the institutions." Dutschke and André Gorz, a French radical journalist, suggest that, where revolution has lost its practical significance, at least in the West, the road to emancipation must go beyond the binaries of resistance and accommodation without calling for the "seizure of state power" as an empty rhetorical device to forestall real alternatives. In the 1960s, together with his colleague Serge Mallet, Gorz popularized the concept of "structural reform"—institutional arrangements that changed the relations of power within and between institutions but did not pose the question of the apocalypse—which, as was demonstrated by the French May 1968 events, could not have been predicted in advance. The strategic implication of this formulation is that radical politics consists in the popular left occupying, by degrees, the spaces of power most in the institutions rather than the legislatures (which does not preclude electoral action, only the tendency toward exclusive focus on this particular arena.)[17]

Of course, one cannot transpose strategies that corresponded to conditions of more than a quarter century ago, in another country. But to a large degree, the heady events of 1968–69 and the subsequent fragmentation of the left tend to obscure the valid core of many of these proposals. These writers worked during the era of postwar boom when there seemed to be room *within the system* for intervention. In spite of these caveats, I would insist that what might be called the "third way" provides a basis for a new strategy. It would, undoubtedly, preserve many of the tactics of the resistance that emerged in the 1960s, to fight a necessary but rear guard action to slow the conservative dismantling of the welfare state. But these would be recognized as just that: rear guard.

Having recognized the validity of other arenas of struggle within the state, a new radicalism would revive direct action as the crucial option for the achieving positive freedoms. Unlike the New Left, a new radicalism is obliged to wage unrelenting struggle against the politics of guilt whose contemporary manifestations, third worldism, compassionate advocacy *for* others and anti-intellectual populism, have all but wrecked radicalism. For this reason, it would insist on a broadly based and nonsectarian discussion of systemic alternatives; crucial

issues such as the social and moral agency of the intellectuals and the middle class; and the achievements and limits of the politics of identity and abjection. It would be a radicalism in which class, gender, race, and sexual oppressions were *not* privileged over one or another but, instead, would dedicate itself to develop new *theory* that explains their mutual relation as well as their specificity.

The analysis I have made, the appeal to radical democracy as a new universal and the strategy of the third way, carries some major entailments. First, one may be a radical sympathizer without belonging to a radical organization, but you can't be a radical without a collective practice. Collective practice is a major expression of the collective will of radicalism. It enables the movement to engage in education, dialogue, and dissemination of its views in the public sphere— much of which is dominated by electronic and print media. And it provides a context for dialogue among intellectuals and activists about the *how* as much as the *what* of transformation. There is an urgent need for a consultative vehicle to provide the framework for radicals working in diverse movements to discover their common ground as well as explore their differences. And, on the basis of these conversations, it may facilitate the development of alliances that can address the common concerns of the movements and provide mutual aid on specific struggles. Among these, interventions in supporting the freedom of peoples on an international scale are, perhaps, most obvious. However, on the emerging struggle for universal health care, on the rapidly worsening economic situation, the cultural crisis and the dangerous spread of racism, it is difficult to see how anything short of a *federation* which, while respecting group autonomy and acknowledging fundamental differences could provide a means for coordinating local and national struggles.

Equally important is the *intelligence* function of the federation. It would be able to gather the efforts and the past work of radical intellectuals in global and national economic, social and political analysis, institutional alternatives and developments. It would be able to sponsor and support a broad range of publications including local newspapers, magazines, and pamphlets on a wide variety of topics; video and film production, and work in the arts. In addition to supplying knowledge, these publications would be arenas of intellectual dialogue, debate, and polemics about ideas. Perhaps most immediately, this federation could support a national weekly newspaper to provide an alternative interpretation of world and national events and information that is simply not available in most, if not all daily newspapers.

Pooling scarce resources, local federations might spawn, down the road, radical schools and study groups for both children and adults, summer camps, theatres, and music groups. Those of us who organized political schools in the 1960s and 1970s (The New York Marxist School remains a standard bearer of these efforts, albeit a more limited one), which, for a time, were relatively successful at least in New York, Los Angeles, and Chicago, know this cultural work

is difficult, if not impossible to support without an organization to help provide the financial resources as well as the workpower needed to start and maintain them.

A new radical federation would provide a *practical* context to engage in the discussions and debates needed to develop new theories of class, and its articulations with sex, gender, race and ethnicity without which alliances among the two broad wings of the popular left would be difficult to envision, let alone establish. Without preempting the many unfinished theoretical tasks, class theory became a virtually neglected project after the 1960s for the reasons I have indicated.

The last U.S. institution which approximated the scope, if not the content of a radical political and cultural program along these lines was the communist party during the Popular Front period (1935–1945 and the first five years after the war). We have a great deal of collective knowledge of the mistakes of that period, but know very little about its achievements. Some tentative efforts were made in the direction of coordinating independent local groups by New Left organizations during the 1960s. SDS published a semi-regular periodical, *New Left Notes*, which served as a discussion bulletin for activists, and a number of influential pamphlets, the most famous of which was the *Port Huron Statement*, which reached the status of a manifesto for the politically hopeful and disaffected. The organization's national office coordinated campaigns mandated by its national council, which was a broadly attended membership body. Antiwar groups published material about the Vietnam War; the underground press, often closely linked to the counterculture, provided worldviews alternative to the traditional left as well as to the mainstream press; small, locally based radio and television stations were started on college campuses and smaller communities which constituted something of a network and syndicate of programs; and radical schools such as the Free University in New York and the various educational projects of NAM in the 1970s are worth reexamining. And *The Guardian*, which began as an Old Left weekly, provided for the last half of the 1960s a common vocabulary for the new movements and was, for many, the publication that provided knowledge of world movements.

In this regard, many activists of the New Left seriously misread the anarchist tradition they tried to emulate. While the anarchists rejected electoralism and criticized the Leninist parties for their doctrine of "democratic centralism" (which always was more centralist than democratic) they did not eschew organization at local, national, and international levels. Within the socialist movement, too, groups critical of the opportunist and bureaucratic tendencies in the parties, tried to build organizations to embody their left-libertarianism.[18]

The second entailment of my analysis is this: one of the major reasons the left does not play is that the playing field has been changed. In this book, I have tried to enumerate some of the changes, particularly the significance of global-

ization, the collapse of the Soviet Union, the utter triumph of liberal ideology (read conservatism) in economics and politics and the fundamental shift in the nature of the opposition. As a prelude for considering a radical democratic regroupment, we need to study and debate the precise character of these changes. We must have the courage to dump the old articles of faith and old formulas which have simply been surpassed by historical developments, and must develop a realistic, but radical vision of a new life.

Finally, I want to briefly discuss three distinctly different attempts to break partially from the old consensus: the emergence of a potentially more vigorous and militant U.S. labor movement; two efforts to break progressives and radicals from the Democratic Party; and new approaches to organizing workers through community-based centers.

The most visible and perhaps intelligible of these is the first, represented by a dramatic shift in the leadership of the AFL-CIO. In spring, 1995 a group of unions, principally those of public employees but also including many organized in large scale industries such as steel, mining, auto and machine production, transportation, and services in the private sector, declared they would contest the top offices of a Federation which had suffered severe decline and virtual public invisibility since 1980. In October, 1995 a slate of new leaders—headed by John Sweeney, president of the million-member Service Employees International Union—was swept into office with more than 55 percent of delegates' votes at the AFL-CIO convention. The new leaders immediately stated that they would undertake a massive organizing campaign among the working poor, an emphasis that had already recruited tens of thousands of hospital workers, janitors, and other formerly low-paid workers into the SEIU, the National Hospital Workers Union, the Hotel and Restaurant Workers, and other unions. Sweeney also made plain his intention to subject the Democrats' record to closer scrutiny and to chart a semi-independent electoral course for Organized Labor. These statements have been sufficient to generate considerable excitement in union ranks. Although Sweeney is no radical, his bold step to open the ranks of labor to new constituents is likely to generate considerable energy at the middle and rank-and-file levels of leadership.

Two relatively new groups, Labor Party Advocates and the New Party are in complementary ways, trying to found a new independent politics. And, perhaps more controversially, some dozen "workers' centers"—some of which are under the auspices of the Ladies Garment Workers Union (now merged with the Clothing and Textile Workers), have been created from New York to California to address the exploitation and the need for organization among immigrant, low-paid workers. Aside from the ILGWU's Justice Centers, the others were created to respond to the *refusal* of most unions to organize among low waged immigrant workers, particularly those from China and other parts of Asia.

The incipient "party" formations have resolutely refrained from offering a national platform on the premise that it is premature, and have, until now, confined their general statements to a critique of the existing two-party system in terms that are familiar. Still, their work occurs at a time of popular disillusion with the right-drifting Democrats, and both groups have managed to attract some support. In spring 1996, Labor Party Advocates drew twelve hundred rank-and-file and low level trade unionists to a conference to discuss the founding of a party. The New Party—the second organization of this project—is building groups in local communities, some of which have already run strong campaigns for elective office, especially in Milwaukee. These efforts appear, early in their respective careers, to be limited to political action; that is, they aim to eventually intervene in electoral politics on the assumption that current dissatisfaction can be translated into a breakaway from the two parties. Whether true or not, the pre-parties are addressing the question of immediate action in the most familiar ways—which, however, may attract some progressive liberal support.

The workers' centers confront a different and, in my view, a more fundamental issue: will the existing trade union movement address the problems of the working poor, many of whom are immigrants working in factories, restaurants and other retail establishments or as construction laborers? While activists in some of the centers do not preclude this possibility, they are not waiting around for the official labor movement to act. In New York's Chinatown the Chinese Workers and Staff Association (CWSA) has organized and supported strikes at several restaurants, but devotes equal energies to dealing with everyday work grievances such as below-minimum wages, bosses stealing tips, abominable working conditions, poor housing, and harassment of undocumented workers by the Immigration and Naturalization Service. Besides fighting against employer exploitation, CWSA have conducted educational, cultural and political activities. But the Justice Centers indicate that some sections of the official labor movement are also prepared to adopt a more long term organizing strategy than the narrowly-based "contract" unions have been willing to entertain. In the early 1990s the Justice Center in Williamsburg, Brooklyn organized and conducted a failed strike among workers at Domsey Corporation, a used clothing wholesaler and retailer. The center has remained open, even after the union spent considerable money in the strike with little or no immediate returns.

Perhaps equally significant, the ILGWU, now merged with the Clothing and Textile Workers, and the independent centers are experimenting with a new model of workers' organization. They are recruiting members without regard to whether they will, in the near future, enjoy the benefits of union organization in the traditional ways such as having a collective bargaining agreement. The model is reminiscent of the old IWW and early craft union practices of partially severing the meaning of unionism from its quasi-juridical forms and membership from contract unionism.

Clearly, we lack an adequate account of the character of this new playing field. But there have been useful beginnings by, among others, Marxists, and other radical intellectuals who have offered analyses of the new shape of economic and class relations; postmodern critiques of foundationalism and post-structuralist anti-essentialism; feminist critiques of the family, and the self; developing academic work on the nature of knowledge, including the emerging histories of the disciplines, critiques of science and technology as forms of domination; the rich work that has recently emerged within the sphere of "subaltern" studies, particularly work on nationalism and postcolonial societies and culture; the deconstruction of popular culture; the feminist and African-American challenge to the traditional canon; the calling into question of the traditional distinction between high and low culture.

But the distance between these theoretical interventions and radical politics remains wide. To our understandable "pessimism of the intellect" we urgently need a good dose of "optimism of the will." Composed while in a fascist prison, Gramsci's celebrated aphorism is no more relevant than now. Such an optimism would span the visionary and the mundane. We are hampered by our own prison-houses: the old ideas, the new anti-ideas, the liberalism of the intellectuals, the anti-intellectualism of the liberals, the fixed identities of the essentialists and the essentialism of the universalists.[19]

~ The objective of this chapter has been to ask some of the hard questions without which a radical revival is all but impossible. Clearly, radicals are not ready to start parties or even national organizations. To parody an old New Left slogan, we need "less action and more talk." Or, as Ellen Willis has remarked, "radicals have always tried to change the world; the task is to understand it."

I do not intend by the invocation of radical democracy to renounce socialism as a strategy of economic change, but I do contend that it can no longer remain a telos, a guiding principle for a movement of social emancipation. Since there is virtually no effective practice of socialist agitation, no serious effort to propose socialist alternatives, no attempt to link the specific ideology of socialism to the changing economic and political context of late capitalism or (on the strategic level), to the new social movements, there is no warrant, except sentiment bordering on religious faith, to hold on to the label *as the universalist unifying ideology*. Instead, I argue that what the left has often considered an entailment of the basic goal of social ownership—radical democracy—must become the new "universal" bond if its revival is at all possible.

The scare-quotes around this term signify a paradoxical characteristic of radical democracy: its pursuit can only be consonant with ideological and economic heterogeneity and the de-centering of political authority. In this frame, there can be no absolute principle of emancipation, let alone one that equates the achievement of freedom and equality with the abolition of all private property

in means of production, certainly no identification of socialism with state ownership. On the contrary, a radical democratic conception insists that more economic and social equality is not identical to the goal of freedom—sexual, gender, ecological, and individual—and that these "social" questions are, relatively speaking, sovereign and cannot be subordinated to class questions. At the same time, the egregious tendency of social movements to ignore class is equally unacceptable. For unless class exploitation and domination in all of its manifestations is addressed, freedom itself is endangered.

The evidence of the past century suggests that human emancipation, if that term may be employed at all in the postcommunist era, may be antagonistic to highly centralized authority and power in both capitalist societies and those in which economic and political power are held as state monopolies, such as the former Soviet Union, Eastern Europe, China, and Cuba. If these themes are at all valid, the condition for the emergence of a revitalized radicalism is a searching and fearless examination of the left's current malaise as well as its authoritarian political legacy.

In contrast to many who have responded to this situation by privatizing their lives, focusing exclusively on identity or local politics or, conversely, by putting on blinders and insisting that with the collapse of communism, socialism will arise like the phoenix from its ashes, I propose that the unifying concept that embraces the rise of new social movements and the end of the old phase in the movement(s) for human emancipation is *radical democracy*.

Throughout this book I have tried to flesh out what this means, in both its historical and contemporary senses. Radical democracy is not an unrealistic "utopian" invention of frustrated ideologues. Nor is it some kind of retreat from the *content* of what is sometimes called libertarian socialism. It has been, periodically, a strong tendency in the popular left and has, at times, become dominant for short periods. It traces its lineage not only to Marat, Babeuf's band of conspirators during the French Revolution's Thermidor and to the Paris Commune when, for a brief period, artisans and laborers controlled all major institutions of the city. It was present in the direct actions of the "crowd" of artisans and laborers who, during the American Revolution, demanded a single cameral legislature and rioted against the independent court system. Radical democracy was among the bases for antifederalism, which during the debate over the Constitution opposed the centralist direction of its leading drafters—Madison, Hamilton, and Jay.

In the twentieth century, radical democracy is the impulse of the formation of the soviets in the 1905 and 1917 Russian revolutions; the workers councils in Germany and Hungary in 1918; the factory occupations in Turin the following year; the 1936–37 sit-down strikes in the rubber, auto, and electrical industries that animated millions of industrial workers to the new mass unions of the CIO. It was the leading ideology of the the New Lefts of Germany and the United

States and became the key slogan of the Paris insurgency of May, 1968.

In contrast to conventional liberal, parliamentary democracy, radical democracy insists on *direct popular participation* in crucial decisions affecting our economic life, political and social institutions as well as everyday life. While this perspective does not exclude a limited role for representative institutions such as legislatures and management, it refuses the proposition according to which these institutions are conflated with the definition of democracy. Moreover, as I have already indicated, the concept of "representation" would be signficantly redefined by a new conception of the polity, the conditions for decision-making and the limits on representation.

Some of the unexamined questions entailed by radical democracy have been raised, albeit cynically, by the right. Do radicals favor, for example, the permanent government? Should politics remain a profession and politicians stand for reelection in perpetuity? In the radical tradition some of the questions have been: should representatives be of, as well as *for* the represented? Does it matter how large constituencies are? Can we have a radical democratic polity without conducting a struggle for *time* for participatory decision-making? For, as we have learned from the experience of past revolutions, work without end is inimical to a genuinely democratic polity.

In the workplace, radical democrats insist on extending the purview of participation to decisions over what is to be made as well as over how the collective product may be produced and distributed.

Proposals such as state ownership of enterprises are evaluated in terms of criteria of democratic management rather than those of efficiency. Democratic management entails further decisions, such as how much working time is compatible with its demands, the size of enterprises and social institutions, the kind and the quantity of resources such as child care and transportation facilities available to provide time for decision-making activities.

Although politics is still waged within the context of a national culture, and radicals have, at their own peril, ignored this fact, radical democracy is a plural universalism and necessarily transnational. It does not insist that there is only one morality, a single set of living and working arrangements, one true sexuality. But, it does insist that the power to make these decisions rests upon those affected by them. In this sense, the only universal is self-governance. Thus, radical democracy is by no means identical with the traditional ideology and practices either of the authoritarian left or of traditional left-liberalism.

In sum, the crucial choice for those considering the rebirth of radicalism today is this: the politics of rights and compassion or the politics of freedom? How do we distinguish negative from positive freedoms in the constitution of the institutions of governance? "Rights" presupposes the permanence of domination and seeks only to ameliorate its conditions. Freedom, both in negative and positive senses, may come in two stages of social development: the first is

liberation or emancipation *from* all forms of domination—familial, sexual, race, class, and state. The second is to establish the requisites for the free exercise of sovereignty over the conditions of life. The aim is not the interests of the community, the nation, the state, or the social group. It is to create the conditions for the free development of the *individual,* upon which the possibility of a satisfying collective life rests.

notes~

~Preface

1. Aileen Kraditor *The Radical Persuasion* Baton Rouge: Louisiana University Press, 1981.

2. Dwight Macdonald *The Root is Man* Brooklyn: Autonomedia, 1995.

~Introduction: The Death of the Left

1. Theodore Draper *The Roots of American Communism* New York, Viking Press, 1957.

2. For an account of the French Revolution from the perspective of the "bottom" see Albert Saboul *The French Revolution: From the Storming of the Bastille to Napoleon* New York, Vintage Books edition, 1975.

3. Emma Goldman *Anarchism and Other Essays* New York, Dover Publications, 1969; Paul Goodman *Nature Heals* New York, Free Life Editions, 1977.

4. Rudolph Rocker *Anarcho-Syndicalism* London, Pluto Press, 1989; Peter Kropotkin *Memoirs of a Revolutionist* Boston, Houghton Mifflin 1899.

5. Fraser Ottanelli *The Communist Party of the United States from the Depression to World War II*. New Brunswick, Rutgers University Press, 1991.

6. Mark Naison *The Communist Party in Harlem, 1926–1936* PhD. Dissertation, Columbia University, 1975.

7. Franz Borkenau *World Communism* Ann Arbor, University of Michigan Press, 1962.

8. Draper *Roots of American Communism* op cit; Paul Buhle *Paradise Lost: Louis Fraina/Lewis Corey and the Decline of American Radicalism* Atlantic Highlands, NJ, Humanities Press, 1995.

9. Peter Drucker *Max Schachtman and His Left*: *A Socialist's Odyssey Through the "American Century"* Atlantic Highlands, NJ, Humanities Press, 1994.

10. Leon Trotsky *The Revolution Betrayed* New York, Pathfinder Press, 1972.

11. V.I. Lenin *Left Wing Communism: An Infantile Disorder* New York, International Publishers, 1937.

12. Lowell D. Dyson *Red Harvest:The Communist Party and American Farmers* Lincoln, University of Nebraska Press, 1982; William Pratt "Farmers, Communists and the FBI in the Upper Midwest," *Agricultural History* Vol. 83, no. 3 Summer 1989.

13. The anti-CP left harbored deep resentment and had political differences with the party and its ideas. Perhaps most important for this animus was the CP's relative success in the 1930s and 1940s in attracting a fairly large group of workers and intellectuals and its broad penetration of many sectors of American life, especially culture. But, the Socialists and Trotskyists had other reasons for anger. The Communists broke up their rallies, sometimes beat them up, and engaged in political and personal vituperation against their activists.

14. Peter Drucker *Max Schachtman* gives several descriptions of the theoretical poverty of the CP, seen from Schachtman's eyes. See especially p. 53–55 on the theory of social fascism and see the critique of the popular front program of the party p. 77–82.

15. Warren Sussman *Culture and History* New York, Pantheon 1987; William Leach *Land of Desire: Merchants, Power and the New American Culture* New York, Vintage Books, 1993; Stuart Ewen *Captains of Consciousness* New York, McGraw-Hill 1976.

16. Daniel Singer *Is Socialism Doomed?* New York, Oxford University Press, 1988.

~Chapter One: When the New Left Was New

1. Ernst Bloch *Heritage of Our Times* Cambridge, MIT Press, 1990.

2. It is no secret that many of those who counted themselves among the so-called Beats were far from being leftists. If Ginsberg and Ferlinghetti were alligned with the New Left, others, notably Kerouac, were social conservatives and evinced little interest in the major political issues.

3. In 1993, Bill Nuchow was elected President of Joint Council 16 of the Teamsters Union. He was the candidate of what may be called the "Feinstein" wing of the union, named after the colorful, but ultimately ill-fated president of the large municipal workers Local 237. Nuchow died of a heart attack in 1994, a few months after taking office.

4. C. Wright Mills "Letter to the New Left" *Studies on the Left* Vol. 1, no.1 1959. Reprinted in C. Wright Mills *Power, Politics and People: The Essays of C. Wright Mills* edited by Irving Louis Horowitz, New York, Oxford University Press, 1963.

5. James Weinstein *Decline of American Socialism 1912–1925* Boston, Beacon Press, 1968.

6. Martin Sklar *The United States as a Developing Country* New York, Cambridge University Press, 1992. This volume contains several of the truly classic articles first published in *Studies,* and *Radical America.* See especially chapters four, five, and six.

7. Gabriel Kolko *Railroads and Regulation*; William Appleman Williams *Contours of American History* New York, Quadrangle Books, 1964.

8. While some versions of the thesis of labor's complicity with corporate capitalism as it developed in the twentieth century do not grant autonomy to the unions and other social movements, Sklar's argument is far more subtle. He links this phenomenon to the capacity of corporate capital to "integrate" its opposition, a perspective close to that of the Frankfurt School's. In chapter seven of *The United States . . .* he argues that revolutionary possibility is increasingly foreclosed by development—or what may be called "late" modernity—itself.

9. A. J. Muste *The Essays of A. J. Muste* edited by Nat Hentoff, Indianapolis and New York, Bobbs-Merrill Co., 1967.

10. James O'Connor "A Theory of Community Unions" *Studies on the Left,* 1965.

11. Jeremy Brecher *Strike* New York, Straight Arrow Press, 1972. Brecher's account of American labor history is perhaps the most resolutely oppositional and virtually unique in the literature. He interprets key labor struggles as veritable uprisings, denies firmly that concessions are granted workers by any other means than struggle and calls the 1946 post-war walkouts in leading industries a "general strike."

12. There are, of course, important exceptions. The work of former SDS'er and union activist Eric Mann in Southern California; the diligent intervention of Independent Socialists in the Teamsters Union through the rank-and-file movement called Teamsters for a Democratic Union contributed crucially to the victory of reformer Ron Carey in the 1990s over an entrenched political machine.

~Chapter Two: The New Left: An Analysis

1. Newt Gingrich "Speech to the Republican National Committee" *New York Times* January 21, 1995 p. 8.

2. Paul Goodman *Compulsory Mis-Education* and *The Community of Scholars* New York, Vintage Books, 1966.

3. Bernard Bailyn *The Ideological Origins of the American Revolution* Cambridge, Harvard University Press, 1967.

4. Lawrence Goodwyn *The Populist Moment* New York, Oxford University Press, 1978; Scott G. McNall *The Road to Rebellion: Class Formation and Kansas Populism 1865–1900* Chicago, University of Chicago Press, 1988. McNall follows Goodwyn's suggestion that populism was not merely a rear guard movement of a declining middle class, but was the political expression of new class formation.

5. Kolko *Railroads and Regulation* op cit.

6. The dialectic between the idea of "community" and democracy has been with us since the Greek city-state. For if the community is not merely a convenient geographic designation but connotes social, cultural, and political consensus among a large majority of the population, the fate of minority opinion, let alone cultural practices, is always in question. The struggle between the two is currently in progress over the cultural implications of alternative sexualities such as those of gays and lesbians. To paraphrase Hannah Arendt's characterization, the question is: "Can democracy flourish in the wake of the cultural or sexual question?"

7. Lewis Feuer *The Conflict of Generations: The Character and Significance of Student Movements* New York, Basic Books, 1969. See especially chapter eight, "The New Student Left of the Sixties," where Feuer offers a neo-Freudian interpretation.

8. The 1960s was the second moment, after the waning of the small merchant and small farmer at the turn of the twentieth century, when the middle class began a decline that was to have important consequences for politics. This time it was the transformation of the independent professional lawyers and physicians into salaried employees and the relative decline of the position of teachers and professors that provided some of the impetus for the student, antiwar, and ecology movements.

9.David Lance Goines *The Free Speech Movement* Berkeley, Ten Speed Press, 1993.

10. The *Man in the Grey Flannel Suit* adapted from a novel by Sloan Wilson was perhaps the most searing indictment of the emergence of the corporate "man" that Hollywood film could offer in the 1950s.

11. Karl Mannheim "The Problem of Generations" in Karl Mannheim *Essays in Sociology* London, Routledge and Kegan Paul, 1954.

12. Ibid.

13 Raymond Williams *The Country and the City* London and New York, Oxford University Press, 1973.

14. Paul Goodman *Growing Up Absurd* New York, Random House, 1960.

15. Kenneth Kenniston *The Uncommitted: Alienated Youth and Young Radicals in American Society* New York, Dell Publishing Co., 1960.

16. In 1962 I was invited by James Forman to give a workshop on economic and labor issues at a SNCC conference. In preliminary conversations, Forman told me that to have these discussions was a risk, since class and economic justice were still very controversial questions for the Southern civil rights movement.

17. Arthur Schlesinger Jr. *The Vital Center* Boston, Houghton Mifflin and Co., 1949. The longest chapter of the book, "The Communist Challenge to America," argues that the main objective of the party, apart from serving Soviet foreign policy, is to eliminate the independent left. Characteristically, Schlesinger accords the party absolutely no independent status and, while acknowedging the dedication and loyalty of many party members to the *issues* of social justice, regards the rank and file with faint condescension.

18. Harvard Sitkoff *A New Deal for Blacks* New York, Oxford University Press, 1978. Sitkoff makes crystal clear Roosevelt's hesitation to act boldly to advocate and provide full civil rights in federal employment and in the military. On Sitkoff's account blacks were largely responsible for the wartime gains in these spheres.

19. David Garrow *Martin Luther King and the FBI*

20. Rustin had to remain a pioneer in the shadows as long as he was the great teacher of tactics of civil disobedience. CORE and SCLC liberally used his services to train sit-in'ers and demonstrators. It was only when he acquired the shield of the Liberal Establishment that he was able to emerge from the shadows and speak in his now modulated voice.

21. C. Wright Mills *The New Men of Power* New York, Oxford University Press, 1948.

22. David Lockwood *The Blackcoated Worker* London, Allen and Unwin, 1958.

23. André Gorz *Strategy for Labor* Boston, Beacon Press, 1967; Serge Mallet *The New Working Class* London, Spokesman Books, 1984.

24. Robert Gottlieb, Gerry Tenney, and David Gilbert "Toward a Theory of Social Change in America" *New Left Notes* May 22, 1967.

25. Tom Hayden, letter to Ken Bacon n.d. SDS Archives, Tamiment Library.

26. Fall Program of *Economic Research and Action Project* September 6, 1964 p. 2. Tamiment Library.

27. Tom Hayden and Carl Wittman *An Interracial Movement of the Poor?* Students for a Democratic Society and Economic Research and Action Project,

1965. SDS Archives series 4B Reel #37 Hayden Reel R2560 p.22, Tamiment Library.

28. Richard Rothstein "Join Organizes City Poor" Students for a Democratic Society n.d. p. 2, Tamiment Library.

29. James O'Connor "Theory of Community Unions" *Studies* op cit.

~CHAPTER THREE: THE SITUATION OF THE LEFT IN THE UNITED STATES

1. Ulrich Beck *Risk Society: Toward a New Modernity* London and Los Angeles, Sage Publications, 1992.

2. Scott Lash and John Urry *The End of Organized Capitalism* Madison, University of Wisconsin Press, 1987.

3. Karl Popper *Conjectures and Refutations: The Growth of Scientific Knowledge* New York, Harper Torchbooks, 1968, p. 19. "There is...a deep analogy between meaning and truth, and there is a philosophical view—I have called it essentialism—which tries to link meaning and truth so closely that the temptation is to treat truth in the same way become almost irresistible."

4. Karl Marx *The Eighteenth Brumaire of Louis Bonaparte* in Karl Marx *Selected Works* Vol. 2, New York, International Publishers, n.d.

5. These remarks were made by Harrington in the early 1980s in many conversations of which I was a part. He made these points especially during the negotiations between DSOC and NAM in Spring, 1983.

6. Richard Hernnstein and Charles Murray *The Bell Curve* New York, The Free Press, 1994.

7. Nathan Glazer and Daniel Patrick Moynihan *Beyond the Melting Pot* New York, The Free Press, 1966.

8. Witness President Clinton's strong support for the Crime Bill in 1993, his advocacy of policies such as Workfare and his strong emphasis on internal security and antiterrorism. In contrast, with the exception of the failed Health Care Initiative, the administration was very slow to fight on his domestic reform agenda including ending the ability of employers to hire replacement workers for strikers.

9. Karl Polanyi *The Great Transformation* Boston: Beacon Press, 1957; Louis Hacker *The Triumph of American Capitalism* New York, Columbia University Press, 1941.

10. Marvin Surkin and Dan Georgakis *Detroit: I Do Mind Dying* New York, Saint Martin's Press, 1975.

11. Partha Chatterjee *Nationalist Thought in the Colonial World* Minneapolis, University of Minnesota Press, 1986, 1993.

12. Frederick Engels *Origins of the Family, Private Property, and the State* New York, International Publishers, 1939; August Bebel *Women and Socialism* New York, Socialist Literature Co., 1910.

13. Mari Jo Buhle *Women and American Socialism 1870–1920* Urbana, University of Illinois Press, 1981.

14. Sigmund Freud *Group Psychology and the Analysis of the Ego* trans. James Strachey, London, The Hogarth Press, 1948.

15. Wilhelm Reich *The Mass Psychology of Fascism* trans. Theodore Wolfe, New York, Orgone Press, 1946.

16. Jessica Benjamin *Bonds of Love: Psychoanalysis, Feminism and the Problem of Domination* New York, Pantheon Books, 1988; Nancy Chodorow *The Reproduction of Mothering* Berkeley, University of California Press, 1978.

17. See, for example Shulamith Firestone *Dialectic of Sex* New York William Morrow, 1970.

18. Joel Kovel *White Racism* New York, Pantheon Books, 1970.

19. David Roediger *The Wages of Whiteness* London and New York, Verso Books, 1991, chapter 7.

20. To be sure, Roediger deals with culture, but largely through representations such as music. The wider sense of culture as a "structure of feeling" or as ritual is largely absent from this otherwise insightful treatment of the construction of whiteness as a social and political category.

21. Sigmund Freud *Civilization and its Discontents* New York W. W. Norton and Co., 1961.

22. During the Cold War most of the nationalist movements within the communist world from Croatia to Tibet failed to win support from most pro-nationalist liberals and leftists because they were not considered *liberation* movements. Instead, many believed them to be agents of the Western powers, especially the United States. In the main, many on the left believed, with incredible naivete, that the Soviet Union could not, itself, be an imperialist power because it supported independence movements throughout the non-communist Third World.

23. Lawrence Mead *The New Politics of Poverty: The Non-Working Poor in America* New York, Basic books, 1992.

24. Robert Reich *The Work of Nations* New York, A. A. Knopf, 1991.

~CHAPTER FOUR: AGAINST THE LIBERAL STATE

I. Alisdair MacIntyre *After Virtue* South Bend, University of Notre Dame Press, 1984. But we don't need a Foucault to tell us what every politician in and out of government knows: control the agenda and you've won half the battle.

The other half is to call everything else out of order.

2. Hannah Arendt *Between Past and Present* "Tradition in the Modern Age" New York, Penguin Books, 1993; Claude Lefort *Democracy and Political Theory* Minneapolis, University of Minnesota Press, 1988.

3. Eric Lichten *Class, Power, and Austerity* South Hadley, Mass., Bergin and Garvey, 1986.

4. This is perhaps the most controversial aspect of ACT-UP's approach to public authority. Contrary to the invocations of, say, Hannah Arendt and Jürgen Habermas to create a public sphere in which discussion between rational actors may resolve differences, the movement has, tacitly, adopted Herbert Marcuse's notorious doctrine of repressive tolerance. According to this view, in a grossly unequal power situation, the oppressed have no obligation to observe discursive decorum. Needless to say the authoritarian implications on both sides of the debate have not yet been fully explored.

5. The question concerning representation is among the perennial issues in political theory, at least since Machiavelli beseeched the Prince to heed his subjects' will and, despite his arbitrary power, to build a base among them. The moment the "subjects" can articulate their own will, political authority contrives to homogenize difference in the service of stability. ACT-UP's contribution to political theory is to assert the impossibility of representative authority, when mandates are secured by ignoring and otherwise subverting real difference.

6. The element of suprise is among ACT-UP's most potent weapons. But, when the unexpected becomes a stock-in-trade of political combat may we speak of the routinization of outrage?

7. But New York ACT-UP has pressed for new laws to ban discrimination against AIDS victims in employment, housing etc. and has entered the budget debate in New York and nationally, without relying on legislation to solve the problems it raises.

8. Recall how the peace movement and many liberals expected that the end of the Cold War resulting from the collapse of the Soviet Union and Eastern European communist states would likely produce a "peace dividend." Instead, under pressure from the tax revolt the slow erosion of the military establishment has become the occasion for a massive campaign to reduce the size of government and to privatize its services.

9. H. L. Nieburg *In the Name of Science* New York, Quadrangle Books, 1965, is the pioneering study of the proliferation of the contract state and its conseqences for democratic politics after World War Two.

10. Among the most extensive discussions of citizenship in modern political theory are the works of Hannah Arendt. See especially "What is Freedom" in

Hannah Arendt *Between the Past and the Future* New York, Penguin Books, 1993.

11. Needless to say, among the most significant developments in the recent history of liberal states is the part played by secrecy, not only in the conduct of foreign policy or so-called national security, but also important so-called "domestic issues" As these words are written, three public interest organizations have threatened a civil suit against the Clinton White House task force on health care because its planning processes were conducted *in camera*. The plaintiffs contend that such activities must be subject to public scrutiny.

12. James Weinstein *The Corporate Ideal and the Liberal State* Boston, Beacon Press, 1968.

13. Hannah Arendt *On Revolution* New York, The Viking Press, 1963, p. 74–85.

14. Gilbert Elbaz ACT-UP *in New York City* City University of New York PhD. dissertation, 1993.

15. For a discussion of the issue of risk in contemporary politics see Danilo Zolo *The Politics of Complexity* State College, Penn., Penn State University Press, 1992 p. 60–62. In this book, under the rubric of *complexity* Zolo addresses directly the problem of achieving political trust and political legitimacy in an environment marked by instability and fear. He notes, without approbation, that under these conditions, from the perspective of oligarchic power, democracy appears to be an increasingly unwarranted risk. See also Ulrich Beck *The Risk Society* London and Los Angeles, Sage Publications, 1993.

16. John Judis "Labor Revival?" *New Republic* May 26, 1994.

~CHAPTER FIVE: TOWARD A POLITICS OF ALTERNATIVES, PART ONE

1. Anatoly Lunacharsky *On Education* Moscow, Progress Publishers, 1966; Mikhail Kalinin *On Education* New York, International Publishers, 1942; V.I. Lenin "The Tasks of Youth" in V. I. Lenin *Selected Works* Vol.2 Moscow, Progress Publishers, 1959.

2. Leon Trotsky *Literature and Revolution* University of Michigan Press, 1960.

3. Stephen F. Cohen *Bukharin and the Bolshevik Revolution: A Political Biography 1888–1938* New York, Vintage Books, 1975.

4. V. I. Lenin *State and Revolution* New York, International Publishers, 1937.

5. Joseph Stalin *Marxism and Linguistics* (pamphlet) New York, International Publishers, 1951; A. Zhadnov *On Literature and Art* New York, International Publishers, 1948.

6. Carl Schmitt *The Crisis of Parliamentary Democracy* Cambridge, MIT Press, 1989.

7. Schlesinger *The Vital Center* op cit; Michael Sandel, ed. *Liberalism and its Critics* New York, New York University Press 1984.

8. The Independent Socialist League—formed after a series of permutations, out of the dissidence of a number of Trotskyist militants with Trotsky's own call for the formation of a new international in 1938—was perhaps the most intellectually vital of all the radical political formations in the 1940s and 1950s. At its apex, among its leaders were the aforementioned Max Schachtman, Irving Howe, Michael Harrington, Julius and Phyllis Jacobson, Hal Jacobs, Lewis Coser, and many other subsequent luminaries.

9. Dwight Macdonald *Politics Past* New York: Vintage Books, 1975.

10. Isaiah Berlin "Two Concepts of Liberalism" in Sandel, ed., op cit pp. 15–36.

11. Jean Paul Sartre *Critique of Dialectical Reason* trans. Alan Sheridan-Smith, London, New left Books, 1976.

12. Hannah Arendt *On Revolution* New York, Viking Press, 1963.

13. ibid., chapter six.

14. ibid., p. 218–19.

15. Michael Sandel "Introduction" to Sandel, ed., *Liberalism* op cit, p. 4.

16. Seyla Benhabib *Situating the Self* Cambridge, Havard University Press, 1992; MacIntyre *After Virtue* op cit; Charles Taylor *Sources of the Self: The Making of Modern Identity* Cambridge, Harvard University Press, 1989.

17. In Sandel, ed., *Liberalism* p. 138.

18. Ian Watt *The Rise of the Novel* Berkeley, University of California Press, 1957; C. B. MacPherson *The Political Theory of Possessive Individualism* New York, Oxford University Press, 1962.

19. Max Horkheimer and Theodor Adorno *Dialectic of the Enlightenment* New York, Seabury Press, 1972.

20. Robert Bellah, et al *Habits of the Heart* Berkeley, University of California Press, 1988; Christopher Lasch *The Culture of Narcissism* New York W. W. Norton and Co.,1978.

21. Lasch *Culture* p. 5.

22. ibid., chapters one and two.

23 Allan Bloom *The Closing of the American Mind* New York, Simon and Shuster, 1987.

24. Lasch *Culture*, p. 111–12.

25. ibid., p. 126.

26. Paul Willis *Learning to Labor* New York, Columbia University Press, 1981.

27. Lasch *Culture*, p. 127.

28. Taylor *Sources*, chapter twenty-one.

29. Murray Bookchin *The Ecology of Freedom* Palo Alto, Cheshire Press, 1982, p. 43.

30. Horkheimer and Adorno *Dialectic*.

31. See Stanley Aronowitz *Science as Power* Minneapolis, University of Minnesota Press, 1988; Manuel De Landa *War in the Age of Smart Machines* New York, Zone Books, 1991.

32. Nicos Poulantzas *State, Power, Socialism* trans. Patrick Cammeller, London, Verso Books, 1978.

~Chapter Six: Toward a Politics of Alternatives, Part Two

1. Jean Cohen and Andrew Arato *Civil Society* Cambridge, MIT Press, 1990.

2. The pioneering studies are Elisha P. Douglass *Rebels and Democrats* Chapel Hill, University of North Carolina Press, 1955; Jackson Turner Main *The Anti-Federalists* Chapel Hill, University of North Carolina Press, 1961; see also Joshua Miller *The Rise and Fall of Democracy in Early America 1630–1789* State College, Pa., Pennsylvania State University Press, 1991. For the documents concerning Federalism and its critics see John P. Kaminski and Richard Leffler eds. *Federalists and Anti-Federalists* Madison, Madison House, 1988.

3. Linda M. Blum *Between Feminism and Labor: The Significance of Comparable Worth* Berkeley, University of California Press, 1991.

4. Stanley Aronowitz and William DiFazio *The Jobless Future: Sci-tech and the Dogma of Work* Minneapolis, University of Minnesota Press, 1991.

5. Jean Baudrillard *In the Shadow of Silent Majorities* Brooklyn, Autonomedia, 1986.

6. C. Wright Mills *Power Elite* New York, Oxford University Press, 1956, makes the argument from the perspective of a Weberian idea: that the military constitutes a relatively independent institutional order; see also Norbert Elias *Power and Civility* New York, Pantheon Books, 1982. For a different, although complimentary perspective see Gilles Deleuze and Félix Guattari "Nomadology" in *A Thousand Plateaus* Minneapolis, University of Minnesota Press, 1987.

7. This perspective is a reversal of Habermas' earlier view. See Jürgen Habermas *The Structural Transformation of the Public Sphere* trans. Thomas

Burger and Frederick Lawrence, Cambridge, MIT Press 1989.

8. Jürgen Habermas *Theory of Communicative Action* two volumes, Boston, Beacon Press, 1984, 1988.

9. Ironically, but consistent with their pose of antibureaucratism, conservatives have spearheaded the recent term limit movement. Of course, when they achieved a majority in Congress, they backed away from enacting a law.

10. C. Wright Mills "Private Troubles and Public Issues" in *Power, Politics, and People* ed. by Irving Louis Horowitz, New York, Oxford University Press, 1964.

11. Mark Fishman *Manufacturing the News* Austin, University of Texas Press, 1980; Debbie Nathan and Michael Snedeker *Satan's Silence* New York, Basic Books, 1995.

12. Michael Lind *The Next American Nation* New York, The Free Press, 1995.

13. Herbert Marcuse *One Dimensional Man* Boston, Beacon Press, 1964.

14. These contributions are well documented in Warren Belasco *Appetite for Change: How the Counterculture Took On the Food Industry 1966–1988* New York, Pantheon Books, 1990.

15 Arthur Schlesinger Jr. *The Disuniting of America* New York, Random House, 1991.

16. Gayatri Spivak *Outside In the Teaching Machine* New York, Routledge, 1994.

17. André Gorz *Strategy for Labor* op cit.

18. George Woodcock *Anarchism* New York, Libertarian Press, 1971.

19. Antonio Gramsci *Selections from the Prison Notebooks* trans. Quentin Hoare and Geoffrey Nowell Smith, New York, International Publishers, 1971.

index~